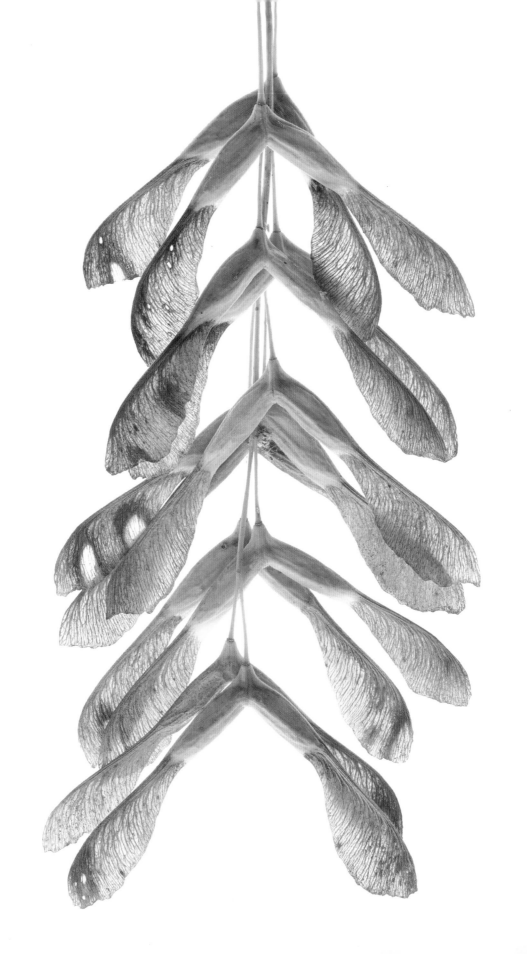

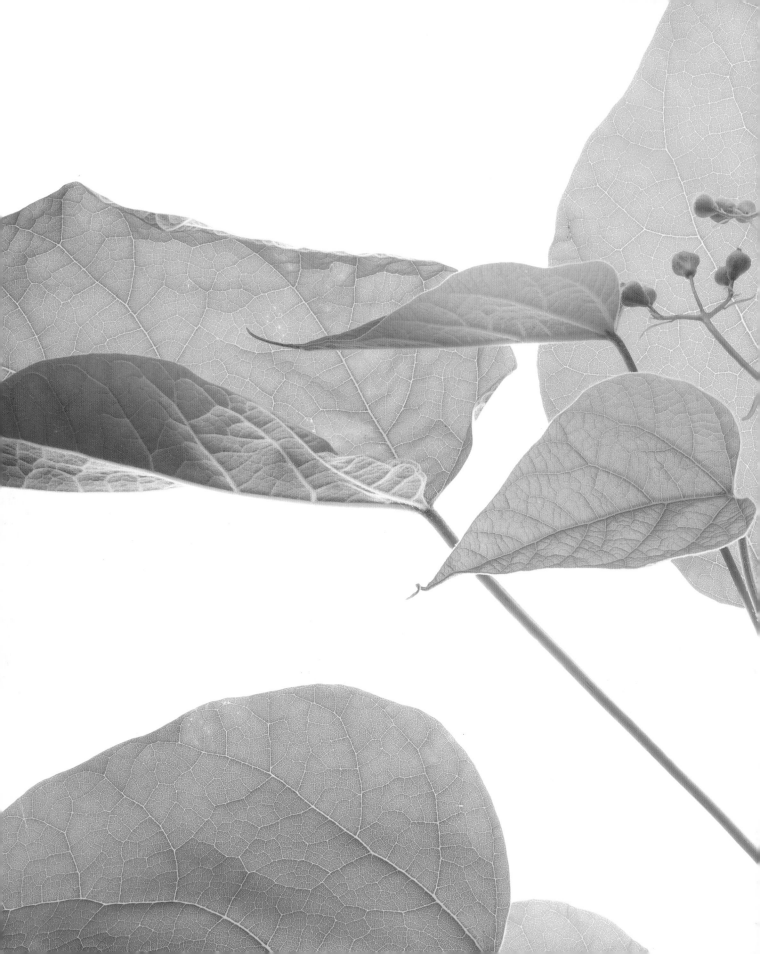

Seeing Trees

Discover the extraordinary
secrets of everyday trees

NANCY ROSS HUGO

Photography by
ROBERT LLEWELLYN

TIMBER PRESS
Portland · London

Page 1: Winged fruits (samaras) of boxelder (*Acer negundo*) hang in long, narrow clusters and often persist into the winter.

Pages 2–3: In addition to showy flowers and long, bean-like pods, northern catalpa (*Catalpa speciosa*) is notable for its large, lime-green leaves and shapely flower buds.

Opposite: The flowering dogwood (*Cornus florida*) leaf has interesting color and a characteristic venation pattern: its veins become nearly parallel as they approach leaf margins.

Information on sweetgum flowering, holly leaf miner, and red maple flowering from *Teaching the Trees: Lessons from the Forest* by Joan Maloof (University of Georgia Press, 2005) is reprinted by permission of the publisher.

Published in 2011 by Timber Press, Inc.

The Haseltine Building
133 S.W. Second Avenue, Suite 450
Portland, Oregon 97204-3527
timberpress.com

2 The Quadrant
135 Salusbury Road
London NW6 6RJ
timberpress.co.uk

Printed in China
Second printing 2011

Library of Congress Cataloging-in-Publication Data

Seeing trees: discover the extraordinary secrets of everyday trees/by Nancy Ross Hugo; photography by Robert Llewellyn—1st ed.
 p. cm.
 Includes bibliographical references and index.
 ISBN 978-1-60469-219-8
 1. Trees—Identification. 2. Trees—Pictorial works.
I. Llewellyn, Robert. II. Title.
 QK477.2.I4H84 2011
 582.16—dc22 2010052455

A catalog record for this book is also available from the British Library.

To JOHN HAYDEN
who helped us understand
what we were seeing

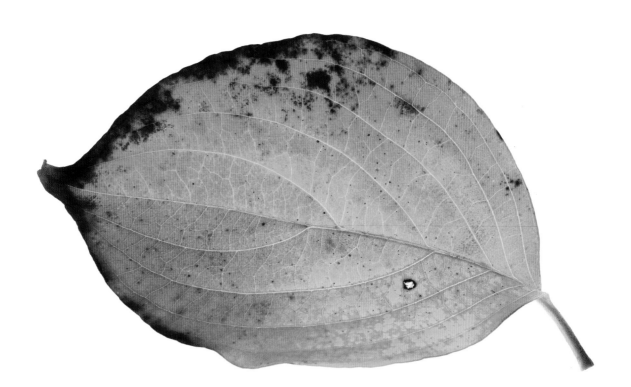

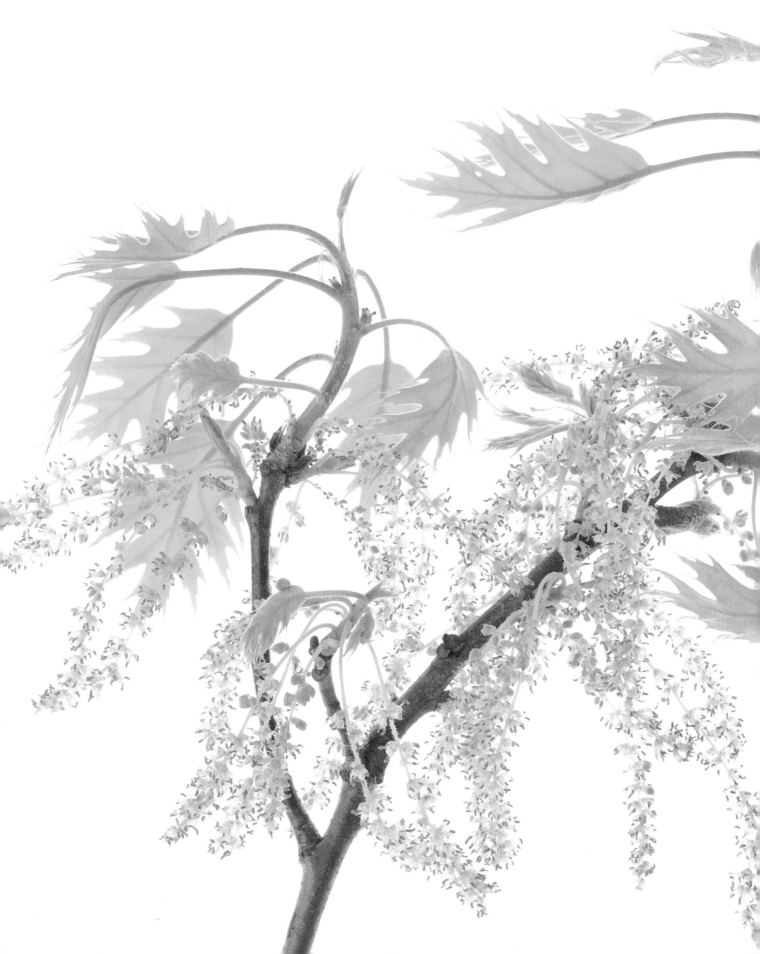

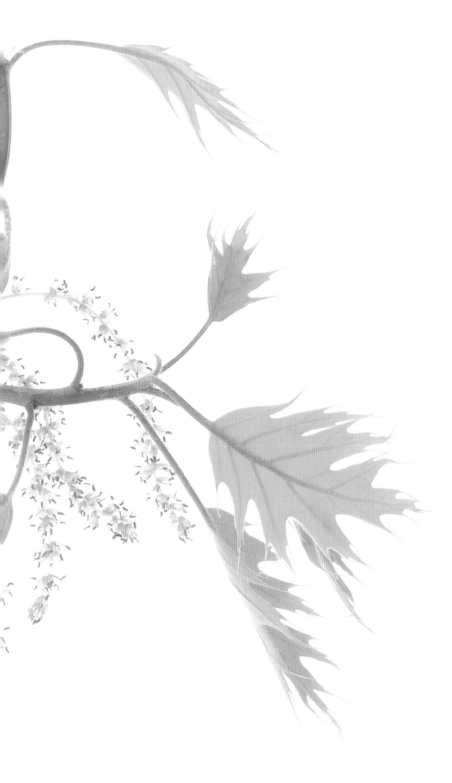

CONTENTS

Introduction	9
Tree Viewing	17
Getting Started	18
Viewing Strategies	24
Observing Tree Traits	37
Leaves	38
Flowers and Cones	52
Fruit	69
Buds and Leaf Scars	82
Bark and Twigs	90
Ten Trees: Intimate Views	103
American Beech	104
American Sycamore	116
Black Walnut	130
Eastern Red Cedar	140
Ginkgo	153
Red Maple	168
Southern Magnolia	178
Tulip Poplar	187
White Oak	198
White Pine	213
Afterword	227
Conversion Chart	233
References	234
Acknowledgments	236
Index	237

Male catkins and new leaves appear
at the same time on northern red oak
(*Quercus rubra*)

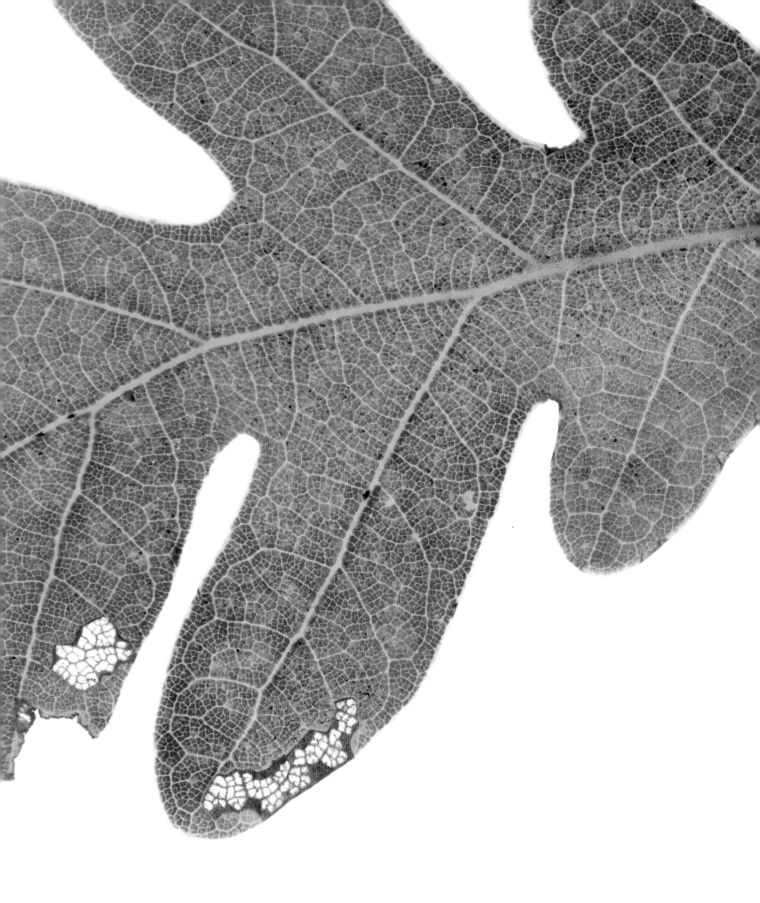

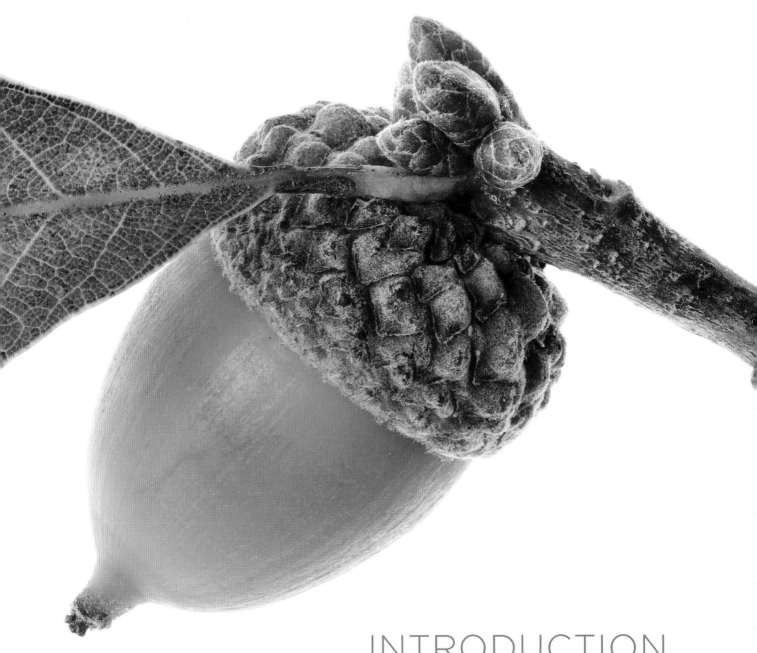

INTRODUCTION

"The greater part of the phenomena of Nature . . . are concealed from us all our lives. There is just as much beauty visible to us in the landscape as we are prepared to appreciate, and not a grain more. . . . A man sees only what concerns him."

— HENRY DAVID THOREAU

T HE ACORNS ARE plumping out." It was late August when my husband, John, made that casual observation, but there was nothing casual about my response to it. I was thrilled, not so much because the acorns were "plumping out," growing fatter and fatter under their caps, but because it meant John had caught the tree-watching bug, which is contagious. I guess you can't spend time with someone who pulls the ladder out to inspect tree flowers or festoons them with yarn bows to mark developing fruit without catching some enthusiasm for the subject.

In truth, John has always been an enthusiastic tree-watcher, but his sensibilities have grown with mine in the recent years we've spent watching trees up close. This kind of tree-watching is different from the kind that takes in trees at a glance, possibly names them, then assigns them to the category of thing to watch, like when they're leafing out in spring or when they're changing color in fall. There is always something to watch when you are paying attention to the intimate details that define tree species and the processes that characterize their life cycles. Like the Chinese, who divide the solar calendar into twenty-four rather than four seasons (among them, fortnights called "excited insects," "grains fill," "cold dew," and "frost descends"), a practiced tree-watcher knows there are dozens of seasons and that one of them could be called "acorns plumping out."

The rewards of observing intimate tree details such as maturing acorns, unfurling beech leaves, and emerging walnut flowers inspired photographer Robert Llewellyn and me to create this book. In a previous project, Bob and I traveled over 20,000 miles and spent four years

describing and illustrating the finest trees in our state, Virginia. We focused primarily on trees and their beauty in the landscape. Bob, who came to photography via engineering and has a keen interest in the way things work, began looking more carefully at the constituent parts of the trees we were visiting, and he was soon collecting twigs, flowers, fruits, and buds to examine and photograph in his studio. He argues that "picking up a camera makes you really see things," and soon he was discovering minute phenomena that further piqued his interest in the way trees work and live. To capture them, he mastered a new form of photography. Using software developed for work with microscopes Bob creates incredibly sharp images by stitching together eight to forty-five images of each subject, each shot at a different point of focus. And, inspired by botanical drawings, he photographs his subjects against a white background, which helps to isolate them and emphasize their detail.

Like a botanical painter, Bob wanted his photographs to "enlighten people about what's going on" in the natural world, but he also wanted to be enlightened himself. As we got into our work, Bob was soon full of questions about the functions of bud scales, fine leaf hairs, and other tree minutiae. He was learning which trees had separate male and female flowers, which had both, and which had "perfect" flowers (or flowers with both male and female parts). He was a question machine, and he looked to me for answers, but I am not a botanist. I am a tree lover from way back, and have been writing and teaching about trees for four decades (as a garden columnist, freelance journalist, and education manager at a botanical garden), but I felt out of my element trying to describe details of tree physiology.

Interestingly, though, when I approached more knowledgeable friends, including botanists, with some of my questions, I realized many of them had never noticed the phenomena Bob and I were observing, even though these phenomena are observable on common trees. And whenever I mentioned to colleagues the thrill of seeing

PREVIOUS In midsummer, white oak (*Quercus alba*) acorns begin to swell and their nuts show more prominently beneath their caps.

RIGHT The oak sprouting from this acorn is a chestnut oak, *Quercus montana*.

something like the pollination droplet on a ginkgo ovule, they were as intrigued as I was. So for *Seeing Trees*, I decided my job was to be the bridge between botanists and ordinary tree lovers who were put off by botanical nomenclature but interested—extremely interested—in seeing more and learning more about trees.

So: instead of traveling thousands of miles to see exceptional trees, as we had in our first collaboration, Bob and I decided to focus on the exceptional traits of ordinary trees. We did little traveling (unless you count walks across the lawn or rendezvous to meet each other), but we were no less impressed with what we saw. In fact, limiting and coordinating our visual fields was a bigger problem than finding worthy subjects to photograph and describe. "I can't keep up with what's going on in the backyard!" Bob admitted one day when we were talking about the surprising challenges of watching intently what's happening right under our noses. We exchanged many an urgent email ("The sassafras is blooming now!"), alerting each other to phenomena worthy of attention, but we soon learned how widely blooming times, not to mention leaf emergence and leaf fall, varied between our Virginia homes. Spring, it is said, advances up the United States at the average rate of about 15 miles a day, and ascends mountainsides at the rate of about 100 feet a day, so we got used to waiting—sometimes as long as two weeks—to observe the same phenomena.

Our goal in creating the book was to get people outdoors searching for tree phenomena like the ones we observed, because what is startling in Bob's photographs is infinitely more inspiring outdoors, where it can be appreciated in context and with all the senses. And it is in the process of discovering these phenomena in nature that the real joy of tree-watching resides.

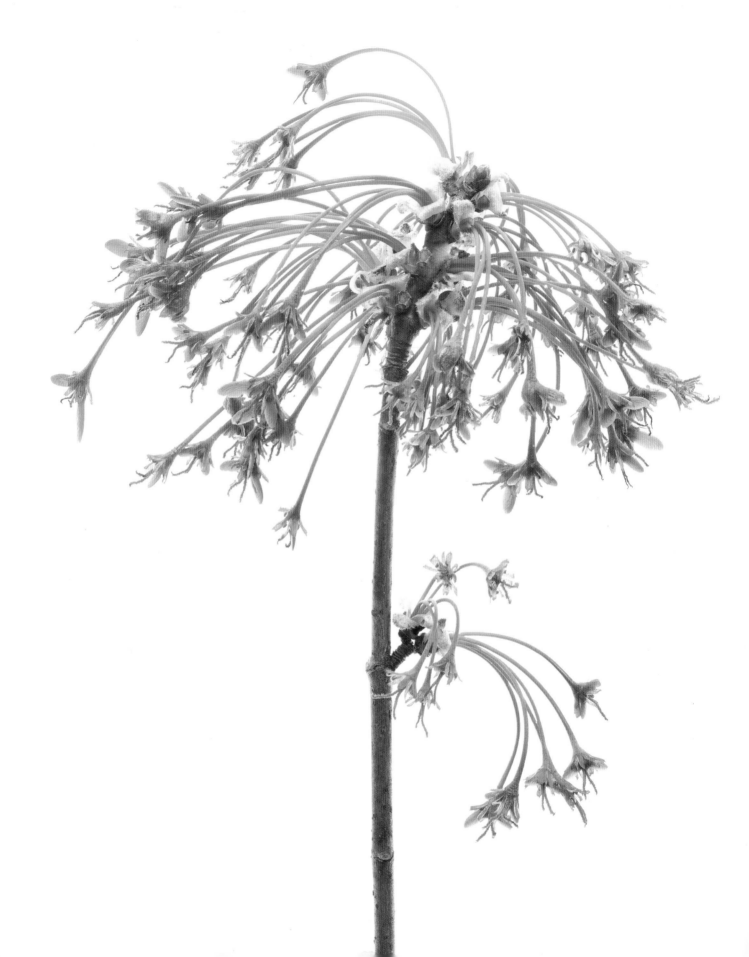

In the pages that follow, Bob and I illustrate and describe much of what we saw in two years of intense tree viewing. The categories of tree phenomena we attended to and the techniques we used could be applied to tree-watching anywhere in the world. In the first section, I describe some of the challenges of tree viewing, the importance of naming trees (or not), and some viewing strategies—activities and ways of watching that will help you see more. In the second section, I discuss in detail various tree traits, including leaves, flowers, cones, fruit, buds, leaf scars, bark, and twig structure, that, as they become more familiar, can inform your tree observations and help you know what to look for. In the third section, I describe my own process of discovery as I watched ten tree species carefully over time and witnessed, up close, their seasonal changes and species-specific behaviors. The ten trees we chose to profile in depth are American beech, American sycamore, black walnut, eastern red cedar, ginkgo, red maple, southern magnolia, tulip poplar, white oak, and white pine.

Choosing which ten tree species to profile was not an easy process. Like all tree lovers, Bob and I had our favorite trees and lobbied each other to include them. We had to include only trees that Bob and I could both watch carefully in our own yards or neighborhoods, which limited us to trees that grow in central Virginia. That was hardly a meager sample of trees, however, since our part of the world is particularly rich in tree species. Criteria we used for selection included the range of the tree (we wanted trees with geographic ranges as broad as possible), the prevalence of the tree (we opted for common over uncommon trees), and the degree to which the tree illustrated, in a compelling way, the features like buds, bark, flowers, and resting buds we had described earlier.

These female red maple (*Acer rubrum*) flowers on elongated stalks (pedicels) show the beginnings of some winged fruits, or helicopters, near their tips.

Charisma also counted. Because its range is limited to the southeastern United States, southern magnolia would never have made our ten species cut unless it had not also been one of the most charismatic trees on the planet. "Woman has no seductions for the man who cannot keep his eyes off his magnolias," a wag once observed, and Bob is among the men smitten by the southern magnolia. The passion that one or both of us felt for a tree species also counted in our deliberations, since it would be hard to write about, or spend time photographing, a tree one had no affection for (although in the case of trees, familiarity tends to breed affection, and any tree I examine closely over time seems to become a favorite).

In addition to the ten featured tree species, you will find a good sampling of additional trees with broad ranges discussed and illustrated throughout the rest of the book. Among them are flowering dogwood, horsechestnut, catalpa, Osage-orange, redbud, persimmon, and sweetgum. These trees richly reward intimate viewing, so if you have one of them nearby, give it a closer look. Sweetgum, in particular, would make a rapid leap from being perceived as a trash tree to being considered a natural wonder if its buds, flowers, and fruit were more often observed up close and its colorful leaves better appreciated for their myriad colors.

In *Seeing Trees*, we want to convey that tree viewing can be as exciting as bird-watching (perhaps even more exciting, if trees are your favorite wild beings) and that through intimate viewing, one's sense of trees as living, breathing organisms, as opposed to inanimate objects, will be enhanced. Look carefully, for example, at the hair, veins, pores, and other wildly vivifying tree characteristics captured in the photographs in this book, and you'll never see a tree in the same way again.

To my mind, the biggest reward of intimate tree-watching is learning to appreciate the vitality of trees. Because trees are big and essentially stationary, there is a tendency to view them almost like monuments—impressive but inanimate. We value trees for their slow,

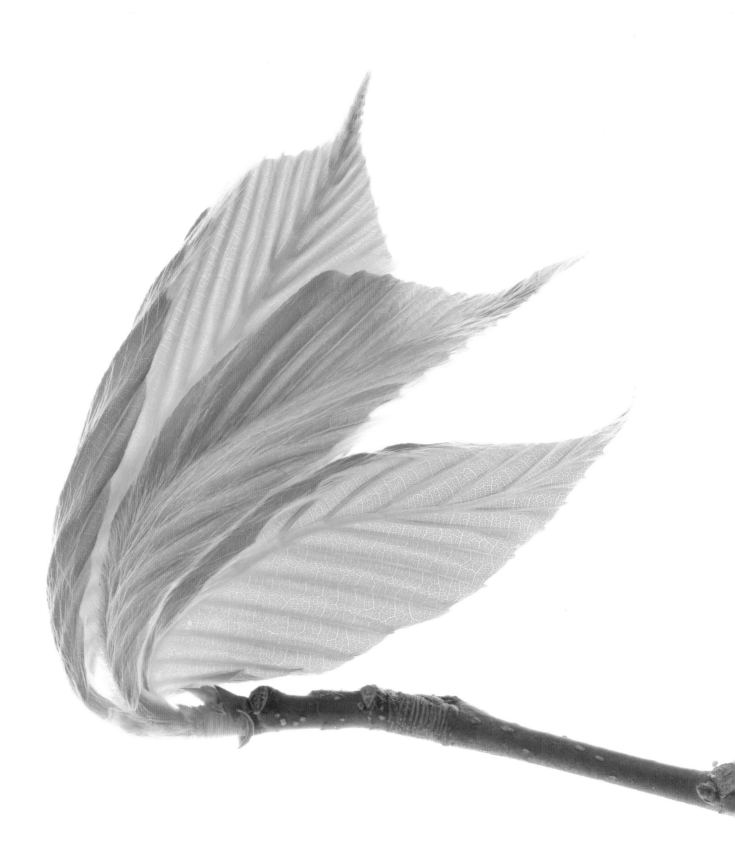

inexorable growth, seeing them as symbols of fortitude and patience, but with slow, incremental growth being almost impossible to observe, the living essence of trees is a bit hard to appreciate. Not so when you are observing actively growing buds, flowers, fruits, and other tree traits that take less time than a trunk to develop. "This is where the action is!" I've wanted to shout more than once when some inarguably animate tree phenomenon has grabbed my attention. And Bob is famous for using the horror-movie-with-aliens phrase "It's alive!" when encountering some startling evidence of tree vitality like gracefully unfurl-ing leaves, protective hairs, working veins, or sticky exudations.

Other rewards of intimate tree viewing include the insight such observations provide to the way trees work (wherever possible, I describe the functions of all the little what-nots Bob has illustrated) and the joy of observing traits trees have taken millions of years to develop. Almost every paean to trees includes some description of what trees do for human beings (wonderful things, important things), but even if trees performed no ecological services, I would want to observe them regularly and intimately just to experience the brilliance of their engineering. Every time I think about, much less witness, the way a pleated beech leaf unfolds from its bud, the way a catalpa flower directs pollinators to its nectar, or the way a sycamore petiole protects the leaf bud below, I am astounded by the genius of the thing and want to observe more. Trees identifiable as trees have been evolving for 397 million years (humans identifiable as humans for only 3 million), and there is no small wisdom in the adaptations they have made to survive in a changing environment.

Like most writers and photographers who value what they describe and illustrate, Bob and I hope this book will help make the world safer for trees. In my most romantic imaginings, I sometimes think that if I could just draw enough people's attention to the beauty of red maple blossoms, to the extraordinary engineering of gumballs, and to the intricacy of phenomena such as pinecones, all would be well in the tree world. That *is* a romantic notion. But sometimes romance can accomplish what rhetoric cannot. As the British naturalist Peter Scott once observed (to author Roger Deakin), "The most effective way to save the threatened and decimated natural world is to cause people to fall in love with it again, with its beauty and its reality."

LEFT Newly emerged American beech leaves, free of their protective bud scales, are pleated, retaining for a short while the folds that were present when they were packed in the bud.

RIGHT Think of the multichambered gumball not as a nuisance but as the masterfully engineered multiple fruit of sweetgum, *Liquidambar styraciflua*. Each chamber of this spiky contraption holds two tiny winged seeds.

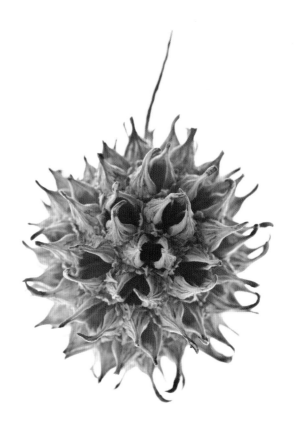

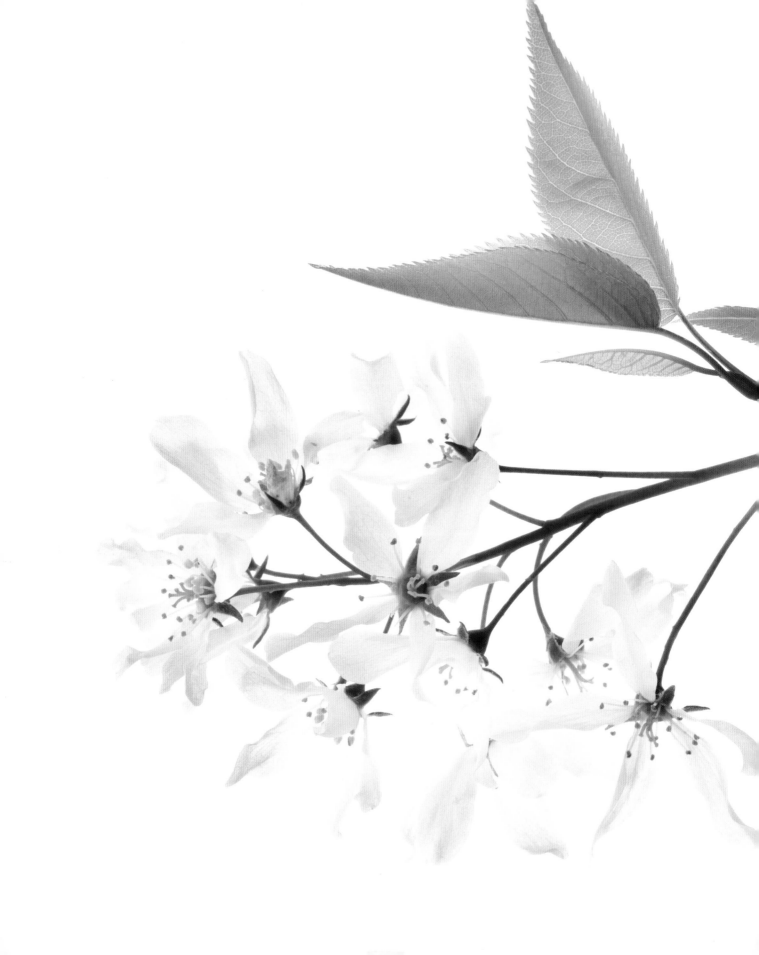

TREE VIEWING

"Thinking is more interesting than knowing,
but not so interesting as looking."

—Johann Wolfgang von Goethe

ON AN EARLY summer morning, walking up the hill from the river, I spotted an unusual plant part on the road. Smaller than a dime, it looked like a puffed-up, four-pointed green star or miniature UFO. It was definitely otherworldly looking and unlike anything I had ever seen before. I carried it up the hill but got distracted and lost it. A week later, walking up the same hill, I looked toward where I had spotted the small UFO and noticed the bark of a persimmon tree with its unmistakable, dark brown checkered pattern. A clue: my little UFO must have come from the persimmon tree. An aborted flower maybe? Its shape seemed somehow reminiscent of the frilly skirt (calyx) around the bottom of a persimmon fruit.

All it took was that prompt—that intriguing, tiny, green plant part—to start me on a learning curve that continued when someone sent me a photo of a persimmon flower, stretched farther when my research revealed that male and female persimmon flowers occur on separate trees, and then took off like a kite line when I found a fruit-bearing branch low enough to watch carefully. Wow! I had always had a passion for persimmon fruit—the apricot color of its seedy flesh alone deserves a praise poem—but the stages of the fruit's development and the flowering that precedes the fruiting were new and exciting categories.

GETTING STARTED

Attending to categories like buds, flowers, and fruits extends both our appreciation and knowledge of trees, and yet we tend to overlook these small phenomena. Part of the reason for this is what I call the "one lens problem." Because we have overdetermined images of trees in our brains, we tend to use only one lens when viewing them— a wide-angle lens that takes in the whole tree and does

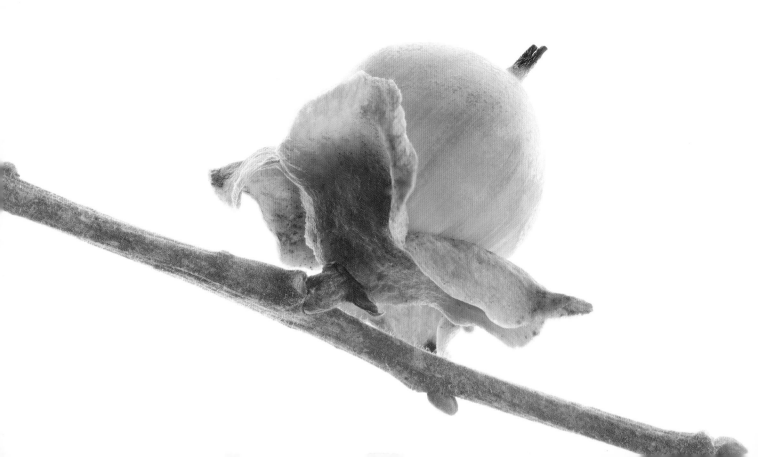

its best to capture that "ball of leaves on a trunk" look. But if we view them with close-up lenses, we can take in much more information. Close-ups of garden flowers and insects have taught us how much microscopic mystery there is in natural phenomena, but trees, because so much of their majesty is in their bigness, have been relatively ignored as subjects for close-up, much less microscopic, views. When I go out to search for a tree flower or an immature fruit or a resting bud or a leaf scar, I know that what I am looking for has been seen before. In fact I am often using a search image, or something that shows me what to look for, that I've found on the Internet or in a field guide. But when I find what I'm looking for or gain some unexpected reward for close-up viewing, I feel as if I'm the first person to have ever discovered that tree feature, so relatively unreported are these phenomena.

Trees don't reveal their secrets as easily as you might think, though. Because they stand still, you'd think tree viewing would be much easier than, say, bird-watching, but even trees can be elusive. For one thing, many tree traits are time sensitive. If you want to find beechnuts or sassafras fruit, for example, you'll have to time your visits to their production (or watch consistently enough that you don't miss them) and get to the fruit before hungry animals do. Leaves, for all their beauty, can also be obstacles to discovery because they sometimes hide phenomena like flowers and fruits, and you may need binoculars to see events in the tops of trees. Looking down on a tree from a high hill or second-story window can also reveal otherwise hidden tree phenomena.

Other complications involve lean years when a tree

PREVIOUS Flowers like these serviceberry (*Amelanchier* species) flowers are considered "perfect" because they have both male and female parts.

LEFT Persimmon fruit is charismatic in all its stages. Here, the immature fruit of the persimmon (*Diospyros virginiana*) still has tiny black stigmas protruding from the top of the fruit; its prominent green calyx clasps the fruit below.

produces little of the fruit you are looking for, late frosts that can wipe out a tree's flowers, drought that can result in premature fruit or leaf fall, and immaturity (some trees don't flower or fruit until they reach a particular age). Then there's the problem of your own unpredictability: missing the catalpa flowers because you're away on vacation, or failing to see the transition between an unfurling and fully formed beech leaf because you let too much time pass between observations. Trees are more committed to their maturational objectives than people usually are to their observational goals.

The best way to see trees is to watch them regularly over many years. The more you watch, the more you see, but any degree of observation can be rewarding. You can watch trees and make discoveries about them without changing your lifestyle. Just carefully observing the trees you pass every day on the way to the mailbox, or attending to the trees near your children's ball fields, or watching the trees near your subway stop can reveal traits and patterns of startling complexity. Once you become alert to them, you'd be surprised how many opportunities there are for tree viewing. I discovered something interesting about red maple flowers while waiting to pick up a friend at the train station; the train was late, providing an opportunity to examine red maples in a nearby parking lot. Turned out they were all males. I've left shopping malls feeling despondent, only to be cheered by leaves that gathered by my car tires while I was indoors (where did you blow in from?!). And traveling provides all sorts of opportunities for roadside tree viewing, especially if you travel regular paths where you can observe seasonal changes. You'd think regular tree-watching would be like checking lobster traps—lots of watching, not much action—but I find the opposite to be true. Like Bob, who said he couldn't keep up with the tree action going on in his backyard, I'm more often overstimulated by the trees I encounter.

And finally, there is one variable associated with tree viewing that I'm not sure whether to characterize as a

help or a hindrance: it is naming. We usually assume that we know a tree if we identify it by name; in fact naming trees is sometimes considered the *sine qua non* of knowing trees. There is certainly a positive correlation, in my experience, between the people who can name a cherry-bark oak accurately and those who can spot a cottonwood crown at 200 yards. These people know their tree names *and* their tree personalities. They are tree experts. For the rest of us, naming can be a trap. It's true that a shared language helps us communicate information about trees, but there is an equal tendency to think that by knowing a tree's name we know all there is to know about it. As if the word *oak* sums up all there is to know about this intricate amalgam of arboreal architecture, evolutionary history, and life energy. Botanical names can be even more troublesome, because they are off-putting—shutting the ears of those who despair of ever learning this secret Linnaean language.

My take on the naming issue is: learn to associate the trees you encounter with some name, even if you have to make it up. This is, in fact, a great activity for children—having them make up names for trees they encounter based on that tree's physical characteristics. If you really were the official namer of a particular tree species, think how closely you'd observe it!

The first Latin names applied to trees were actually long descriptive phrases like "beech tree with spear-shaped leaves sharply serrated, with knobby, thread-like catkins" for the tree we commonly call American beech. Swedish botanist Carl Linnaeus changed that system, but all names are human inventions, so you should feel free to make up a new common name if you want to. The rub comes when you want to communicate with others and discover that the tree you call bee tree is blackgum or tupelo to others. The system of binomial nomenclature invented by Linnaeus—the Latin genus name followed by

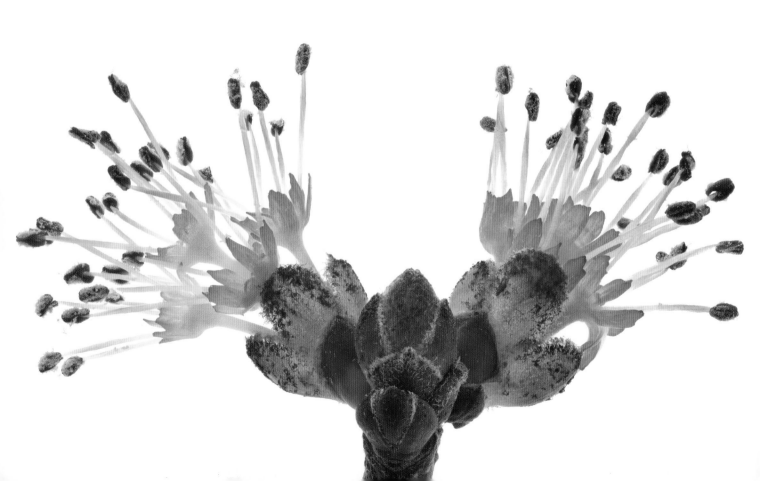

Latin species name—provides naming consistency. Even backyard naturalists will discover that a Google search of *Nyssa sylvatica* (bee tree, tupelo, or blackgum) turns up more authoritative information than a search of bee tree does. But I have learned many intriguing facts about trees from people who do not know the Latin names. In the same way that I feel more connected to friends whose legal names and nicknames I know, I feel more connected to trees whose many names, common and scientific, I know, but I think it's more important to be an honest, careful observer than it is to be an accomplished namer. It is quite possible to know a tree intimately—by bark, leaf, posture, flower, fruit, or an infinite number of other characteristics—without knowing what other people call it, but a name will help you organize and communicate what you see.

In the end, it's not the changeable names so much as it is the consistent, species-specific, physical characteristics of the tree that provide the most satisfying tree connections. We like what we know, and the pleasure is profound in being able to recognize the obvious and the not-so-obvious characteristics of particular trees. "I was so sad to hear ailanthus is a bad tree," a friend once told me in response to an article I'd written about the invasive tendencies of this common tree (also known as tree-of-heaven). "I loved it because I could recognize it when it wasn't in leaf." Ah yes, the heart-shaped leaf scars, the stout, velvety twigs, and the peanut butter smell of ailanthus. I love all these things about ailanthus, too, and not because they are so inherently loveable but just because I know them. "What we can't identify doesn't exist for us,"

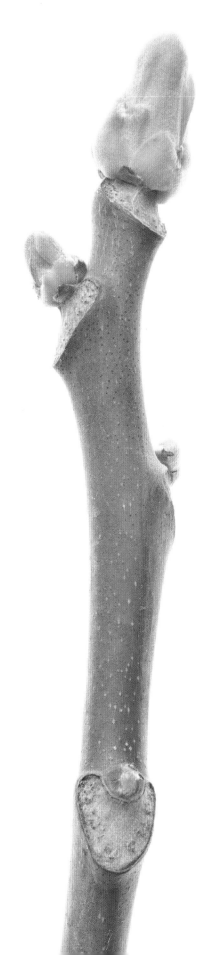

LEFT Anthers, the dark brown tips on the pinkish filaments, of these male red maple (*Acer rubrum*) flowers are releasing pollen.

RIGHT One of the easiest trees to identify without leaves, *Ailanthus altissima*, tree-of-heaven, has stout twigs with a velvety texture, heart-shaped leaf scars, and an unusual fragrance (like peanut butter) when its bark is abraded.

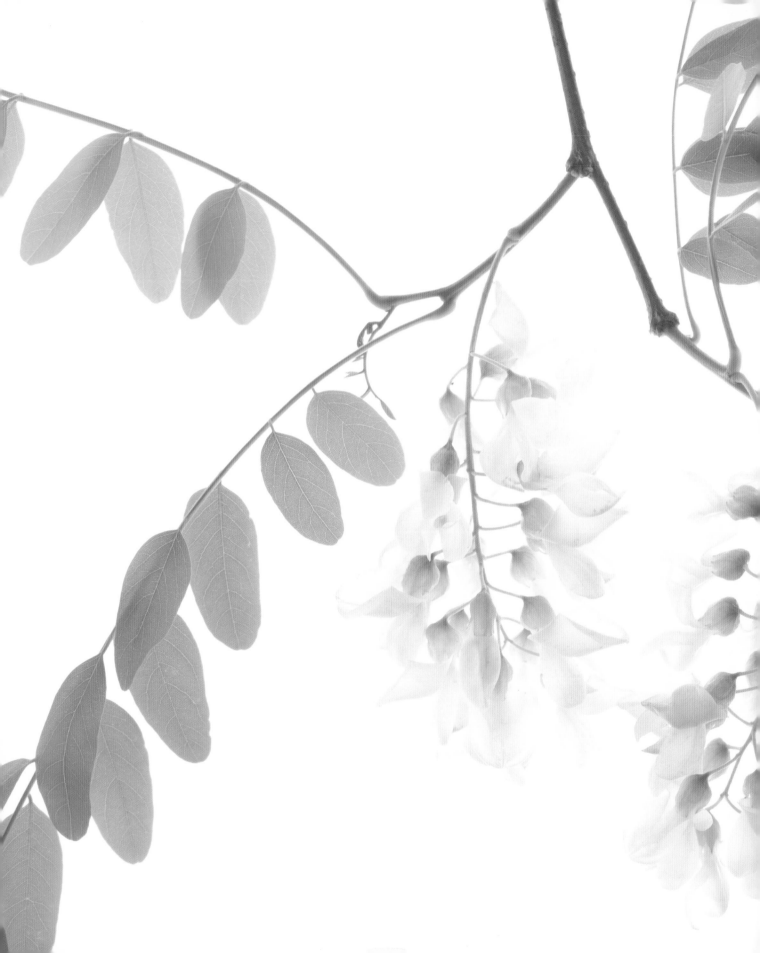

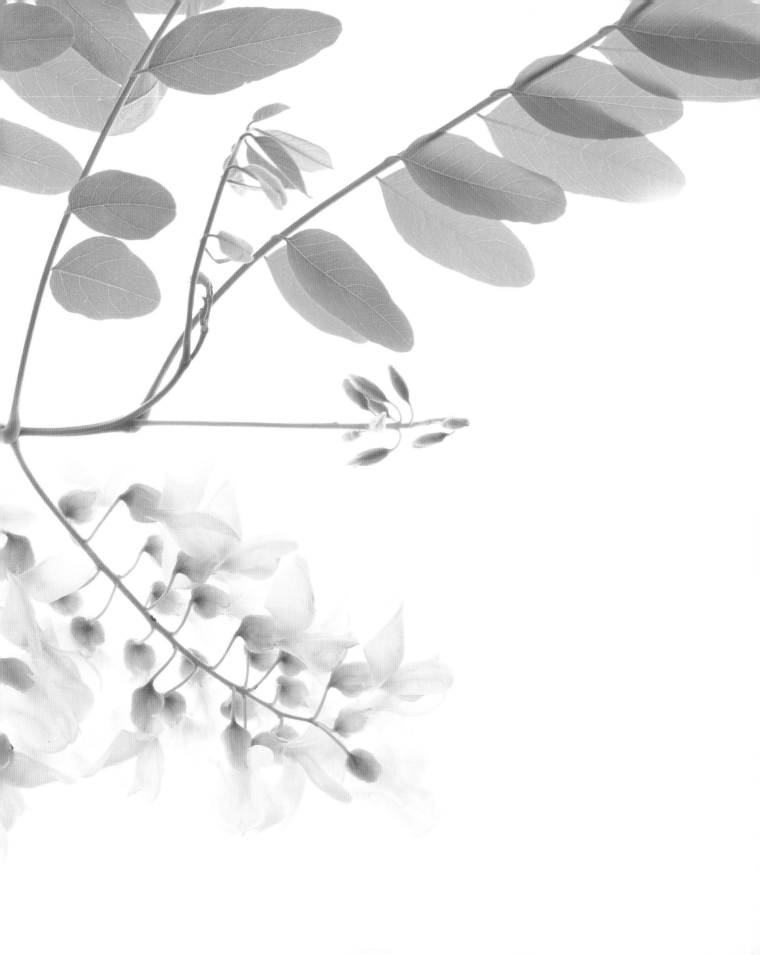

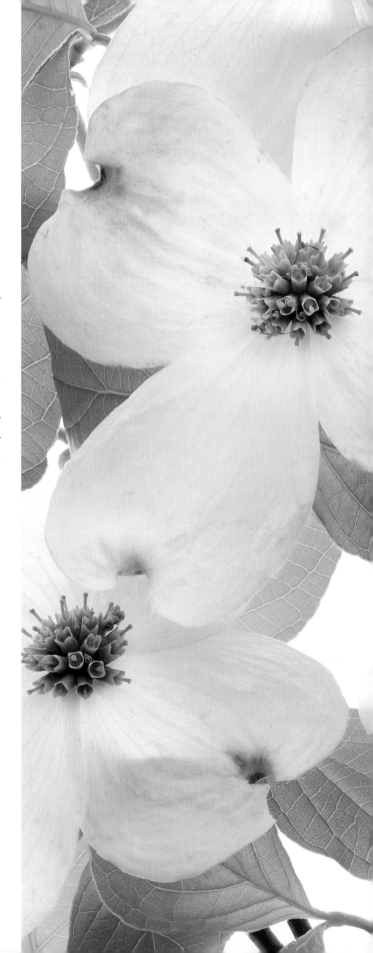

Bernd Heinrich points out in *The Trees in My Forest*, and by extension, what we can identify, we own.

We take psychological possession of the things we can recognize. To me, getting to know a tree is like getting to know a human being—the more you know, the more the relationship deepens, and a person's (or a tree's) capacity to surprise you never ends. You may, for example, think you know the flowering dogwood. If it is your state tree, as it is mine, you have probably learned that the white appendages that look like its petals are technically bracts (modified leaves) and that its real flowers are in the center of what we think of as the blossom. But only when you look closer, into the dogwood's real flowers—about twenty of them clustered in the middle, each with four yellow-green petals—and actually see them blooming, each tiny flower with its complement of four stamens and pistil, does this distinction become meaningful. Like discovering that a person you knew for one talent is accomplished in another (my brain surgeon plays the clarinet?), discovering new tree traits broadens your appreciation of the tree. And there is absolutely no end to the tree traits waiting to be discovered even in an ordinary backyard.

VIEWING STRATEGIES

It is midspring and the peonies and irises are eliciting appreciative gasps, but it is the American holly flowers I want to point out. "See. Here. These are the flowers that precede the famous December berries." Fragrant and beloved by bees, these tiny female flowers (which

PREVIOUS The fragrant, nectar-rich flowers of black locust (*Robinia pseudoacacia*) bloom in late spring and are as attractive to bees as they are to people.

RIGHT A favorite landscape tree throughout its range (most of the eastern United States and parts of Canada), flowering dogwood, *Cornus florida*, offers four-season beauty, but its spring blooms are particularly noteworthy.

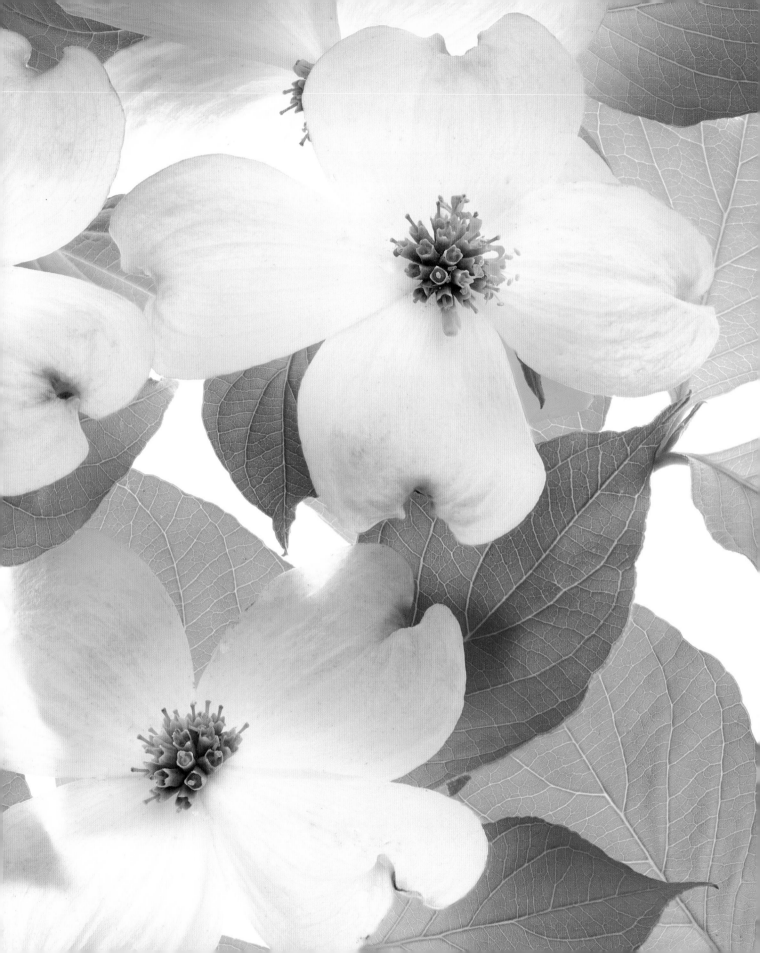

appear on trees separate from the male trees) may never inspire the raves that showier garden flowers do, but there is something tremendously satisfying about observing them. For one thing, they are seldom observed, so being familiar with them makes you feel privy to a special secret. And for another, it may dawn on you that there isn't one miraculous moment when these flowers morph into berries; rather, there is a series of stages as these flowers mature into berries—and you haven't witnessed them all!

Watching the same tree part—big or small—over time is one of the many strategies for getting to know trees better, and there are more opportunities for doing it than most people realize. To see performances like the unfurling of a beech leaf, the maturation of a holly flower, or the swelling of a horsechestnut bud, you don't have to own a forest or dedicate an hour a day to the process. Not only do parks offer opportunities for viewing but trees on the street can be as interesting as trees in the forest. I have seen ginkgos growing along Manhattan sidewalks that could occupy one's eyes for a lifetime, and weedy ailanthus trees growing in alleys make fine subjects for viewing. Picking one tree or tree part to watch intently actually helps narrow one's field of vision, and even if there is only one tree you pass on your way to work, paying it some attention can reveal far more than you might imagine.

One strategy for seeing more is to look down instead of up. Most trees are tall and, yes, most of their mass is usually above our heads, but you'll find an enormous amount of tree material discarded on the ground. I'm avoiding using the words "tree debris" or "tree litter" because I don't consider this material trash. I consider it detritus laden with treasures, like shells on a seashore. For one thing, the leaves and fruits of many trees are so far above our heads, we can't experience them up close until they fall to the ground. For another, the timing of these discards (when does all that sycamore fluff get in the gutters? when do the mulberry leaves fall, before or after the sugar maples?) is as revealing of natural rhythms as the much ballyhooed arrival of fall leaf colors. It is an event to mark time around. Old leaves, needles, pods, nuts, acorns, seeds, twigs—this is not tree litter; it is shed tree information.

During the planning process for the children's garden at the Lewis Ginter Botanical Garden, I worked with a coordinator of children's education who had the wisdom to insist that some "messy" trees be included in the landscape plan. She made a list of all the trees that "dropped good kid stuff"—petals, pods, cones, twigs, leaves of vary-

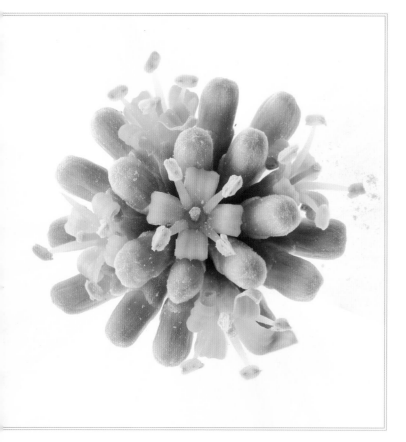

LEFT *Cornus florida*'s true flowers cluster in the center of the tree's white, petal-like bracts.

RIGHT A large, sticky bud is one of the identifying features of common horsechestnut, *Aesculus hippocastanum*.

ing descriptions—to make sure the garden was engaging to students. There are maintenance issues with all this material, of course, but without sweetgum balls, what would the kids throw? The movement to breed tidiness into trees (gumball-less sweetgums, key-less maples, fruit-less fruit trees) seems to me misguided. I wish we could change the people instead, making them more apprecia-tive of all the doodads it has taken trees millions of years to engineer.

Anyway, where you have trees that drop "debris," do look down. And be alert to the gifts associated with wind-falls. Sometimes, in addition to reminding you how much wood a tree has been holding aloft, a storm will bring down a branch laden with phenomena that usually remain hidden to the viewer. A Virginia botanist once called me just to report her vast good fortune when a sweetgum branch fell near her house, because in addition to still holding some gumballs from the previous year, it was bedecked with seldom-seen sweetgum flowers. Squir-rels also often add to what we can see by sending buds, fruits, and flowers dropping to the ground.

Another tree viewing strategy is to find yourself a good guide—a person who can show you tree traits you might overlook. Master naturalists, good gardeners, biologists, tree stewards, arborists, foresters, anyone who spends lots of time outdoors around trees (and even some window naturalists) can point out interesting tree traits to you. This is the way I learn best—with a good guide at my side. I don't know that I'd have ever noticed the unique engi-neering involved in the plunger-like way a sycamore leaf attaches to its twig, totally surrounding the resting bud, but that phenomenon, pointed out to me by an arborist, is now something I share with anyone who happens into my space and a sycamore's at the same time.

We twenty-first century folk also have access to a resource that you might call "the new neighborhood nat-uralist," and in some ways, this resource—the Internet—puts the old neighborhood naturalist to shame. You prob-ably won't have the sun on your back while you're doing

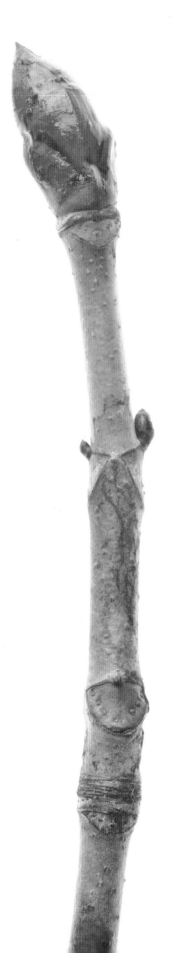

it, but you can use the Internet to guide you to more tree information than has ever been available to humankind. Name the tree and someone out there (probably hundreds of someones) has created a website profiling it. All you need to know is the common or botanical name of the tree and on the Web you can find photos and detailed descriptions of its flowers, fruit, posture, twig characteristics, leaves, bark, insect companions, bird friends, and more. (The USDA plant database and two volumes of *Silvics of North America*, all available online, are particularly useful.) Sometimes the photos and descriptions you find will be good, sometimes not so good. And sometimes the information you find will be incomplete or scientifically outdated. Fortunately, however, all you're usually looking for are search images or descriptions of phenomena that can be easily confirmed, or not, outdoors. Field guides provide lots of this information, too, and I have a library full of field guides, but I'd never seen a photo or a drawing of a female walnut flower until I discovered it on the Internet (and then in my neighbor's yard).

Other aids to seeing include books by tree experts and talented naturalists, which can extend your awareness of what there is to see, and many of them do so even without photos. Will Cohu's descriptions of trees near the lay-bys and car parks of England in *Out of the Woods: The Armchair Guide to Trees* are better than photos in providing incentive to look harder for the "two sorts of dangly wotsits" (cones and catkins) on the alder and the "filthy fingernails" (resting buds) of the ash. Since basic tree biology doesn't change, even old books can be a huge help, and in fact, it is the "old" naturalists who seem to have had the time and inclination to provide some of the best tree descriptions. Books that I've found particularly helpful include classics by Donald Culross Peattie, Joseph S. Illick, and Walter E. Rogers, which are listed in the

Any American holly (*Ilex opaca*) that bears red berries will have female flowers like these before the fruit.

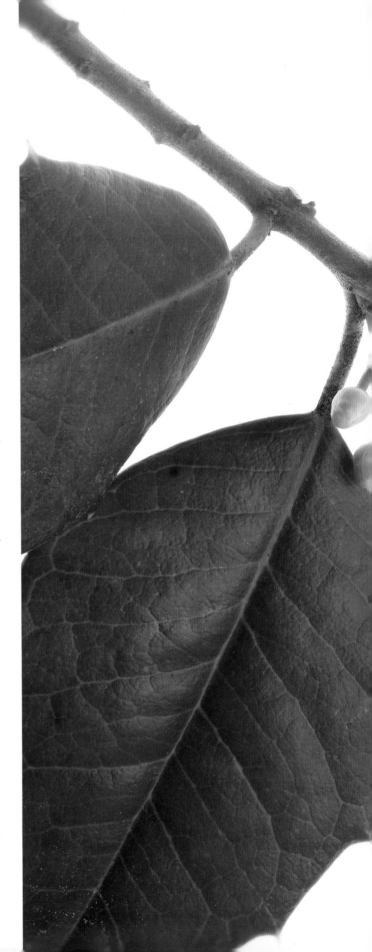

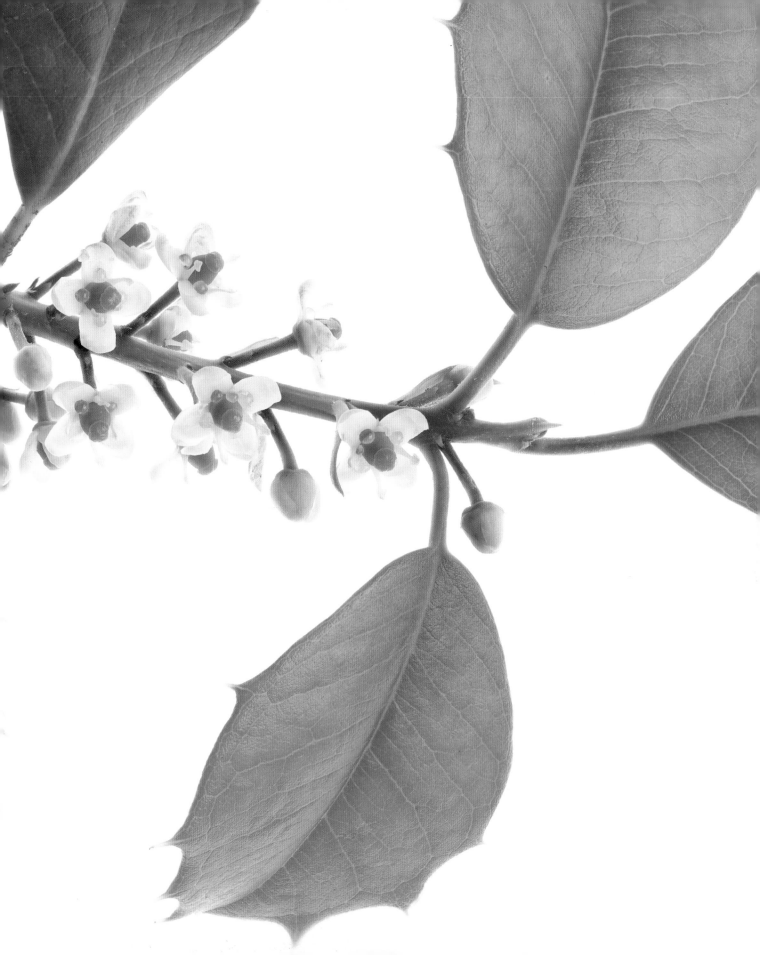

references at the back of this book. What I search for in these and other books are bits of information that relate to the trees in my backyard and my immediate experience. I credit Joan Maloof, author of *Teaching the Trees*, for example, with saving me the trouble of searching for sweetgum flowers on young trees, because it was she who alerted me to the fact that sweetgum trees don't begin to flower until they are at least twenty years old.

Drawing, photography, and journaling are other useful adjuncts to tree viewing. Any time you draw something, no matter how successful you are from an artistic point of view, you learn more about it, so it's good advice to draw more if you want to see and remember more. If we all approached drawing as a means of fixing a memory as opposed to creating a work of art, we'd do more of it and see more as a result. One April day, I spent several hours drawing an unfurling hickory bud (a drawing I proudly

titled "Birth of a Hickory Leaf"), and I now respond to that phenomenon in the woods with a joy of recognition and almost kinship that I don't have for things I haven't drawn. Having observed every detail of that tree trait so closely also opened me up to learning more about it. I was thrilled, years later, to get an e-mail from a botanist who was describing the same phenomenon, when she wrote, "It happens when the protective scales around the elongating terminal bud reflex and take on amazing salmon and gold coloration. The effect is something like an otherworldly magnolia." Yes, oh yes, that's my "Birth of a Hickory Leaf."

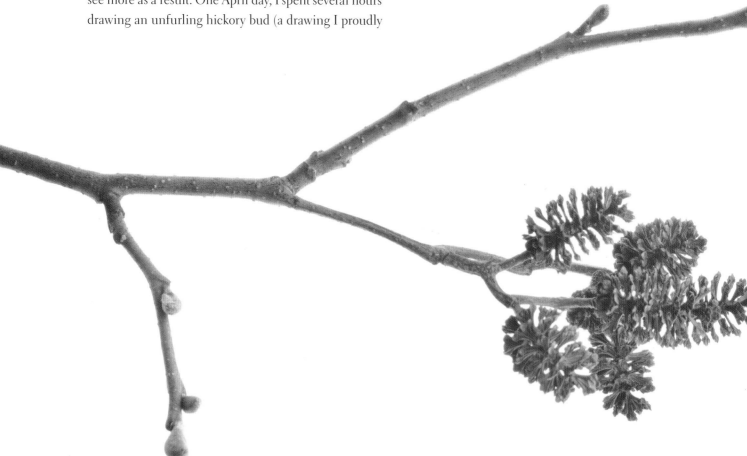

Photographing trees can be revealing, too, but whole trees are surprisingly hard to capture photographically. Anyone who has aimed a viewfinder or LCD screen at a tree knows that what you see through a camera is a pale, almost disturbingly diminished, version of a tree in the round. Like people, trees have presence, and you can see that (and feel it) only when in contact with the real thing. It is not just the angle of light, the sound of birds, the action of wind in the leaves that help form one's overall impression of a tree; it is myriad other attributes, including its size relative to yours and its position in the landscape. To see a tree in a photograph is not to see a tree. On the other hand, photographing trees, like drawing trees, requires you to focus on them through both your eyes and the camera lens and often reveals things you might have missed—the intricacies of a branching pattern, a pattern of bark, or a striking leaf posture, for example. And up close . . . well, nothing illustrates better than Bob's microviews what close-up tree photography can reveal.

Dating observations is another way to enhance your viewing habits. Keeping a record of when you saw what will not only reveal how predictable trees are but will alert you about when to look for certain phenomena in subsequent years. I remember being startled when I first noticed, because I penciled the dates into my field guides, that the wildflowers in my neighborhood bloomed on almost exactly the same dates every year. I had expected the dates to be close, but not so close. With occasional departures from the norm, tree leaf fall, blooming times, and fruit fall are also predictable, and it's somehow reassuring to know the tulip poplars are running on schedule even when the buses are not. Trees are incredibly consistent, programmed to respond more to unalterable patterns of daylight hours and night length than they are to fluctuations in weather. So, again with some exceptions, the tree events you view on your birthday one year are likely to be the same ones observable on the next. How much more useful, in terms of grounding them in the world, would it be to tell children that instead of being a Scorpio, a Capricorn, or a Taurus, they are a ripening acorn, a budding buckeye, or a blooming maple!

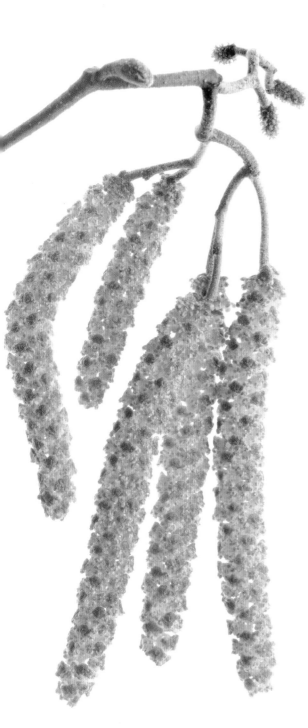

Female cones and male catkins appear on the same twig of smooth alder, *Alnus serrulata.*

To keep track of what tree activity happens when, an alternative to keeping a nature journal or making marginal notes in a field guide is to scan actual tree parts on a flatbed scanner. Obviously, flat things like leaves scan better than fat ones like acorns, but you'd be surprised how many tree phenomena you can press well enough to get a record of them onto a single, dated sheet of typing paper.

Binoculars are a piece of equipment that we don't usually associate with tree study, but because so many tree fruits and flowers are high up in the branches, a good pair of binoculars can dramatically increase the number of them you can see, and binoculars will obviously bring distant trees into closer view. It was through binoculars that I first spotted the immature fruit of the Osage-orange (with its hairy protuberances, so different from the mature fruit), and how I wished I'd had binoculars the day I was on a sailboat and spotted a tree with a glowing white canopy on a distant shore. What could it possibly be? (Answer, as revealed later: a blooming chinaberry.) Birders often know a fair amount about trees because, while in the process of using binoculars to view birds, they see the tree fruits and seeds birds are feeding on. Similarly, while you're in the process of looking into the crown of a sweetgum with binoculars, don't be surprised if a goldfinch, interested in the seeds in the gumball, flits into view.

For tree phenomena you can view up close, another useful piece of equipment is a hand lens, magnifying glass, or photographer's loupe. I recommend a loupe, or at least something that will magnify small objects by a factor of five or more. I resisted buying one for so long Bob finally gave me his old loupe (many photographers who no longer need to examine slides carefully with a loupe may be discarding them), and now I wonder how I ever did without it. With a loupe I can see details of small tree phenomena such as flower stamens, fine hairs, and seeds that were almost invisible to me without it.

Overall, the three things that most enhance tree knowledge and appreciation are contact, contact, and contact. Such contact can be with your eyes alone, but I learn best by getting my entire body involved in the experience—touching trees, hugging trees, and even climbing into them when possible. It's unfortunate that tree-hugging ever got a bad name, because it's a fine form of relating to trees: there are few better ways to experience the mass and solidity of a tree than to wrap your arms around it and press close, skin to bark. While you're there, if the tree is big and sturdy, try pushing it over. Yes, try with all your might to push the tree over. You probably know, intellectually, that it won't budge, but feeling this lack of response to your best efforts is a startling reminder of how stalwart trees are, and is one of the best ways of "seeing" tree strength.

At the very least, don't make the mistake of viewing trees only from afar. It is always tempting, especially in a broad, open landscape, to assume that if you can see the entire tree, from bottom of trunk to tip of canopy, that

Pinkish bracts spread gracefully below new leaves of shagbark hickory (*Carya ovata*).

you have seen it. But I have had the experience of walking up under the tree and realizing that my distant view was almost a mirage. The *real* tree, with its enormous trunk and impossibly weighty limbs, can be experienced and understood only by standing under it, with your feet firmly planted under its canopy. Only then can you appreciate its massive bulk, its presence, and its ineffable relationship to you—small, short-lived life form that you are.

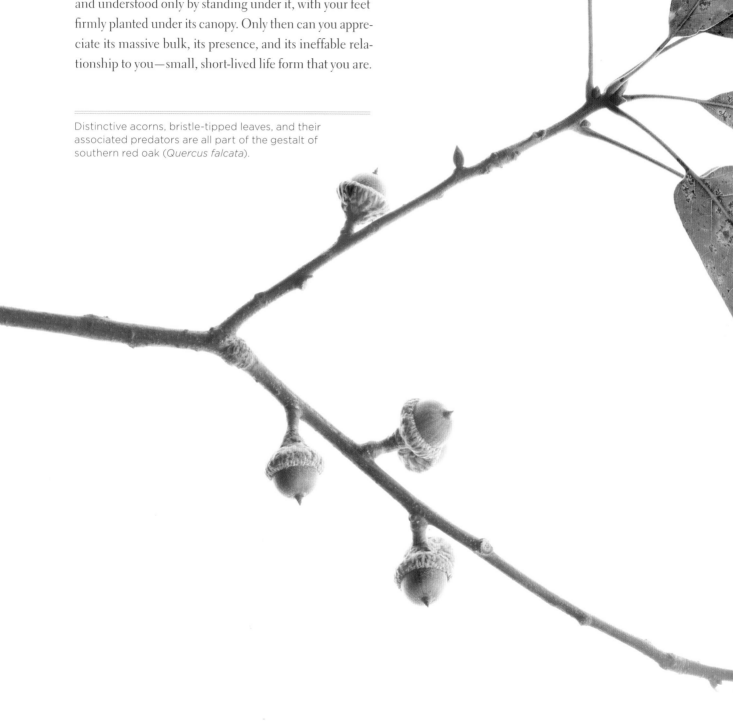

Distinctive acorns, bristle-tipped leaves, and their associated predators are all part of the gestalt of southern red oak (*Quercus falcata*).

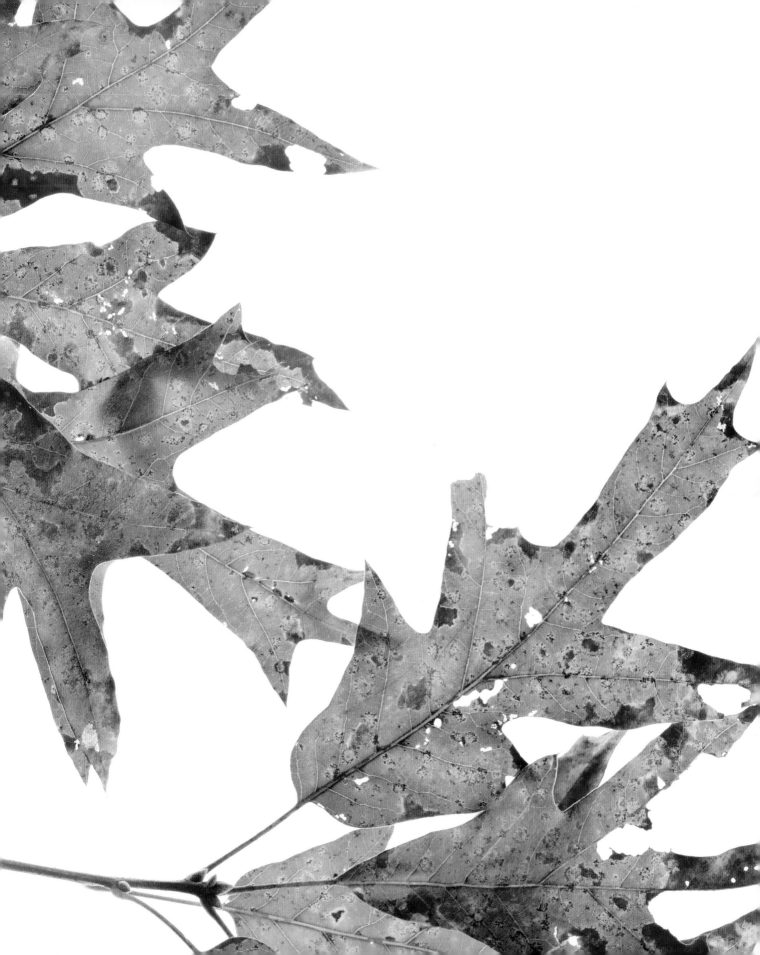

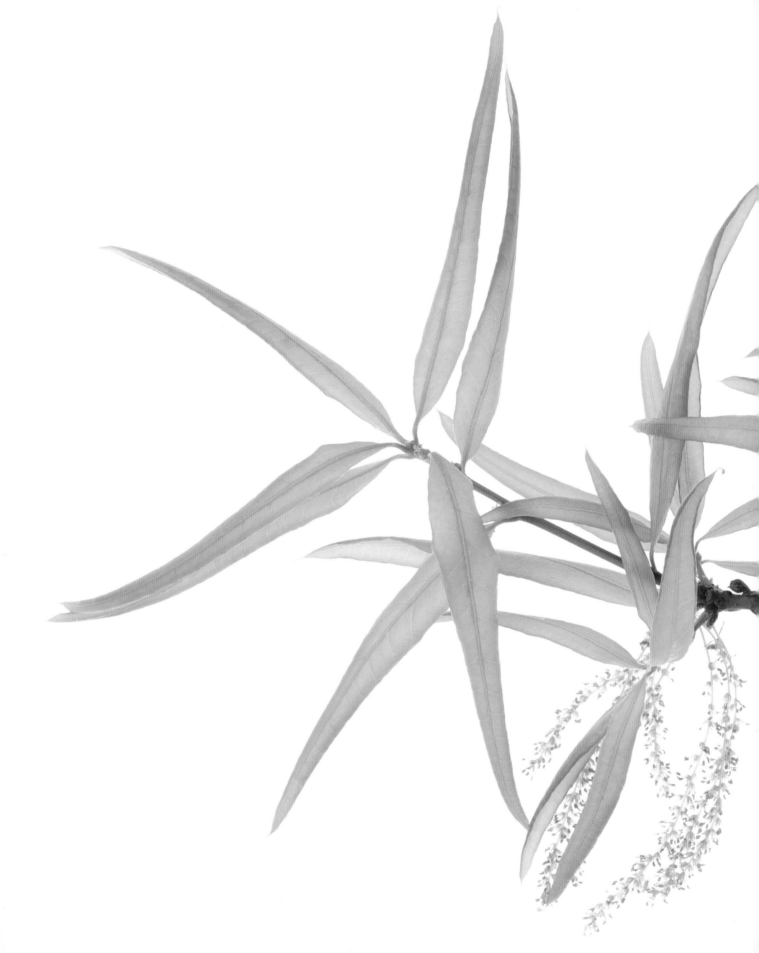

OBSERVING TREE TRAITS

"The real voyage of discovery consists
of not in seeking new landscapes but
in having new eyes."

—MARCEL PROUST

W HEN YOU BEGIN to examine trees up close, many traits, seen only sketchily from a distance, come into focus. Leaves, flowers, fruit, twigs, and bark, among other features, become more arresting, and their details help you appreciate the tree's singularity (as well as its similarity to others of its species). Such features have value beyond what they impart alone, however. The beauty of near viewing is that while you are observing small tree traits, you also encounter features like the tree's overall shape, its branching pattern, its animal companions, its habitat, and even the patterns of its shadows on the ground.

Just by virtue of being in a tree's presence, one develops an overall impression of the tree that is more than the sum of its parts. The word birders use to describe such an impression is *jizz*. Forget any other meaning you may have learned for this word; for birders, jizz means the overall impression or appearance of a bird garnered from such features as its shape, posture, flying style, size, color, voice, habitat, and location. It is a word that could also be applied to trees, because those who know trees best know them not as collections of identifiable parts but as organic wholes, like friends or family members whose recognizable features and behaviors have blended into one unmistakable, and beloved, presence. A black locust, for example, is not just a collection of parts that include compound leaves, drooping racemes of white flowers, deeply fissured bark, and pea-like seed pods. It is the sweet fragrance of May flowers dripping from broken branches on a ramshackle trunk, not to mention bees visiting the flowers and leaf miners devouring the leaves. To experience the jizz of trees, one needs to know them

intimately, and the information that follows should help you accomplish that.

LEAVES

On my dining room table, I have two leaves that I dried and pressed between pages of newspaper. One is a huge tulip poplar leaf, about 14 inches wide and 12½ inches long. The other is a tiny tulip poplar leaf, about ¼ inch square, and a perfect replica of the larger leaf. I save these leaves because I am engaged in a contest with myself to find the smallest tulip poplar leaf and the largest tulip poplar leaf in my neighborhood. I think I'm pretty close to the limit on how small a tulip poplar leaf can get and still resemble a leaf, but a bigger leaf is probably out there somewhere. For such a competition you don't need any equipment, and similar contests could be conducted relative to the leaf sizes of any tree. Newly emerged oak leaves, for example, have the same cute quality that small tulip poplar leaves do, but the size difference between the largest tulip poplar leaf and the smallest is more striking.

Leaf size: it's such a simple category on which to focus, but few people do. And focusing on leaf size is not just an enjoyable pastime, it can teach you something about trees. Leaf size varies not just because some leaves are young and others more mature. Sometimes leaf size varies depending on where the leaves are on the tree. For example, many trees have relatively small sun leaves and larger shade leaves. The reduced surface area of sun leaves, which typically grow on the sunny side and in the top of the tree, reduces their exposure to drying sun and wind. Larger shade leaves, on the other hand, are usually found in the bottom (shaded) part of the crown or on the north side of the tree, and their increased surface area helps them collect adequate sunlight. In reduced sunlight, trees need to increase the size of their solar collectors—leaves—without making them so big they transpire too much water. (As part of the flow of water through the

plant body—transpiration—water evaporates from leaves and escapes to the surrounding atmosphere.) Sun and shade leaves, then, represent not just a fluke of growth but rather one of the tree's masterful methods for maintaining the delicate balance between food-making, which requires sunlight, and water conservation.

Sometimes, too, young growth, especially on trees that have been cut back to the ground, produces shockingly big leaves. The paulownia, or princess tree (*Paulownia tomentosa*), produces much larger leaves on young growth than on mature growth. I puzzled over what these plants were for years, with their 24-inch, almost heart-shaped leaves, until I figured out they were not a herbaceous garden plant but were princess trees that were being cut back regularly by roadside mowers. "They just get overenthusiastic," one botanist commented facetiously, when I asked her about this. Then another expert chimed in with the actual reason: Such trees, growing from a stump, have well-developed root systems that are able to provide the new shoots and leaves with an overabundance of nutrients. Oaks, too, seem to produce inordinately large leaves on shoots coming out of stumps, but nothing rivals the umbrella-like leaves of the cut-back princess tree.

Leaf form, because it is a key to tree identification, gets more popular attention than leaf size, but unfortunately, most of us were taught the basic leaf forms before we had any real interest in trees or motivation to tell trees apart. Only when you really care whether you're looking at a swamp white oak (*Quercus bicolor*) or a regular white

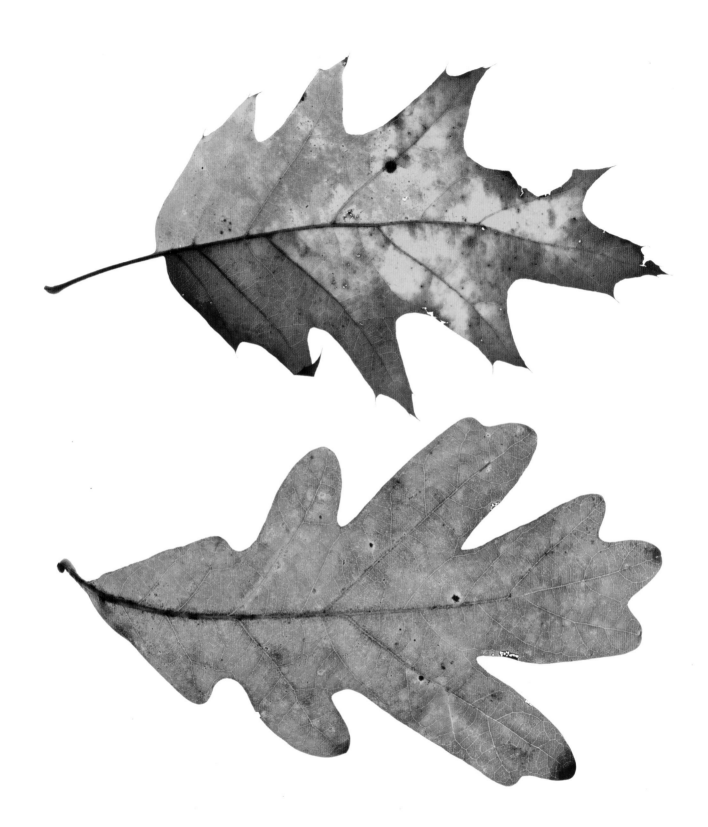

oak (*Quercus alba*) do the deeper indentations (lobes) of the latter's leaves really mean anything to you. A good field guide or appropriate website can teach you the basic leaf shapes, but the following discussion will alert you to some of the categories to be aware of. Here's the shortest leaf tutorial in the history of the world: Leaves can be simple (one connected piece), compound (a collection of smaller leaflets), or doubly compound (each part of the compound leaf is itself a collection of smaller leaflets). Examples of simple leaves include oak, maple, and tulip poplar. Examples of compound leaves, which can be arranged around a central point or scattered along the main line of the leaf stalk, include buckeye and horsechestnut (leaflets arranged around a central point) and locust, walnut, hickory, and ash (arranged along a central axis). Kentucky coffee tree, mimosa, and chinaberry are trees with doubly compound (or bipinnate) leaves, which means that along each central leaf stalk there is a series of subordinate stalks, each of which is lined with leaflets.

The arrangement of tree leaves on the twig is another identifying tree feature. Leaves of a few species (maple, ash, dogwood, princess tree, horsechestnut, and buckeye) are positioned opposite each other on the twig, while the leaves of most tree species, including oaks, alternate along the stem, and a very few, like the catalpa, appear in a whorled arrangement (three or more leaves distributed regularly around the twig at the same point). In addition to looking at the overall shape of a leaf, look at the shape of its tip, its base, and its edges, because they are all clues to a tree's identity. Shape, color, surface texture, fragrance, and vein pattern are other leaf characteristics to look for.

Interestingly, leaf shape varies not just between species but within species and even in individual trees. You could spend a lifetime attending to the variety of forms in a single species of Japanese maple (*Acer palmatum*), because leaf forms in cultivated varieties of Japanese maple vary from fern-like to star-shaped, from shallowly cut to deeply cut, and have colors ranging from

chartreuse to dark green, red, maroon, and even pinkish. Tree lovers could check Japanese maple cultivars off their life lists the way birders do warblers, but the owner of a single open-pollinated Japanese maple could be equally entertained just observing the size, shape, and color of the leaves on the thousands of seedlings that come up under such a tree. (Open-pollinated trees, as opposed to trees created by controlled breeding, produce offspring that vary widely genetically.)

White oak (*Quercus alba*), too, is notable for the wide variety of its leaf shapes, and while all white oak leaves have characteristic rounded lobes (as opposed to the bristle-tipped red oak leaves), some white oak leaves look like fiddles, with a broad terminal bulge, and others look like spilled molasses, so deeply indented are their curves. The southern red oak (*Quercus falcata*) presents a different challenge, because the shape of its leaves sometimes varies depending on where they are positioned on the tree, with leaves in the bottom half of the tree sometimes resembling those of the turkey oak (with relatively V-shaped bases) and those in the top half having the species' more typical bell-shaped bases. The mulberry has several leaf shapes (from leaves with no lobes to leaves with five), and the sassafras has three—oval, partly divided into three lobes, and mitten shaped.

Leaf color is another tree trait we could view more regularly than we do, and it's an activity that should definitely not be limited to the fall. I actually prefer the subtle greens, pinks, and ochres of spring leaves to the blazing colors of fall, and winter is way undervalued for its leaf color. In December, there are russet, red, and scarlet leaves on my oak trees that make some maple reds seem overobvious, and a winter woodland dominated by American beech trees is as interesting a color study (all in

Oaks in the red oak group have bristled tips; oaks in the white oak group have smooth lobes. Illustrated here are leaves of (top) northern red oak, *Quercus rubra*, and (bottom) white oak, *Quercus alba*.

parchment hues) as the most eye-catching autumn mountainside. From tan to bleached-blonde white, American beech leaves hang on the trees' branches like socks on a clothesline, and they remain there, becoming almost translucent, until early spring. There's a name for these old leaves that stay on the trees until a strong wind or new spring leaves push them off—marcescent. Contrary to popular belief, leaves of this type do not stay on the tree just to irritate obsessive rakers. No one knows for sure why some trees are marcescent and others aren't, but it probably has something to do with protecting the buds below the leaves.

As for fall leaves, here are some strategies for seeing them in new ways. First, think of fall as a verb, not a noun. The action of leaves in air, when they're falling, provides the most compelling images of this season. As they move

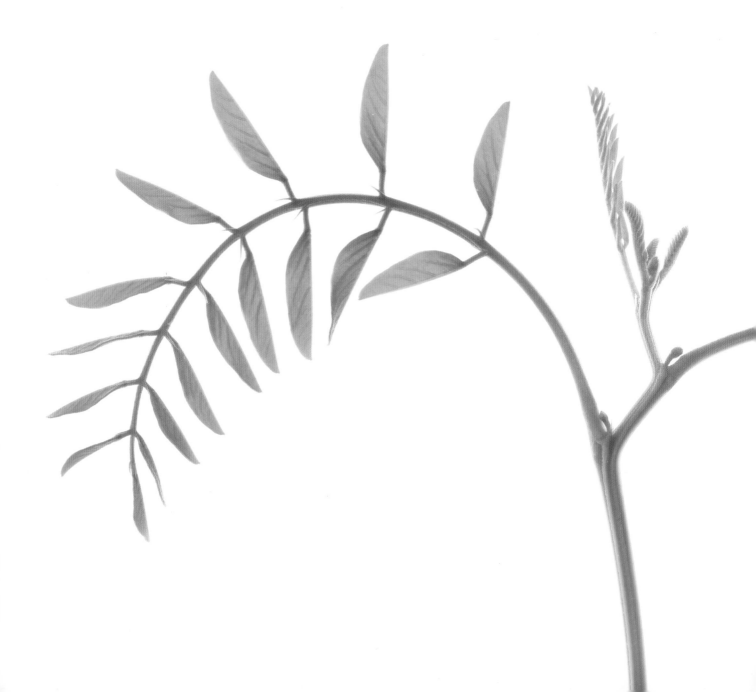

between limb and ground, the air becomes animated, and you can see how, depending on their construction, leaves twist, twirl, float, or spin in the air. The float of a big Norway maple leaf is different from the pinwheel twirl of a sycamore leaf, and the whoop-de-do of an elm leaf caught in an updraft (leaves sometimes fall up!) is entirely different from a thud of mulberry leaves brought down by rain. You can't plan for real fall—as in "let's go see the fall leaves this weekend." Real fall, the verb, happens when the wind kicks up, creating a shower of willow oak leaves or a frost loosens the latches of the ginkgo leaves.

To experience the idiosyncrasies of falling leaves on a visceral level, try catching them. "Every leaf you catch this month means a happy month next year," I once read, and I've made it my business to catch twelve leaves each fall ever since. It's harder than you think, nabbing leaves from the air. Football coaches would do well to have their wide receivers practice leaf-catching, so unpredictable are airborne leaves in their flights. (The higher up in the tree they start, the more rewarding the catch.)

Once trained for spotting leaves in the air, you may also notice a fairly common fall phenomenon that few people seem to see—a leaf stalled in midair. This gravity-defying feat occurs when a leaf gets caught by the long, trailing silk line of a ballooning spider. Young spiders (spiderlings) extrude long strands of silk that they release to the wind, the lines helping them move from place to place. There are lots of these silk lines around in the fall (since many spiderlings are born then), and a leaf caught on such an almost invisible thread looks for all the world like it is hovering without support. On a path near my home, I encounter fall leaves caught on silk lines fairly frequently, and I've tried to wait to see how long a leaf could stay suspended there, only to discover the silk is more enduring than my patience.

Making leaf collections is another way to relate to tree leaves. Why should third graders have all the fun? It's true that the basic shapes of common trees don't change, leading some to think "you've seen one leaf collection, you've seen them all," but the constitution of our forests and urban landscapes (not to mention our addresses) does change, making a good leaf collection function as a nature journal and sometimes even an important historical record, particularly if the dates the leaves were collected were recorded. Collecting leaves also helps imprint leaf colors, textures, and shapes on our brains. And just handling leaves will teach you something about trees—how incredibly soft a young sassafras leaf is! In his autobiography *Speak, Memory*, Russian novelist Vladimir Nabokov described a teacher who had her students, including

Leaves of black locust, *Robinia pseudoacacia*, are compound—each leaf (like the two curving left and right, as well as the younger ones emerging in the center) is a combination of smaller leaflets.

Nabokov, attend to leaves' colors: "Autumn carpeted the park with vari-colored leaves, and Miss Robertson showed us the beautiful device . . . of choosing on the ground and arranging on a big sheet of paper such maple leaves as would form an almost complete spectrum (minus the blue—a big disappointment!), green shading into lemon, lemon into orange, and so on through the reds to purples, purplish browns, reds again and back through lemon to green (which was getting quite hard to find except as a part, a last brave edge)."

Since reading about Miss Robertson, I've made many a leaf collection based on color, but I do it in my hand as I walk, instead of on paper. I arrange the leaves like a hand of cards, slipping a yellow tulip poplar leaf in here, moving an amber hickory leaf over in there, until I have a wide spectrum of leaf color. In this collection, a dark maroon sweetgum leaf becomes as valuable as the ace of spades, a blue leaf as exciting as a wild card. Nabokov was right, a blue leaf is hard to find. You can cheat with evergreen needles, but if you look hard enough, you can actually find a few leaves, like those of the maple-leaved viburnum (OK, it's a shrub) and those of the silver maple (undersides only) that are bluish. You can also make a pretty good collection of colored leaves from sweetgum trees alone, because their fall colors range from yellows, reds, and oranges to an almost black maroon.

Red leaves deserve special attention, because their color results from chemical changes a bit different from those coloring other leaves. Most of us know that shorter days result in less chlorophyll and thus less green color in leaves. Unmasked by green, the yellows and oranges in leaves are more visible to us. But there's something else going on with reds and purples. The same pigment that puts the red in apples and cherries is produced under

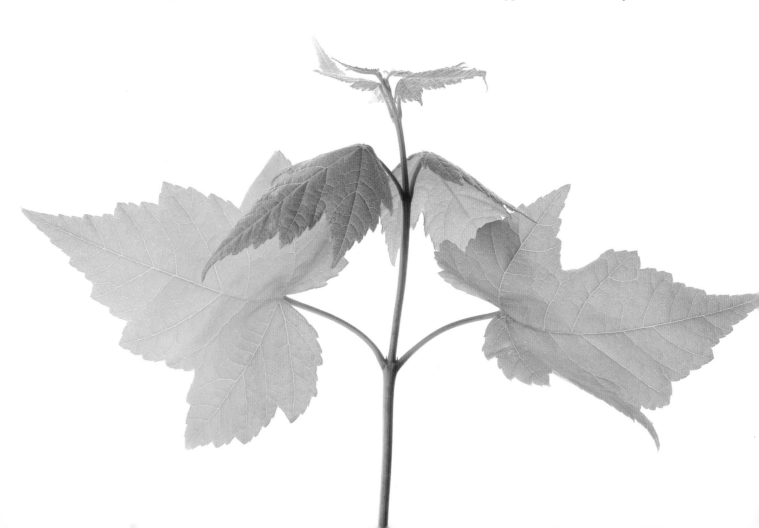

some conditions in the leaves of some trees, like maples. The pigment is anthocyanin, and its production depends on sunlight, rainfall, and weather, unlike the chemicals responsible for yellow, gold, and orange coloration, which remain more or less consistent from year to year. Cool (but not freezing) nights and sunny days favor anthocyanin production, so some years the fall foliage will be redder than in others. Because bright light favors anthocyanin production, you will even notice that some parts of a maple will be redder than others, since more red color develops on exposed leaves.

How we talk about displays of leaf color! "This year is the worst (or best) because of the drought (or rain, heat, or cold)." Few of us have any idea what we are talking about, but oh, how we want to know! The fact is, anthocyanin's involvement in the production of reds is only half the story: the tree's sugars and other factors are also involved, and any simple account of changing leaf color is half-wrong if it implies the process is simple. For me, the wonder lies in knowing that the colors I am seeing are the result of carefully calibrated chemical responses to fluctuation in day length, weather, and light; and because the weather and light vary from year to year, each fall display is different from the previous one.

It seems to me a big mistake to hype only the two or three weeks in autumn when fall leaves are supposedly at their peak. This may help drive tourism, but it does nothing to improve seeing. There is actually a long progression of leaf color turning in the fall, and watching the progression is much more satisfying than just showing up for the climax. For me, fall actually begins in July when I find the first red tupelo leaf on the ground, proceeds through the yellow walnut leaf showers of August, progresses through the sumac reds of September, crests with the multicolored maples of October, then winds down

Young leaves of red maple (*Acer rubrum*) display their characteristic opposite arrangement on the twig.

with the hickory ambers of November. The late burst of ginkgo yellow in November is almost a curtain call.

Another way to appreciate the leaf color of fall is to view it on the ground. Too often, as Bob and I traveled Virginia looking at fine trees, we arrived at a particular site only to find that well-meaning owners had just raked up all the leaves under a tree we were planning to photograph. Near one particularly fine American beech in Falls Church, Virginia, the brilliant yellow leaves were still in piles close enough to the trunk that I considered asking the groundskeepers to rake them back out beneath the tree's branches, but thought better of it.

An expanse of colored leaves under a tree is a beautiful thing—think of it as a cape the tree has thrown off—and to rake it away before looking at it is to miss a significant piece of the tree's wardrobe. Certainly from an ecological point of view, leaving tree leaves where they fall so they can insulate the tree roots makes infinitely more sense than raking them away. And raking a tree's leaves away only to replace them with mulch made from the bark of other trees seems misguided at best. Tree leaves can be as ornamental on the ground as they are on the tree, and I've known gardeners who deliberately paired the colors of their late-blooming perennials to the colored leaves that would fall into them. Inspired by them, I planted lavender fall asters under my sugar maples, where, in the fall, the tree's yellow- and apricot-colored leaves sit on top of the asters like frosting on a cake. Gorgeous! The effect is short-lived, but many of the best things are.

I'd also like to make a case for the beauty of imperfect leaves and for the information that can be gleaned from them. One way to recognize a tupelo leaf is by the black spots on its surface. Many cultivated varieties of tupelo are now resistant to this leaf spot disease, but in the wild, a dappling of black spots on the surface of a shiny red or green tupelo leaf is just part of this tree's physiognomy. Also, something like the tracks of a leaf miner on an American holly leaf (usually perceived as a blemish or worse) can be indicative of a rich ecological connection.

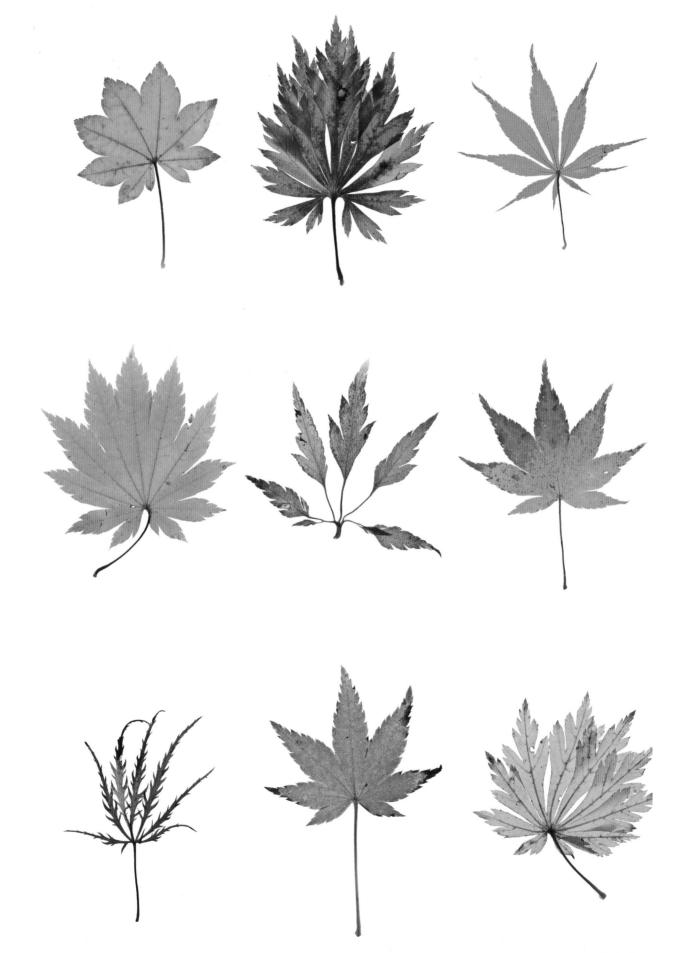

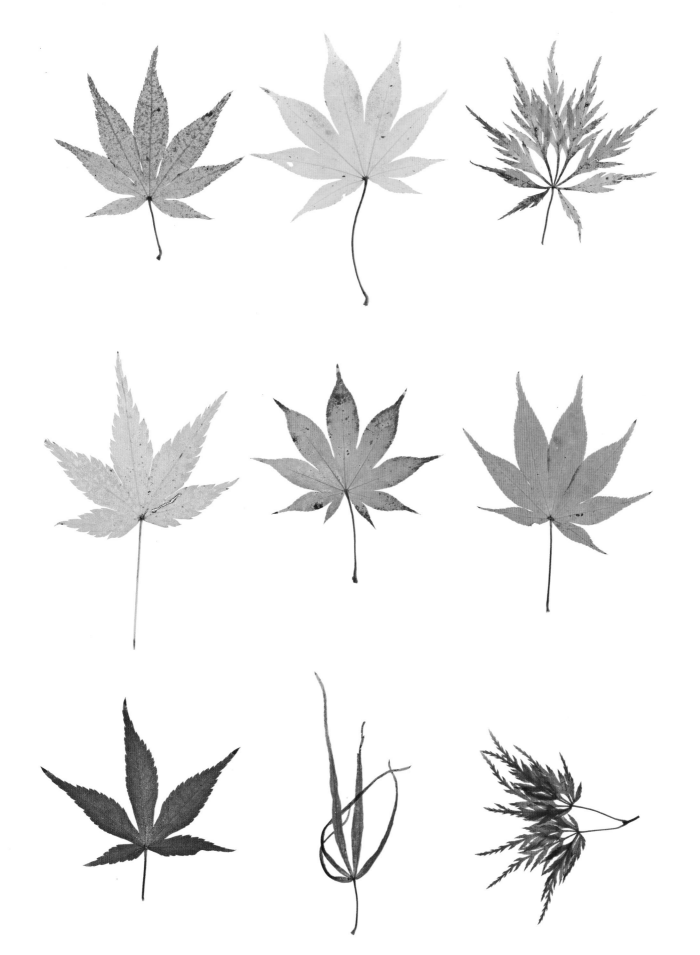

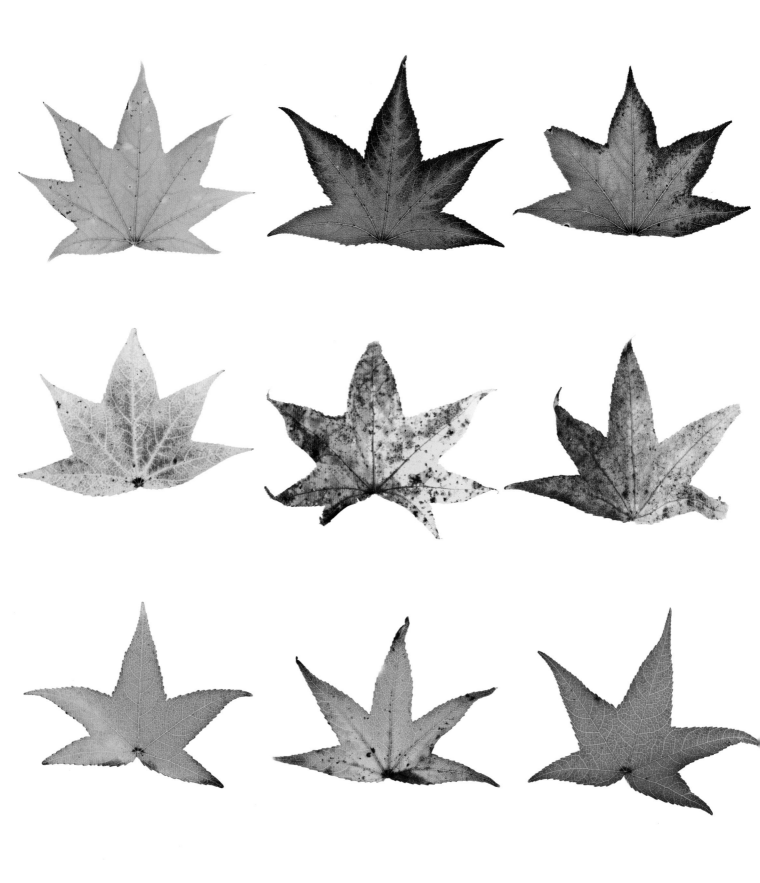

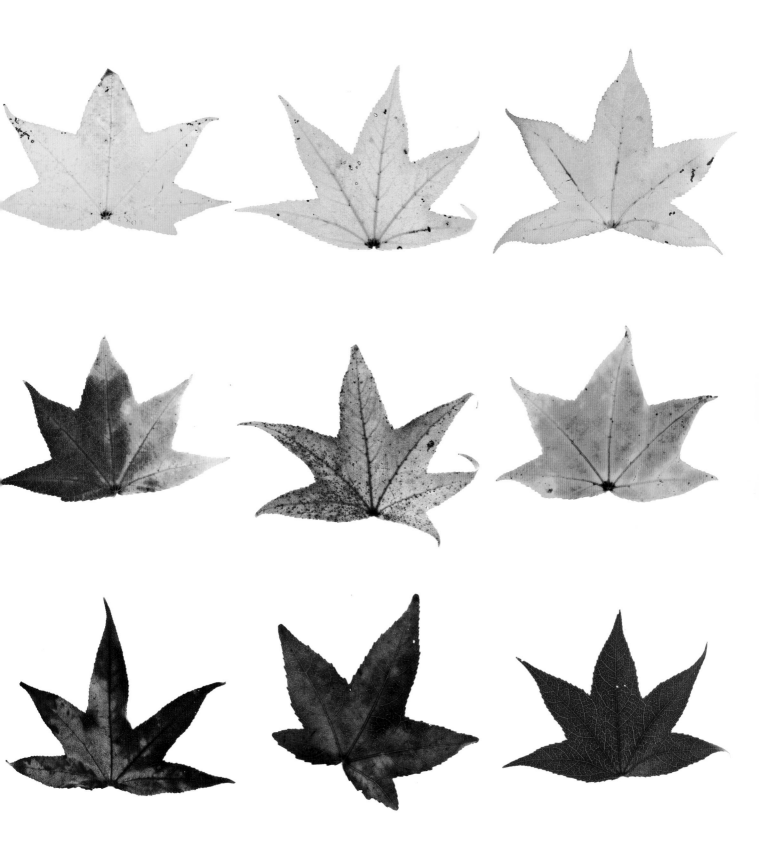

Some of the best descriptions you'll ever read about the connections between trees and insects—layers upon layers of connections—are collected in Joan Maloof's *Teaching the Trees*, in which she describes, among other things, the life cycle of the holly leaf miner. To the eyes of many horticulturists, the serpentine tracks of the holly leaf miner are cause for alarm, although the trees seem to put up with the miners just fine. To Maloof, the tracks are a map of the activities of a life form intimately connected to other life forms. This leaf miner larva, she points out, feeds on plant cells between upper and lower surfaces of the American holly leaf (and only the American holly leaf), and the larva of a parasitic wasp lives only on this particular holly leaf miner.

PAGES 46–47 A collection of leaves from cultivated varieties of Japanese maple (*Acer palmatum* and *A. japonicum*) reveals how varied their leaves are.

PAGES 48–49 Leaves of sweetgum (*Liquidambar styraciflua*) cross the spectrum from greens, yellows, and oranges to reds and purples.

BELOW Leaves of American beech (*Fagus grandifolia*) are often tissue-thin before falling from the trees in early spring.

OPPOSITE TOP This American sycamore (*Platanus occidentalis*) leaf was probably skeletonized by the young caterpillar of the sycamore tussock moth.

OPPOSITE BOTTOM This fall tupelo (*Nyssa sylvatica*) leaf has a story to tell.

Skeletonized leaves—leaves that have been made lacy by insects—also have as much visual interest to tree observers as they do to entomologists. Wild grape leaves are the leaves most likely to be skeletonized in my neighborhood, but sycamore leaves are often chewed into lace, too. Researcher Mark McClure has identified five species of leaf-sucking insects that feed on different parts of the sycamore leaf blade, but entomologist Arthur Evans tells me it is a sixth insect, the young caterpillar of the sycamore tussock moth, that is probably responsible for the sycamore leaf damage I have been noticing.

I don't suppose there's much hope of changing the garden club and horticulture society rules that favor an unblemished leaf over a blemished one, but maybe such groups could create separate categories for horticulture exhibits of the imperfect variety, so gardeners could display leaves with holes in them, describe what made the hole, and why. This approach would require much more expertise, and careful watching, than spraying with insecticides does. I don't want to go too far out on a limb with this—my eye does not rejoice at the sight of gypsy moth damage, for example—but not every imperfection in a leaf is a problem. To my eye, holes in leaves, leaf galls (swellings usually resulting from insect egg deposits), the tracks of insect visitors, and other imperfections contribute to leaf beauty as often as they detract from it. I would argue for a tree leaf aesthetic that is closer to Japanese *wabi-sabi* than it is to the American beauty pageant; such an aesthetic acknowledges the beauty in the imperfect and the impermanent. The following line from artist and author Richard Bell, applied to leaves as well as to flowers, sums up my philosophy: "Perfect blooms can leave me cold; I like a plant with a story to tell."

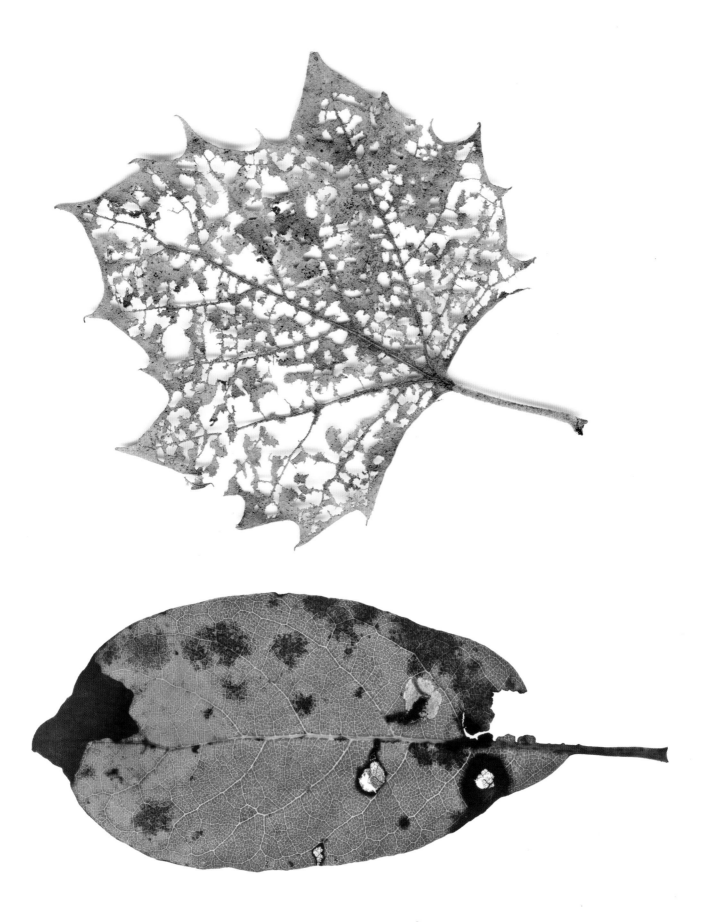

FLOWERS AND CONES

In a 1738 letter to fellow Englishman Peter Collinson, John Bartram made this observation: "I think to be diligent in my observation on the flower of our Sweet Gum, to gratify thee and thy curious friends. It seems strange that some accurate botanist hath not already taken notice of it; but I suppose the difficulty of procuring flowers hath been some reason of the neglect, for the tree generally groweth straight and tall, and seldom bears seed before the tree is forty or fifty feet high." I don't know where John Bartram made his sweetgum observations (probably on his farm in Pennsylvania), but I finally made my first contact with sweetgum flowers at a perennial plant nursery. Sandy McDougle, of Sandy's Plants in Mechanicville, Virginia, grows her shade-loving perennials under towering sweetgums, and I was thinking what a hassle it must be to clean the gumballs out of all those pots, when it occurred to me to look up to see if I might spot the flowers. It was late March and, while the flowers weren't yet visible, the big, fat, green buds that would produce them were. Sandy let me go home, get my telescoping pruner, and clip a couple of branches, which I took home and put in water indoors. ("Thousands of priceless perennials on the ground," Sandy must have been thinking, "and this woman wants a free branch from the sweetgum!")

A week later, on April 5, each pregnant bud had produced four to seven nickel-sized, star-shaped leaves, a 3-inch upright cluster of male flowers, and one dangling precursor to a gumball—a peppercorn-sized green ball of female flowers. Covered with gelatinous-looking, pale green protrusions (stigmas), this flower ball would eventually develop into a spiky gumball. I don't know what kinds of discoveries others thrill to encounter in a day,

Both male flowers (pointing up) and female flowers (hanging down) grace this sweetgum (*Liquidambar styraciflua*) twig.

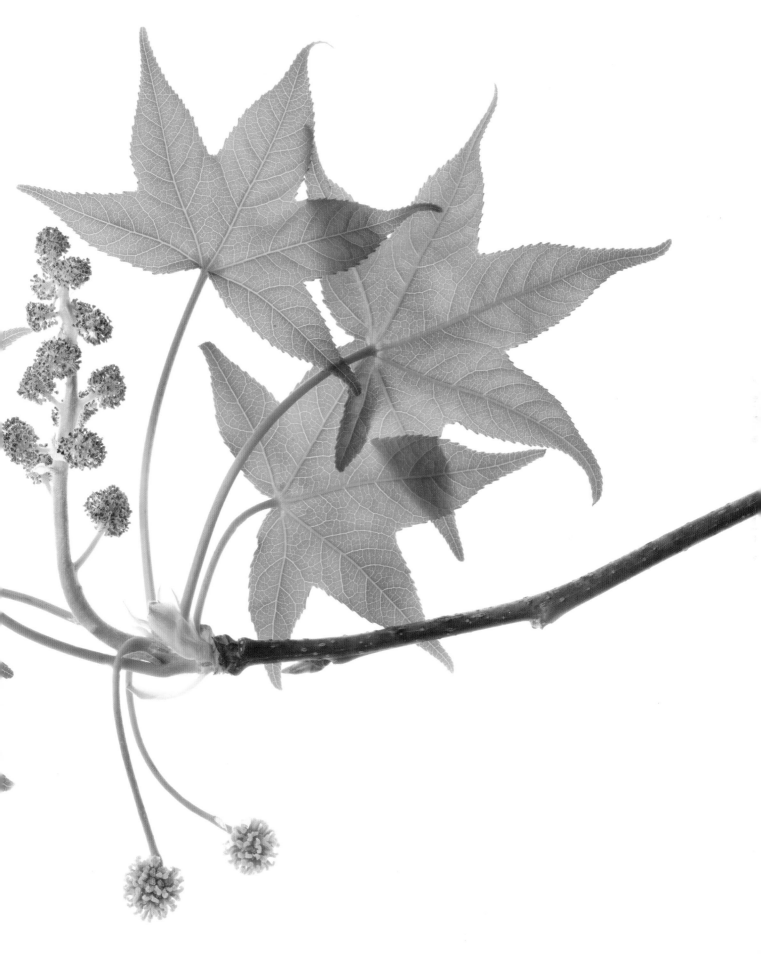

but seeing that premature gumball, so perfectly formed and predictive of what it would become, certainly added a rush to mine.

Hard to see and up high—that's the story with many tree flowers—but it's not impossible to examine even the most elusive of them. The trick lies in knowing first, that such flowers exist, and second, when and what to look for.

It comes as a shock to many people that most North American trees even have flowers. We recognize the tulip poplar flower, celebrate our apple blossoms, and prize a few other ornamental flowering trees like the magnolia, but ask the average person to picture an oak, ash, sweetgum, or maple flower and you will probably get a blank stare. It's true, though: with the exception of trees that bear cones (and a few other related trees), all North American trees have flowers. So why are we so unaware of them? The "invisibility" of most North American tree flowers relates to the fact that many are

RIGHT Flowers, not new leaves, create the first greenish red color in the canopies of American elm (*Ulmus americana*) in early spring.

BELOW This close-up of two American elm flowers shows each flower's male and female parts.

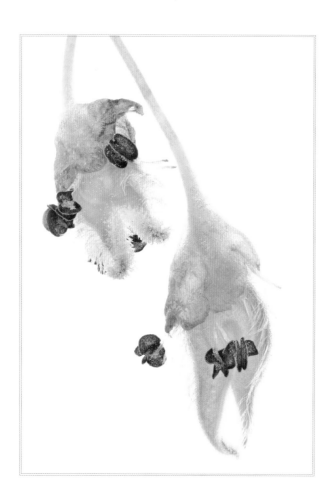

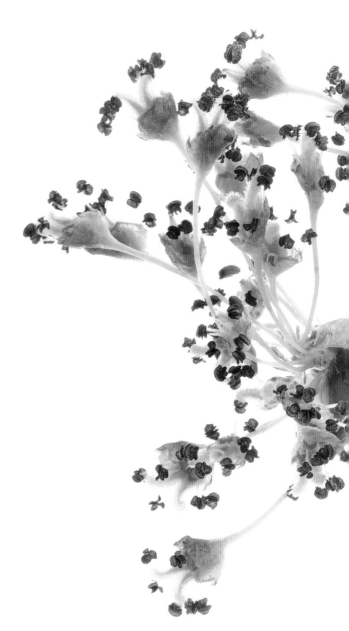

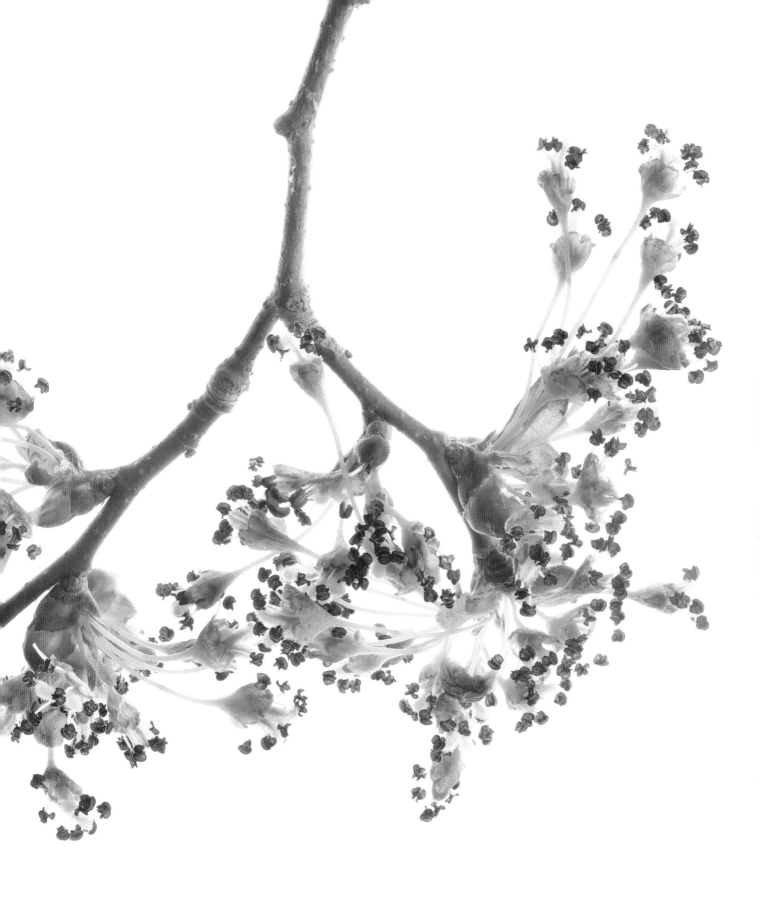

pollinated by wind, not animals, and so they don't need to be conspicuous.

The function of conspicuous flowers is to attract animal pollinators (primarily insects), and like most garden flowers, conspicuous tree flowers do that. The conspicuous flowers of the catalpa, for example, are not only showy enough to attract bees but they have purple lines on them, directing bees to the nectar inside. And the conspicuous flowers of the tulip poplar are all decked out in orange and yellow not to impress human beings but to lure bees. If you're not advertising yourself to pollinators, however, such fancy dressing is a waste of energy.

The flowers of wind-pollinated trees, which include oak, willow, alder, walnut, beech, ash, sweetgum, boxelder, birch, elm, aspen, cottonwood, hickory, and mulberry, are known for many things but not for large, conspicuous flowers. Maples, which are both wind and insect pollinated, also have small, relatively inconspicuous flowers. This is not to say, however, that the flowers of the maple or other inconspicuous tree flowers aren't gorgeous. Because they are not always easy to see, one part of their charm lies in finding them, another lies in observing them up close (many of their forms are as dramatic as those of conspicuous, animal-pollinated flowers), and yet another lies in their repetition. You may, for example, have observed the flowers of more wind-pollinated tree flowers than you think, if you have witnessed the red tops of red maples in early spring (that red is the tree's flowers, not its leaves), observed the first pale greenish red tinge in the canopy of an American elm (that color is coming from dangling, earring-like flowers), or spotted an intensely yellow male weeping willow (when its spring catkins are loaded with pollen). (Both male and female willows have flowers arranged in catkins, but they appear on separate trees.) This mention of male and female flowers brings me to another characteristic of most wind-pollinated trees: they have flowers that are either male or female, as opposed to having flowers with both male and female parts as most (but not all) animal-pollinated flowers do.

When searching for tree flowers, it is important to know that some trees bear only male flowers, some bear

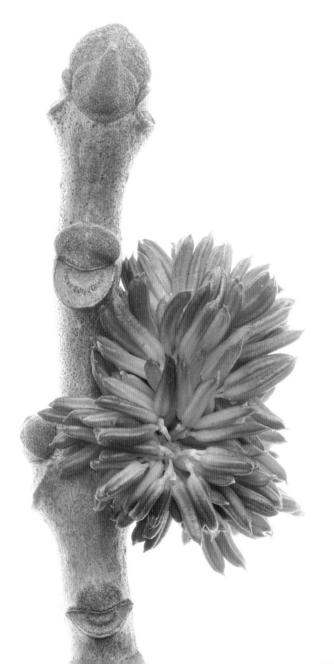

LEFT Tight clusters of immature male flowers bloom along this white ash (*Fraxinus americana*) twig.

RIGHT Although they emerge before the leaves, white ash flowers, like these mature male ones, often go unnoticed.

only female flowers, some bear both male flowers and female flowers, and some bear "perfect" flowers that have both male and female parts. You can find out which tree species have which flower arrangements by consulting a good field guide or appropriate website, and having that information is invaluable in not only helping you know what you're looking for but in interpreting what you see. Beech and oak trees, for example, have separate male and female flowers on the same tree (that is, individual trees of each species bear flowers of both sexes); white ash and willow trees have separate male and female flowers, but they are usually on different trees (that is, individual trees of either species usually bear only male or only female flowers); magnolias, serviceberries, and elms have perfect flowers, with each individual flower possessing both male and female parts. Tree-watchers can have a fine time observing tree flowers without ever telling a pistil (female flower part) from a stamen (male flower part), but the more you know about the reproductive parts of flowers, the more informed your observations will be. It's one thing, for instance, to be able to tell a male from a female walnut flower (not too difficult, because the female flower

is a furry, fruity thing, the male flowers hang in catkins), but it's something else to appreciate why the tip of the female flower has enlarged, sticky stigmatic surfaces (the better to catch air-borne pollen).

A piece of information less easily obtained has to do with when tree flowers appear, and this is important to know, particularly when searching for the small ones. (Websites are better resources for this information than field guides.) Some tree flowers appear before their leaves, others as their leaves unfurl, and still others after they have produced leaves. Red maple, alder, American elm, birch, white ash, and sassafras, for example, bloom before their leaves unfurl. Oak, walnut, hickory, sweetgum, and tupelo bloom as the leaves are emerging. Wild black cherry, sourwood, and linden bloom after their leaves have unfurled, and the native witch hazel *Hamamelis virginiana*, latest of the native North American trees to flower, doesn't bloom until after it has lost its leaves in late fall.

Like wildflowers and garden flowers, tree flowers also vary in form, color, and arrangement. They are borne singly (like pawpaw, magnolia, and tulip poplar flowers) or in clusters (like the flowers of sweetgum), and the shapes of those clusters can vary from the long, drooping male catkins of birch to the short, dense spikes of willow, and from the tightly packed round heads of sycamore flowers to the loose racemes of sassafras. (The terms panicle, raceme, spike, head, umbel, and corymb apply to the various tree flower arrangements just as they do to garden flowers.) The arrangements of the tree flowers we commonly call catkins are of particular interest, because not only are they relatively easy to see, their forms and "behaviors" are dramatic. These strands of unisexual flowers (all male or all female, never both) can be upright on some tree species, but more often they are dangling tassels of flowers that hang gracefully from tree branches and respond like windsocks to air movement. Oaks, hickories, chestnuts, mulberries, and walnuts have male catkins that whither and drop after they have released their pollen, and even

when they are on the ground, their forms are interesting. In the air, however, you can see how well designed they are: as they rock back and forth, set in motion by wind, they disperse their pollen the way a Roman Catholic priest waving a thurible disperses incense.

Unfortunately, pollen is not as popular as incense. In addition to being despised by allergy sufferers, pollen is disliked for leaving yellow dust where people don't want it. But remember that if you are seeing pollen, you are seeing part of a tree. And a sexy part, at that, since pollen produces the tree's male sperm cells. Male tree flowers on wind-pollinated trees produce prodigious amounts of pollen not to antagonize allergy sufferers but to ensure fertilization of the female flowers. By one estimate, a single birch catkin releases 5 million pollen grains, and each tree has hundreds of thousands of flowers. Why so much? Insurance. Wind is a fickle thing—not nearly as reliable as bees in transferring pollen—and if you are a wind-pollinated tree, you produce lots of pollen to increase the odds of one pollen grain finding a receptive female stigma. An analogy: if I throw a hundred balls at the Skee-Ball target, maybe one will land in the hole.

You may find more tolerance for the pollen on your car if you can remind yourself that pollen is required for tree flower fertilization, and hence, for the reproduction of trees. Although it is not something we can see with the naked eye, picturing the process of a pollen grain landing on the female part of a tree will also give you a greater appreciation of the complexity, if not the eroticism, of what's happening when fertilization occurs inside a tree flower or cone. The most vivid description of this event I've ever read appears in David Suzuki and Wayne Grady's *Tree: A Life Story*. Here is their description of the fertilization of a Douglas-fir seed: "The female cone of the Douglas-fir remains receptive to male pollen

Male and female sassafras (*Sassafras albidum*) flowers usually bloom on separate trees. These are female.

grains for twenty days, until about the end of April. Once a pollen grain has slipped down the smooth surface of the seed cone bracts, it becomes enmeshed in the small, sticky hairs at the tip of the female ovule. For two months it luxuriates on this pubic patch while the ovule's labia swell around it; slowly the ovule engulfs the grain, which sinks into it like a croquet ball into a soft, silken pillow." And that's just one pollen grain penetrating the nucleus of one ovule in one Douglas-fir. No wonder, when the air is full of pollen, spring feels so ripe for romance!

With the Douglas-fir, a West Coast species, I have wandered not only away from my backyard trees but into the types of trees that don't, technically, have flowers. These trees, the gymnosperms, do, however, include species distributed across the globe, and they have flower-like structures easily observable in backyards. From an evolutionary point of view, the gymnosperms, which include, among other trees, the pine, spruce, fir, hemlock, and red cedar, are older than the angiosperms (the flowering trees) and their reproductive structures are different.

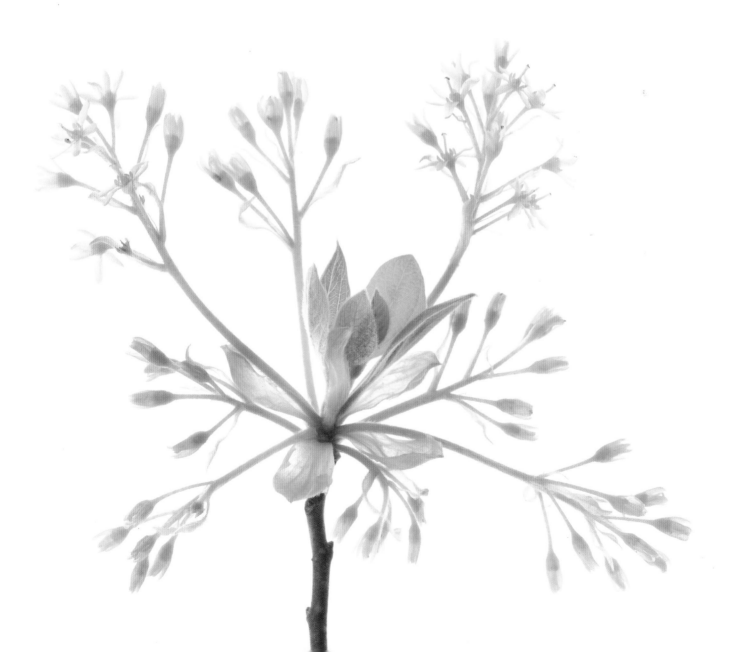

Their defining difference is the fact that they have "naked seeds"—there is no fruit tissue surrounding their seeds—but this discrimination is more relevant to botanists than backyard tree-watchers. To the backyard observer, the interesting thing about the gymnosperms (or at least the subset of them called conifers) is that most of them are evergreen, most of them have needles, and all of them have cones.

Conifers produce quite different male and female cones, which are usually on the same tree. What most of us think of as cones are the female cones of a conifer—the woody structures, like the archetypal pinecone, that persist on the tree for at least a year (and on some conifers, for over a decade) and in which the tree's seeds develop. The structure of female cones, as well as their position on the branch, varies among conifers and is one of the features used to identify them. Female cone shapes vary from almost round to torpedo-shaped, and their sizes range from that of a small olive to a small football. Their orientation to the branch also varies: the female cones of the spruce, for example, hang down, while the female cones of the fir point up. Immature female cones are usually smaller, greener, and softer versions of their grown-up selves and they have a more succulent, fleshy texture, but with age female cones take on the hard texture, browner color, and woody look we expect of them.

Most people don't see, or at least don't recognize, male conifer cones as what they are, because they aren't woody and don't fit our expectations of what cones should look like. Male conifer cones, often referred to as pollen cones, are usually much smaller and stubbier than female cones, they are simpler in structure, and they are much more numerous. There is a rice grain–sized male pollen cone, for example, at the tip of almost every male red cedar branchlet. Compared to female seed cones, male pollen cones are relatively short-lived, usually falling from the tree and quickly deteriorating as soon as they have released their pollen. As with female cones, it is almost impossible to generalize about the shape of male pollen cones, but many look like a cross between a pussy willow catkin and a miniature ear of corn. Some appear singly but others appear in clusters, making them look almost like flowers. The colors of immature pollen cones vary from green to brown to purple to yellow to reddish, but when mature and loaded with pollen, they all look yellow or orange.

The male cones of the pine occur in clusters of what look at maturity like conglomerations of swollen, pollen-coated Q-tips. Once they have released their pollen to the wind, they die and fall to the ground. If you've seen such structures on a pine tree and wondered why they never developed into "real" pinecones, it's because they are the tree's male pollen cones not its female seed cones.

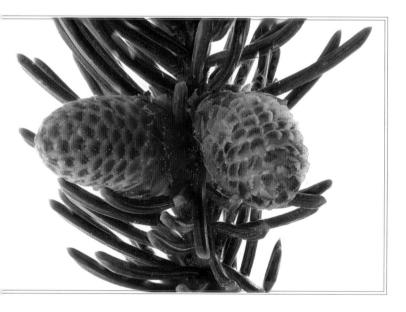

LEFT These cones are young, female cones of Norway spruce (*Picea abies*).

RIGHT This twig of Virginia pine (*Pinus virginiana*) presents (from bottom to top) a mature cone, a year-old cone, and three newly emerged cones on the new green part of the twig.

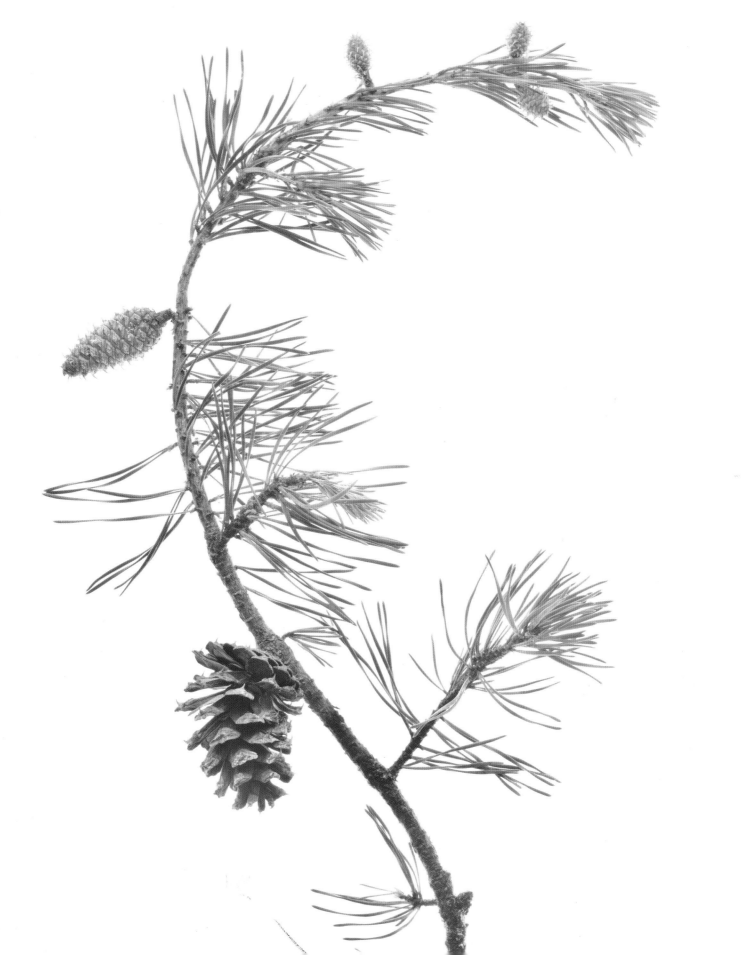

Interestingly, for cones of spruce, pine, and fir trees, although male and female cones sometimes appear on the same branch, more often the female cones are located higher in the crown than the male cones. This arrangement not only facilitates dispersal of the female cone's winged seeds but also may improve the chances of cross-fertilization, since pollen is unlikely to be blown vertically upward in the same tree. And if you see a cloud of pollen in the fall (as opposed to spring), you must be in the vicinity of a true cedar (like the cedar of Lebanon, the Atlas cedar, or the Deodar cedar), because only the true cedars (members of the genus *Cedrus*) produce pollen in the fall. "It's absolutely wonderful to watch," says horticulturist Peggy Singlemann of the cloud of pollen that wind often swirls around the Deodar cedars growing on the grounds she oversees in Virginia. "It's something not many people get to witness, but I run for my antihistamine the minute I see it."

Because they are often overlooked and deserve attention, in this book I spend more time describing cones and inconspicuous tree flowers than I spend describing conspicuous tree flowers. But there are many showy tree flowers that we could also be viewing in greater detail. In addition to the black locust, dogwood, magnolia, and tulip poplar flowers portrayed elsewhere in this book, trees with conspicuous flowers that deserve a closer look include catalpa (upright panicles of frilly white flowers spotted with purple), horsechestnut (tall towers of white flowers with red blotches at their bases), paulownia (panicles of purple flowers resembling foxglove blossoms), apples and crabapples (too familiar to describe), and buckeye (pale yellow to cream-colored flowers growing in upright clusters). Even the weedy ailanthus (tree-of-heaven) has flowers that reward closer inspection. The ailanthus tree invades habitats in almost every state of the Union, but few people can tell its flowers from those of sumac, much less differentiate its male flowers from its female flowers. It does, in fact, bear its yellow-green male and female flowers on separate trees, so if you find ailanthus in a waste place or elsewhere, see if you can determine its sex.

Two other relatively common trees with noteworthy flowers include the linden or basswood (*Tilia* species) and the redbud (*Cercis* species). The American basswood (*T. americana*) and little leaf linden (*T. cordata*) both have clusters of pale yellow flowers dangling from leafy skateboard-like structures which, together, have the open, airy grace of a mobile. The eastern redbud (*C. canadensis*) and other redbud species have pinkish pea-like flowers that cling closely to the tree twigs, and it is their collective impact that most people take in when they observe this tree.

LEFT Speckled purple lines and two yellow stripes direct pollinators to nectar in frilly catalpa flowers.

RIGHT Large flowers and graceful buds are among the attractions of northern catalpa, *Catalpa speciosa*.

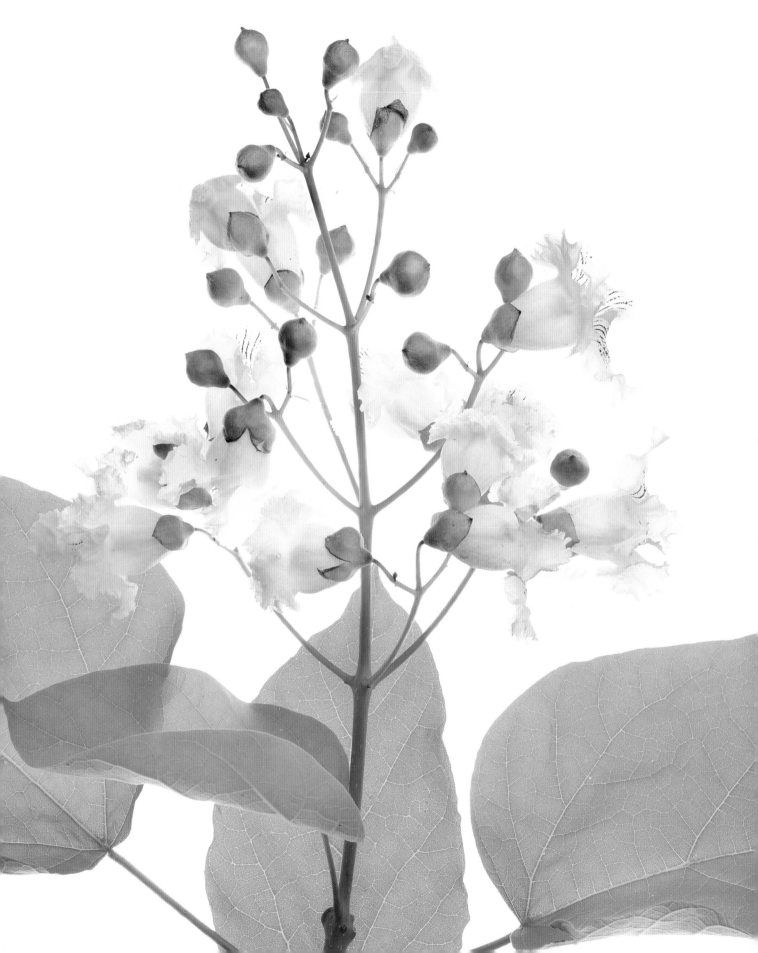

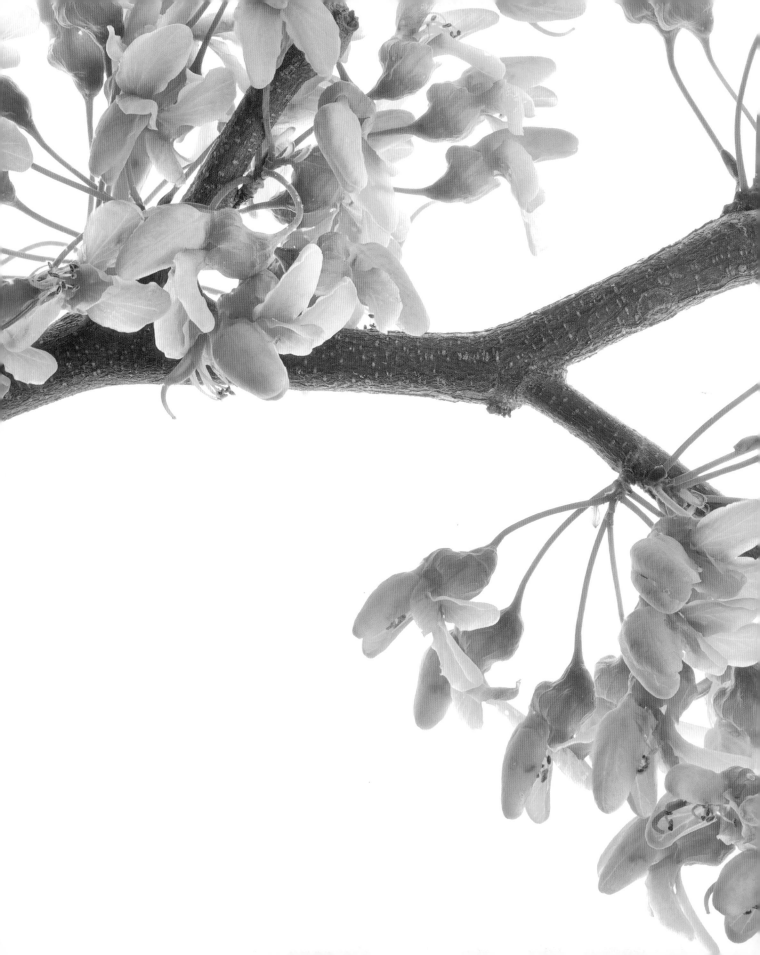

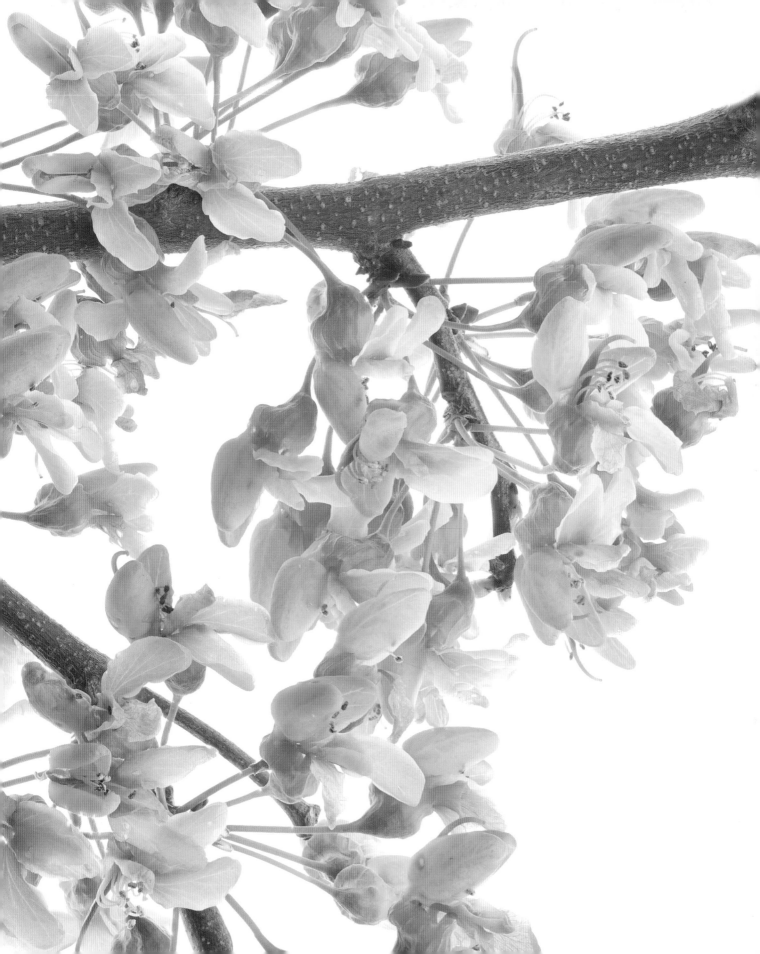

An adaptable tree with a broad range, from southern New England south to Florida and west to parts of Texas and Michigan, the eastern redbud often grows at the edge of the woods and blooms in early spring, when its bare branches are covered with clusters of ½-inch magenta-pink flowers. Although its flowers are sometimes pale pink or even white, the redbud's flowers are never the flat-out red implied in its name. Redbud is a legume, and its fruits look like typical pea pods, its flowers like pea flowers: with a central vertical petal, two petals called wings, and two fused petals that look like a boat's keel. If you examine each flower closely, however, you'll discover, as my grandson, then age nine, did, that each blossom looks like a miniature hummingbird. Talk about seeing with fresh eyes!

Another interesting characteristic of redbud flowers is that they sometimes come straight out of the tree's trunk. There is actually a term for this phenomenon, *cauliflory*, which refers to flowers that develop directly from the trunks, limbs, and main branches of woody plants. Evidently, such "stem flowers" are much more common in tropical rain forests than in temperate regions, and although some other plants native to temperate regions reportedly do this, there is no other flower event remotely similar to this going on in my backyard. My redbud, and only my redbud, has delicate flowers growing straight out of a gnarled, woody trunk. I have dozens of redbuds growing on my property—they naturalize where their seeds fall—and only one of them, an old tree, exhibits this trait. When I see it on my tree or on others', it's one of those small astonishments that enriches a day.

PAGES 64-65 The creamy yellow flowers of American basswood or American linden (*Tilia americana*) hang below long, curving, conspicuous bracts.

PAGES 66-67 The pea-like flowers of eastern redbud, *Cercis canadensis*, are "perfect," meaning they have both male and female parts.

BELOW Turn an eastern redbud flower on its side, with its stalk pointing out like a beak, and it looks like a hummingbird!

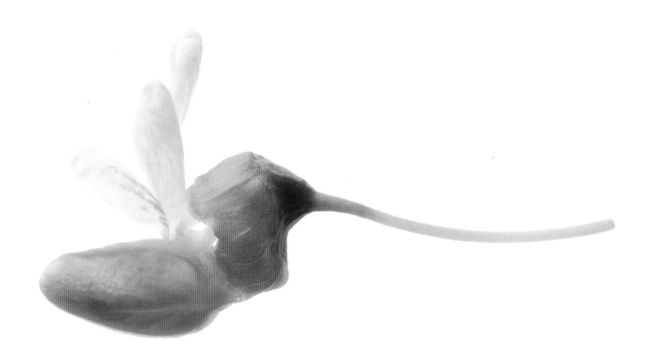

FRUIT

When most of us think of fruit, we think of the kinds of pulpy fruits with which we top our cereals. Tree fruits include many pulpy, edible fruits (think apple, persimmon, cherry, mulberry), but tree fruits also include the hard nut of the hickory, the pea-like pod of the mimosa, the gumball, and the maple helicopter. There is tremendous variety in tree fruits because the category includes every seed-enclosing structure produced by a flowering tree. Some botanists even refer to pinecones as tree fruits, but most reserve the "fruit" designation for the seed structures of flowering plants, which excludes the conifers.

Tree fruits are sometimes hard to write about because the technical terms describing them are often quite different from the common names we apply to them. To describe tree fruits accurately, botanists use words like pome, drupe, follicle, capsule, samara, strobile, and achene, and writers who don't want to use technical terms often have to resort to cumbersome phrases like, say, "cone-like fruiting body" and "berry-like fruit" to refer to seed structures that look like cones when they are technically woody strobiles (alder) or look like berries when they are technically fleshy cones (eastern red cedar). Fortunately for the casual observer, it is possible to become a more accurate observer of tree fruit without learning new technical terms, but the complexity of the language describing them reflects the complexity of these seed structures themselves. The fruit of the common mulberry, for example, is actually a cluster of many small drupes, each a fleshy fruit containing a single small seed; the fruit of the tulip poplar is a cone-like aggregate of samaras, or tree fruits with flattened wings; and the fruit of the American sycamore—the sycamore ball—is a collection of dry, hairy, one-seeded fruits called achenes.

RIGHT The globular "fruit" of the persimmon (*Diospyros virginiana*) is technically a berry.

Some tree fruits are fleshy and some are dry (no flesh or pulp). Some appear singly, others in clusters. Some have protective coverings that look like leaves, such as the clustered fruits of ironwood; others have spines, like chestnut and beech; and still others have coverings that range from the thin, bladder-like bags of golden rain tree to the thick husks of walnut. In size, fruits of common North American trees can range from small and nearly weightless (like the wafer-like fruits of elm), to softball-sized and over a pound (such as the Osage-orange).

If you think of tree fruits as seed delivery systems, their diversity will seem even more remarkable. There is clearly more than one way to deliver a seed to a place where it might successfully germinate. Just as human beings have invented brown trucks and bubble wrap to help deliver packages safely, trees have developed seed structures to accomplish safe delivery of seeds. Their structures are designed to help move the seeds to auspicious locations for germination, keep them alive as they travel, protect them from predation by animals, prevent them from germinating at the wrong time or in the wrong spot, and

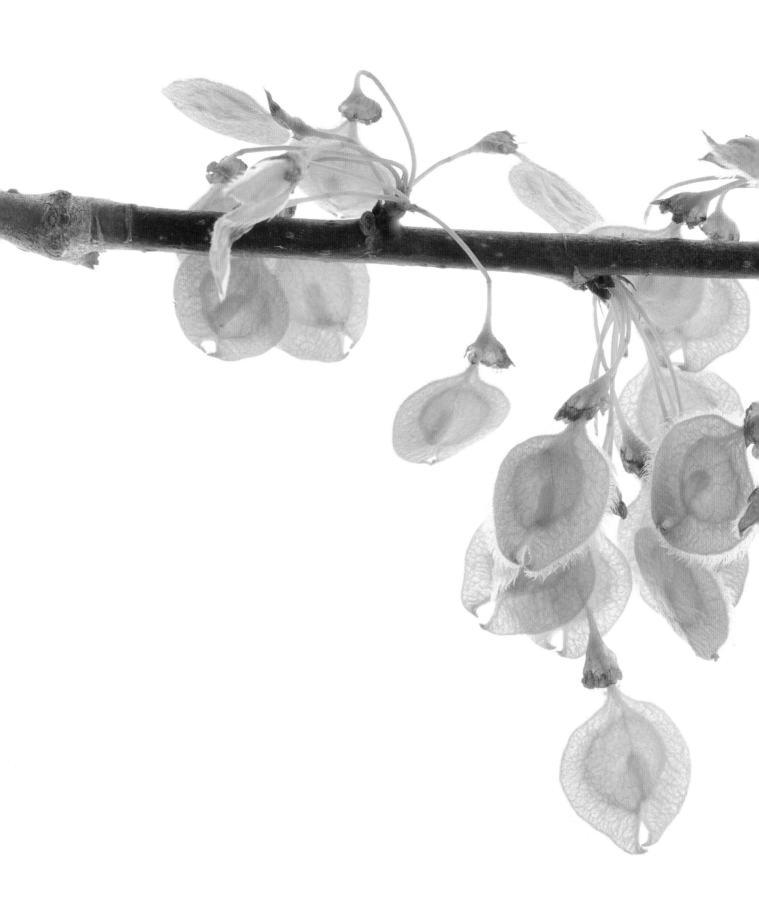

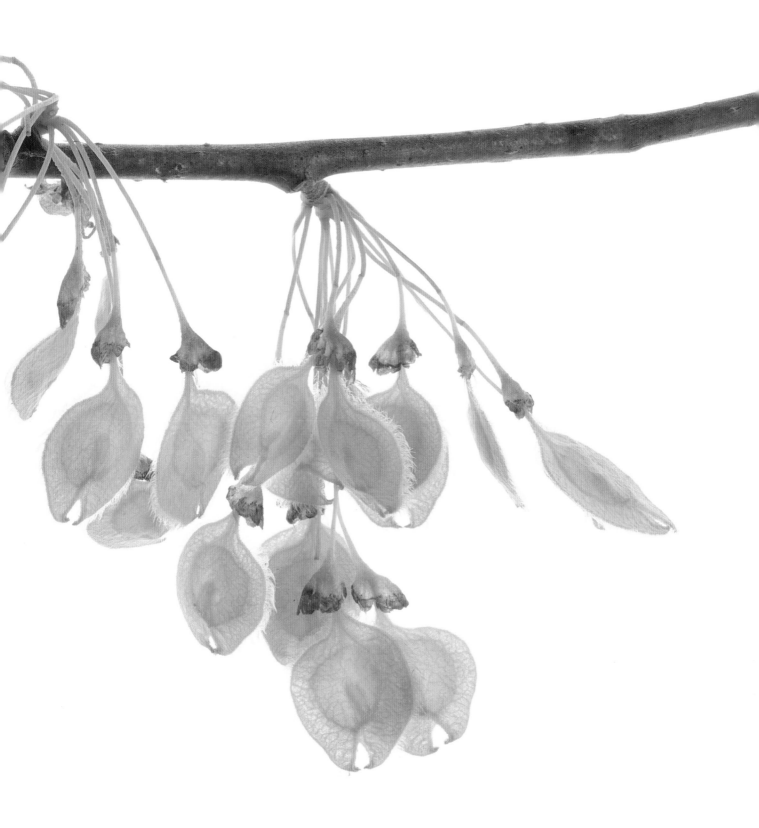

supply them with enough energy to keep them alive until they can develop succoring roots. Assign the problem of accomplishing all that to 1000 species of North American trees (100,000 species worldwide), give them millions of years to work on it, and you have the incredible range of tree fruits we observe today.

Questions to consider when looking at a tree fruit include: What does it look like? When does it mature? How does it travel? When and under what conditions do its seeds germinate? Some tree fruits mature in spring (elm, willow), some in summer (cherries, mulberries, some maples), and most in fall (oak, chestnut, persimmon, tulip poplar). Tree seeds are dispersed by wind, water, propulsion, gravity, man, and other animals. Light

seeds, like the whirligigs of ash and maple, ride the wind. The witch hazel propels its seeds, bullet-like, into the air. Gravity acts on all seeds to bring them to the ground, but gravity really exerts itself on big fruits like Osage-oranges, which roll like bowling balls away from a parent tree on a slope. Willow seeds often ride the wind, then travel by water to the riparian areas in which they are most likely to germinate.

Animals disperse tree seeds in ways both obvious and not so obvious. Tree seeds travel on the coats of mammals (including the tweedy overcoats of humans); people move tree seeds around when they collect or purchase tree seeds in one place and plant them in another; and all animals move tree seeds around when they eat tree fruits in one place and excrete the seeds elsewhere (assuming the seed is still viable). In some cases, the viability of tree seeds is actually enhanced when the seed moves though the digestive systems of birds or other animals, because it helps break their dormancy, sometimes removing pulp and sometimes weakening the seed coat through mechanical abrasion or chemical breakdown.

Squirrels are obviously tree seed movers, inadvertently planting trees when they fail to retrieve nuts they've stashed in the ground, and the blue jay has been dubbed "the avian Johnny Appleseed" because of its role in forest regeneration. In a study at Virginia Tech, researchers Susan Darley-Hill and Carter Johnson found that a

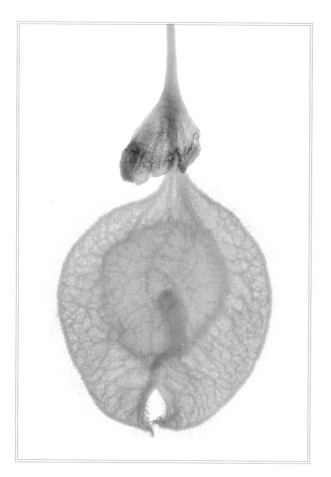

PREVIOUS The dangling, winged fruit of American elm (*Ulmus americana*) is remarkable not only for its wafer-like shape but for its translucent green color.

LEFT This close-up showcases the notch in American elm's winged fruit (a single samara) as well as the hairs along the fruit's edge and reddish sepals above it.

TOP RIGHT The hickory nut resides inside a hard shell and a four-valved husk (two valves of which have been removed for this photo).

RIGHT The nut of the Chinese chestnut (*Castanea mollissima*) is as smooth as its bur is prickly.

blue jay, with its expandable esophagus, can fit as many as three white oak acorns, five pin oak acorns, or fourteen beechnuts in its throat at one time, and that over the course of twenty-eight days, fifty jays (each marked with identifying leg bands) transported 150,000 acorns to new sites. Unlike squirrels, jays also transport acorns over long distances, sometimes more than two miles, before planting them in the open far from the parent trees. Studies like the one at Virginia Tech help explain how oaks moved so quickly back into areas that had been deforested during the last ice age, but they also inspire us tree-watchers to pay more attention to the behavior of birds and other small animals.

In addition to seeing a blue jay transporting a dozen beechnuts in its gullet, I'd like to observe an animal opening a Chinese chestnut. "They must wear boxing gloves!" a friend commented one day, when we encountered scores of these empty husks under a Chinese chestnut tree, each one too spiny for human hands to handle but obviously manageable for a squirrel or maybe a raccoon. Those prickly husks—a deterrent, one presumes, to some four-legged animals—are just one of many strategies trees have developed to protect their seeds from predation. Predator satiation is another. This term relates to the "mast years," or boom years, we witness when trees, particularly oaks, produce a significant abundance of fruit. In such years, trees produce more fruit than their predators can eat, thereby assuring that some of the seeds escape predation. Bust years of seed production, which typically follow a mast year, further ensure seed survival by keeping predator populations low. (Food scarcity reduces

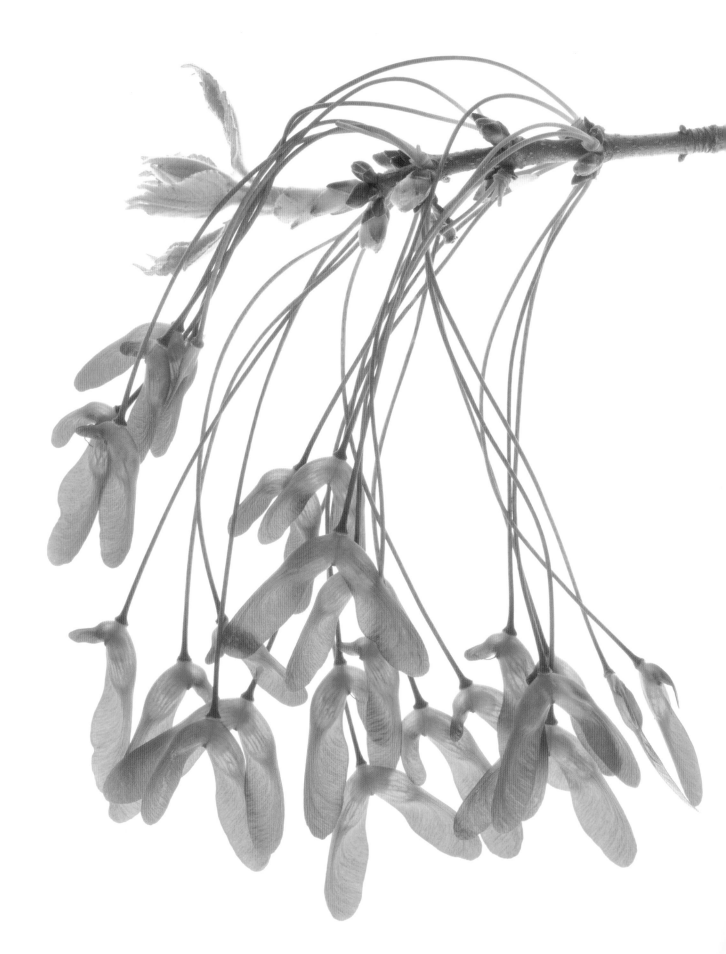

predator populations, so there are fewer predators around in subsequent years to feed on available seeds.)

Although Henry David Thoreau did a good job of it, most of us can't observe tree fruits carefully or long enough to add substantially to scientific knowledge. But, particularly when we combine what we read with what we see, we can gain insight into why tree fruits have evolved the way they have and what some of their survival strategies are. There is also pure pleasure to be had from observing a tree fruit in greater detail, regardless of the purpose of its attributes. The more you look, the more you see, and you don't have to look at unusual or exotic tree fruit for this to be true. To prove the point, let's look at three entirely different but equally study-worthy tree fruits: the gumball, the acorn, and the Osage-orange.

I choose the gumball because it is probably the most universally disliked tree fruit. Product of the sweetgum (*Liquidambar styraciflua*), the gumball is famous for littering the ground and sidewalks, where it can make walking hazardous, but examined as a work of engineering or art, it is a downright charismatic tree fruit. My encounters of the gumball kind have involved stringing thousands of them for garlands (a signature holiday decoration at a botanical garden where I worked), happening upon them topped with snow and ice (a spectacular combination), and raking them into and out of dozens of flower beds over a lifetime of gardening in sweetgum territory. I have also viewed them green in the tops of trees, been halfway aware that they turn yellow as they mature, seen them silhouetted dark brown against winter skies, and noticed that after they've matured and fallen to the ground, there are empty chambers under their woody spikes. Not until I wanted to understand more about where the gumball's seeds came from, and how they relate to the fruit structure, did I really look at a gumball, however.

If asked to draw a gumball from memory, I'd have probably drawn something that looked like a mace—a round ball with straight, pointed spikes coming out all around it. Closer inspection reveals a fruiting structure that is much more interesting: Most of the spikes on a mature gumball actually have curved tips, like crochet hooks, which occur in pairs, like open birds' beaks, above empty seed chambers that you see as voids beneath the spikes. Gumballs have twenty or more such seed chambers (capsules), each topped with a beak-like pair of spikes, and each seed chamber usually contains (before the seeds are released to the wind) two tiny, winged seeds. Nearly all the gumballs we encounter on the ground have already released their seeds, but some are still seed-filled and some contain aborted seeds, the remnants of which look like sawdust.

If you put a mature gumball that hasn't released its seeds in your pocket or on the kitchen counter, it will dry, open, and spill its two seeds (or seed dust) like a saltshaker from each chamber. The seeds are about ⅓ inch long and less than half that wide, dark brown, with a tannish, translucent wing at one end. "If you told people they were insect wings, they would believe you," Bob once observed, and he thinks gumballs look like "alien things" overall. Certainly their structure suggests some

LEFT Immature fruits often called helicopters dangle from a red maple (*Acer rubrum*) twig

RIGHT Although the only true embryo in this winged red maple seed resides in the seed itself, when viewed this close, the entire structure (half of its two-winged fruit) looks embryonic.

out-of-this-world engineering, and while you may not be ready to see them as art objects, once you've studied the structure of a gumball, you'll never rake one away with the same indifference again.

The acorn suffers from overexposure even more than the gumball does. "Seen one, seen them all" is most everyone's attitude toward the acorn, and they conjure up the iconic image of a brown, ovoid nut with a woody tam o'shanter on top. But the acorn is way more variable than that. Tree lovers, collectors, and life list keepers take note: a fine travel goal would be to collect one acorn from all seventy species of oak trees that grow in North America, or just to collect one acorn from every oak species that grows in your county, because such a collection in most cases would reveal how varied in size, shape, and styling these tree fruits are.

Every fall, I get a call from someone in my hometown asking a question that begins: "Near the railroad station, beside the college parking lot . . . ," and before he or she says any more, I know the answer—sawtooth oak. The college has planted a row of sawtooth oaks, *Quercus acutissima*, to shade their parking lot, and this tree's large acorns attract enormous attention, as well they should. The shaggy caps of the sawtooth oak acorn look like the hair of someone who has stuck his hand in a socket: curved woody scales extending in all directions from the surface of the cap. If the college had known when they planted these oaks how many questions they would inspire, they might have instituted their own help line for oak inquiries. But I like getting the calls, because they remind me that these trees are still generating little vortices of excitement, and that in my hometown there are still people willing to go to some trouble to investigate an interesting acorn.

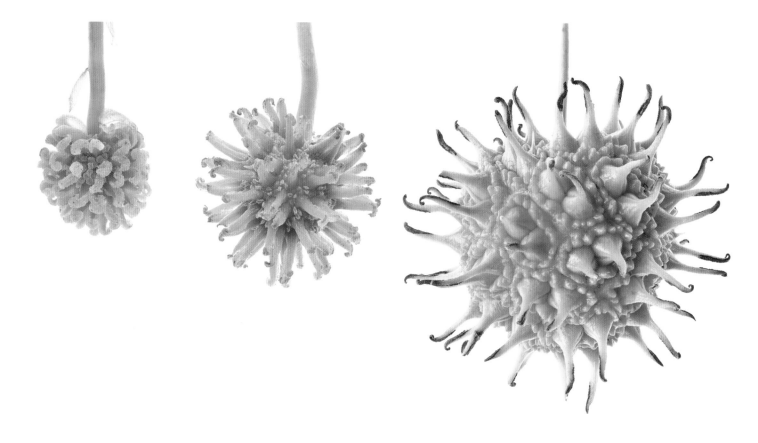

Sawtooth oak (and burr oak, which has an acorn cap with an equally outlandish hairdo) may produce the most startling acorns, but there is tremendous variety, and pizzazz, in the designs of others. Even on the same tree, acorns vary somewhat in size and shape, but each oak species has a distinctive acorn, with some variations more easily spotted than others. Variables include the size, color, and texture of the nut; the shape, size, and texture of the cap (including how tight or loose its scales are); the percentage of the nut covered by the cap and how it fits over the nut; and the length and heft of the stalk at the apex of the cap. At this moment, I have three acorns on my desk that are entirely different from one another. One is from the live oak (*Quercus virginiana*), and it is a tiny (½ inch), refined-looking acorn with a very slender nut and a cap that looks miniaturized in all its details. Collecting such a tiny acorn from under an enormous

live oak is a mind-altering experience, requiring you to confront the reality that not only do mighty oaks from small acorns grow, but some of the mightiest grow from the tiniest. (Willow oak acorns, which are rounder but also startlingly small—under ½ inch wide—present the same contrast when encountered under a massive old tree.)

Another acorn on my desk is that of the overcup oak (*Quercus lyrata*). This 1-inch acorn, which I picked up in a Virginia swamp, has a bumpy cap that almost completely covers the large nut beneath. When you observe immature acorns on a tree or on the ground, many of their caps almost completely cover the nut below, but they are smaller and don't have the "peephole" quality of this acorn. The cup of my mature overcup oak acorn covers three quarters of the nut, and only a round hole about ¼ inch in diameter allows you a peek at the nut inside. Interestingly, unlike most acorns, healthy overcup acorns float, an adaptation to swamp and bottomland living.

A friend sent me the third acorn on my desk, a jaunty specimen from a hybrid oak (probably a cross between a white oak and a chestnut oak). It's another large acorn (about ¾ inches wide and 1½ inches tall) with a very smooth, almost lacquered nut surface, long stalk, and cap that sits on its head like a brimmed fisherman's hat. Because the brim of this hat is turned up, it doesn't look like the "berets" that top many acorns. In fact, neither I nor my friend, Byron Carmean, who is the most knowledgeable tree person I know, have ever seen another oak (other than those Byron has propagated from the original hybrid he found) that bears acorns like this. If people collected acorns the way kids do trading cards, this acorn would be worth a lot, and I'm sorry I let it dry up before planting it. (By the time it reached me, it had already sprouted the root-like appendage called a radicle.)

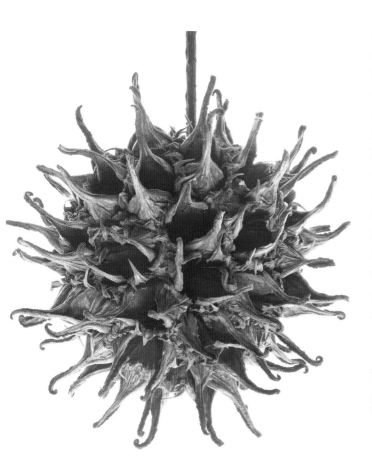

The familiar gumball, the multiple fruit of sweetgum (*Liquidambar styraciflua*), develops (left to right) from female flower to mature gumball in about seven months.

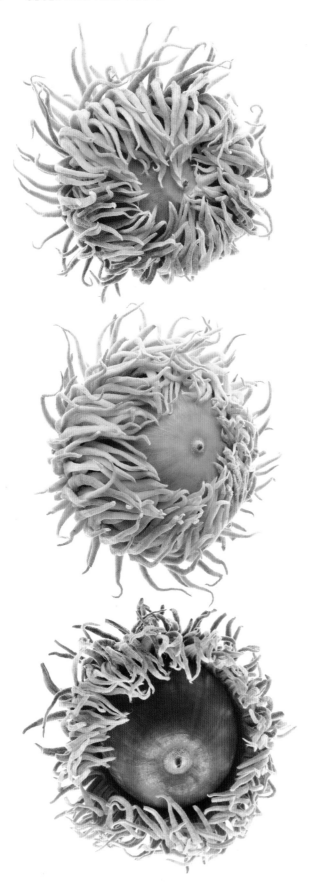

This is something else to watch for in acorns—how long it takes them to mature and when they germinate. There are two major divisions of oaks, the white oak group (which includes white oak, post oak, burr oak, chestnut oak, and overcup oak, among others) and the red oak group (which includes northern and southern red oak, black oak, live oak, willow oak, and pin oak, among others). Oaks in the white oak group have leaves that are smooth-lobed (meaning their edges are rounded, not bristle-tipped), their acorns take one year to mature on the tree, and they germinate in the fall—almost as soon as they hit the ground (and sometimes in the envelope if someone is sending you one). Oaks in the red oak group have bristle-tipped leaves, their acorns take two years to mature on the tree, and their acorns germinate in the spring.

No one takes the third featured tree fruit for granted. The gargantuan, yellow-green fruit of the Osage-orange is a traffic stopper—literally. People wanting to use them for decorations will slam on the brakes and hop out of their cars for Osage-oranges faster than you can say "What's that giant green ball that looks like a brain?" Three to five inches in diameter, Osage-oranges have a pleasant, citrusy smell and a bizarre texture that makes them interesting objects piled in baskets for table decorations, not to mention decorating roadsides and other landscapes. When you look at this tree up close, also look at its thorns, because they are one reason this tree now grows far outside its original range (parts of Arkansas, Texas, and Oklahoma), and you can now find this adaptable tree, with its oversized fruit, growing across most of the United States. In the nineteenth century, Osage-orange

LEFT No, these are not alien beings. They are maturing acorns of sawtooth oak, *Quercus acutissima*.

RIGHT Borne singly or paired, acorns of southern red oak (*Quercus falcata*) have shallow caps.

(*Maclura pomifera*) was the most widely planted tree in the country, particularly in the Midwest, where it was used to make living fences because of its thorns. You can train the thorny trees to grow into nearly impenetrable barriers, and, according to plant historian Peter Hatch, in 1868 alone, 60,000 miles of Osage-oranges were planted in this country. The invention of barbed wire put an end to "hedgemania," but the tree has continued to spread in the wild as well as in the landscapes of people who plant it for its beauty and its fruit.

In the 1990s, my husband and I planted several Osage-oranges from 6-inch seedlings, and only ten years later one was bearing fruit. The trees are of separate sexes, and I presume the fruiting tree is our only female. What a rewarding tree it has been to watch! It was only around 15 feet tall when it bore its first fruit, and it seemed way too small to be holding up those weighty green balls. Even more surprising, several years later, was the fact that our small tree produced scores of these fruits, a bonanza followed by a year when it produced less than a dozen

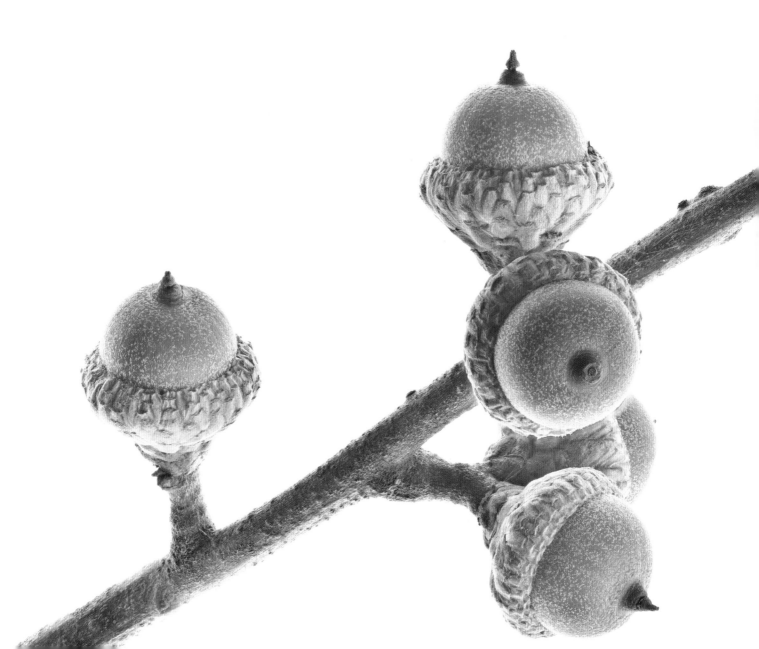

fruits. The lean year, of course, was the year when I'd hoped to watch the fruit development much more carefully. Because of the scarcity of fruit, I drew an eagle-eyed friend into the process, and she spotted something I had never seen and didn't know existed. With binoculars, she found the tree's immature fruit, as small as golf balls, among the tree's green leaves, and when she gave the binoculars to me, I gasped, because each small green ball was covered with dark, stiff-looking hairs about 2½ inches long. Talk about an alien-looking object! Although I now know what those hairs are (styles, each arising from a separate ovary in this compound fruiting body), I'm glad I didn't know at the time because discovering them was such a thrill.

Watch, too, for what eats Osage-oranges and what doesn't. Although squirrels, birds, and a few other modern animals eat their seeds, most animals seem to avoid the big fruits, which are filled with a bitter, milky sap. I have heard reports of horses and cows eating them (Osage-oranges are sometimes called horse apples), but I've also heard that horses can choke on them. Evidently, it is not to the taste of modern animals, but rather to ancient ones, that Osage-orange is adapted. Some scientists hypothesize that prior to the end of the last ice age (more than 10,000 years ago), the Osage-orange was eaten regularly by large animals like the woolly mammoth, mastodon, camel, and giant ground sloth, and, given this fruit's prehistoric styling, that's easy to imagine.

The softball-sized fruit, technically a multiple fruit, of Osage-orange (*Maclura pomifera*) packs a wallop when it falls.

BUDS AND LEAF SCARS

When most of us think of buds, we think of spring phenomena—and usually in association with garden flowers. But tree buds, which contain embryonic leaves, stems, and flowers, are usually formed the summer before they grow into the forms they take in spring, and winter is one of the best times to view them.

During the summer and fall, tree buds grow to a certain size then stop, or rest, for the winter. At that stage, they are called winter or resting buds, and they remind us that life hasn't fled the body of a leafless tree, it's just in waiting, and the shapes of next year's leaves and flowers

are already programmed into its buds. Resting buds also provide one of the best ways to identify trees in winter, because their designs are unique to each tree species.

Compare, for example, the terminal bud of the beech to the terminal bud of the tulip poplar, oak, and horsechestnut—four of the trees easiest to identify by their resting buds. (A terminal bud occurs at the end of a tree twig, as opposed to lateral buds, which occur along the twig's sides.) The terminal bud of American beech is unmistakable: shaped like a thin spear, it is a pale, yellowish brown and covered with dry, shingle-like scales. Its tip is so sharply pointed I've always thought it could be in a CSI episode—"murderous botanist dipped beech bud in poison"—or something like that. In addition to having an unmistakable shape, beech terminal buds always occur singly, which is entirely different from the terminal buds of oak, for example, which occur clustered at the tips of the twigs and are coarse, stout, and hoary in comparison with the beech bud's refined, narrow, well-chiseled look.

The terminal bud of horsechestnut is large—about the size of a night-light bulb—and its scales (the protective covering of the bud) are covered with a sticky resin that makes them look and feel as if they've been dipped in molasses. The resting bud of tulip poplar (and its protective covering) is also relatively large, but, while actively growing, it is a study in soft, smooth, unblemished green. (Later it turns a purplish brown.) The two scales (modified stipules) covering the tulip poplar bud come together like praying hands or ducks' bills, depending on your perspective. At the end of the summer, the terminal buds on a cutover tulip poplar (one that has been cut down and then comes back with vigor) are often very large, and I

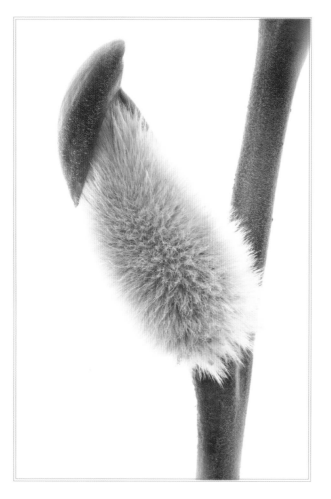

LEFT Pussy willow catkins (on this *Salix* species twig) often wear their bud scales like caps before they fall off.

RIGHT Distinctive terminal buds, lateral buds, leaf scars, and lenticels provide clues to the identity of post oak, *Quercus stellata*.

have had the experience of pulling them apart to discover an identifiable, folded leaf pressed against the other plant material inside. Folded down its midvein the way a valentine is often folded down the center for cutting, this embryonic leaf is miniscule but unmistakable in shape. Imagine that tiny leaf waiting patiently in those praying hands all winter, and you'll never see a leafless tulip poplar as lifeless again.

Tree buds vary in the way they are "packed," in the nature of their contents (leaves and stems, leaves and flowers, or flowers alone) and in the way they are arranged on the twig. In some species, like dogwood, it's easy to tell flower buds from leaf buds (the flower buds look like clenched fists), and many trees' flower buds are rounder than their leaf buds. But on most forest trees, leaf and flower buds are indistinguishable until the leaves or flowers begin to emerge. On an oak, for example, it is impossible to tell just by looking at it which of the tree's lateral buds will produce flowers. Only the lateral buds of an oak (as opposed to its terminal buds) produce flowers, but you just have to wait and watch to see which of those buds will bloom.

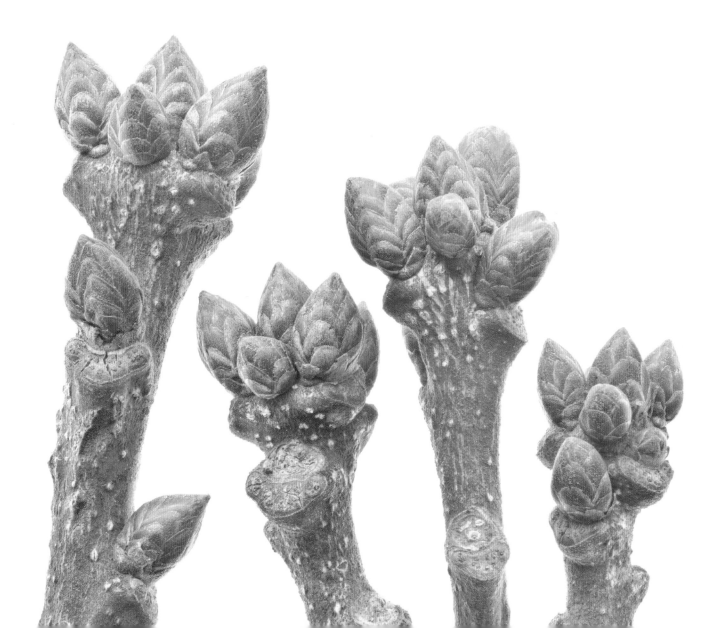

Like the leaves that follow them, buds are arranged in an alternate or opposite (rarely whorled) pattern along the twig, and these arrangements can help you identify trees in winter when leaves are absent. The leaves (and buds) of maple, ash, dogwood, paulownia, horsechestnut, and buckeye are positioned across from each other on the stem (opposite). On most other common trees, they are alternate.

The buds of different tree species also vary in the way they are protected from drying out. Some trees have what are called naked buds (the terminal buds of the pawpaw and witch hazel, for example, are protected only by their outermost waterproof leaves), but most tree buds have protective scales covering the embryonic plant material inside. The number of scales varies from one to many, with the willow having, for example, a single cap-like scale covering its bud, the bitternut hickory (like the tulip poplar) having a pair of scales meeting but not overlapping in the middle, and most tree species having numerous overlapping scales arranged in various patterns like shingles on a roof.

There are all sorts of other bud characteristics that help differentiate tree species, and a good field guide or website will alert you to things like the lopsided bud of the American basswood (its scales are asymmetrical), the pale wooliness of the black oak bud, the embedded bud of the black locust (sunken below the surface of the twig), and the stalked bud of the smooth alder (raised above the surface of the twig on a short stem).

LEFT The alternate arrangement of sharp, pointed resting buds is clearly visible on this American beech (*Fagus grandifolia*) twig.

RIGHT These three photos illustrate (left to right) the terminal bud of sweetgum (*Liquidambar styraciflua*) with leaf scars below, the sticky buds of horsechestnut (*Aesculus hippocastanum*) with leaf scars below, and the flower bud of flowering dogwood (*Cornus florida*). The photos are not to scale.

The sizes, shapes, and positions of leaf scars—the areas, usually below the buds, where the previous year's leaves have fallen off—also vary among tree species and are equally useful in identifying trees in winter, not to mention being interesting for their visual variety alone. I like to think of leaf scars as tiny family crests, because many of them are shaped like crests or shields, and the markings inside them provide clues to the species' identity.

Probably the easiest leaf scar to see on a common tree is the large, heart-shaped leaf scar of ailanthus. On the smooth, slightly furry surface of *Ailanthus altissima*, this leaf scar stands out like a scab on a knee. Other leaf scar shapes include some that are triangular in outline, some round, some oval, some scalloped, some shield-shaped, some crescent-shaped, and many other shapes, each indicative of the species. Leaf scars also vary in their

relationship to the stem (raised above, depressed into, or flush with the surface of the twig), in their texture, and in the number and configuration of the bundle scars within them.

Bundle scars? If you don't know this term, it's a good one to learn, because it is materially useful and metaphorically fascinating. To look at a tree up close and miss its bundle scars is to overlook its leaves' broken connection to the tree (and all the back and forth energy and water exchange that implies). Bundle scars are the tiny, raised spots, usually looking like dots or bars, that occur inside a leaf scar and that mark the places where the leaf's "pipes" have been broken. The word "pipes" works for me best in this context, but what we are talking about is the tree's vascular tissue, or veins, through which water and nutrients pass from the tree into the leaves and

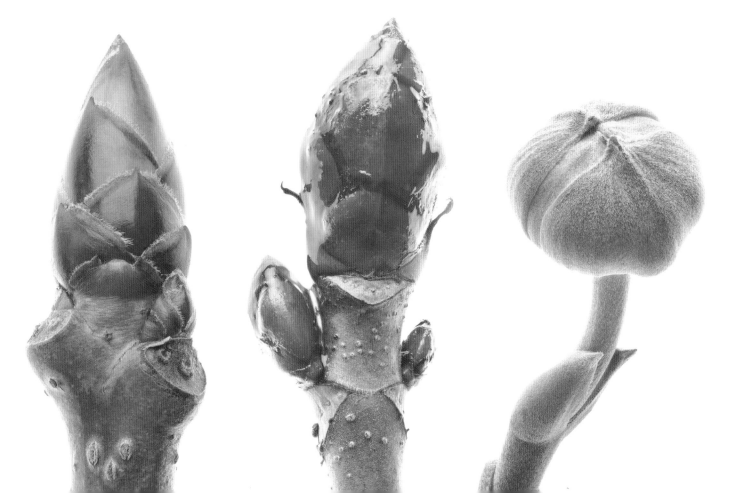

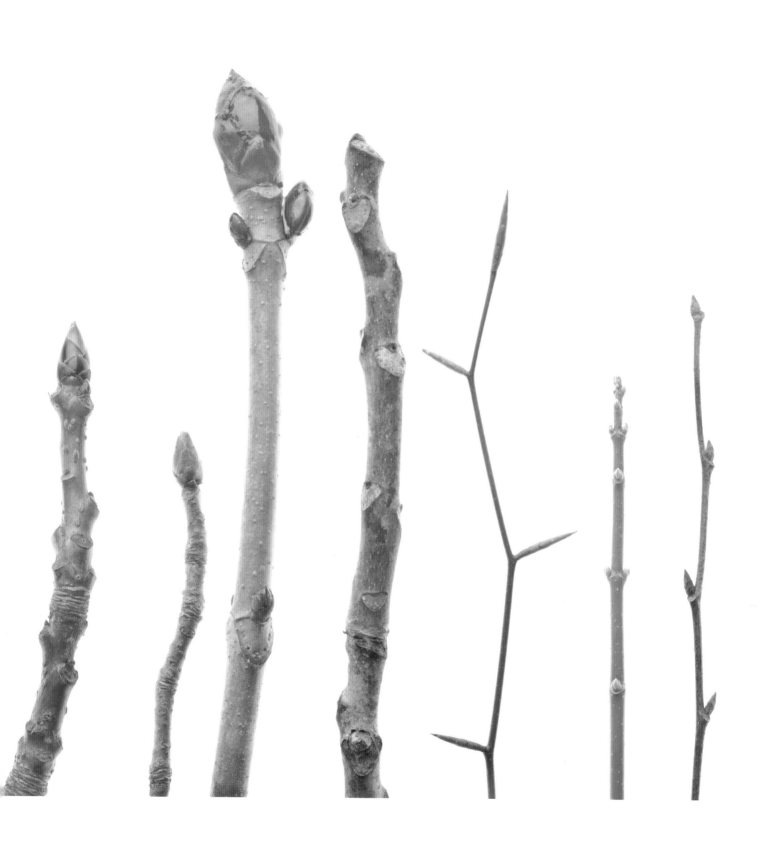

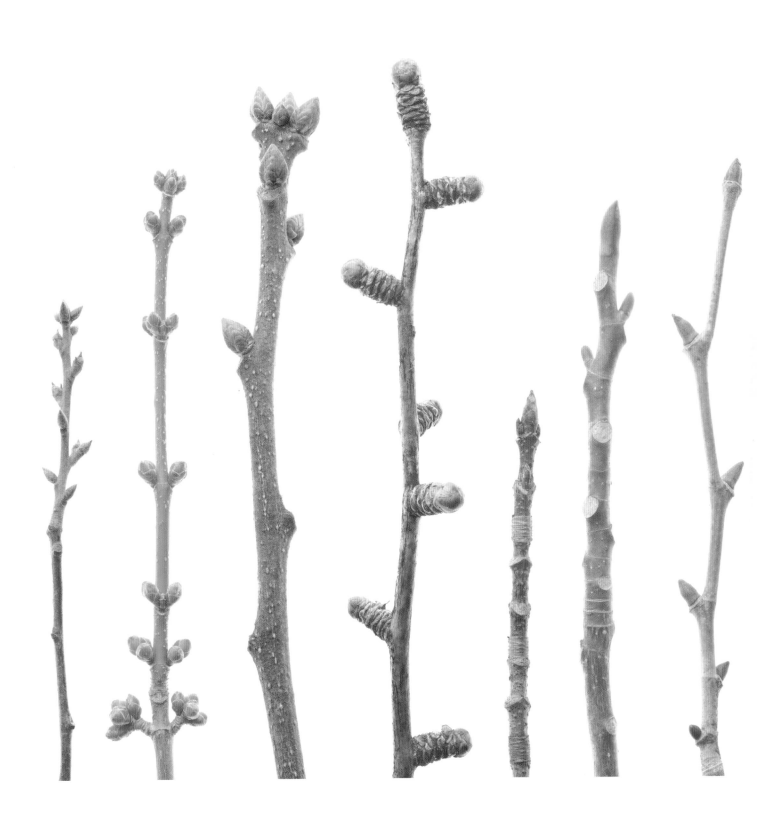

PREVIOUS Illustrated here (left to right) are twigs of sweetgum (*Liquidambar styraciflua*), tupelo (*Nyssa sylvatica*), horsechestnut (*Aesculus hippocastanum*), ailanthus (*Ailanthus altissima*), American beech (*Fagus grandifolia*), boxelder (*Acer negundo*), slippery elm (*Ulmus rubra*), southern red oak (*Quercus falcata*), red maple (*Acer rubrum*), post oak (*Quercus stellata*), ginkgo (*Ginkgo biloba*), sugar maple (*Acer saccharum*), tulip poplar (*Liriodendron tulipifera*), and American sycamore (*Platanus occidentalis*).

BELOW Twigs of (left to right) white ash (*Fraxinus americana*), horsechestnut (*Aesculus hippocastanum*), and sweetgum (*Liquidambar styraciflua*) show identifying features including sizes and shapes of leaf scars and number and configuration of bundle scars.

BELOW RIGHT The leaf scar, bundle scars (inside the leaf scar), and bud of *Ailanthus altissima* (tree-of-heaven) are all distinctive. Characteristic lenticels, or pores for gas exchange, are also visible in the bark.

BELOW FAR RIGHT Look for the shape of E.T.'s head in the leaf scars of black walnut (*Juglans nigra*). Also visible on this twig are the tree's pubescent resting or winter buds.

through which food passes from the leaves into the tree. Trees of each species have different "pipe arrangements," and when you look at the bundle scars in a leaf scar, what you are seeing is where the pipe arrangements have been broken.

The number, shape, and pattern of the bundle scars within a leaf scar provide additional keys to a tree's identity. The number of bundle scars varies from one to around thirty, and depending on the species, bundle scars can be irregularly arranged or arranged in patterns that vary from lineups that look like smiles and horseshoes to clusters that look like socket holes and paw prints. The naturalist Ruth Cooley Cater once suggested looking for faces in the patterns of bundle scars in leaf scars, and while she saw more faces in leaf scars than I do, following her lead I can find the face of E.T., the Extra-Terrestrial, in the leaf scar of a black walnut. On the black walnut leaf scar, which is sort of a flattened shamrock shape, like

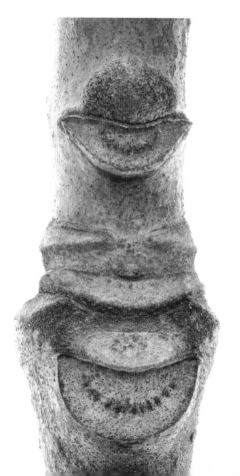

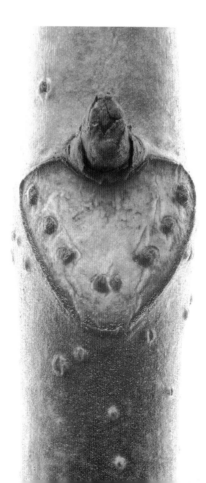

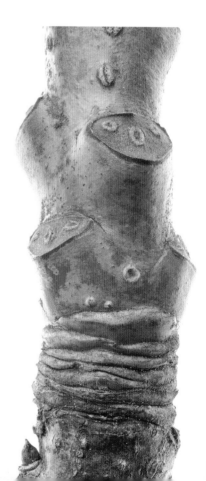

E.T.'s head, are three tiny horseshoe-shaped clusters of bundle scars that look like eyes and a mouth.

What leaf scars represent—their symbolic significance—intrigues me as much as their physical appearance, however. Everywhere you see a leaf scar and its accompanying bundle scars, you are seeing a healed-over spot where a tree has, in order to keep itself alive, discarded a leaf. Because in winter, with reduced sunlight, a leaf is a liability to a deciduous tree (kept on the tree, it would continue to lose water to the atmosphere while producing little food), trees break their connections to their leaves and instead put their resources into maintaining their other living parts, including their resting buds. Not only does this process seem intelligent, efficient, and elegant to me, but there is something about it that seems to represent a life lesson—the wisdom of marshaling your resources when they are limited and you are under stress, so you can survive to live more productively another day.

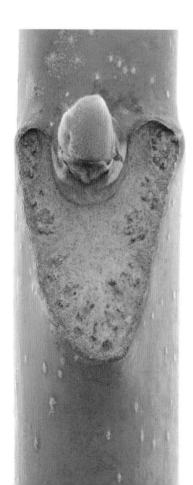

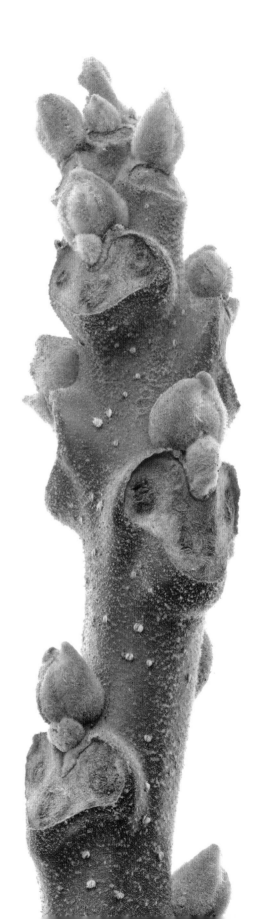

BARK AND TWIGS

My husband and I have lived in the same town for almost forty years but only recently did I take him to see my favorite grove of black locust trees on a nearby college campus. I wanted his help describing the color and configuration of the trees' bark, and I got that, sort of. What I received unequivocally was reinforcement of my opinion that these trees, ignored except when their fragrant flowers bloom in May, deserve exalted status for their bark alone. "Those are some interesting trunks," John commented, after we had finished examining the five trees I'd taken him to see, and for a man who doesn't gush, that's high praise.

Unfortunately, we found describing the trees' bark harder than appreciating it. A sampling of our varied descriptors included longitudinally striated, deeply fissured, sharply indented, craggy, and basket-weavy. With color, we did little better. I thought the predominant color was a taupe, or gray. John suggested milky brown. And what about those orangey areas where the tree's bark had been abraded? Unlike wall color, tree bark color is almost always a combination of colors, which is one reason describing it is such a challenge. Tree bark color and texture also vary depending on the age of the tree, position on the tree, and even the individual genetic makeup of the tree, so one descriptor doesn't fit all when it comes to describing the bark of even a single species. Virginia tree expert Byron Carmean once told me that he, too, found bark particularly hard to describe. When teaching his students to recognize different tree barks, he said he often had trouble finding words to fit the discriminations he could easily make in the field. "What is it that I see that I can tell them to look for?" he often wondered. "I finally told them they just had to go outside and look at enough trees to see the difference themselves."

Different species of trees do have bark with characteristic colors, textures, and configurations, and some of those characteristics are relatively easy to identify. Bark is, as most people know, protective covering for living parts of the tree beneath. Some of its less known functions include protecting the tree from parasites, preventing water loss, and insulating the tree from heat, thereby reducing the tree's vulnerability to fire. On young trees, bark is usually smooth (on the sassafras, it stays smooth and green for a long time). A few species, like beech and ironwood, have bark that stays smooth throughout the tree's life, but on most trees, bark roughens up as the tree ages.

As the interior of the tree grows, the tree's outer bark begins to crack open or peel off in a way that is characteristic of the species. Those with exfoliating bark (the peelers) include river birch, yellow birch, sycamore, crape myrtle, red cedar, northern white cedar, and shagbark hickory. Many more species have bark that cracks or divides in characteristic ways to accommodate the expanding trunk. How it cracks and divides—into what patterns and to what extent—can be a clue not only to the tree's identify but to the age of the tree. Things to look for include the shape and orientation of the bark's furrows or fissures. Do they run up and down the tree, diagonally across the tree, or do they crisscross? Are they short or long, close together, or far apart? Do they break the surface of the bark up into longitudinal ridges, irregular squares, or rectangles? The ridges between bark furrows also have characteristic shapes and textures. They can be smooth or scaly, pointed or flat-topped, tall or short. As tupelo (*Nyssa sylvatica*) ages, for example, its bark gets thicker and thicker, and the furrows in the bark of a really old tupelo can be 2½ inches deep. "They're so deep you could plant corn in them," a friend observed as we stood in the presence of a particularly ancient tupelo in Shenandoah National Park.

Descriptions of bark can be helpful—or not. I realized

The thick bark of an old black locust (*Robinia pseudoacacia*) has deep furrows and interlacing ridges.

I was being less than helpful when I tried to describe, for my grandchildren, bark on the lower trunk of a white oak we were passing and referred to it as "alligatored." I thought the alligator part would get their attention, but then it occurred to me that they had no category for alligator hide, having seen no alligators and probably no products made of alligator leather either. "Plate-like," a term often applied to pine bark, can be equally unhelpful if it conjures images of dinner plates rather than tectonic plates. "Broad ridges of irregularly rectangular purple-tinged plates" is a good description of white pine bark I found on the Internet, but I'm not sure anyone who doesn't already know pine bark could pick a pine out of a lineup using it.

We probably need an entirely new language, with contemporary references, to describe bark and other tree traits to a new generation of naturalists, but even more important is just getting people outside to witness these phenomena. Bark and characteristic twig features are particularly valuable for tree viewers to know in winter, because not only do they help you identify trees after the leaves have fallen off but they allow you to continue relating to and learning about trees when the ground is frozen. Even if you discover you can't identify a particular tree by its bark, twig structure, or other winter feature alone, you can combine these clues with other features, like spring leaves that develop later, to develop the gestalt, or jizz, that will someday make this tree unmistakable in all seasons.

There are dozens of trees in my own neighborhood that, shown their bark alone, I don't think I could identify, but instead of finding that discouraging, I think it's pretty wonderful that there's so much left to learn nearby. And

RIGHT Young black cherry (*Prunus serotina*) bark has conspicuous breathing pores, or lenticels.

FAR RIGHT Ironwood (*Carpinus caroliniana*) is also called musclewood because its branches and trunk are so sinewy.

it is reinforcing to have a subset of trees I can identify by their bark. Among them are the following seven trees that are among the easiest to identify by bark alone.

BLACK CHERRY
Prunus serotina

Black cherry, a weed tree, is common throughout most of the eastern United States and is easily identifiable by its young bark. The twigs and trunk of a young black cherry are a shiny olive green to dark reddish brown with horizontal slits, like dashes, along their surface. These pale beige slits are lenticels, or breathing pores—openings gases pass through to the tree's internal tissues. Somehow seeing these pores, a reminder that trees breathe, always enhances my sense of trees as living organisms. Most trees have lenticels, which vary in shape, distribution, and size, but they are most visible on certain young trees with smooth bark such as cherry, birch, and boxelder. (Boxelder has white, raised lenticels on its smooth, green bark.)

Mature black cherry trees have entirely different bark. It is darker, rougher, and broken up into scaly plates that often curl up along the edges like potato chips.

IRONWOOD
Carpinus caroliniana

The limbs and trunk of ironwood have tight, smooth, steel-gray bark that looks muscled. This muscled look is the result of rounded, longitudinal ridges creating fluted contours that is unique to ironwood. This tree could be used in weight-training ads, so hard, sleek, and sinewy is its frame. Unfortunately, although it can be found in almost all of the eastern United States and is common in some wet bottomlands, ironwood is seldom recognized as the superior small tree it is. Informed landscapers describe it as choice, handsome in the landscape, and infused with subtle beauty. A relative once invited me

over to help her decide which trees to save on property she was cleaning around her suburban home, and I discovered the dreaded yellow tape meaning "remove this tree" tied around half a dozen mature ironwoods. I couldn't rip that tape off fast enough. It was a hard sell, convincing her of the wisdom of this decision in winter (the tree's muscled wood and delicate twig structure were the only assets I could point out at the time), but I did finally convince her that these slow-growing trees were not only fine, old examples of their kind but that, being native to the area, they were more valuable than anything she could replace them with. Let this be a cautionary tale for anyone clearing land in winter: don't do it unless you can identify your trees without leaves.

AMERICAN SYCAMORE
Platanus occidentalis

Bark may be the least obvious distinguishing feature of some trees, but for American sycamore, it is the tree's most striking feature. You can almost always identify a sycamore just by looking at its bark. If you see a tree with blotchy, brown-to-green-to-gray outer bark that has popped off in patches to reveal smooth, almost white, inner bark, you're in the presence of an American sycamore (or the closely related London plane tree). You'll find some of the whitest sycamore bark in the tree's upper branches, which, rising above other trees and illuminated by winter light, look like arms waving above the surrounding trees. Famously attached to watercourses, a distant line of sycamores skirting a river's edge can be almost as reliable as a map in leading you to a riverbank.

RIVER BIRCH
Betula nigra

This tree is another one most easily identified by its bark, at least among young trees. River birch bark peels off in broad scroll-like sheets, and its colors range from tans and browns to creamy white and salmon. Because it peels off in such large, thick pieces, you really can use river birch bark as paper—the perfect writing surface for pokeberry ink. As its name suggests, you'll usually find river birch growing along watercourses. Because it tolerates pollution and oxygen-deprived soil, landscapers like to plant it in the esplanades of parking lots, where it often shelters the rack for shopping carts. (No excuses for not teaching your kids to recognize this tree by its bark; they don't even have to get out of the car!) Growing farther south than other native birches, river birch is less resplendent than New England's white birch, but to the eyes of those of us who can't grow white birch, it is equally appealing.

Like wild black cherry, young twigs of river birch are characterized by visible lenticels (breathing pores), although on river birch they are longitudinal, not crosswise on the stem. Unfortunately, an old river birch is characterized not by curling, paper-like bark but by thick, deeply furrowed, dark brown bark, making mature river birches less easy to identify by bark alone than young ones.

PERSIMMON
Diospyros virginiana

Walking up the hill from the barn, in a grove where I hadn't noticed it before, I spy the unmistakable bark of persimmon, and in that moment of recognition is pleasure. Why? I'm not sure. Maybe this is like spotting a friend across a crowded room? Persimmon bark is often darker than the barks of other trees around it (dark gray to brown or black), and it is broken into small, square blocks that remind me of brownies that have been cut

Multiple layers and colors of the bark of American sycamore (*Platanus occidentalis*) give sycamore trunks an army camouflage look.

in the pan and begun to pull away from each other as they cooled. Checkered is a word often used to describe persimmon bark. If you look carefully, you'll also notice that on some older persimmons, the furrows or valleys between the "brownies" are a reddish brown suggestive of cinnamon.

EASTERN RED CEDAR
Juniperus virginiana

Long strips of bark in varying shades of gray and brown that look as if they have been plastered onto the trunk by a kid using school glue characterize this common evergreen. "Shreddy" also describes this bark, which peels off in vertical strips and is often underlain with reddish brown. An old red cedar that has been "limbed up" (had its lower branches removed) to reveal its shreddy bark is a thing of beauty and seems of a different order from the multitudinous red cedars that pop up like weeds in abandoned fields. When considering bark alone, the only trees you might confuse red cedars with are some of the true cedars, like northern white cedar (*Thuja occidentalis*), which also have shreddy bark.

AMERICAN BEECH
Fagus grandifolia

Journalist Will Cohu captured the essence of beech bark when he described the beech as looking like a woman who has "just emerged from a wax and a massage." The beech, he wrote in *Out of the Woods: The Armchair Guide to Trees*, looks like a woman who works out, takes care of herself, and maybe even gets a bit of botox.

Cohu was describing the European beech, but the

Illustrated here are (left to right) river birch (*Betula nigra*) bark, persimmon (*Diospyros virginiana*) bark, and eastern red cedar (*Juniperus virginiana*) bark.

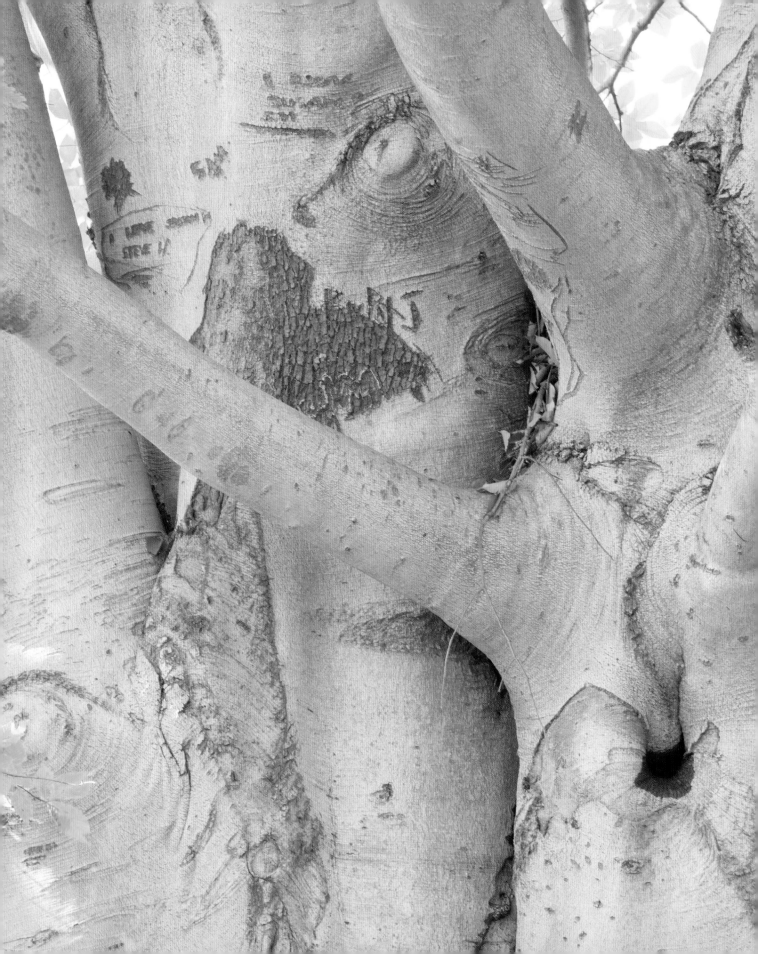

American beech is equally sleek, with gray bark stretched tightly across what looks less like wood than musculature. Although sometimes mottled with dark blotches and bands, beech bark is characteristically smooth and looks close-fitting. Because where you see one beech you usually see many (beeches often form colonies), there is often a repetition of the beech bark effect—many trunks

LEFT The thin bark of American beech (*Fagus grandifolia*) often proves irresistible to scribes.

BELOW Corky, winged bark characterizes young sweetgum (*Liquidambar styraciflua*) trunks and twigs.

exhibiting smooth bark in the near, middle, and far distance—multiplying their impact.

You'll find American beech trees in hardwood forests throughout most of eastern North America, but in suburbia, not so much. The native American beech has been called the Indian of trees because it doesn't take well to "civilized" conditions—conditions often characterized by compacted, half-dead soils. Here and there, remnant beeches remain in developed areas, however, and where they do, they merit our attention.

Other trees easy to recognize by their bark include shagbark hickory (mature trees have long strands of peeling

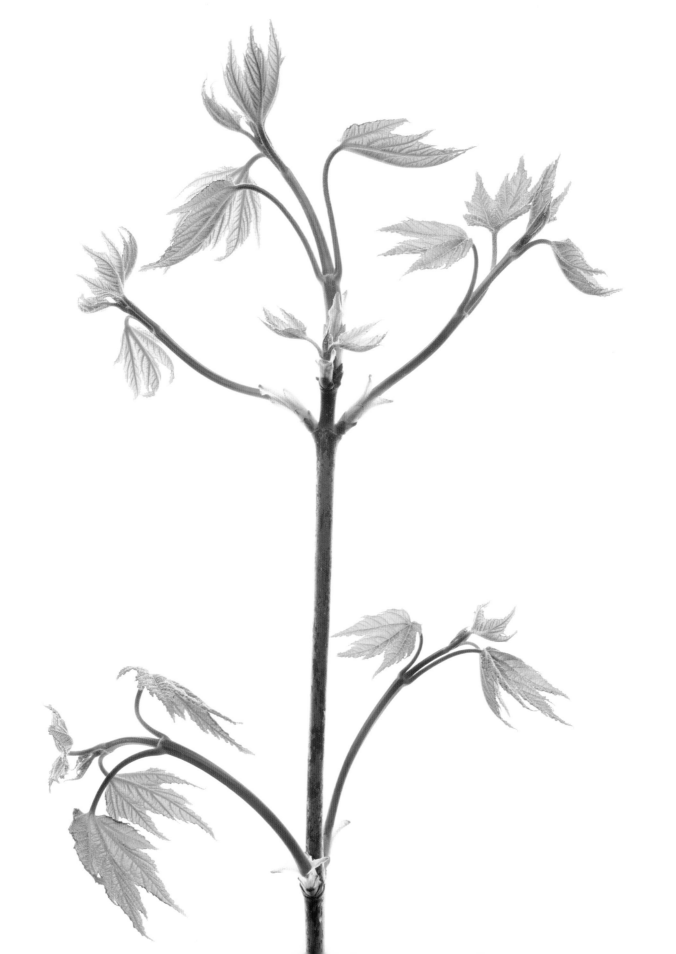

bark curling up at the ends), hackberry (warty bark), crape myrtle (slick bark sometimes peeling off in colorful patches), and striped maple (green and white vertical stripes on young bark). Other bark features to look for include the shiny, light gray longitudinal lines that run down the center of northern red oak's bark ridges (many naturalists refer to these as "ski trails"), the "alligatored" look of black oak, dogwood, tupelo, and sometimes white oak, and the orange-brown striations in Osage-orange bark.

Twig structure or pattern of branching is another tree trait to be alert to, especially in winter when you don't have leaves to distract you. Like tree leaves, which can appear on tree twigs in an alternate, opposite, or whorled arrangement, the twigs themselves develop in an alternate, opposite, or whorled arrangement. A tree that has an opposite leaf arrangement will also have an opposite twig arrangement, a tree that has an alternate leaf arrangement will have an alternate twig arrangement, and a tree with a whorled leaf arrangement will have a whorled twig arrangement. The mnemonic many naturalists use to help them remember which common trees have opposite leaf and twig arrangements is Damp Horse, in which the letters of the first word stand for dogwood, ash, maple, paulownia, and the second word stands for horsechestnut

This silver maple (*Acer saccharinum*) twig shows its opposite branching arrangement.

(and by extension, the closely related buckeye). The great majority of other trees have leaves and twigs that alternate along the twig or branch respectively.

If you are a wildflower enthusiast accustomed to successfully using leaf arrangement to help you identify wildflowers, you may find tree leaf and twig arrangements confounding. To my eye, these arrangements, partly because mechanical injury and animals destroy so many tree buds, are much less obvious on trees than they are on herbaceous plants, but occasionally you'll look up into a tree or down at a twig on the ground and see, say, the characteristic opposite twig arrangement on a red maple and think, aha, now I know you undressed. Other twig characteristics to look for include their heft, texture, color, and posture. The twigs of some tree species, like horsechestnut and hickory, are stout; others, like the twigs of beech and birch, are thin and graceful. The twigs of ailanthus are so fat it seems like a misnomer to call them twigs; the twigs of ironwood are so thin they seem thread-like. Some young twigs are roughed by lenticels (which can be raised or level with the bark), and some, like those of winged elm and sweetgum, have corky, wing-like appendages. Young red maple twigs are red, some willows yellow, boxelder green, and, although this moves us into different sensory categories, you can recognize some tree species by the characteristic smell of their twigs. Abrade the twig bark of black birch for the fragrance of wintergreen, sassafras for root beer, wild black cherry for almond, and ailanthus for peanut butter.

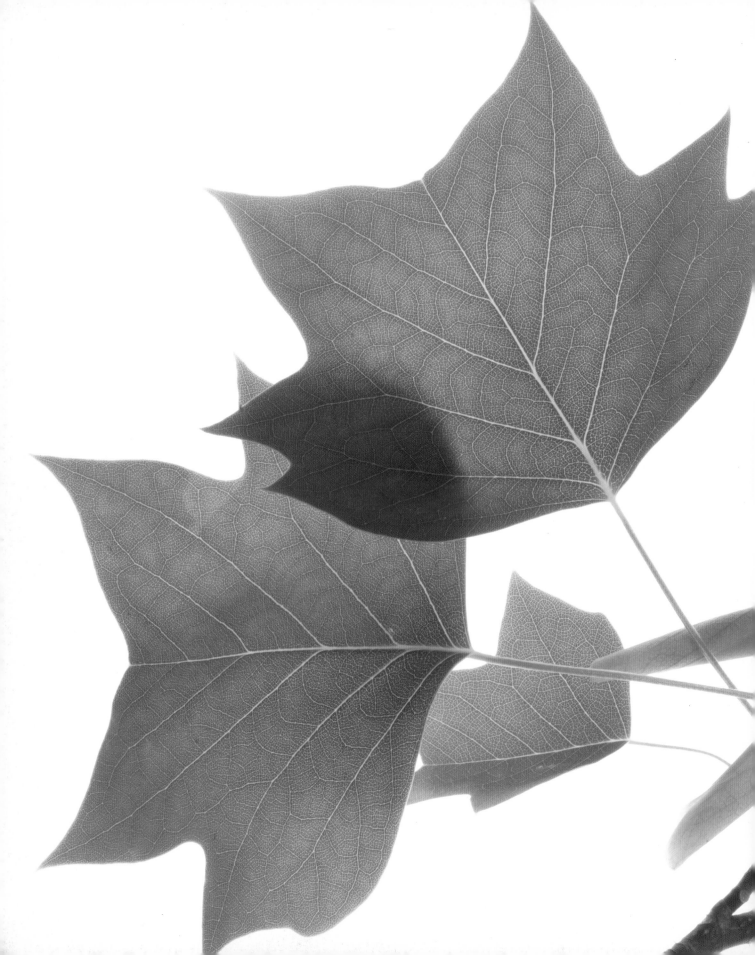

TEN TREES: Intimate Views

"Nature will bear the closest inspection.
She invites us to lay our eye level with her
smallest leaf, and take an insect view of its
plan."

— HENRY DAVID THOREAU

IN THIS SECTION, Bob and I profile ten trees that are easy to find and a pleasure to observe in our neighborhoods. You may be able to find them in your neighborhoods as well. The best way to check is to look them up in *Silvics of North America* (available online), where you will find the geographic ranges of almost every tree featured here. Look under "Hardwoods" for American beech, American sycamore, black walnut, red maple, southern magnolia, tulip popular, and white oak. Look under "Conifers" to find eastern red cedar and white pine. Although ginkgo has been planted throughout most of the United States and other parts of the world, it is the one tree you won't find in *Silvics of North America* because it is not native and rarely spreads from cultivation in North America.

Of the ten trees we feature, most have ranges that include much of the eastern United States and parts of Canada. Exceptions include white pine, which is primarily a northeastern species, and southern magnolia, which grows primarily in the coastal plains of the southeastern United States. *Silvics of North America* will also tell you the types of habitats in which you are likely to find these trees.

Even if the particular species we profile doesn't grow where you live, a species in its genus (*Acer, Fagus, Juglans, Juniperus, Magnolia, Pinus, Platanus,* or *Quercus*) might, and trees in the same genus exhibit many similar traits. Of the featured trees, only ginkgo represents the sole species within its genus (*Ginkgo*), and tulip poplar belongs to a genus (*Liriodendron*) with only one other species. Our tree profiles should prove helpful even if you can't find a tree in the particular genus we feature, because they describe a process of discovery that can be applied to any tree with equally satisfying results. In the end, it is not so much the particular tree species you examine but rather how you look at it that will determine how rewarding your tree observations can be. So pause, look carefully, repeat observations over time, and you'll discover the small wonders in these massive plants.

Tulip poplar (*Liriodendron tulipifera*) leaves.

AMERICAN BEECH

Fagus grandifolia

The magnificent beech is usually appreciated for its macroattributes—its smooth bark, its massive trunk, and its layered branching pattern. But it was a baby beech, with its seed leaves and the microattributes of individual beech leaves that inspired me to look more closely at this tree. It's hard not to find something of interest in any tree when you decide to view trees more intimately, but the beech rewards careful scrutiny particularly well.

"People don't know what they are," a botanist friend commented one day, when I told her I was on the prowl for beech seedlings still holding their seed leaves. "They mistake them for orchid leaves." At the time, I had never seen beech seed leaves in the wild, only in books, but I was determined to find them. What had alerted me to the fact that these unusual leaves exist was a figure in *Trees, Woods and Man* by British author Herbert L. Edlin, in which the seed leaves (cotyledons) of sixteen tree species are illustrated. Their variety had intrigued me, and,

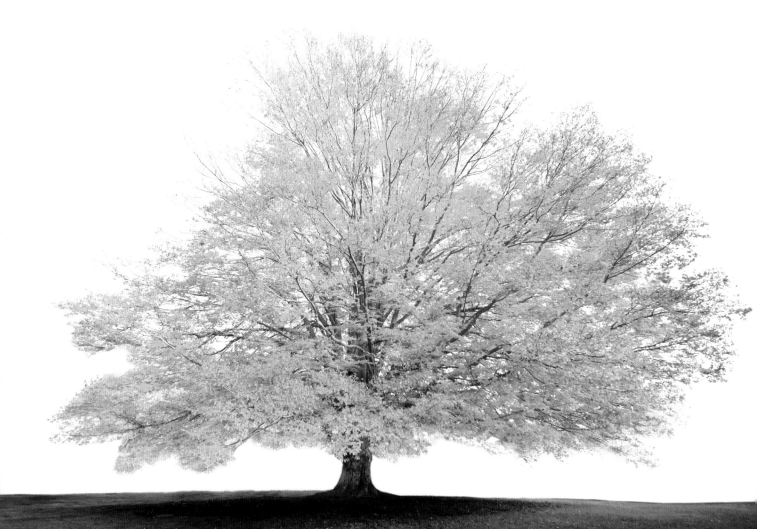

because very few of them looked familiar, I realized this was a category of tree phenomena I should add to my "wish list" of things to see. Like many cotyledons, the seed leaves of broadleaved trees—the first two leaves they put out—are quite different in form from their mature leaves, and, while some may last six months on the plant, others last only a few weeks, which makes seeing them all the more challenging.

Among the illustrations in Edlin's book, the one that interested me most was the beech. Its seed leaves grasped the stem like broad butterfly wings, forming what looked like a platform under the more typical pair of leaves above. In a nature journaling class, I actually traced the drawing and put it in my journal, an exercise that I now realize helped cement the image in my brain. A year later, however, I was afraid I might overlook these emerging seedlings under distant beeches in my woods, so I asked another botanist friend, who said they came up every year in his garden mulch, to let me know when he saw them. Chris Ludwig called to report his first beech baby sighting on April 13, and I hurried over. Sure enough, coming up in Chris's deep mulch (in borders along the edge of a beech woodland) were several beech seedlings. Each one had a pair of seed leaves attached to a thin stalk topped with the bud of the more typical leaves that would develop next. The shape of the seed leaves was exactly as illustrated in Edlin: each leaf was sort of fan-shaped with rounded edges, but the pair together formed an almost square platform (with rounded corners) under the upper bud. The look and size overall was not unlike

RIGHT Finding a beech seedling with seed leaves (cotyledons) still attached isn't quite as hard as finding a needle in a haystack, but it often requires a significant search.

a nasturtium leaf, but it was the color and texture of the leaf that I found most striking. Thick and almost leathery, the beech seed leaves were nothing like the tree's thin, uniform green, mature leaves; they had creamy white and pale yellow striations, making them look almost like variegated nasturtium leaves but more muted.

The next chance I had time to look for beech seedlings in my own woods was almost a week later. I'd have never found them without the color clue I learned from Chris's seedlings, because the very few seedlings I could find were already hidden by the first pair of mature leaves now unfurled above them. But how satisfying it was to spot those unmistakably striated seed leaves under their more typical brethren! Imagine how much more intimately you'd know a bear after also seeing a bear cub; that's how I felt about finding these infant beech trees.

A week later (May 1), on a walk with half a dozen nature journalers, my friends and I found many more beech seedlings (which some naturalists wryly call "sons of beeches"). Like the few I had spotted earlier, they were all still bearing their seed leaves, but, on this walk, the thrill of discovering seed leaves was eclipsed by an even more startling discovery. We had stopped to examine a square of earth and moss that seemed to be rich in tree castoffs—oak catkins, beechnuts, beech bud scales—when someone spotted something we had never seen before. It was a beech baby so young it still had its shell hat on. I pulled the hat off and below was something that seemed premature and almost fleshy looking—two smooth, tannish green leaves balled up almost like a fist. Preemie seed leaves they were. I tried to jostle them to get them to unfold, but they weren't ready, remaining folded in what Julia Ellen Rogers (*The Tree Book*) once described as a "crumpled green bundle."

The male and female flowers of American beech are often overlooked among its emerging leaves. On this twig, female flowers appear near the center of the leaf cluster; a long-stemmed cluster of male flowers releasing pollen appears to the left of the twig, lower in the photo.

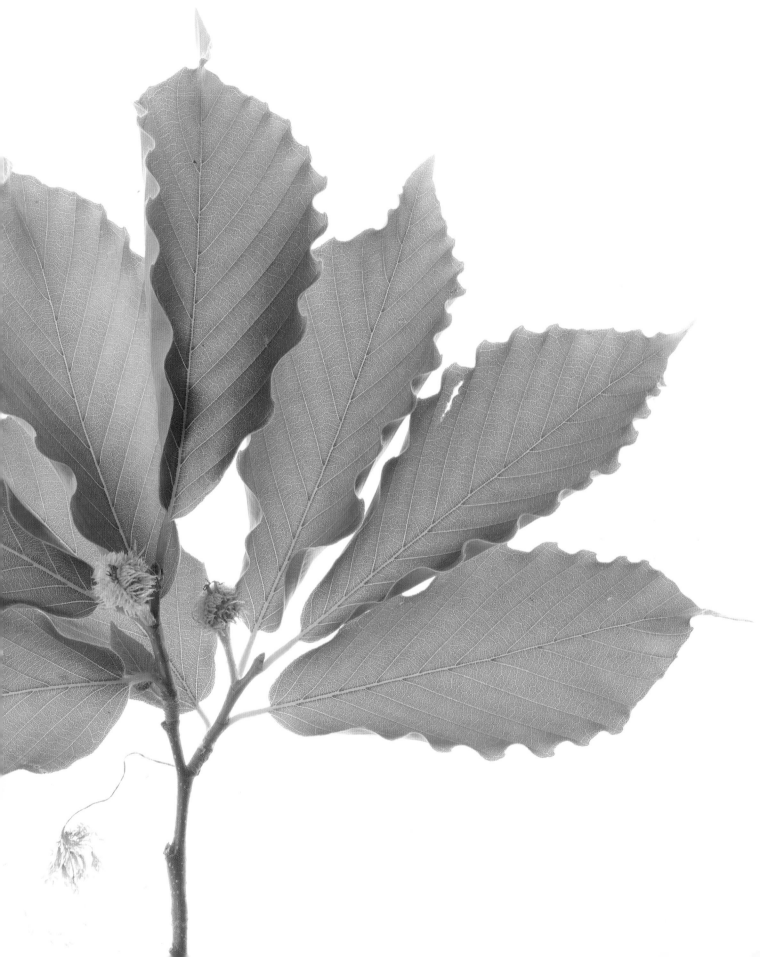

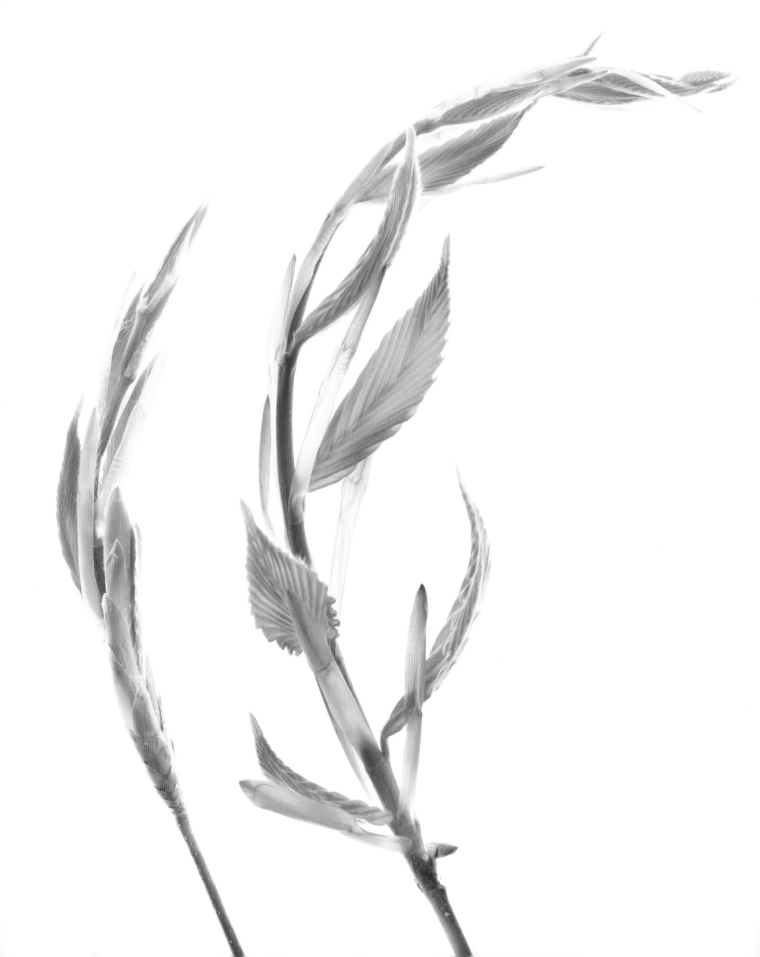

American beech (*Fagus grandifolia*) grows in hardwood forests of eastern North America, from southern Canada south to northern Florida and eastern Texas. Because its shallow roots dislike soil disturbance or compaction, this tree doesn't do well in urban or suburban situations. If you see a large American beech growing in those environments, it is usually in a park-like situation or in an area where it germinated and matured before the area was developed. More adaptable and native to other parts of the world (the British Isles, continental Europe, and western Asia) is the European beech (*Fagus sylvatica*), a tree often grown in the United States as an ornamental. Young beeches are typically understory trees, germinating and growing slowly in the shade of other trees until they become the dominant (climax) tree in the forest. There they grow for hundreds of years, often in the almost exclusive company of other beeches.

I have already described the beauty of smooth beech bark, the dagger-like beech bud, and the color of fall and winter beech leaves, but the beech's spring leaves, its flowers, and its nuts are no less remarkable. If, for example, there were a listing of small, common natural wonders of the world, the unfurling of the beech leaf would be included, not only because the phases involved are so exquisite, but because the process is so complex. First there is the lengthening and loosening of the winter, or resting, bud, its dagger-like shape becoming more feathery as the exterior scales loosen. As the scales pull back to reveal the leaves inside, you can see a fringe of hairs along the edge of each scale and, below, the undersides of the new leaves, which are shiny with white, silky hairs. The bud scales are a gorgeous honey blonde color, and, once you've learned to recognize them, you'll see them not only on the buds and around the emerging leaves but all over the ground after they have fallen and are clinging to mature leaves after a rain. Sometimes they even create a rain of their own. One spring day (on April 11), I was out looking at tulip poplars, when I heard the faintest trickle of something falling behind me and realized it was a shower of beech bud scales. The sound seemed incredible, because these inch-long slivers of plant material seem

LEFT Graceful and gradual, the unfurling of American beech leaves is almost balletic.

RIGHT Golden bud scales peel back, revealing the first sign of young green American beech leaves.

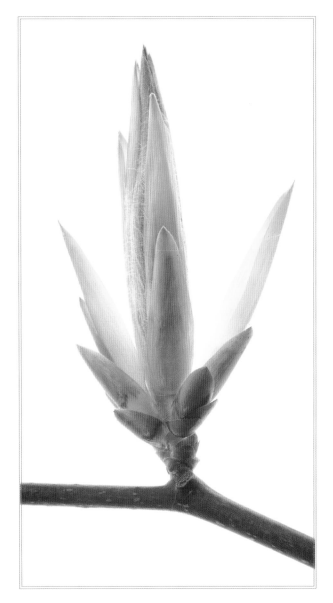

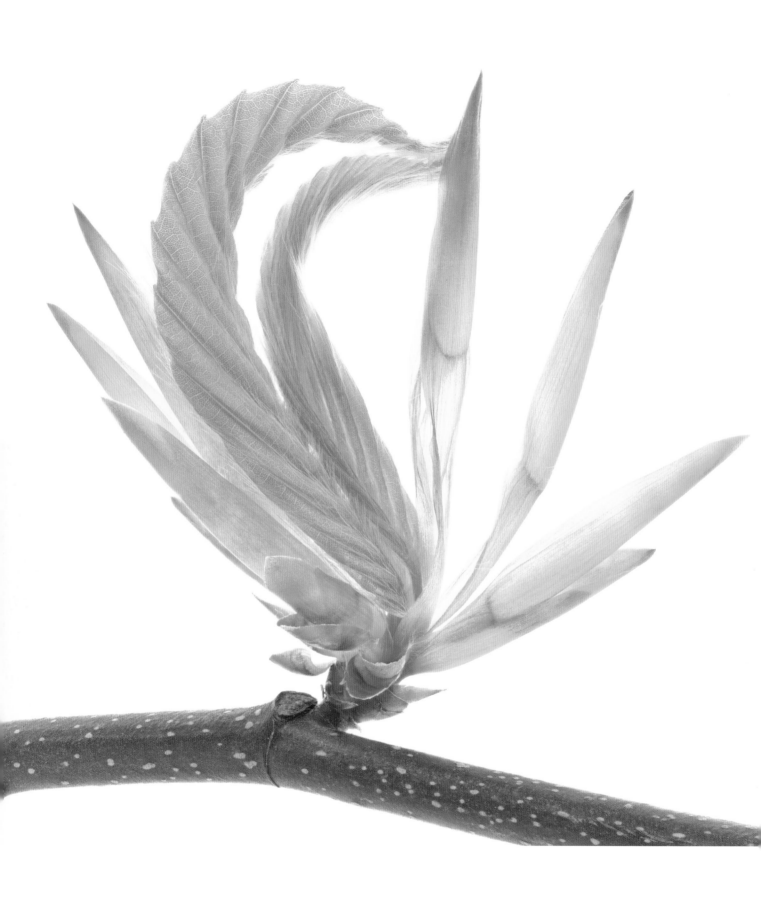

almost weightless and way too insubstantial to make a sound as they fall, but they do.

In addition to the outermost scales covering young beech leaves, there are additional scales covering the leaves inside the bud, and as the leaves unfurl, it is not unusual for the tip of a leaf to remain attached to the tip of its scales, causing a young leaf to curve like a comma. Some of the new leaves also remain rolled inward along their edges for several days, creating a beautiful scroll-like affect, and because, prior to emergence, they have been folded like fans along their veins (which radiate from their midribs at about 30-degree angles), they have a corrugated texture.

Watching beech leaves unfold, you may also notice just how long some terminal buds get just before the first leaf is visible (as long as 4 inches), and what an abundance of plant material that terminal bud can produce. I keep besting my previous record for finding "new stem with most leaves produced in a month," but my current record for length of new stem and leaves produced from one beech terminal bud is a 14-inch stem and eleven leaves. Other beech buds produce fewer leaves, but the experience of watching the contents of a beech bud emerge is awe-inspiring no matter how abundant or meager the leaf production. Julia Ellen Rogers captured part of the reason why when she wrote: "It is plain to see that the leaves in the opening buds were all made and put away over the winter, and that they have only to grow." Rogers also alerted me to something else on the beech twig I might have missed: After all the beech bud scales have fallen, there is a band of scars at the base of the new shoot that looks like the threads of a small screw. (You'll need a magnifying device to see the threads.) All along the twig, you can find such bands, which represent the beginning of a year's growth and can be counted to determine the age of the twig.

Two other things worthy of note related to observing new beech leaves are these. First, if you can't visit beech trees frequently enough to observe their leaves unfurling outdoors, consider bringing a twig indoors. Unless you can find a way to keep your twig horizontal (try putting the twig in a floral tube filled with water), the leaves may emerge with postures different from what you'd observe outdoors, but the drama of their emergence is still impressive. Second, be alert to the fact that you can speed the emergence of a beech leaf just by jiggling the twig. Once, on a woodland walk, I saw someone try to detach a beech twig from a tree without clippers, and the resultant jostling of the burgeoning winter bud caused it to open to

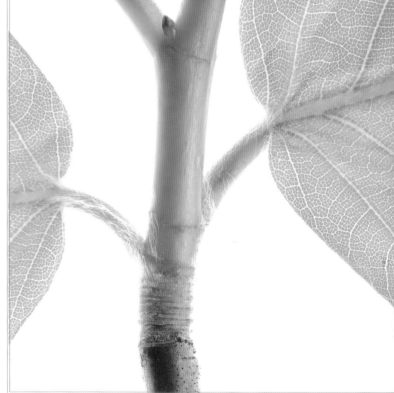

LEFT Emerging American beech leaves stretch free of their golden bud scales.

RIGHT A band of yellowish bud scale scars marks the transition from old to new growth on this American beech twig.

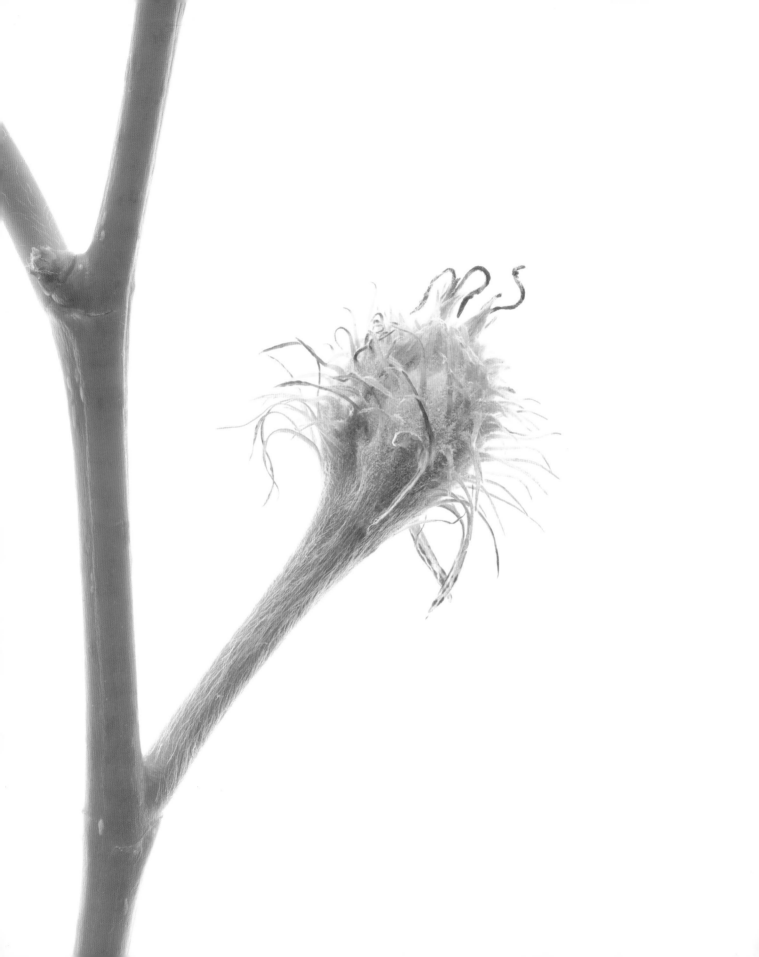

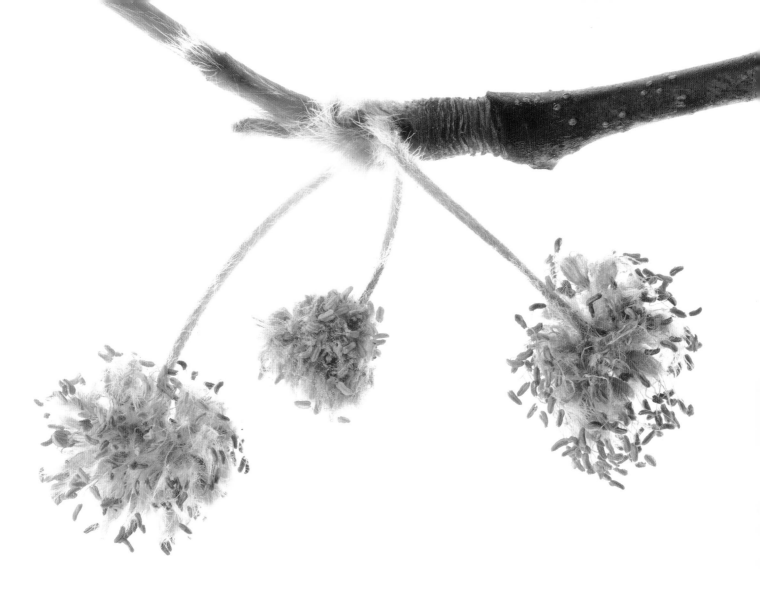

the point that you could see some of the leaves. (I wonder if wind sometimes does the same thing?) Also, it's interesting to note that on the same spring day, I saw a friend coming up the hill holding an old beech twig still clad with the previous year's parchment-colored leaves. That image, and others collected that day, have merged to form a collage that captures early spring for me—a transitional season characterized by bluets, fern fiddleheads, old beech leaves, and resting buds so gravid you can shake their leaves free.

As the new beech leaves are emerging, watch, too, for beech flowers. Because they are pale, delicate, and really well hidden among the leaves, more than one author describes them as "seldom seen." I missed them the first year I started looking for them, and to describe them I had to "import" some from a willing stranger (botanist with a beech connection) who lived nearby. (Picture the

LEFT Female American beech flowers, usually two to a cluster, bloom on upright stalks. In this photo, the flowers' brown stigmas protrude from the top of the inflorescence.

ABOVE Clusters of male flowers dangle from an American beech twig.

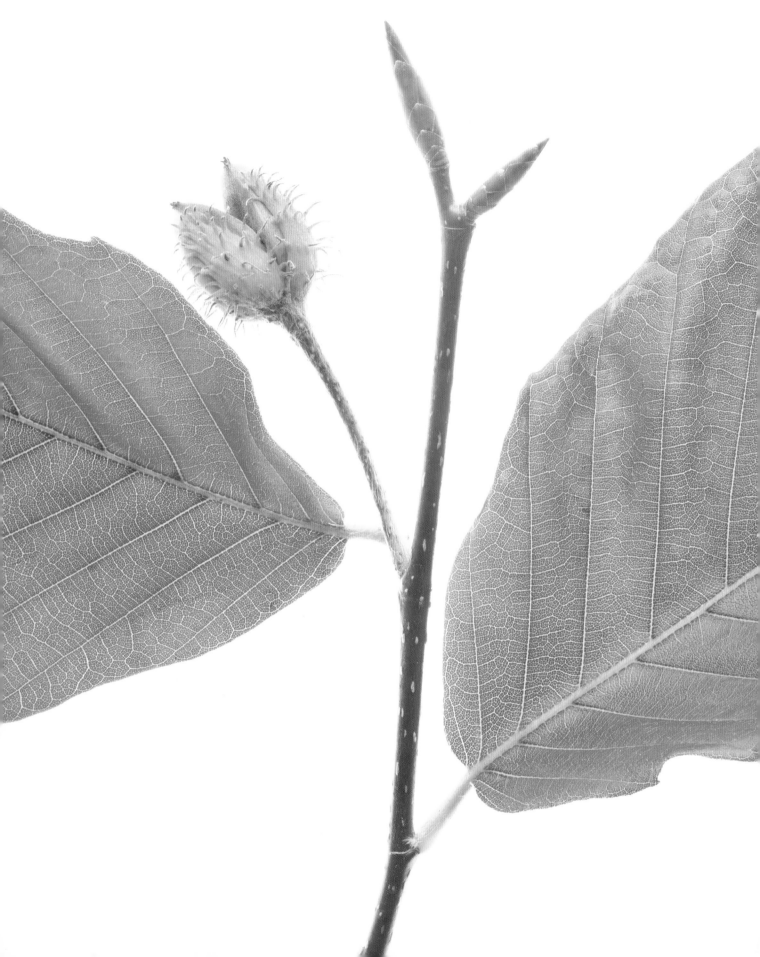

handoff, which looked like a drug deal, in the McDonald's parking lot. "I'll be driving the Subaru with the TREE HUGGING DIRT WORSHIPER bumper sticker on it," said I. "I'll be driving the white Toyota RAV4 with beech branches in the back seat," said he.) Beech flowers are easier to find once you've seen how they hide among the foliage, and they're easier to find before the leaves are fully emerged, not after. Male and female flowers occur on the same tree but in separate clusters. The male flowers hang in puffy, pendant balls about ¾ inch in diameter before releasing their pollen, breaking up, and falling away. As they mature, they change from yellow-green to the tannish color of a luffa sponge. The female flowers also appear in what look like yellow-green balls, but they are smaller than the male flower clusters and stand on short, upright stalks. Each female ball usually contains two flowers, and you can see their reddish brown stigmas protruding from the top of the ball, itself covered with a collection of woolly looking outgrowths, as they mature. There is something reminiscent of the prickly exterior of the nut in these protrusions, and in fact, the cup-like structure underneath will morph into the familiar beech bur.

The prickly little beech bur with its two (sometimes one, sometimes three) shiny, triangular nuts inside is, to my mind, one of the most exquisite creations in nature. The word *precious* in all its meanings—something of great value, refined, beloved, and even cute—applies. The ½-inch burs are, in fact, cute, and the nuts inside, with their well-polished coats and pinched-pyramid shapes, are nothing if not refined. They ripen in the fall (between September and November where I live) and usually split open, spilling their nuts, after a hard frost.

Mast years—years of heavy seed crops—come along every two or three years, and are said to be the result of higher than average reserves built up the preceding summer or summers. A mast year is usually followed by a lean year because the tree has exhausted its reserves. Sweet and nutritious, beechnuts are relished by all sorts of wildlife.

There was a time when the value of a woodland was assessed based on the number of swine it could feed, and because swine go hog-wild over beechnuts, a beech wood was particularly valuable real estate. If this were still the case—woodlands assessed for the wild or domesticated animals they could feed—I imagine our forests would be in better shape, and we would all be more attuned to boom and bust years of nut production.

LEFT Immature American beechnuts, enclosed in a prickly husk, develop below a pair of spear-shaped winter buds.

RIGHT The four-valved husk of the beechnut often splits open after a hard frost, releasing the mature nuts inside.

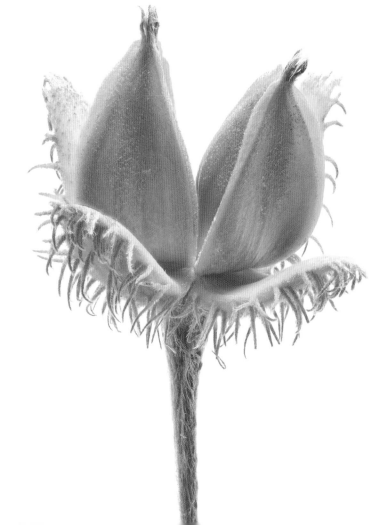

AMERICAN SYCAMORE *Platanus occidentalis*

July 10, Ballowe Creek. Big sheets of sycamore bark are draped over rocks, hanging in the pawpaws, and floating in the water. Many are over a foot and a half in length and have long, oblong holes in the center. The way some of them hug rocks underwater makes me think of Rock, Paper, Scissors—the "paper covers rock" part. I explain to Grace, my five-year-old granddaughter, that this bark

has popped off the nearby trees as they grew. She's unimpressed and maybe even disappointed. She'd thought they were beaver skins.

Ah, the animal-like qualities of the sycamore. When the sycamore's outer bark pops off, it really does look like skin (although more like human skin than beaver skin), and its smooth inner bark is even more epidermis-like. Poets have

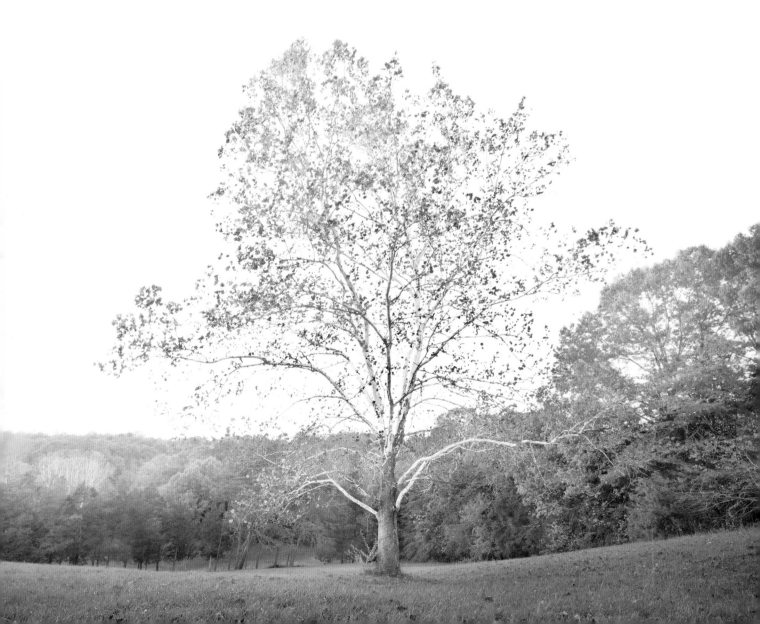

been comparing tree limbs to human arms for centuries, but when a sycamore reaches its pale limbs heavenward, it's hard not to imagine human arms raised in praise.

Sycamore is such a great subject for viewing. This tree is common, and not just in the rural riparian areas it loves. The native American sycamore (*Platanus occidentalis*) grows in almost every state in the eastern United States, and its cultivated relative, the London plane tree (*P. ×acerifolia*), is a fixture in many of the most populous urban areas of the country (including New York City, Washington, D.C., and Boston) as well as in many European cities. Yes, this is a tree that loves the side of a river or stream, but it will also survive in the hole in the sidewalk provided beside a Brooklyn brownstone.

This tree also has more visual attractions than an art gallery, and two of my favorites are easily observed but seldom seen. One is the way the sycamore leaf stalk is attached to the twig. The base of the sycamore leaf stalk, where it attaches to the twig, is enlarged, like the cup of a candlesnuffer. And where the stalk (technically a petiole) attaches to the twig, it completely surrounds the large, pointed bud beneath (imagine a candlesnuffer surrounding a flame). As soon as the leaf stalk has begun to loosen from the twig, you can pull the leaf off and see both the perfect circle inscribed by the leaf scar around the bud and the concave indentation at the end of the petiole where it so perfectly enclosed the bud. This engineering is impressive and an identifying feature of sycamores.

A second interesting sycamore trait is the tree's stipules. Stipules are leafy outgrowths on either side of the leaf stalk. On most tree species they are inconspicuous, but on some they are quite decorative. You can see relatively large stipules curving back from the stem of tulip poplar leaves on pages 39 and 191. On the American sycamore, the stipules are often fused into a short tube with a 1- to 2-inch, collar-like appendage on top. (On the London plane tree, the stipule consists of the tube only.) With its relatively large size, sharply toothed edges, and collar-like appearance, the top of the American sycamore's stipule looks like it belongs on an elf outfit.

PREVIOUS Bark sloughed off by American sycamore often gathers under the trees and along rivers and streams where it dries and curls into phantasmagorical shapes.

LEFT Detach an American sycamore's petiole (leaf stalk) from the bud it covers, and you can see its concavity.

RIGHT This close-up view reveals the downy hairs covering American sycamore stems and leaves. Collar-like fused stipules and new leaves are also visible emerging from the stem on the right.

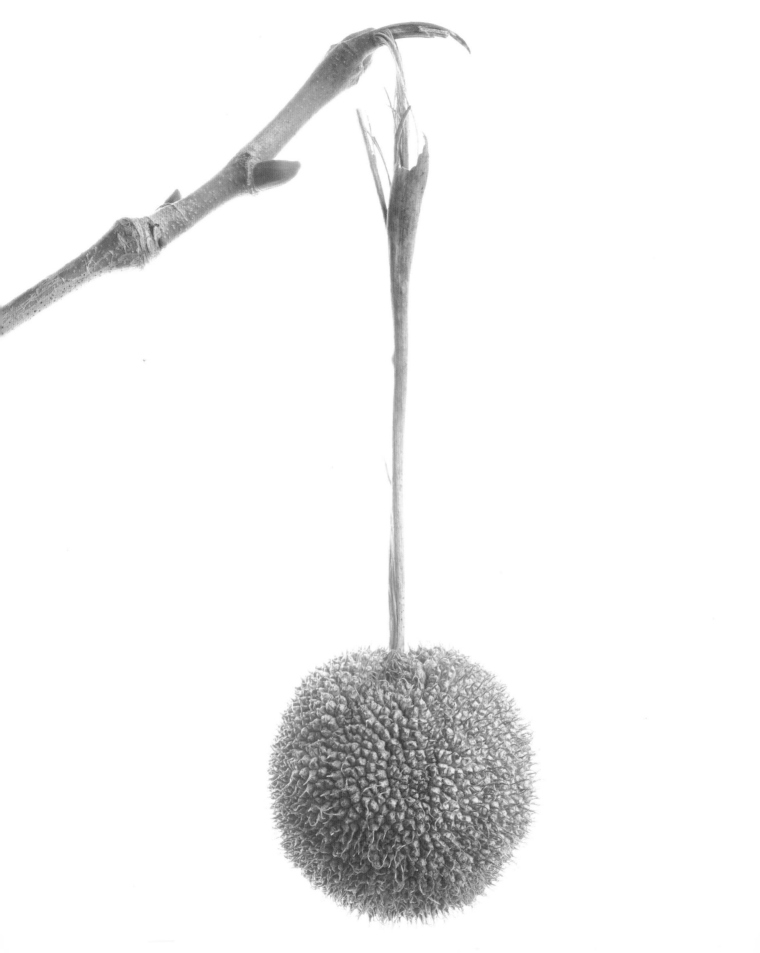

When the stipule dries out and turns brown, as it will before the leaves do, it separates a little from the leaf and you can slip it up and down the stem like a bead on a string. Do that a few times, however, and you will discover a less appealing aspect of sycamore stems. Sycamores have cream-colored fuzz on their twigs and leaves, which comes off in the wind (or when you rub them), and that hairy fuzz can make you cough or sneeze. I first experienced the problem on a week-long trip down Virginia's James River in June, when the air was sometimes thick with sycamore fuzz and lots of people were suffering from mild, sycamore fuzz–induced, respiratory problems. The hairs on sycamore seeds can also irritate some people's lungs.

Other easily and not so easily observed sycamore traits include the tree's fruits and flowers. The fruits, tan to brown balls about 1 inch in diameter, are easy to spot, especially in late fall and early winter when the tree's leaves have fallen off. They dangle like Christmas decorations on long stalks, and you'll occasionally see them being worked over by goldfinches. A sycamore bedecked in fruits is a tree loaded with tiny bird feeders. You can use sycamore balls to help you determine whether the tree you're viewing is an American sycamore or a London plane tree. On the American sycamore, they usually dangle one to a stalk, whereas on the London plane tree they are usually borne two to a stalk. I once felt like a naturalist extraordinaire when I looked out my godchild's Manhattan window and was able to identify the tree she looked out on as a London plane tree as opposed to an American sycamore, because its fruits dangled in pairs. Don't bet the ranch on this discrimination, though, because sometimes American sycamores have fruits that

dangle in twos, and a London plane tree may, rarely, have fruits that dangle singly or in threes. London plane tree is an especially good bet if it's growing in the city, however, because it is particularly resistant both to pollution and to anthracnose, a fungus that plagues American sycamores, so it is often planted as an urban street tree. My hometown uses American sycamores as street trees, however.

Sycamore balls merit close observation. Up close, you will see that they are actually aggregates of feathery seeds (nutlets called achenes), and when the wind or your hand breaks the ball up to disperse the seeds, you'll see how tightly packed they were—around 800 seeds to a ball. I had never noticed how intricately shaped each of these

LEFT An American sycamore ball dangles from a winter twig.

RIGHT In this close-up, a sycamore seed (achene) is surrounded by some of the fine hairs that help it ride the wind.

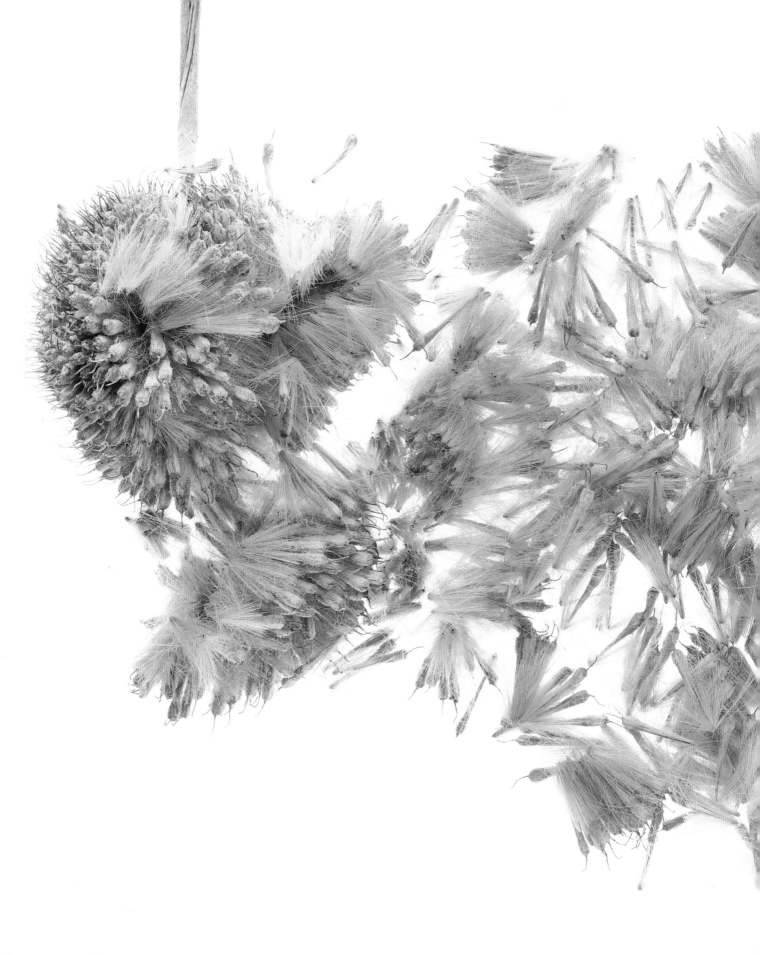

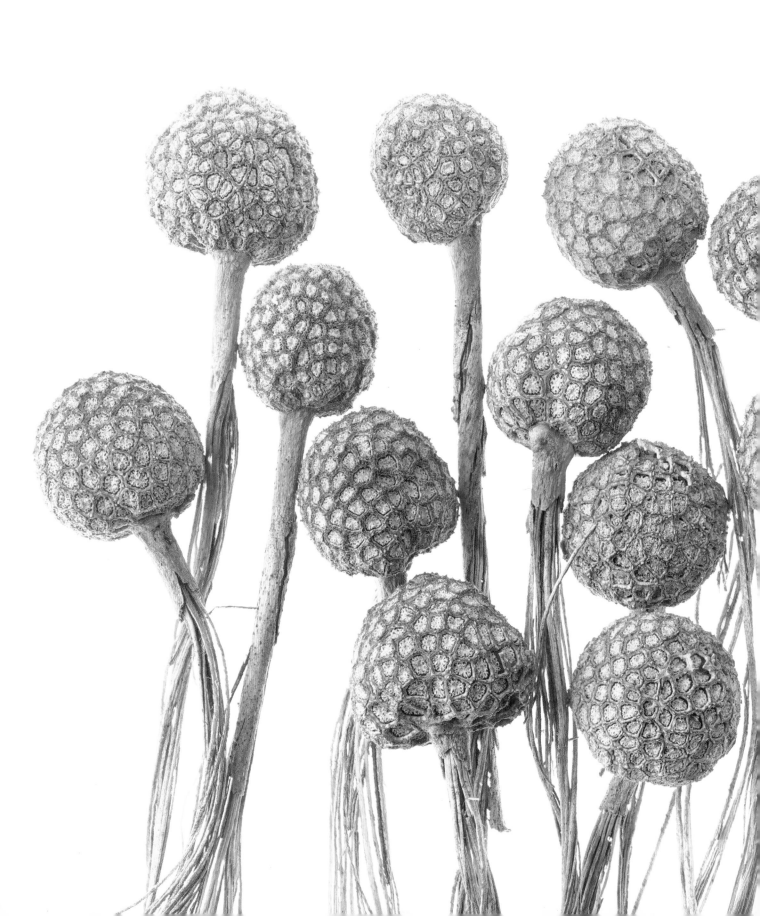

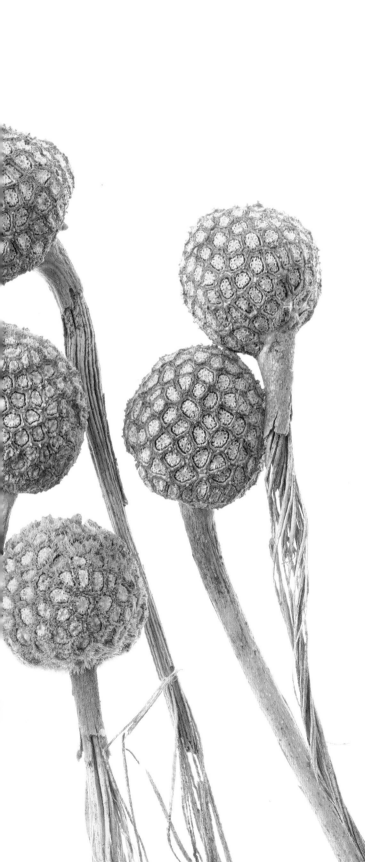

seeds was until Bob photographed one up close, but his photograph (and close observation) reveal that each $2/3$-inch seed consists of a center "pole" that tapers from a relatively weighty base to a narrow apex topped with hairs arranged like the spokes of a half-closed umbrella. Once you're familiar with sycamore seeds, you'll start seeing them everywhere, not only gathered in gutters and drains but in the early spring air, where they drift like parachutes and get snagged in spider webs. In early spring, when I'm cleaning spider webs from under outdoor benches, it's cheering to know the identity of these seeds. It changes what I see from "anonymous fluff caught in spider web" to "sycamore seed waylaid in its travels," and where I shake my dust rag suddenly has significance.

The stem and core of the sycamore ball are interesting, too. The stem looks unremarkable until its exterior begins to degrade, and then you can see that it is actually a series of multifilaments surrounded by a stem cover—much more complex than you might have imagined. And the core in the center of the sycamore ball looks, after the seeds have fallen off, like a mini moonscape, its round surface pocked with tiny craters. Bob tells me his clay tennis court is littered with these sycamore remnants in winter almost a year after the seeds have been dispersed, and that playing tennis on a surface dotted with them, especially after they get coated with clay, is like playing tennis on ball bearings.

Later in the spring, early to mid-April where I live, you'll want to look for the new sycamore balls. Sycamore trees have both male and female flowers on the same tree, but they are borne in separate spherical clusters. You can

PREVIOUS American sycamore balls, made up of tightly aggregated seeds (achenes), usually remain on the tree over the winter and break up the following spring, dispersing their seeds.

LEFT Following seed dispersal, the cores of sycamore balls look like mini moonscapes. As their coverings degrade, the many thread-like filaments inside the stems also become visible.

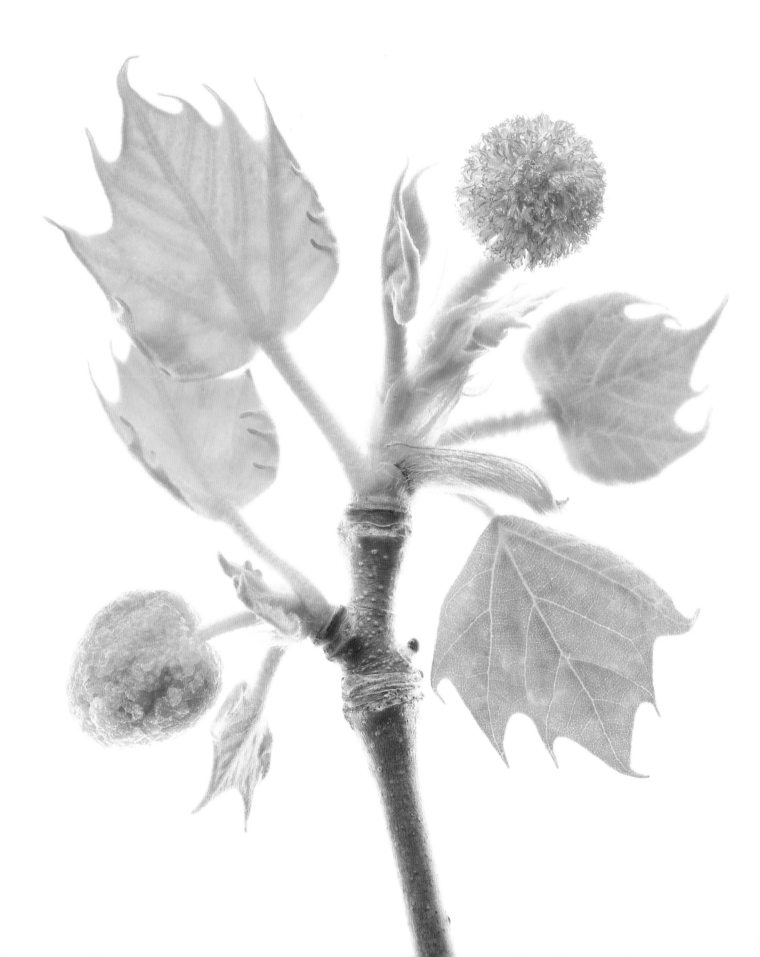

recognize the female flower ball by the wine red protrusions (stigmas) that extend from its green interior when it is about the size of a small marble or large pea. Male sycamore balls are roughly the same size, textured like golf balls, and bright green until covered in yellow pollen. They both appear when the new leaves, which are thick and felty, are unfolding or have reached about a quarter of their mature size. Once it has dispensed its pollen, the male sycamore ball will break up and fall away, but the female ball will persist on the tree until it has produced seed, dispersed seed, and been reduced to the cratered core that often falls in midwinter but is sometimes still hanging on the tree, looking worn and furry, as the new balls are emerging.

More obvious to the casual observer, but no less interesting to examine with fresh eyes, is the highly advertised sycamore tree trait, its bark. Exfoliating is the term usually used to describe it. Sycamore bark pops off in patches, giving the tree a mottled look, like army camouflage, because the colors of the tree's inner bark and outer bark are different (see page 95). The most effective way to see sycamore bark in more detail is to try to paint it. Trying to include a watercolor of sycamore bark in one of my journals, I discovered straightaway that there isn't much brown in sycamore bark. Instead, it is a study in greens, grays, even dull yellows, and whites. Under some weather and light conditions, the upper branches and parts of an old sycamore's lower trunk appear almost pure white, with some of them shining so brightly they seem to have lumen power.

There are few trees more dazzling than American sycamores when they are lined up along a riverbank, their white tops signaling "Water! Water! It's here!" When they are barren of leaves, you can, in fact, find the paths of rivers and streams just by looking for the nearly white-barked trunks and canopies of the sycamores, and more than once I've gotten a pathfinder feeling when I knew, from spotting the tops of sycamores in the distance, that I was approaching a river. Traveling toward Waynesboro, Virginia, for example, you can you see the tops of the sycamores lining the Shenandoah River long before you see the bridge, and in some places the sycamores lining Virginia's James River are as good as a map for leading you to its banks.

There is a widely held belief that sycamores actually get brighter and whiter in the winter. Is it true? Certainly the trees look whiter when their leaves fall off and their trunks and branches become more visible. The quality

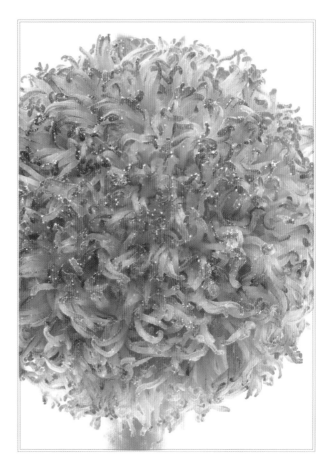

LEFT On this twig, male American sycamore flowers appear in the lower left (the greenish ball), female flowers in the upper right (the reddish ball).

RIGHT Reddish stigmas receiving pollen are clearly visible in this close-up of female American sycamore flowers.

and angle of winter light may also brighten them. One botanist also suggested to me that sycamores may stop chlorophyll production in their bark tissue in winter, making their bark appear less green, more white. Like the bark of the aspen and the beech, sycamore bark does contain chlorophyll, but to my knowledge, no one has actually measured the relative whiteness of sycamore bark in the different seasons or come up with a definitive explanation for the difference in color if it exists.

Having once traveled my state trying to choose the "best" sycamore, I became something of a sycamore connoisseur. In addition to finding scores with startling bark colors, I found dozens with a look I can only describe as "molten." The thin bark of many sycamores looks as if it has been melted onto their trunks. And with very old sycamores, the trunks themselves seem to melt into the tree's aboveground roots, which in turn melt into the ground. At the base of one famous sycamore, the

tree's commemorative plaque had been almost entirely engulfed by a flow of liquid-looking wood.

Anyone chasing sycamores will soon discover how enormous they can get. American sycamores grow fast—as much as 2 feet a year in a congenial location—and their trunks, which are often hollow, grow to prodigious proportions. The largest American sycamore in the United States at this writing is a tree in Ohio that is 122 feet tall and over 35 feet in circumference. I haven't seen a sycamore that big, but I have seen hollow sycamores, including one within two miles of my Virginia home, that a person would be comfortable sleeping inside. After deserting the British army in the 1760s, two brothers, the Pringle brothers, reportedly spent three years living in a hollow sycamore that grew in what is now West Virginia.

I've also seen sycamores that leaned so precipitously they seemed to be defying gravity and sycamores with roots so exposed, tangled, and tenaciously attached to a riverbank that they seemed to be practicing advanced yoga poses. My all-time favorite sycamore is a tree my husband and I moved from the banks of the James River up to the edge of a ditch near our barn ten years ago. We needed a tree there, near the roadside, and the spot near the ditch seemed an appropriate home for a water-loving sycamore. The seedling was about 2 feet tall when we moved it; it is now about 20 feet tall. I have been watching its progress relative to the ridgeline on our barn and have been startled to see how fast it has grown. But you don't have to live in rural Virginia to witness the growth of a sycamore. My goddaughter could be watching the growth of the London plane tree in front of her Manhattan apartment: How fast is its trunk filling that little opening provided for it in the sidewalk? How does its

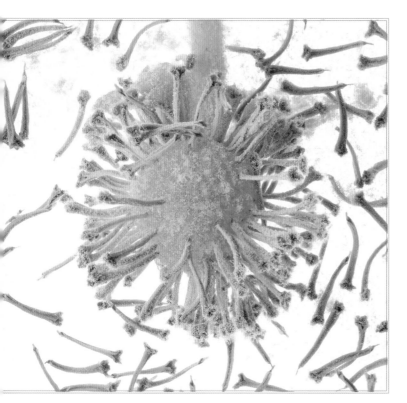

LEFT Male American sycamore flowers drop off following pollen release.

RIGHT In fall, American sycamore leaves turn shades of gold and brown.

height compare to the roofline of the building across the street? Under adverse urban conditions it won't grow as fast as my American sycamore in a rural setting, but it will grow, and provide a benchmark to other changes in the neighborhood.

In my lifetime, my transplanted sycamore will never get big enough for me to live in it physically, but I already live in it psychologically, gauging its growth and changes against my own. How nice is it, when you're waning, to be able to watch a tree you've planted that is waxing! Already, this sycamore has dramatic bark, imposing posture, and the authority I'd hoped it would command along our roadside, and I wonder if anyone else even remembers the day when the tree wasn't there. Barring a hurricane, a rogue heavy equipment opera- tor, or some other natu- ral disaster, our syca- more has the potential to outlive not just John and me but the barn and maybe even the road, which, like many rural roads, changes course incrementally every year. If so, there may come a day when our sycamore domi- nates the landscape the way our barn does now, when no one knows it didn't ger- minate where it grows, and when it will be remarked upon as just a fine old sycamore. It may be just another fine tree with a secret, and for that, I value it all the more.

BLACK WALNUT

Juglans nigra

"We wouldn't still be living here if it weren't for the Nut Wizard." That's what a friend told me one day before proudly showing off the contraption that has enabled her and her husband to remain living with a lawn full of walnuts. The Nut Wizard is a well-engineered device, something between a watermelon-sized wire whisk and a push mower, that miraculously picks up walnuts as you roll it across the ground. Once it is filled with walnuts, you can open the wire cage over a bucket to release the walnuts, and dispose of them, as my friend does, in the landfill.

That's how fond most people in my neighborhood are of walnuts. They see them as a source of dastardly debris—black twigs and car-denting fruit, the nuts of which are too difficult to get at to eat. Then, too, these trees are famous for exuding juglone from their roots, leaves, and nut husks, a chemical that can inhibit the growth of some

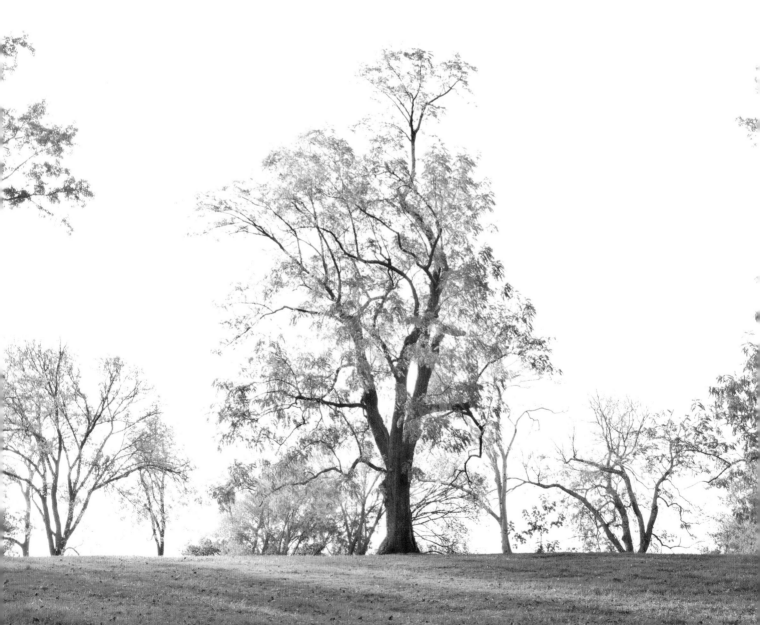

other plants. "Not the gardener's friend" is the reputation of the walnut in my neighborhood, and I imagine it has the same reputation in many other neighborhoods where this native of the eastern United States grows.

In Kyrgyzstan, on the other hand, the walnut forest *is* the garden. The same week I was hearing about my friend's Nut Wizard, I was reading in Roger Deakin's *Wildwood* about the walnut harvest in Kyrgyzstan, where walnut gathering is as much a part of the culture as backyard barbecuing is here. In this Central Asian country, thousands of people camp out for ten days to a month under the country's walnut trees and gather nuts so prized they are often used instead of money as legal tender. In Kyrgyzstan, the best walnuts are given away as gifts, and everyone's hands are stained black from walnut juice.

Part of the explanation for these radically different views of walnuts has to do with the fact that the English or Persian walnut, *Juglans regia*, grows in Kyrgyzstan, whereas the black walnut, *Juglans nigra*, grows in my neighborhood. The English walnut is easier to shell and more mildly flavored than the black walnut, but that doesn't entirely explain the difference. I think the flavor of an English walnut is sort of bland compared to that of a black walnut (which has a more woodsy taste), and, although black walnuts are hard to shell, shelling them is far from impossible.

In Kyrgyzstan, the walnut forests are large and historically significant—over a million acres of some of the oldest wild walnut forests in the world. And where subsistence farming is a way of life, edible walnuts are more prized than they are in a country where lawn mowing is

Gardeners removing black walnut seedlings from their gardens occasionally find their nuts still attached to their roots.

a way of life. Still, the contrast seems too stark between the people singing in Kyrgyzstan's English walnut trees (having climbed up into them to shake more nuts down) and the people cursing black walnuts on Virginia lawns. Deakin's lyrical description of the walnut gatherers of Kyrgyzstan made me want to understand these trees better, so I started visiting my neighbor's black walnut trees.

Prior to these visits, I knew black walnut trees by having lived with one (in a prior home), visited several (a succession of state champions), and watched many from afar. I knew them by their tropical-looking foliage (compound leaves with nine to twenty-three leaflets) and by the dark brown twiggy leaf stalks they drop in August. I also knew them by the yellow leaves they begin dropping in late summer and early fall, by their winter silhouettes (especially when some dark fruit still clings to their branches), and by the smell of their husks when my lawn mower shaved off their tops. (Yes, I, too, could have used a Nut Wizard.)

I knew nothing. And I still wouldn't challenge the average Kyrgyzi (or even a California orchardist) to a walnut knowledge contest, but I know so much more about black walnut trees now than I did two years ago, solely by wandering over into my neighbor's yard and watching one carefully, that I now feel about these trees the way I do about acquaintances who have become friends. I can pick them

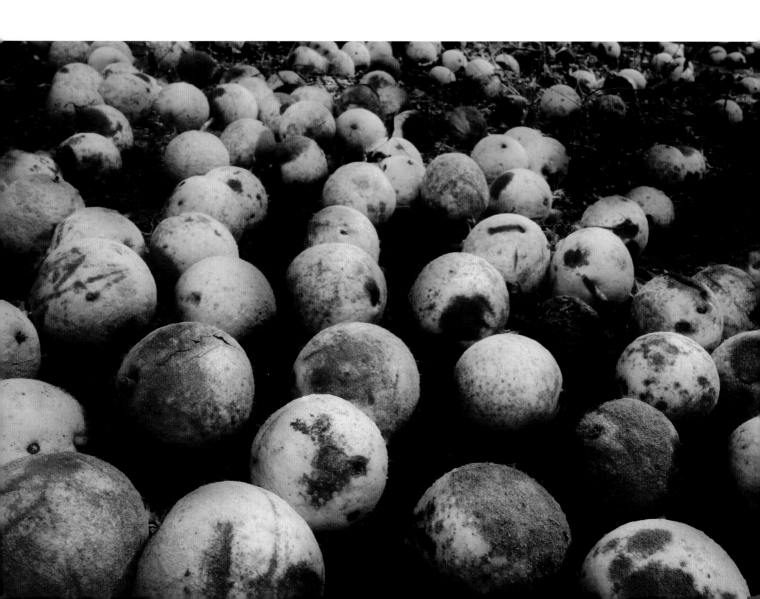

out of a stand of trees the way I could a friend in a crowded train station, and just running into one in an unfamiliar place makes me feel more connected to the site.

First, the nut. I honestly believe many people who have black walnut trees don't realize the billiard- to base-ball-sized green orbs that fall into their yards have edible nuts inside. And the ignorance is understandable. The black walnut has more layers than a Bergman movie. First there is the husk, which changes from yellow-green to rich brown and eventually to black as it rots. When still green, it has a rough, leathery surface that smells citrusy if you abrade it with your fingernail. I don't believe in aromatherapy, but I practice it, scratching the green wal-nut fruit and putting it to my nose occasionally, because my body knows, although my mind struggles to believe, it makes me feel good. Black walnut leaves also have a distinct fragrance, and William Reid, nut specialist at Kansas State University, taught me that an easy way to tell the black walnut from the ash and pecan is by the fragrance of the black walnut's leaves.

According to Reid, the black walnut is ripe and ready to harvest when the husk is still yellow-green but has become soft enough that when you press your thumb into the husk it will leave an indentation, not when the husk has become deep brown or black. The round fruits ripen between September and October, and if you handle them then or even earlier, you'll discover the husks will turn your fingers black. Boil black walnut husks in water, drop an old cotton cloth in, and you'll see how easily and beautifully black walnut can be used as a dye. It will turn your cloth a rich yellow-brown.

LEFT Black walnuts, still protected in their husks and shells, litter the ground. Whether this habit is a boon or bane depends on your perspective.

RIGHT In cross section, black walnut nut meats are visible inside their shell, which is surrounded by the fruit's dark husk.

Inside the pithy husk is the shell of the black walnut. Famous for its abrasive properties (walnut grit can be used like pumice), the shell is dark brown to black with deep ridges that I have heard compared to ridges in the tree's bark. I wish I could see the resemblance, because I love the idea that the walnut has "matching outfits"—patterns in its nut shell that are repeated in its bark—but I can't. The convolutions in the walnut shell also remind some of a brain, and according to the doctrine of signatures (the old belief that whatever a plant part looked like, it must be helpful to the corresponding human part), walnuts were believed to be good brain food. Deakin (quoting his Kyrgyz guide) says the Romans wouldn't allow their slaves to eat walnuts because they might grow too clever.

The actual nut of the black walnut fills hollow chambers in the shell like muffins in a tin (albeit a convoluted tin). Wrangle the tannish brown nutmeats out of their hard shell and you'll find, miracle of miracles, that they taste

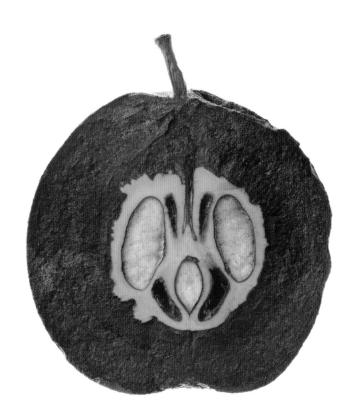

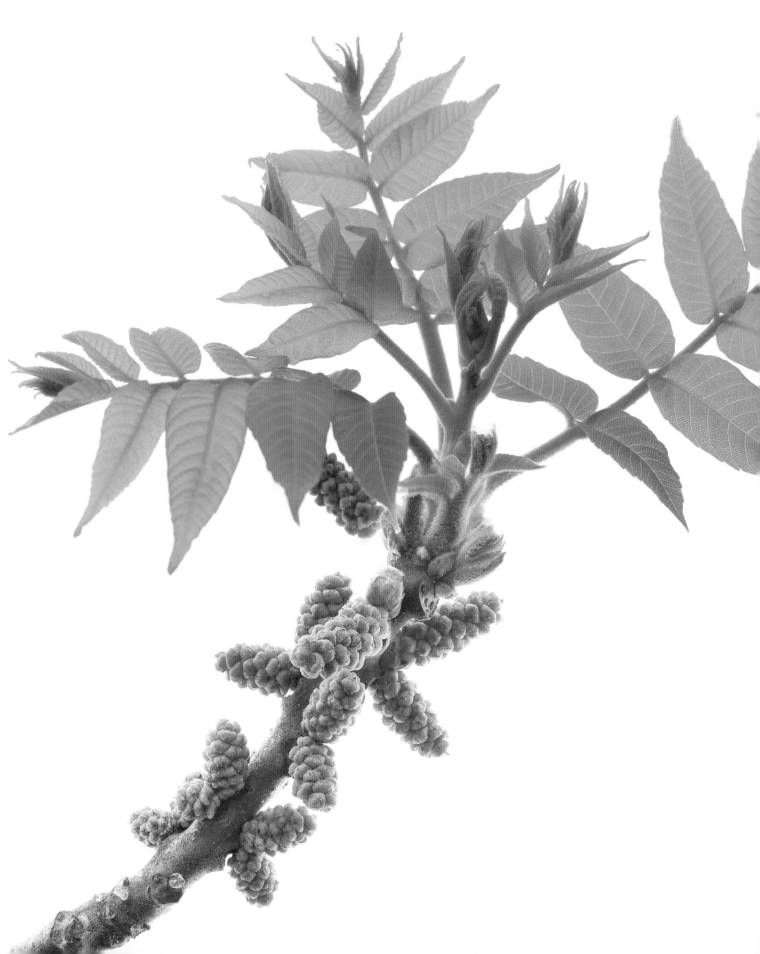

just like the black walnuts you buy in the grocery store for $18 a pound. In fact, they *are* the same walnuts. Most black walnuts in the grocery store come from the Midwestern states (primarily Missouri), and they are gathered from wild, not cultivated, trees, so the nuts you buy are identical to the ones you could collect from the backyard.

That's if you're willing to collect and crack the nuts. I was discouraged in this endeavor by the very person who encouraged me to do it. Frank Boldridge, professor of chemistry, was famous in my community for shelling every walnut he could get his hands on—he and his wife took a confection containing black walnuts to every church supper—and if the Nut Wizard had existed when he did, we'd have all collected our black walnuts and given them to him. Unfortunately, the Rube Goldberg–type contraption that Prof. Boldridge used to remove the husks from his walnuts (a tumbler of some sort) and his cracking device (an ingenious collection of recycled gears, vise, crank) made me less willing to tackle the operation than I might have been otherwise. Only a man who made his own blue jeans, as Prof. Boldridge did, would try to shell black walnuts, I concluded. But two things changed my mind.

First, I wanted to show my granddaughter where walnuts came from, so I decided to risk the black fingers thing (which turned out to be not quite as bad as advertised) by removing the husk from the shell. Then, expecting to be thwarted by this famously hard shell, I got a

hammer, put the nut on a rock, and whammed. That was easier than expected—too easy. I crushed the nut as well as the shell, but in the process, realized that while a walnut is not a peanut (practically inviting you to crack it), it's not a cast iron safe either. Cracking black walnuts one at a time and wresting out the nut meats may be tedious but it's doable. The father of a friend of mine used to spend winter nights sitting by the woodstove cracking black walnuts with a hammer and slowly removing the nut meats. "He'd work for an hour and get a cupful," she says. Bench vises and specially designed walnut crackers are recommended these days.

A visit with Jeff Kirwan, in Blacksburg, Virginia, provided my second insight into black walnut shelling and eating. A member of the Nausa Waiwash American Indian tribe and lover of wild foods, Jeff steps outside his backdoor every morning to crack and eat a black walnut or two before breakfast. His equipment: two stones, one about the size of a dinner plate, the other about the size of a softball. He puts a walnut, nicely dried in its shell, on the bigger stone, strikes it smartly with the smaller stone, and, voila, great protein source full of unsaturated fat and no cholesterol. Jeff also loves the way black walnuts taste and is sort of disdainful of the prissy English walnut. "The squirrels, like me, are eating last year's walnuts, now,"

LEFT Look for black walnut male catkins as the new leaves are emerging.

RIGHT Female black walnut (*Juglans nigra*) flowers have pear-shaped ovaries and feathery stigmas that look a little like insect antennae.

said Jeff in June. The previous fall he had removed the green husks of the walnuts by stomping on them. Then he dried the unshelled nuts over the winter in the garage. You reportedly get a better tasting walnut if you remove the husk while it's still green, then dry the nut in its shell at least two or three weeks.

Walnuts look different to you after you've husked, cracked, and eaten them. At the very least, you see them as insurance to keep you from starving. If you're a gardener and have a black walnut tree nearby, unfortunately you'll still see walnuts in less positive ways. In addition to the juglone issue (preventing some other plants from growing near them), walnuts can be annoying weeds. They seem to go from nonexistent to knee-high tree seedlings overnight, and of all the weeds that bedevil my garden, walnut seedlings are the most likely to require a shovel to remove. I have two remedies for walnut seedling sufferers, and both involve looking for something new, if not something positive, in the situation. First, see them as representing a map of your local squirrels' activities.

It is almost impossible for me to believe that a squirrel actually planted every walnut seedling I dig out, but there is no other explanation. Here, you were *here*? And *here*? And *here* and *here* and *here*! Where was I when you were doing all this? Whatever else you curse them for, you've got to admire squirrels for their industry.

Second, you can learn a lot about walnut trees by digging them out. Its unusual but particularly instructive to find a seedling still attached to the nut from which it emerged. Usually the whole shell is gone, sometimes half the shell is still attached between the stem and root, and rarely, but thrillingly, you can get the root up with the entire nut, both sides, still attached. I'm always wishing I had a child at my side when I find such a thing, because the connection between seed and tree is so clear.

Digging up walnut seedlings also reveals just how impressive their taproots are. I don't even try to pull up walnut seedlings by hand. But in the early summer of 2009, my yard was so wet I could pull even walnut seedlings up without breaking their roots; the soil was like soup. And what incredible roots they had! One seedling I miraculously pulled up without breaking its root had a leafy top 26 inches tall and a root 22 inches long. It looked like an arrow that had been shot into the soil.

Other things to know about black walnuts: they like full sun, so you'll almost always find them growing in the open; they are prized for their wood (your grandmother's secretary is probably embellished with walnut veneer); and they have distinctive bark. Ah, the challenges of bark. Here's how plantsman Michael Dirr describes black walnut bark: "dark brown to grayish black divided by deep, narrow furrows into thin ridges forming a roughly

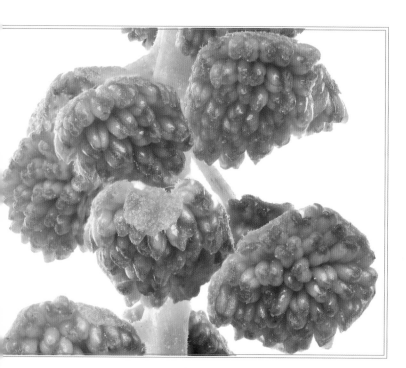

LEFT Magnified, the anthers of immature, male black walnut flowers become visible.

RIGHT As they mature, black walnut male catkins lengthen and dangle gracefully. Female flowers are also visible in the upper left portion of the photo.

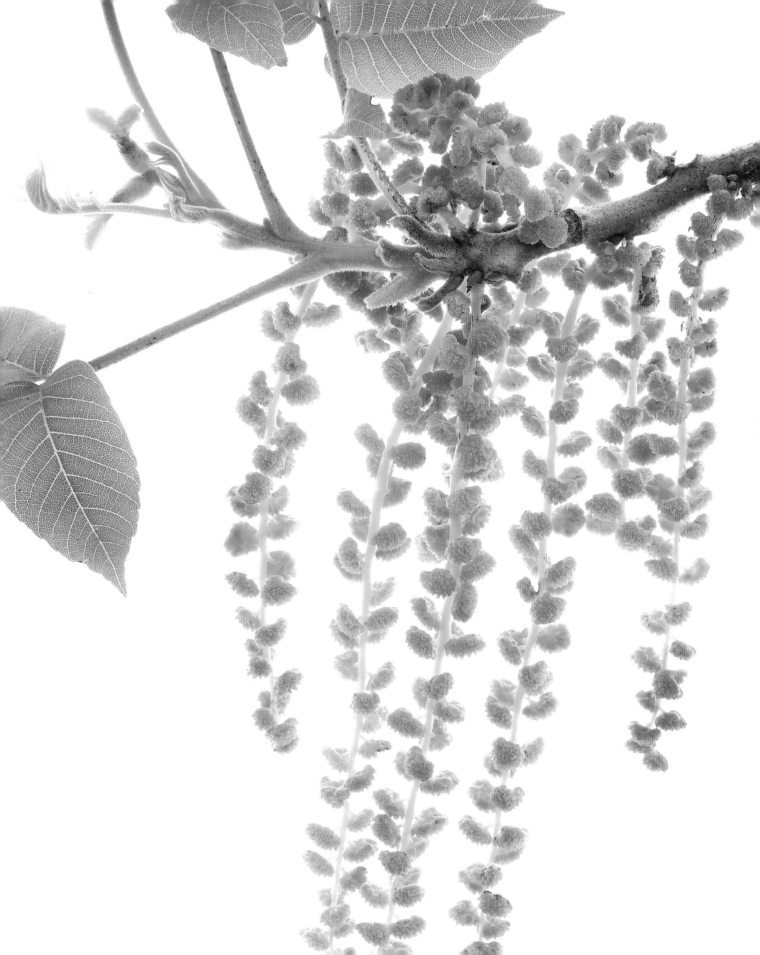

diamond shaped pattern." I just walked over to my neighbor's walnut tree yet again to see whether I could see the diamond pattern in the bark. Maybe, in one spot. Actually, my neighbor has five black walnut trees, all about 75 feet tall and two over 8 feet in circumference, so I have a good sample of black walnuts to examine. What strikes me most about their bark, limbs, and trunk is what good candidates they would be for drawing with a soft-leaded pencil; their darks are so dark, their lights quite gray. And the tracery of a staunch black walnut branch loaded with lush, almost palm-like foliage against a white house seems to beg you to sketch it.

The black walnut feature I find most thrilling to the eye, however, is its flowers. And to think I could have lived near them for a good part of my life and never seen them! I think it was an Internet search that alerted me to the fact that they existed. Of course they had to exist, because this tree produces fruit, but such is the ignorance—or inattention—of some of us that we don't see some of the most astonishing phenomena right in front of us.

In my journal, in my most rushed handwriting, is a description of male and female walnut flowers next to an even more hurried sketch that I now have trouble deciphering. Even those rough renditions, though, have an immediacy, and truth, that I like because I was in the thrall of the flowers when I drew them—just trying to get something down so I could remember it—and there is always honesty (if not clarity) in such renditions. Here's part of what I wrote: "Each cluster of male flowers is sort of the teal green of early pokeberries, round like mini Brussels sprouts, attached to drooping green stems. Gorgeous green. Rich. Female flowers come out of three claw-like green things that remind me of sundew flowers in their fringyness (at least one is fringy—the other two are sort of linear and curved toward the stem on which the flower structure ascends). On this half-inch green pole are three things that I assume are flowers. Each has a green base shaped like a Perrier bottle, and coming out of the top of each bottle is a pair of fuzzy things that look sort of like pudgy antennae. They are greenish underneath with pinkish 'fur' on top.

These black walnut views (left to right) illustrate emerging leaves and a pair of female flowers, the developing fruit with female stigmas still attached, and the maturing fruit.

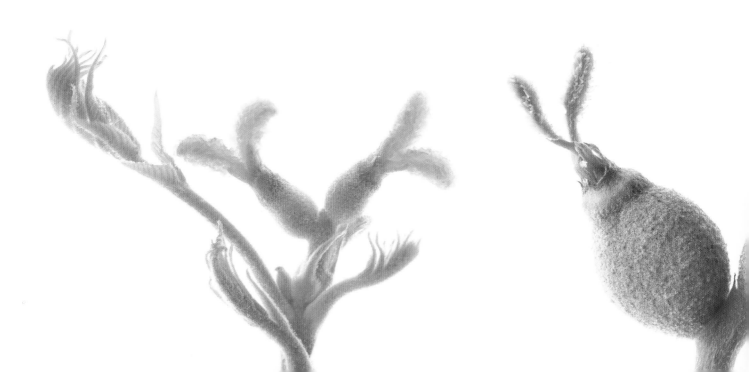

I'm guessing these [the Perrier bottles] will mature into walnuts?"

Botanists will have recognized the "drooping green stems" on which male flowers reside as catkins, the "pudgy antennae" on the female flowers as stigmas, and the bottle-shaped bases of the female flowers as ovaries, which do, indeed, mature into walnuts. The ovaries are probably better described as pear-shaped, which perfectly describes the shape of the developing fruit. All these sexual parts are obscured by the developing leaves, which are delicate, finely formed, and reveal themselves a few leaflets at a time. Male flowers appear on the part of the twig that is a year old, and female flowers appear at the end of new shoots.

Following my period of walnut flower-watching, I felt like such an expert that I wrote "no!" in the margin of a book I read soon afterward when it said you needed two walnuts in order to produce fruit. Hadn't I seen with my own eyes both male and female flowers on the same tree? Only later did I learn that walnut is one of those trees that has a mechanism for preventing self-pollination. According to William Reid, the nut specialist, although sometimes the timing is reversed, the black walnut's female flowers usually mature before the same tree's male flowers release their pollen, thus promoting cross-pollination (pollination between different trees). It is, then, usually pollen from neighboring trees, not pollen from male flowers on the same branch inches away, that fertilizes the black walnut's female flowers. According to Reid, the trees do sometimes self-pollinate, but when they do, there's a high probability they'll produce poor, runty seed.

It's almost impossible to consider strategies like this and not marvel at the intelligence of trees. And yet it's not so much what I've been told but what I've seen that has changed my attitude toward black walnuts. I think it was the discovery of the black walnut's female flowers, with their "pudgy antennae," that transformed these trees from gorgeous growing things into living organisms for me. Until then, I thought of them as beautiful, sometimes majestic, often productive, and economically valuable trees, but it took seeing those antennae-like appendages on the female flowers for me to feel they were alive. *Sensate* is the word that comes to mind when I think of those delicate sexual parts on these rock-solid trees. No wonder those who know them best want to crawl up into their limbs and sing.

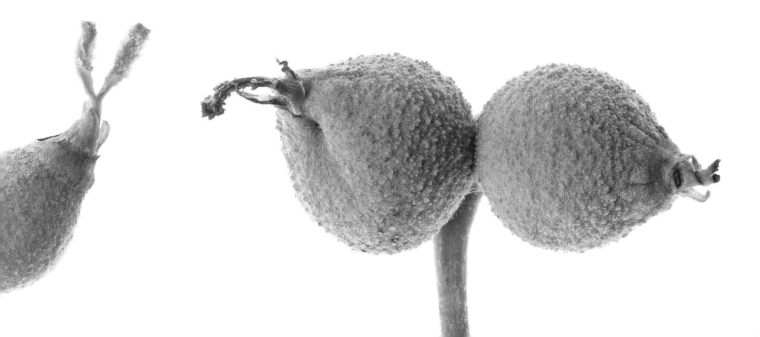

EASTERN RED CEDAR *Juniperus virginiana*

"The everyday things get the least attention," one botanist observed as we were chatting about red cedars. "People think anything that's common isn't any good." In my neighborhood, red cedars are so common they are considered a trash tree, and even though there are some gorgeous old specimens around, nobody pays much attention to them. When they are noticed at all it is usually in the winter when some of them are loaded with blue "berries" (fleshy cones), but otherwise they stay in the background of nearly everyone's consciousness. It's hard to imagine how prized these trees were in eighteenth-century England, where gardeners wanted to plant them in their landscapes. According to Andrea Wulf in *The Brother Gardeners*, red cedar "berries" were ordered by the bushel and suppliers like Pennsylvania's John Bartram had trouble keeping up with demand from gardeners. Like many native trees, eastern red cedar is least appreciated in its homeland, but observe this tree closely, and you'll discover attributes even its European admirers probably overlooked.

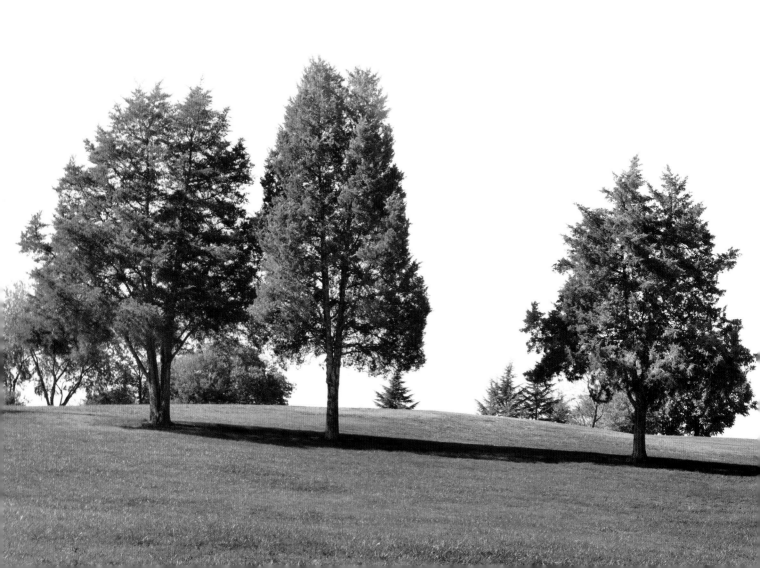

First, I want to share some information about this tree's relatives and its distribution, because even if you don't have an eastern red cedar in your neighborhood, you may have one of its relatives. The tree we call eastern red cedar isn't really a cedar (member of the genus *Cedrus*); it's a juniper (member of the genus *Juniperus*), and other junipers, including the California juniper, the Chinese juniper, and the common juniper, share some of its traits. The shrubby common juniper, *J. communis*, has a particularly broad range, growing across most of the United States and Canada to Greenland, to Europe, and across Siberia and Asia. The range of eastern red cedar (*J. virginiana*) isn't that broad, but it is reportedly the most widely distributed conifer in the eastern United States. It is native to eastern North America from southeastern Canada to the Gulf of Mexico east of the Great Plains, and range maps show it growing in almost forty states. (Planting and natural regeneration have extended its range into the Great Plains, among other places, where it is sometimes the only evergreen in the winter landscape.)

One reason eastern red cedar is so common is that it is a pioneer species: it is one of the first trees to colonize abandoned farm or pasture land. It is a familiar feature of old fields, highway embankments, graveyards, power line easements, and other habitats where the soil has been disturbed. Most of us associate this tree with rural areas, but I was reminded of how ubiquitous this tree is, even in urban areas, one winter weekend when I'd hoped to have some rural red cedars in view as I wrote about them. Stranded in the city instead, I was bemoaning the fact that I'd be out of contact with my familiar trees, when on the way to the grocery store I noticed a line of impressive red cedars behind the shopping center. Back there, across from the dumpsters and the loading docks, was a smorgasbord of eastern red cedars. Some were dripping with blue "berries," others had yellowish "cones" at the

tips of their branchlets; some were dull olive green, others bronzy in color, and one had foliage I can only describe as a drab, grayish pink. They all looked pretty stressed—surviving as they were in a ribbon of soil between the concrete loading dock and a parking lot—but the trees were big and there was enough variation in their foliage and physiognomy that one could have used these trees alone to conduct a pretty rewarding study of red cedars.

Anyone who has ever tried to find the perfect red cedar for a Christmas tree knows how variable this tree is. In the southern part of the red cedar's range, young trees are usually columnar, older trees more pyramidal; in the northern part of their range, red cedars tend to stay columnar. Many of the red cedars that look the fullest actually have double trunks (a problem if you're choosing one for a Christmas tree), and their foliage varies tremendously in color and texture. Young trees' foliage (and some of the foliage on older trees) is pointed and prickly—some of it a silvery blue-green. Examine the 3/8-inch, awl-shaped needles up close and you'll discover that they all point away from the stem like daggers. Most of the foliage of mature red cedars is quite different; it looks more like scales or the overlapping shingles on a roof than it does like needles. Pressed close to the stem, it is textured in a way that reminds me of a braided rope or lanyard. Foliage color varies by tree and season. Red cedars tend to "brown out" in the winter and green up in the spring, but some trees are "rustier" than others all year long. Part of each tree's brownish cast is due to natural coloration and part is due to old foliage that stays on the tree several years after it is dead. Those who like the bronzy look of red cedar foliage consider it warm and subtle; those who don't, consider it a poor substitute for spruce green.

Contributing to the bronzy look of red cedars are the yellowish brown pollen-producing structures on male

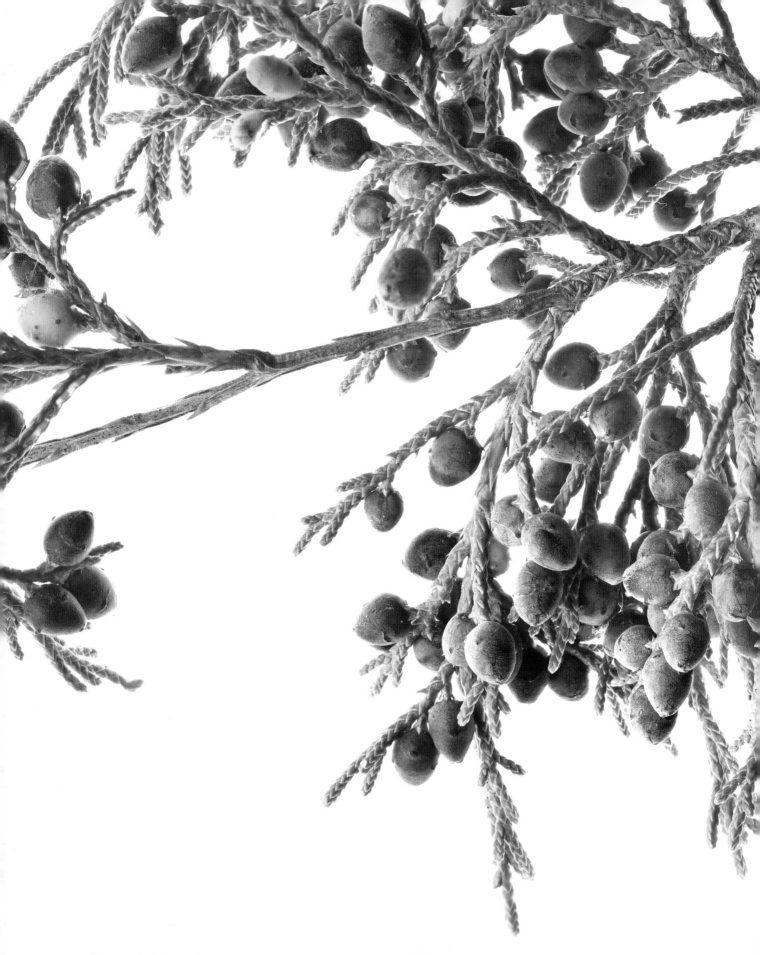

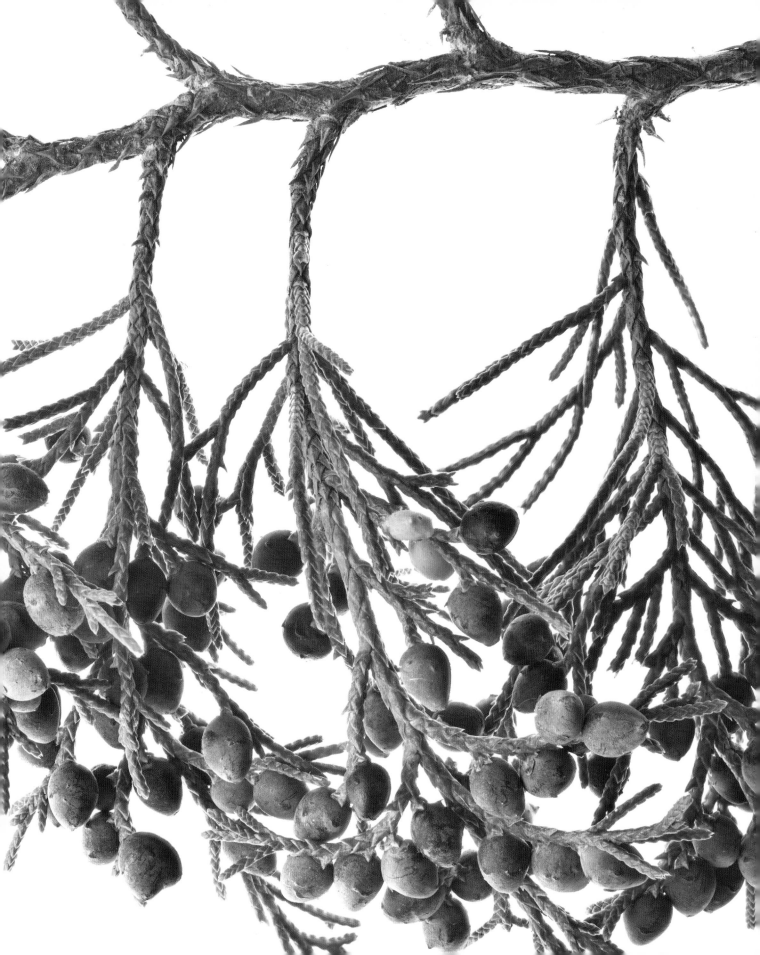

trees. Most naturalists refer to them as male or pollen cones; botanists call them strobili. About the size of rice grains and looking scaly or shingled like the foliage, these pollen-bearing structures are so small and so numerous (there's one on the tip of nearly every branchlet) you're unlikely to immediately recognize them as such, but male cones they are. Look for them in winter and early spring, because after they have released their pollen (in March where I live), they soon disintegrate and drop off. A red cedar loaded with pollen cones reaches the climax of its bronzyness, turning almost mustard brown just before all that pollen is released.

If you examine each male cone as its scales begin to pull away from each other and its pollen sacks swell—something best done with a magnifying device—you'll see tiny, burgeoning, pale yellow blobs behind each scale. It is from these sacs that the pollen will sift when the slightest breeze, or even the landing of a bird, shakes the branch. "This morning [March 18] I saw numerous 'puffs' of pollen escaping the red cedars, mostly from gentle winds," a friend once wrote me, "but in one case a small bird took off and shook the branch enough to make it look like there was a small fire smoldering in the tree." These gentle events can be beautiful, but a red cedar pollen event can also be startling. Turn the March wind from gentle to strong and you may see an entire line of red cedars go up in yellow smoke. The first time I ever witnessed such an event was a blustery March day when you could trace the path of the wind through a stand of red cedars as surely as if it had been drawn in yellow chalk dust. *Lots* of yellow chalk! You can create a similar but smaller cloud of yellow smoke yourself just by shaking a male red cedar branch at the proper time, but you might want to reach for your allergy meds before doing it. Bob once complained to me that he should have been issued a Hazmat suit before being asked to photograph red cedars loaded with pollen, and I, who share his allergies, understood.

By now you'll have figured out that red cedars are dioe-cious, which means some trees are male, some female. The distinguishing feature of female trees is their blue "berries" (although occasionally, a male tree will bear a few, too). "Berries" is actually a misnomer for these fruits, because what is called the red cedar berry is technically a cone with fleshy scales that give it the appearance of a berry. Everyday observers always call them berries, though. The red cedar berry, which starts forming long before it is recognizable, goes though many color stages, but by the time it is recognizably round (around the first of May, where I live), the progression goes from a pale, frosted blue-green, to steel blue, to bluish black. There can be over 1.5 million of them on a single tree, and every two to three years there is a bumper crop.

Not only do these blue berries look gorgeous on the trees but they are an important food source for birds. Think of them as fast food for frugivores (fruit-eating birds). The analogy is apt because red cedars are as common as fast food restaurants (they even pop up beside new highways), they offer food to flocks of hungry travelers, and, at least in the case of the red cedar, they offer low-quality food. Red cedar berries aren't high in nutrition (dogwood berries are far richer in carbohydrates, lipids, and proteins), but what they lack in quality they make up for in quantity and availability. Red cedar berries ripen just when many birds migrating south need them (August through October), and partially because they aren't many birds' first choice when it comes to food, berries are still on the trees in late winter when other food choices aren't available.

There is a reciprocal relationship between red cedars and the birds that feed on their berries. The berries provide the birds nourishment, and in return the birds help

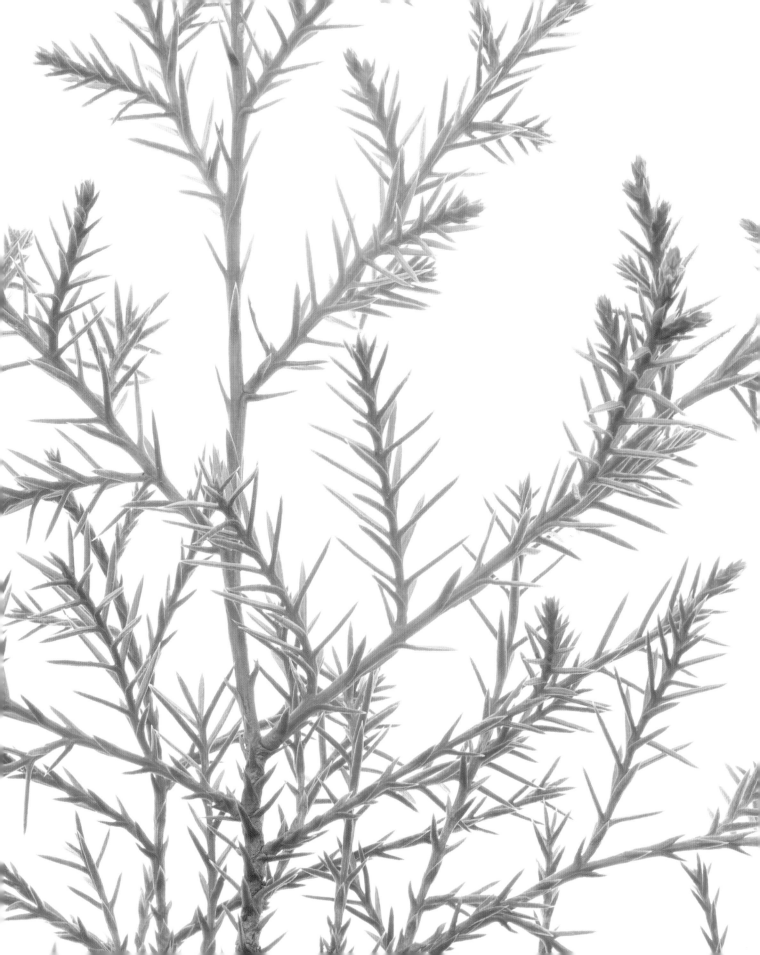

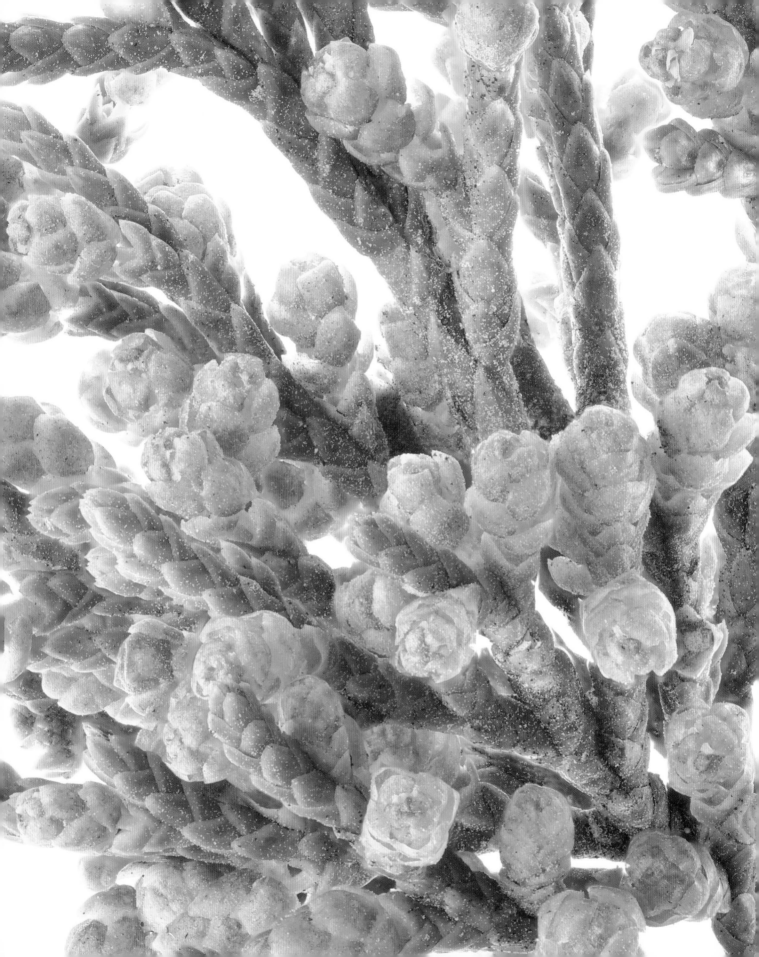

disperse the seeds. If you've ever noticed how often red cedars line a fence row, or cross a field in a straight line where a fence used to be, you are witnessing the result of red cedar seed dispersal by birds, who have excreted the seeds while sitting on the fence. And birds not only disperse red cedar seeds but improve the seeds' chances of germination. According to biologist Anthonie Holthuijzen, red cedar seeds that have passed through the digestive system of a bird are 1.5 to 3.5 times as likely to germinate as seeds that have not. Which brings me to a little reversal of our usual thinking about birds competing for tree fruit. In a paper on interactions between birds and fruit in temperate woodlands, A. E. Sorensen once pointed out that "fruits may compete more heavily for birds than birds do for fruit," the services of the birds being so essential to the tree. I like this paradigm shift because it helps dispel the inaccurate image of trees as passive beings and conjures for me the image of a red cedar marketing its fruit, as in some sense all trees do.

People who remember that the red cedar is actually a juniper (*Juniperus virginiana*) may also wonder if its berries are the juniper berries people eat. Juniper berries are sold in the spice section of the grocery store and are used to flavor gin (the word *gin* reportedly derives from *genievre*, the French word for juniper), but such berries come from the common juniper, *J. communis*, not the eastern red cedar, *J. virginiana*. Although they have been used medicinally and for flavoring for centuries, red cedar berries (and sometimes even common juniper berries) are actually listed as poisonous by many poison control centers, so eating them in large quantities is definitely not recommended.

Much less visible than mature red cedar berries are the developing structures—sometimes called flowers—that precede them. Until I started searching for tree flowers, I had never considered what sort of structure might precede the red cedar's berries, and so I was intrigued when I read this sentence in Walter E. Rogers's *Tree Flowers of Forest, Park and Street*: "Among Gymnosperms, the Red Cedar, next to Ginkgo, offers perhaps the flower hardest to recognize as such. The lack of a strongly differentiating color, the minuteness of the parts, the apparent similarity to the foliage—all conspire to conceal from an observer the true nature of the flowers." A line like that operates on me like an incentive; the harder something is to find, the more I want to see it.

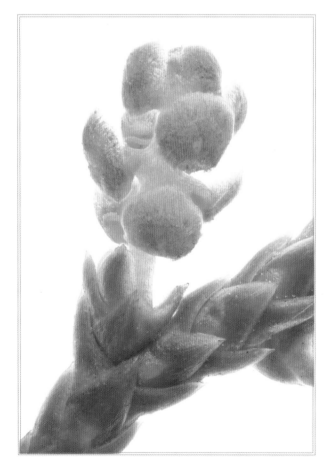

LEFT Male pollen cones are responsible for some of the bronzy spring color of eastern red cedars.

RIGHT In this magnified view, the chambers of an eastern red cedar pollen cone, which have released its pollen, are visible.

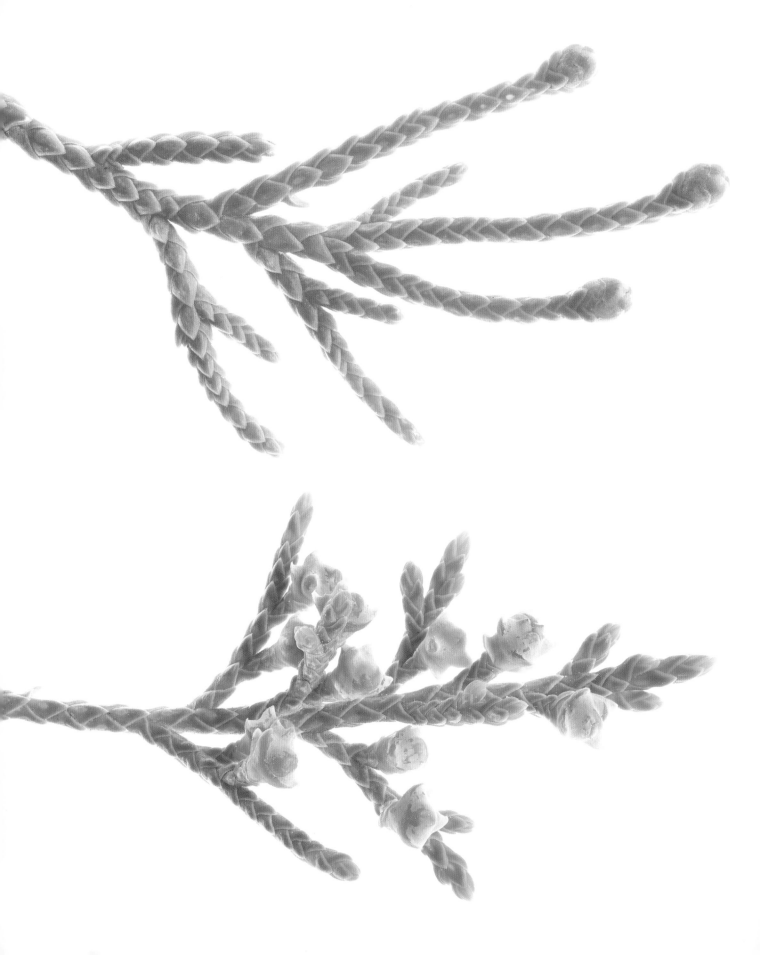

It makes sense that some sort of "flower" (technically an immature cone, not a flower, since this is a conifer) must precede the red cedar's mature berries (seed-bearing cones), but what kind and when? Illustrations accompanying Rogers's discussion provided me my first search image for red cedar "flowers," but it was a photograph (with arrow indicating where to look) on the website of a midwestern Nature Center that gave me the locational clue I needed. Bob's photographs will serve the same function for you. Another clue that helped me was a remark from a fellow native plant enthusiast who commented that while he hadn't seen them himself, he knew red cedar "flowers" bloomed "crazy early."

I now know the red cedar's female "flowers" (ovulate cones) begin forming in late summer or fall before any hint of them can be seen with the naked eye. Although it is not impossible to see them with the naked eye earlier, I don't think I'd try to show anyone the developing ovulate cone ("flower") of the eastern red cedar until late March, and even then we'd need to use a magnifying device. You'll want to look on female trees (the ones from which birds have by this time nearly or completely stripped the previous year's berries), and the place to look is on the tips of foliage relatively close to the stem on the previous year's growth. Look not at the side of the foliage but down into the twig tip where the terminal scales seem to be missing. The area will look like the throat of a bird

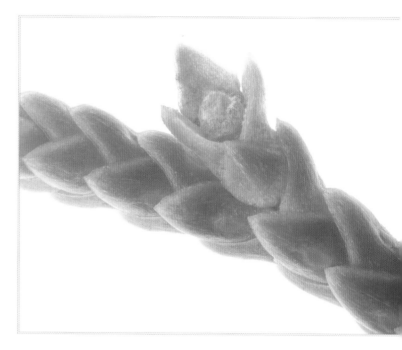

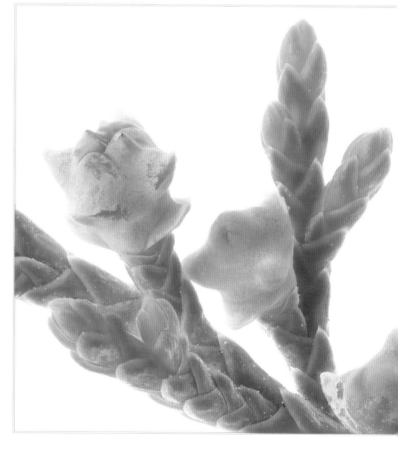

TOP LEFT Male eastern red cedars produce tiny pollen cones, or strobili, at the tips of their branchlets.

LEFT Female eastern red cedars produce female cones, or "berries," which are particularly interesting and seldom observed in their very early stages.

TOP RIGHT The first visible sign of eastern red cedar's female reproductive structure (sometimes referred to as a flower) emerges from the tree's scale-like foliage in late winter.

RIGHT Fleshy scales, which will give it the appearance of a berry, cover the female eastern red cedar cone.

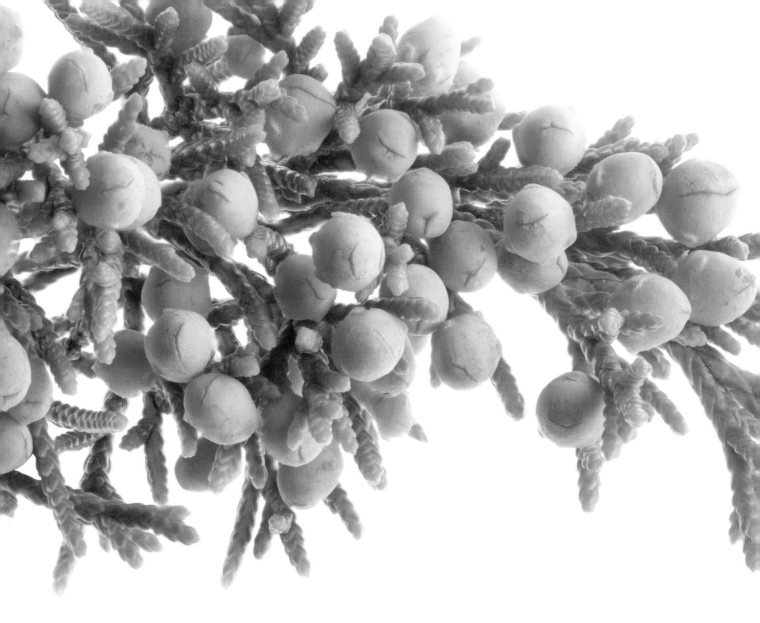

with four beak-like prongs surrounding it. It is down in that "throat" that the female ovule develops. (The places where the previous year's cones have fallen off look similar, but they have a bit of woody-looking debris, instead of developing ovules, in their "throats.")

By late spring, eastern red cedar's female cones, which look like berries, have taken on their characteristic round shape and pale blue color.

At first, the developing ovule will look like a tiny orb about one-fifth the size of a peppercorn, then like an inflated little yellowish tan balloon with a reddish brown tip. Neither stage is particularly awe-inspiring, but by midspring, prepare to be flabbergasted, because, at this stage, the developing red cedar berry is a knockout. As the berry develops, it looks like the sides of the scales (those pronged protrusions that resemble bird beaks) are melting over the ovule in the middle, and the color of these structures is a combination I've variously described in

my notes as "blue-gray-grape with yellow/orange undertones" and "blue-green with pinkish yellow lumps in the middle." Bob's photo illustrates this painterly mix as well as the "lumps"—globular ovules over which the scales are fusing to form the familiar red cedar berry. "It looks like something is living inside," Bob commented as we compared notes on this structure, and of course he is absolutely right—tree seed is forming inside—but seldom do we observe tree phenomena looking quite so curiously amorphous. Never, before seeing this stage in the developing red cedar berry in the wild, had I ever observed it in any photo or seen it described in text, and I'm still amazed to think I'd been overlooking this bit of tree anatomy during the four decades or so I

thought I knew this tree well. To see it, look for dots of pale blue color at the tips of the red cedar branchlets about a month after the male trees' pollen has been dispersed, then get out your loupe and look closer!

Other red cedar phenomena that deserve closer inspection include the tree's bark and manifestations of the fungal disease called cedar apple rust. Long, narrow, vertical strips of red cedar bark peel off the tree in ribbons (see page 97). Such exfoliating bark is particularly impressive when an old tree has either lost its lower limbs naturally or been limbed up. Given enough room and sunshine to develop healthy crowns, red cedars demonstrate how stately they can become in old age. A grove of such trees is a joy to walk in because the area under their uniform trunks is as sheltering as a portico, the ground beneath them is yielding (having been amended by decades of sloughed-off foliage), and the fragrance under their sheltering crowns smells like the inside of a cedar chest. Any walk down a lane lined with red cedars may afford you the rush associated with red cedar fragrance, but you can also create the smell by abrading red cedar foliage between your fingers.

The fruiting body associated with cedar apple rust is a phenomenon of a different color—literally and figuratively. Cedar apple rust, a fungal disease that affects eastern red cedar and its alternate host, apple trees, requires two hosts—the cedar tree and the apple tree—to complete its life cycle. And if both hosts are present, the disease can be really damaging to apple trees, not so much to red cedars. The manifestations of this disease on red cedar are pretty spectacular, though. Look first on cedar twigs for brown galls ranging from the size of marbles to golf balls. During rainy spring weather, these galls will sprout long, gelatinous, orange tendrils (spore horns), transforming them into something that looks like a tennis ball–sized sea anemone. Spores discharged from these tendrils and then carried by wind to developing apple leaves and fruit are so destructive that red cedars are about as popular in apple-growing country as bears in a beehive. Do

not expect to find eastern red cedars in apple country, because orchardists have effectively removed them, but elsewhere the fruiting bodies of cedar apple rust are pretty ubiquitous.

A red cedar associate I hope to see, but haven't yet, is the olive hairstreak butterfly (*Callophrys gryneus*). The caterpillar of the olive hairstreak feeds almost exclusively on eastern red cedar foliage, and the adult butterfly likes to feed on mountain mint, a plant that happens to grow in close proximity to a line of red cedars near my garden. Small but beautiful, the olive hairstreak has patina green wings and bronzy brown and white markings. Butterfly expert Judy Molnar tells me that both male and female olive hairstreaks feed on nectar near their host plant (the eastern red cedar) and that the males are highly territorial, often perching in the top of the tree all day. Obviously, says Molnar, this makes them hard to see, but if you "gently jiggle the trunk," they may fly around a little before returning to their perch. Molnar further explains that the olive hairstreak lays its well-camouflaged eggs on the tips

of red cedar branches, that in the southeastern United States it has at least two broods, and that the best time to see the adults flying is during the mating seasons from late March to early June and from mid-July to September.

You'd think with all this information, I'd have spotted an olive hairstreak by now, but I haven't. I'm consoled by the fact that Virginia naturalist and butterfly photographer David Liebman tells me he looked for olive hairstreaks for fifteen to twenty years before he finally saw one. They could be rare in your area, he says, or they could be common and I'm just not seeing them. It's the latter possibility that keeps me jiggling red cedar trees, which isn't the best way to establish your sanity with your neighbors but is a fine way to stay in touch with your cedars.

BELOW LEFT Cedar apple rust galls are a familiar feature on eastern red cedars.

BELOW RIGHT Gelatinous spore horns sprout on cedar apple rust galls during rainy spring weather.

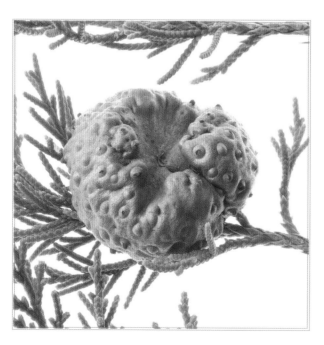

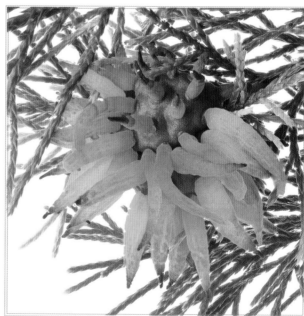

GINKGO

Ginkgo biloba

How to make trees seem more dynamic, less static? How to make them seem more like living things, less like objects? What about a film showing swimming sperm fertilizing the ovule of a ginkgo? Works for me. In fact, I can't watch the short film of this event on YouTube without thinking: every man, woman, and child should see this! Granted, swimming sperm are extremely unusual in trees—among woody plants, only the ancient tropical cyads also have swimming sperm—but the fact that *any* tree exhibits this trait, and that it is possible to watch it on the Internet, is, as my husband put it, "pretty slick."

Picture what looks like two pulsing ponds in a large chamber of fluid, punctuated by whirlpools created by the swimming sperm. Biologically, the events aren't equivalent, but for me, seeing this event was like seeing my first ultrasound, a technological breakthrough making observable something that had been previously hidden throughout history. We modern people tend to think of the natural world we inhabit as somehow attenuated—a poor, abridged, depleted, and damaged version of the original. But it is worth remembering that despite the tragic loss of plant and animal species during our tenure

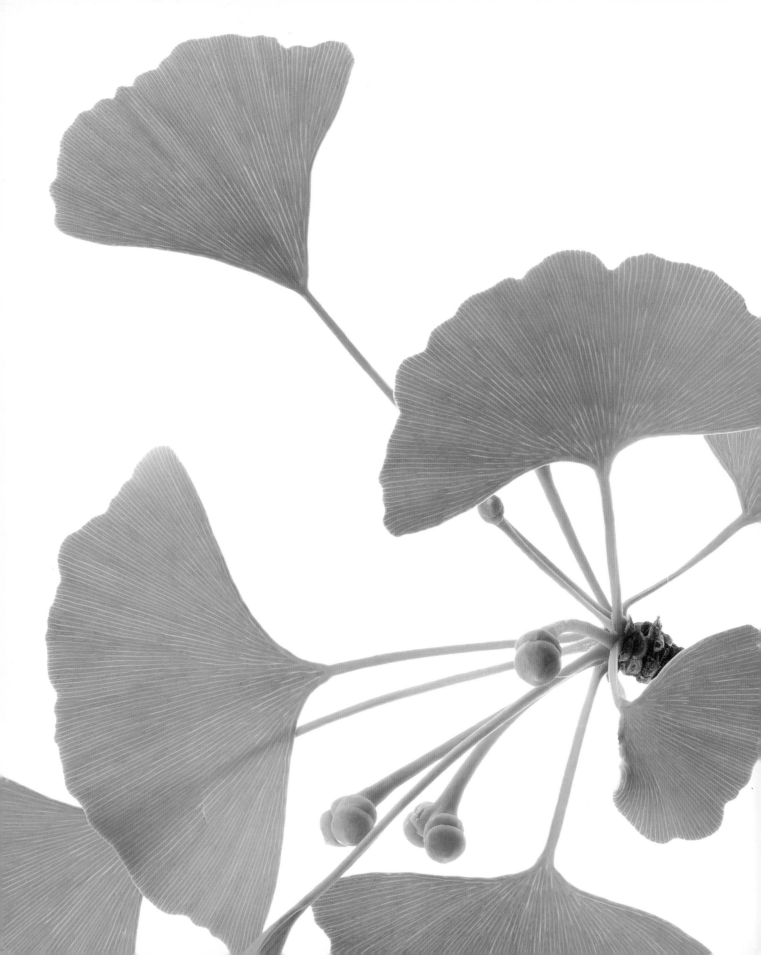

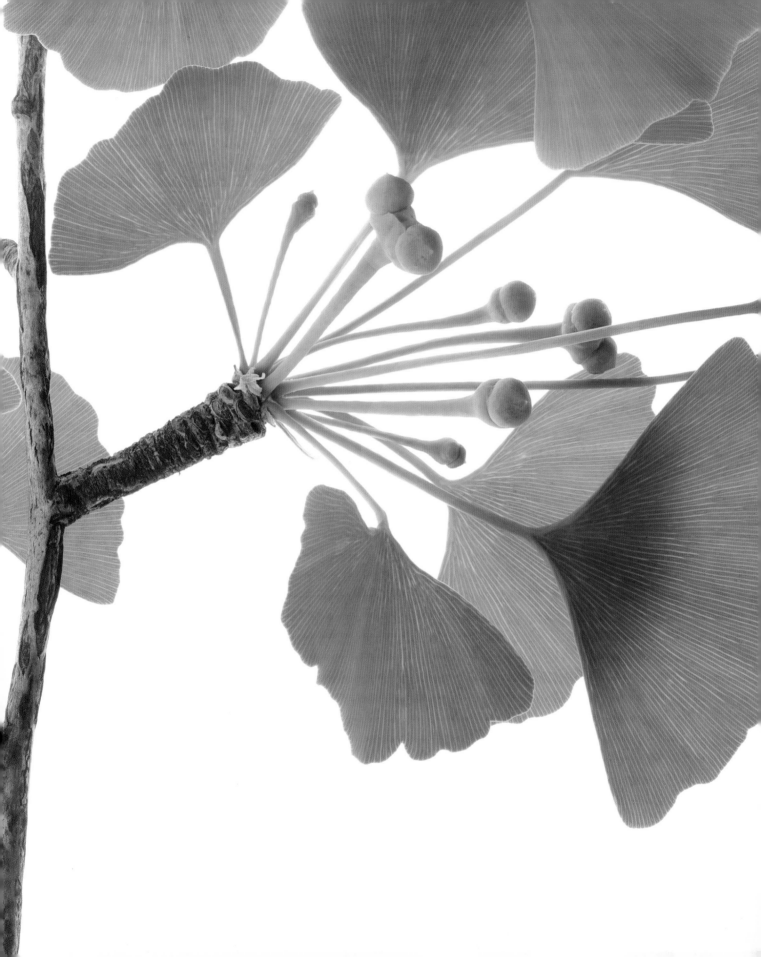

and before, modern men and women are privileged to be able to witness many natural phenomena never observable before.

Ginkgo seed fertilization takes place inside the female "fruit," and to understand it, it helps to first appreciate the tree's history and some traits you don't need cutting-edge microscopy (or YouTube) to observe. Ginkgos have been called "living fossils" or "fossils minus the rocks" because their forebears go back so far in evolutionary history and because they have persisted into the modern era relatively unchanged since the Triassic Period 200 million years ago. Members of this tree family, which was once as varied as it was widespread, saw the rise of the dinosaurs as well as their decline. By the Cretaceous Period (145 to 65 million years ago), however, the ginkgo family itself was in decline, and only a few species remained by the Tertiary Period (65 to 1.8 million years ago). During the ice ages that followed, successive waves of global cooling wiped out almost all of the remaining ginkgos, and Europeans thought the entire plant family extinct until the late seventeenth century, when ginkgos belonging to the one remaining species, *Ginkgo biloba*, were found growing in China. Soon ginkgos were also found growing in Japan and Korea, where they had probably been under human cultivation for centuries.

Plant collectors, as you might imagine, went wild over the ginkgo: everyone wanted this primitive tree growing in their gardens, and soon it was being distributed all over the globe. Today you can find ginkgos, which will grow in almost all temperate and subtropical regions, growing in parks, arboretums, and yards around the world. And because it is so adaptable, tough, and tolerant of pollution, it is often used as an urban street tree. "Immediately outside the window the fan-like leaves of a thriving ginkgo tree were just beginning to lose their summertime green," observes Nathan Zuckerman, a fictional character of Philip Roth's who proves you can make fine ginkgo observations even from a West Side Manhattan window. There is also a fine website, The Ginkgo Pages, edited by Dutch teacher Cor Kwant, where you will find a list of "special" ginkgos and where they grow worldwide. Traveling to Sydney, Seoul, Capetown, or Tokyo? You could plan your trip around the ginkgos in that city. I found three ginkgos growing near the cafeteria steps at Zurich University Botanical Gardens, in Switzerland, right where The Ginkgo Pages said they would be. I can't say they were particularly "special"—ginkgos planted in 1854 within miles of my home would put them to shame—but a huge copper beech I was seeking nearby made my trip to the Zurich Botanical Gardens worthwhile.

Whether outside your own window, in a park, or in a foreign city, here are some ginkgo traits to look for. First, the shape of the tree is distinctive. Young ginkgos look awkward to me, like adolescent boys who don't know where to put their fast-growing arms and legs. The widely spaced branches create a scaffolding that looks more like a coatrack than a tree, and the positioning of ginkgo leaves on branches exaggerates that effect. In addition to growing alternately along the tree's straight new twigs, ginkgo leaves on older growth emerge from woody structures called short shoots or spur shoots. Spur shoots, which look from a distance like thick thorns scattered along the branches, typically range from about ½ to 1½ inches long but can grow up to 3 inches long on older trees. From the tips of these spurs, which are actually stacked leaf scars, emerge clusters of leaves as well as the ginkgo's reproductive structures. The result is clusters of leaves—you could almost think of them as bouquets of leaves—held close to the branch, which make each branch look as if it is plastered rather than clothed in leaves.

PREVIOUS Hidden among its leaves are the female reproductive structures (ovules) of ginkgo.

RIGHT On this ginkgo twig, resting buds appear at the tips of woody structures called spur shoots.

Pyramidal and characterized by voids between branches in youth, the ginkgo loosens up in old age, and fills in and spreads out, exhibiting a more rounded crown. In fact, people who complain about the awkward look of the young ginkgos planted near their townhouses should head for the nearest arboretum to see what a ginkgo will look like after, say, 150 years. To my eye, except for a certain characteristic branching angle (branches angling up and away from the trunk at about a 45-degree angle), it doesn't look like the same species.

Ginkgo leaves are also distinctive. They all have an overall fan shape, but they vary widely in size and outline. Some ginkgo leaves are entire, meaning they are not divided into lobes; they are like fans with no tears between the ribs. Others have a cleft in the middle, creating two lobes, which is where *Ginkgo biloba* gets its species name *biloba*. And still other leaves have two clefts creating three lobes. Because of their shape, ginkgo leaves can't be confused with leaves of any other tree and are reproduced over and over again in jewelry and other decorative items. But the leaves are interesting for other attributes as well. They have unusual texture (sort of waxy), an unusual vein pattern (radiating out from the stem end and continually dividing in twos), long, flexible stalks (which allow them to flutter in slightest breeze), and brilliant fall color.

In the fall, ginkgo leaves are a bright clear to golden yellow, and they are among the latest leaves to fall, in November in my neighborhood. If there is one leaf fall event that surpasses all others for drama, it's the fall of the ginkgo leaves. I've never seen the most dramatic ginkgo leaf fall event, when all of a ginkgo's leaves fall within a matter of hours. That must be thrilling. But I've seen the ginkgo leaves falling almost all at once, over a matter of a couple of days, from my neighbor's tree. The day when the leaf shower was heaviest was the morning after a hard frost when warmth from the early morning sun must have unlatched the already loosened leaves and brought them

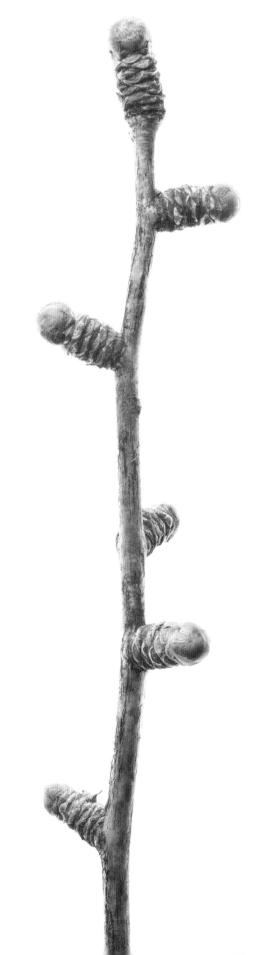

down like a steady rain. That event not only had its own rhythm, it had its own sound, sort of a metallic click as the frozen leaves hit each other and the branches below. Once on the ground, ginkgo leaves are amazing, too, creating a brilliant yellow carpet under the tree, and it is a shame people rake them away so quickly. If such "lawn carpets" were sold at Lowe's Home Improvement and marketed as garden ornaments, people would be lining up to buy them.

There's also some irony in the fact that people raking ginkgo leaves away pay big bucks for medicinal extracts made from ginkgo leaves. The ginkgo extracts sold in health food stores come from the leaves of the same ginkgo species that grows in lawns and gardens all over the world. Such leaves are usually harvested from ginkgo farms, however, and they are harvested in the summer when the leaves are still green. I once fantasized about what a 1000-acre ginkgo operation like the one in Sumter, South Carolina, might look like when viewed from the air; I pictured a vast yellow blanket of leaves. But, alas, the 10 million ginkgos grown there are shrubby and their leaves are harvested before they turn yellow.

In addition to having distinctive leaves, ginkgos also have noteworthy "fruit." (Nomenclature alert: It's not technically accurate to refer to the ginkgo's ripened ovules as fruit. The ginkgo has a naked seed with a fleshy outer layer, not a seed embedded in a ripened ovary wall like a plum or a peach, but many naturalists and most ordinary observers refer to it as fruit.) Most people who are aware of ginkgo fruit think only of the smelly orbs that fall from female trees in the fall, but there's more to the ginkgo's reproductive structures than the female fruit's notorious final stage. Ginkgos bear their male and female reproductive structures on separate trees, and because of the offensive odor of the female fruit, people plant more male than female ginkgos. Or they think they do.

Most nurserymen propagate male ginkgos from cuttings of male trees, so they are selling "certifiably" male trees. If, however, you buy a ginkgo propagated from seed,

LEFT Ginkgo leaves vary in shape (some having no lobes, some two, some three), but this leaf exhibits the two lobes from which the tree takes its species name *biloba*.

RIGHT On older twigs, ginkgo's male reproductive structures (strobili) emerge from woody spur shoots.

the tree has only a fifty-fifty chance of being male, and you won't know what sex it is until it bears male catkin-like structures (strobili) or female fruit (ovules), and that can take twenty to thirty-five years, sometimes longer. Imagine the homeowner's surprise when the tree he or she thought was a male starts producing female fruit at age forty! It happens. In fact, Peter Enz, garden manager at the Zurich Botanical Garden, told me that when university horticulturists planted the three ginkgos I visited there, they didn't know what sex they were but hoped the trees closest to the pedestrian path would turn out to be male. "Naturally, the opposite happened," he said, because in 1998, at age thirty-nine, the tree closest to the path bore fruit.

You need to have a mature tree to be able to find reproductive structures on a ginkgo. In early to midspring, as its leaves are emerging, look on a male tree for tight, elongate clusters of pollen-bearing structures that grow from the tree's spur shoots under the leaves. About 1 to 1½ inches long at maturity, they'll be green at emergence (actually bearing spores, not pollen at that point), whitish yellow when ripe with pollen, brownish before they fall off. Although they will eventually droop a little, they are relatively upright when they emerge, but most people overlook them because they emerge from spur shoots with the leaves. The female reproductive structures are even more interesting. On a female tree, again in early to midspring, as the leaves are emerging, look for slender, yellow-green stalks supporting a pair of tiny, round, green orbs. The orbs (ovules) have pointed tips and are

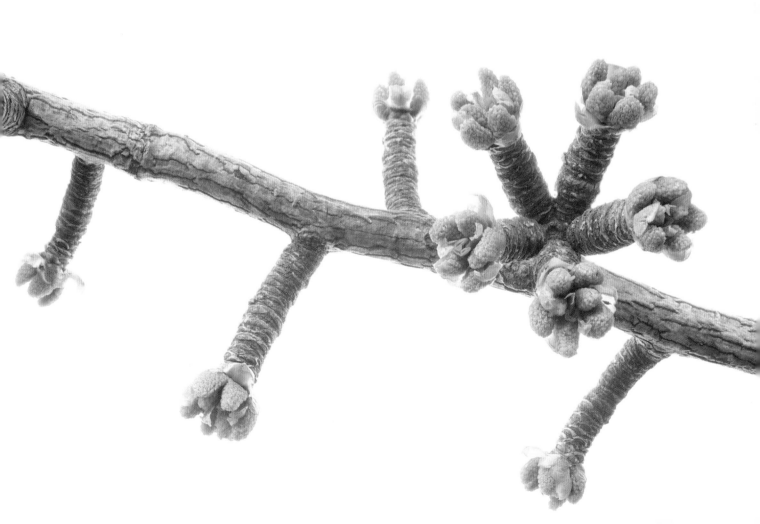

held atop the cup-like ends of the stalks. To me, this stalk looks like a miniature crutch, the ovules like breasts with nipples angled away from each other. These ovules will receive pollen from the male catkin-like structures and develop into ginkgo fruit.

Ginkgos, and other gymnosperms, have something called a pollen droplet that assists in the pollination of their egg cells. It is a tiny drop of sticky fluid that emerges on the surface of the ovule (that rounded structure with a pointy tip) and catches pollen grains. The ginkgo doesn't sit passively waiting for pollen to fall on a stigma; it creates

BELOW In this close-up view of emerging ginkgo strobili (the green structures), the previous years' leaf scars are also visible on the woody spur shoot.

RIGHT These more mature, elongate clusters of reproductive structures (strobili) develop with male ginkgos' new leaves.

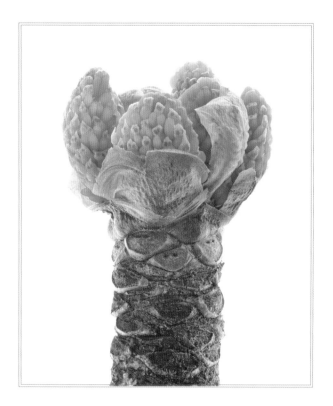

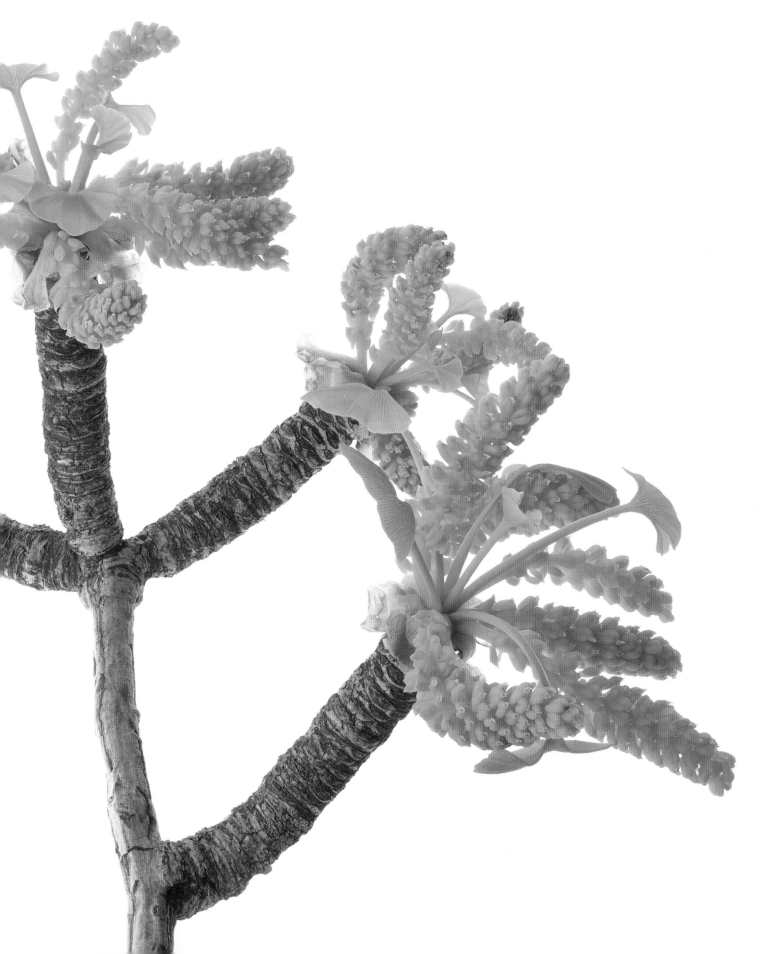

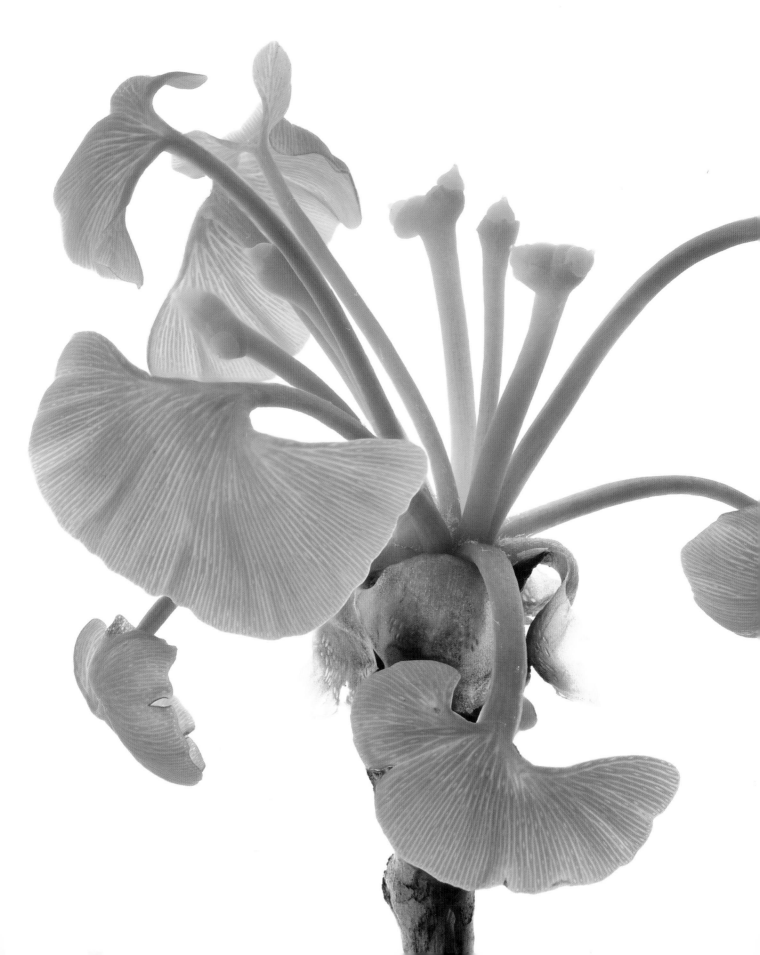

this tiny droplet of fluid that essentially goes out, grabs pollen, and brings it in to the female cells. On the ginkgo, you can see the pollination droplet with the naked eye, but you can't observe what it does once it retracts into the ovule. Charts on the Internet can help you visualize that. Such charts will show you that when the pollination droplet retracts through a tiny opening into the interior of the ovule, it takes pollen with it, and there, in what is called a pollination chamber, the pollen rests among female tissues until actual fertilization takes place months later.

I had never heard of a pollination droplet until I saw one in a photograph on the Internet, but evidently, although on many gymnosperms they occur where they can't be seen (like inside the scales of a pinecone), they are visible on others. My botany mentor, John Hayden, told me he had seen them only once, on plum yew (*Cephalotaus*) shrubs in a botanical garden, where he happened upon them one moist, early spring day. They are not only tiny (about ¹/₃₂ inch across) but also short lived, possibly lasting only a matter of hours on a dry day, but their evanescence made me want to see them all the more. Unfortunately, there were obstacles to my "ginkgo pollination droplet viewing," as there might be to yours.

None of the three ginkgos in my backyard was old enough to bear fruit, and my neighbor's mature ginkgo was a male, so I sent out a PDM—pollination droplet memo—to all my neighbors and friends asking them to be on the lookout for female ginkgos coming into "flower." (Gymnosperms don't have true flowers, but the word works better than the alternatives here.) "We'll camp out if we have to!" one enthusiastic group of friends responded, and other arborists and tree enthusiasts seemed equally willing to be on ginkgo alert. "It should happen when the males are approaching pollen release," I advised. But soon my scouts were calling in their excuses (limbs too high, schedules too busy), and I decided I needed a backup plan.

So I clipped a branch from a friend's female ginkgo some miles away (a ginkgo bearing female ovules) and

LEFT On female ginkgo trees, female reproductive structures (ovules) appear on green stalks surrounded by new leaves.

RIGHT In this magnified view of ginkgo female reproductive structures, two ovules appear at the tip of a green stalk.

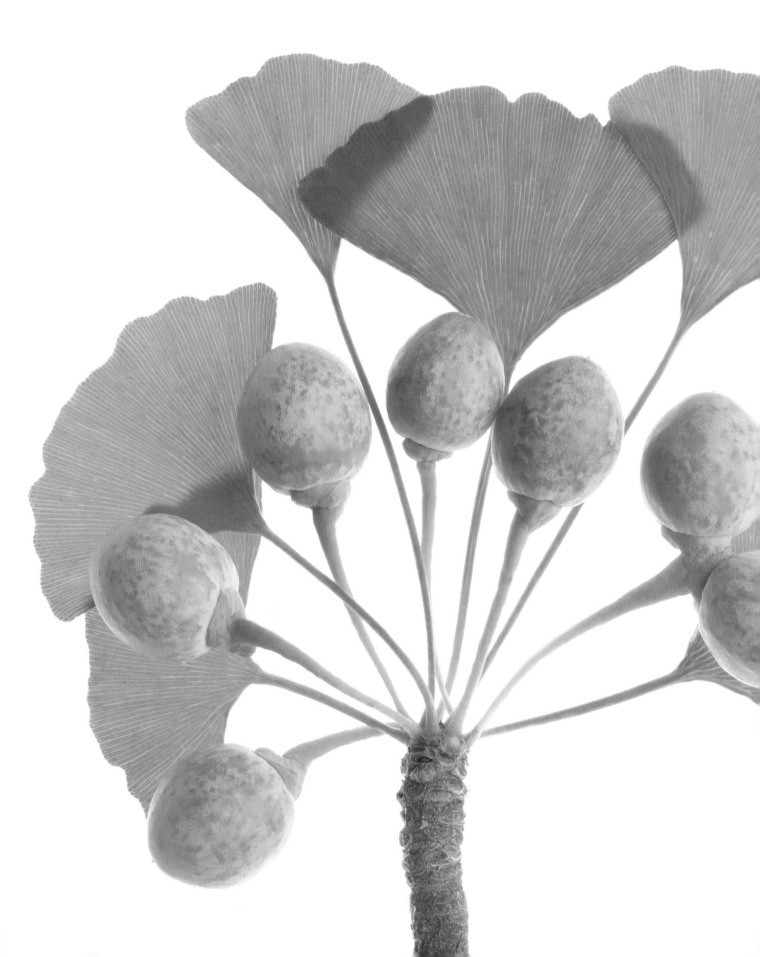

brought it inside. In about two weeks (on April 6), I looked up from washing dishes and saw two pollination droplets glistening on the ginkgo "flowers" blooming on my kitchen windowsill. You'd have thought I'd birthed them myself, so deep was my delight. Those two droplets, plus one more, were the only droplets the ovules produced on my ginkgo branches, but they lasted a surprising amount of time, over twenty-four hours, probably because they were inside. *Longing* was the word that came to mind every time I looked at them, because they seemed so primed for pollen they would never get.

I used the same tree, this time without cutting a branch, to watch the months-long development of fruit after it has been pollinated, which goes through several stages during the spring and summer. By the end of May, the green orbs are about the size of a marble, by the end of the summer they are about the size of a persimmon, and they have changed color from green to light yellow-orange to orangey tan. You can see them swelling and changing color, but fertilization of the ginkgo egg, which doesn't happen until late summer or early fall, occurs inside the ovule, where, unless you have special equipment, it is unobservable. In preparation for fertilization, the ovule develops a fluid-filled pollen chamber. The pollen grain forms a tube extending into that chamber, and the pollen releases two swimming sperm cells (complete with 1000 flagella) into the fluid in the pollen chamber. The sperm cells

As it develops, ginkgo "fruit" (technically a seed in a fleshy seed coat, not a fruit) often takes on a silvery bloom that makes it look frosted.

then swim toward the narrow entrance to the egg cells, one makes its way through the portal, then it fuses with the egg, fertilizing it. It is part of this process, the primordial pulsing of the ginkgo sperm in the pollen chamber, that can now be witnessed on YouTube. No flowering tree (angiosperm) and no conifer has swimming sperm in its reproductive repertoire, and, in fact, such an adaptation is more characteristic of mosses and ferns than of trees. And the ferns and mosses rely on external water, not a convenient little internal pool, to transport their spores. I am told that this extraordinary process—fertilization of the ginkgo egg by swimming sperm—usually takes place when the developing ovules are on the tree but that it can occur on the ground where unripe fruit have fallen, a fact that lends new interest to any ginkgo fruit you might find littering the sidewalk.

At maturity, the ginkgo fruit is about an inch in diameter and has a seed about the size of an almond inside. Because of their underlying color and a silvery bloom on their surface, they are sometimes referred to as silver apricots. After they have been shed (typically between August and November, before the leaves fall) and after they have begun to rot, they develop the objectionable odor they are famous for, and that lends the tree its common name "stink bomb tree." The smell of rotting ginkgo fruit has been compared to canine feces, rancid butter, vomit, or rotting flesh—all odors you don't want outside your front door or on your shoes. The smell reportedly has advantages to the tree—attracting carnivores that might consume, scarify, and transport its seeds—but it is decidedly unpleasant to humans. I once had to take the last parking spot on a busy street even though I could see I would be parking in a pile of rotting ginkgo fruit, and the smell, on my tires and in my nostrils, accompanied me in my travels the rest of the day.

Why, then, would I be so foolhardy as to plant ginkgo seedlings that could grow up to be females? First, they were free: they were the tiny progeny of those impressive ginkgos in my county that were probably planted

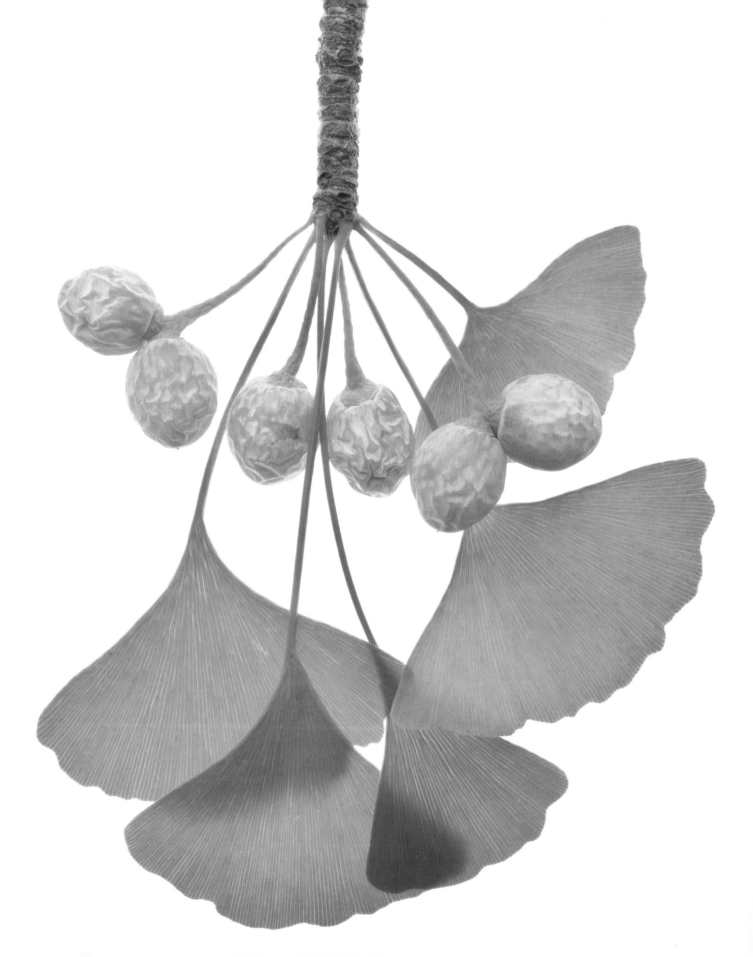

around 1854. I dug them up one day about twelve years ago when I was visiting the historic Hickory Hill property. I knew when I planted them that each tree had a fifty-fifty chance of being a female, but at the time the disadvantage of female ginkgo fruit seemed less important than the advantage of procuring free ginkgos. Second, although I usually have no use for pedigrees of any kind and find tree pedigrees especially silly (why should the progeny of a tree that grew on George Washington's property be any more valuable that progeny of a fine tree that grew elsewhere?), I'm intrigued by the history of my trees because I know their Asian origin. Their mother and father were gifts from the Emperor of Japan to Admiral Perry, who gave them to the notable landowner in my county, who planted them at Hickory Hill. To my knowledge, no one has created male clones of these particular trees, and it was just too easy to accept the offer of tiny seedlings growing under the parents.

And third, somebody's got to grow females if the species is to maintain its genetic diversity. (Male clones,

Although admired for its apricot color, ginkgo "fruit" is not so beloved as it rots. It emits the odor responsible for one of this tree's common names, "stink bomb tree."

grown from cuttings, have the exact same DNA as their male parent, whereas offspring grown from seed are a genetic mix of both parents.) Since the time I first planted them, I've also become aware of another problem associated with growing only male trees (a practice usually undertaken to avoid messy female fruit, not just of the ginkgo but of many tree species). The problem with growing exclusively male trees is that the more male trees we grow, the more pollen we are exposed to, and this is not a positive development for allergy sufferers. So now I can feel virtuous for doing what I wanted to do anyway, which was grow ginkgos of unknown sex from seedlings. And I hear you can avoid the worst of the female ginkgo fruit smell if you clean up the fruit quickly after it falls.

I'm now actually hoping I'm growing ginkgos of both sexes, so they can demonstrate, for me and for landowners who come after me, phenomena like the pollination droplet on the female ovule (which would be much easier to watch for in your backyard than across town) and the male "flowers" that produce the pollen that produces swimming sperm. Surely a yard with a mated pair of living fossils should be more valuable than a backyard with a ginkgo of one sex alone, although I'm not sure I'd want to be the real estate agent convincing prospective buyers of that when the yard is littered with "stink bombs."

RED MAPLE

Acer rubrum

February 14, a note in my journal: "This morning, encased in ice, were signs of spring—red maple buds littering the ground." And this on March 13 of the following year: "Today, on the shiny black road, broad expanses of red maple flowers. Cars make tracks through them as they pass."

The red maple flowers I observed on those days were brought down by weather, but I think squirrels sometimes detach them from the treetops as well. In early spring, the ground under a red maple is often awash in flowers, but it is the tops of the trees where these flowers make their most impressive show. Against a deep blue sky, illuminated by late afternoon sun, red maple flowers glow, and to overlook them is to miss half the beauty of this tree. Most people assume, because many wild red maples (and almost all cultivated varieties) have red fall foliage, that the tree is named for these leaves, but probably not. The red maple's flowers and its young twigs are more consistently red than its fall foliage, which can range from dull yellows and maroons to bright yellows, oranges, and reds. Probably the red maple's early spring flowers—small, red, and appearing in dense clusters before the leaves—led to the tree's name, not its leaves.

And what interesting flowers they are. When Bob first photographed them for one of our tree talks, he referred to them as "Las Vegas showgirls." They *are* extravagantly showy when you look at them up close, but like so many tree flowers, they are what horticulturists call "of little ornamental value." Translation: they are small. But even small flowers can be dramatic when there are thousands of them, and any tree that blooms in February or early March is worth fifty blooming in May. Red maples also have the advantage of being incredibly common trees, so you can view their flowers almost anywhere in the eastern United States. They grow from Nova Scotia south to Florida and west to Wisconsin. They are the most common tree in my state, and in many states their abundance is increasing, sometimes alarmingly so. Some ecologists are worried that red maple, which is an opportunistic species, may overtake the oaks and hickories that have dominated eastern hardwood forests for the past 10,000 years.

Whatever their ecological merits or demerits, red maples reward close viewing, and for many of us their flowers are one of the first signs of spring. Don't use them as an indicator that it's time to put your tender annuals out, however. According to biologist Joan Maloof (*Teaching the Trees*), they "bloom when night temperatures are still below freezing," and my observation of red maple flowers encased in ice is not unusual. Maloof describes red maples as "precocious"—in a hurry to do everything—and calls their early flowering a "clever strategy" to beat other tree flowers to the punch. Most eastern trees, she observes, flower in the summer, drop their seeds in the fall, and their seeds germinate the following spring. But red maples bloom early, drop their seeds the same spring,

RIGHT Clusters of flowers bedeck red maple twigs in early spring. These are female.

and germinate quickly. As a result, their seeds aren't exposed to the predations of animals that are looking for seeds to eat all winter long.

The red maple's early flowering provides other advantages, too. Maple flowers are pollinated both by wind and insects, and for wind to assist the pollen in moving from the tree's male flowers to female flowers, it helps that the tree's leaves aren't in the way. This preleaf flowering also makes the flowers highly visible, and why they aren't more often remarked upon is a mystery to me. Certainly there are plenty of opportunities to *see* red maple flowers. Not only are red maples widespread and abundant, they, unlike many other trees, flower when they are relatively young (as young as four years old), so their flowers aren't always terribly high above your head. These days there's even a website (Project Budburst) where you can track the progress of red maple flowering across the tree's range.

All red maple flowers, although small, are showy, but while some can be accurately described as "Las Vegas showgirls," others can't, because they are male. Some red maple trees are male (bearing primarily male flowers), some are female (bearing primarily female flowers), and some are both male and female (with flowers of each sex appearing usually on separate branches). As if to hopelessly confuse the issue, some individual red maple flowers can exhibit traits of both sexes. All this complexity may seem daunting until you become familiar with red maple flowers, but once you can tell male from female flower parts, it just makes red maple flower viewing more interesting.

With the naked eye, you can distinguish male from female red maple flowers (or flower parts), but you'll increase the "wow factor" of your viewing dramatically if you use a loupe or other magnifying device in your observations. Flower parts that look intriguing to the naked eye become startling when magnified. Look for winter buds containing red maple flowers near the ends of the

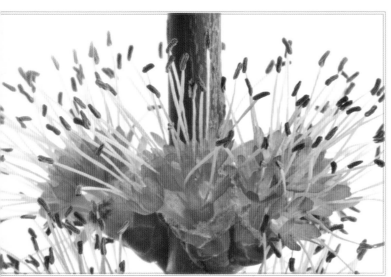

TOP LEFT Anthers emerging from immature male red maple flowers look like tightly packed hot dog buns (although they're tiny and red!).

LEFT Dark brown anthers top pale filaments that rise above the petals and sepals of clustered male red maple flowers.

RIGHT The male flowers of red maple are attractive to the naked eye, but they are spectacular under magnification.

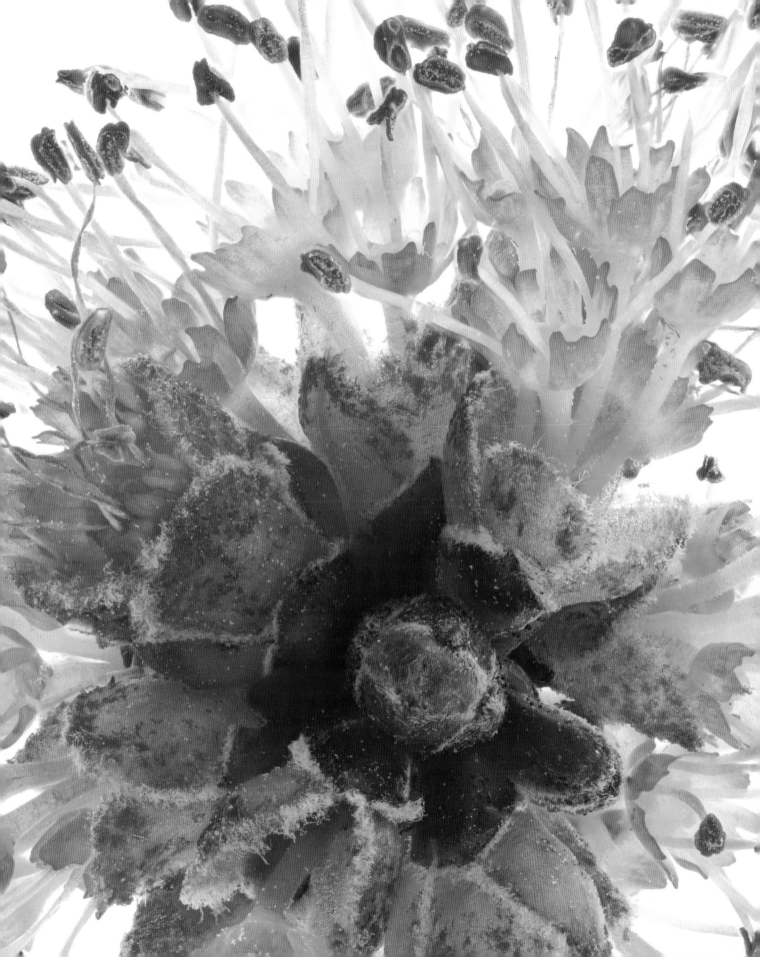

tree's twigs, where, unlike leaf buds, they are clustered in tight groups. Within each of these buds are several flowers, whose parts you can begin to see as the bud scales start to open. Depending on the weather, red maple buds in my region begin opening in late February or early March, about the time the spring peepers start peeping. The first parts of male flowers you may see, nestled inside the opening bud scales then protruding slightly above them, are the tightly packed anthers—velvety red "sacks" shaped like miniature hot dog buns. These will rise on pale, yellowish white stalks (filaments) as the stamens elongate. The anthers become yellow when covered with pollen, dark blackish brown after the pollen is released. At maturity, male red maple flowers appear quite yellowish, making it possible to distinguish some male from female trees at a distance, but remember that even the colors of the female flowers vary from scarlet reds to brickish reds with a yellow cast, so I wouldn't bet the ranch on telling a male from female red maple from afar.

As female red maple flowers open, the first thing you will see are the curved, antennae-like stigmas that protrude above the bud scales (four to five pairs per winter bud). On some red maples they are a ruddy red, on others a brilliant scarlet. As the female flowers mature and other parts of the structure protrude above the rim of the bud scale, they begin to look more and more like

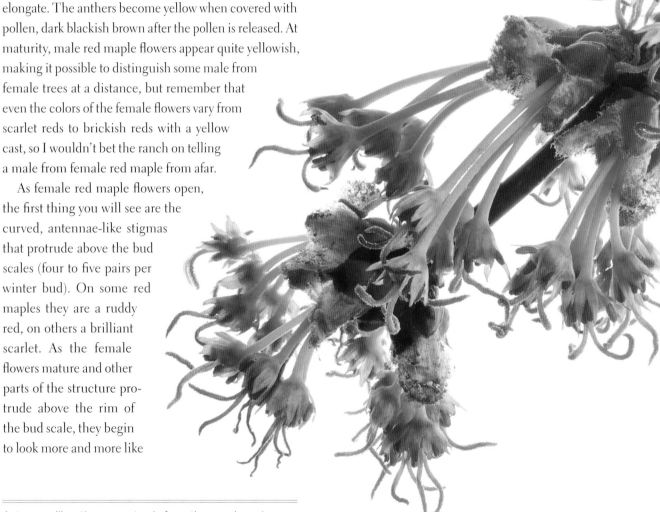

Antennae-like stigmas protrude from these red maple flowers. At this stage, the flowers' elongated stalks (pedicels) are green; they get redder as they mature.

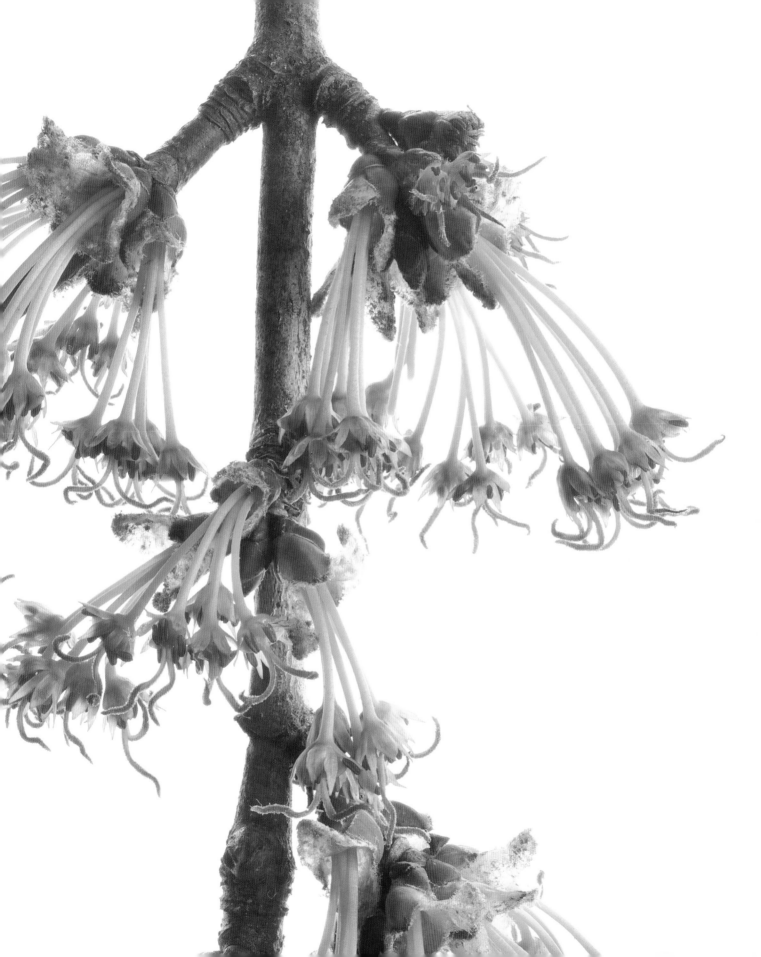

recognizable flowers, with red sepals and petals forming a cup on long, slender flower stalks. After the female flowers have been pollinated and fertilization has taken place, you'll notice a tiny pair of "wings" emerging from inside each flower's corolla. Soon these expanding winged fruits are recognizable as the familiar maple "key"—the seed structure that many of us refer to as a helicopter. If you like the shape of the maple key (and most of us do), you'll love these miniature versions, particularly when they are less than a half inch wide and dangling, newborn red, from the fading flowers.

As they continue to mature, you'll find clusters of light brown to reddish helicopters dangling on long, slender stems at the ends of the red maple's branches. At least you will, if the tree is female, or has some branches that bore female flowers. On a tree-viewing walk through a parking lot one day, I noticed that every flower on every tree there was male, and I now assume those trees, all cultivated varieties of red maple, had been selected partly because they were male—hence no helicopters to litter the premises. Too bad, because maple helicopters are the one form of tree debris that most people seem to enjoy. We like their shapes and we like the way they twirl.

Before they split, which they usually do before they fall, the red maple fruit is a double-winged affair with two bulges in the middle where the seeds are. The shape of each half reminds me of a tadpole, and, up close, their venation makes them look embryonic (although the true tree embryo is hidden inside the seed). Ripening from late spring to early summer, these winged seeds often fall during a one- to two-week period from April through July. (I can expect showers of them

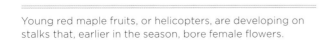

Young red maple fruits, or helicopters, are developing on stalks that, earlier in the season, bore female flowers.

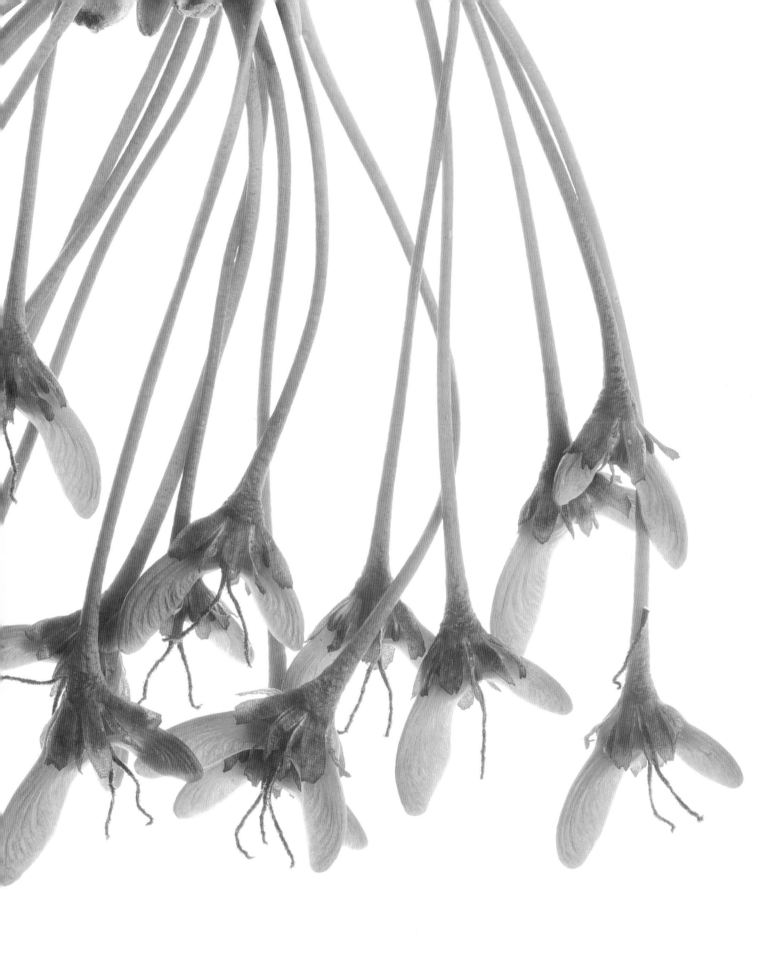

around April 15 in my neighborhood.) Because of the way they twirl, we call them whirligigs and helicopters, and their impressive flights have even been studied by NASA scientists. You can find technical explanations of why maple keys fly the way they do on the Internet, but suffice it to say that their rotations have to do with their asymmetrical construction, their center of mass, and their center of lift. This intriguing design evolved, of course, not to entertain us but to get the maple seeds where they need to be, which is far from the parent tree. Landing under your parent is not a good thing for a tree seed, since there it would have to compete with the well-established parent for resources.

Later in the year, red maple has other attractions, including reddish green resting, or winter, buds. In late summer, you will already find these buds, which will open as flowers or leaves the following spring, gathered in the leaf axils. By September, where I live, each bud is about half the size of a peppercorn, and clusters of these buds, which will remain on the trees all winter, are appealing not only because of their visual interest but because they are so future oriented. A friend once complained to me that when she used red maple winter twigs, complete with resting buds, in a garden club flower arrangement, her arrangement was disqualified because dried material was not allowed. She tried to explain to the judges that her twigs weren't dead, they were just sleeping, but the judges wouldn't budge. That's too bad, because a fresh red maple twig loaded with resting buds is not just alive, it deserves a blue ribbon.

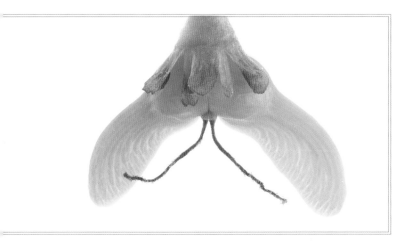

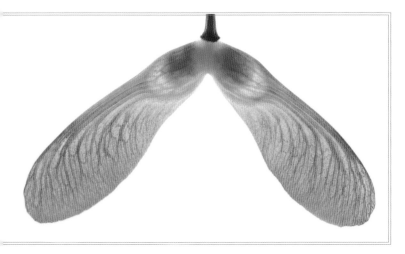

LEFT (Top) Immature red maple fruits, or helicopters, still have their antennae-like stigmas attached. (Bottom) As they mature, red maple's winged fruits develop seeds near the base.

RIGHT Red maple leaves have a wide range of fall color, not just red.

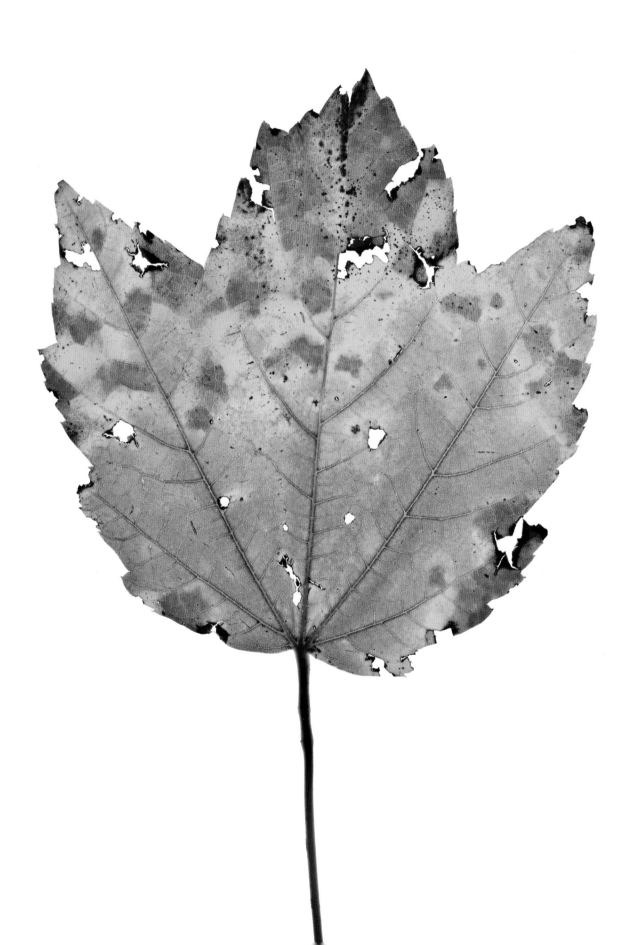

SOUTHERN MAGNOLIA *Magnolia grandiflora*

"Yankees would kill to have this tree," plantsman Michael Dirr writes, describing the southern magnolia. He's probably right, and featuring this southern tree may be unfairly tantalizing to New England readers, but Yankees have the white birch and Robert Frost, which, taken together, may be an equally valuable birthright. Besides, many magnolia species with features as compelling as those of the southern magnolia grow north of the Mason-Dixon Line, and this description is as much about learning to see a familiar tree in new ways as it is about a particular tree.

Features we southerners prize in the southern magnolia include this tree's size, its dark, shiny, evergreen leaves (some with brown, felt-like undersides), and their huge, white, fragrant flowers. Many a southerner can tell you about a treasured magnolia climbed on by generations of kids in the same family, and some heritage magnolias loom as large as the memories associated with

them. I once visited a prized southern magnolia with a 400-foot perimeter. That one had lost its original trunk and had sprouted a forest of new stems underneath, but single-trunked southern magnolias can get enormous, too. When we complain about our magnolias, it's usually because of their thick, waxy leaves, which blow across the lawn and seem to take forever to decompose. (Now there's a subject for investigation: put a specific magnolia leaf in a place where it will stay put outdoors and see how long it *really* takes to decompose.) We treasure our magnolia leaves for decoration, though, and many of us take pride in recognizing their idiosyncrasies. As a flower arranger, I have been known to turn up my nose at a bucket of magnolia foliage whose posture or color I didn't like, because, particularly with trees grown from seeds, the foliage can vary from anemic green and gangly to almost black and gracefully positioned on the stem.

It is the flowers, which perfume late spring and early summer nights, that southern magnolias are most famous for, however. With their 8- to 12-inch petals, southern magnolia flowers are among the largest flowers native to North America, and for tree flowers, they are gargantuan. Their size is one of the characteristics that reveals their ancient lineage. Plants identifiably belonging to the Magnolia family existed 95 million years ago (a mere 92 million years or so before people), and primitive flowers like the magnolia's were among the first flower types to appear on earth. Pause here to ponder "primitive." For another writing project, I once spent many weeks trying to find out exactly what, besides size, was so primitive about magnolia flowers. Botanist friends explained several characteristics to me in terms I only partly understood, and by the

time my writing deadline arrived, I felt comfortable saying only that evidence of the magnolia's ancient lineage could be found in "the structure of the flower's reproductive parts and in their large size and shape, designed to attract beetles and flies, rather than bees and butterflies that evolved later."

A week later, the Rosetta Stone of magnolia flower explanations landed in my lap. On page 3 of May Theilgaard Watts's classic *Reading the Landscape of America*,

RIGHT The southern magnolia cone (technically a follicetum) turns shades of blushing pink in early fall.

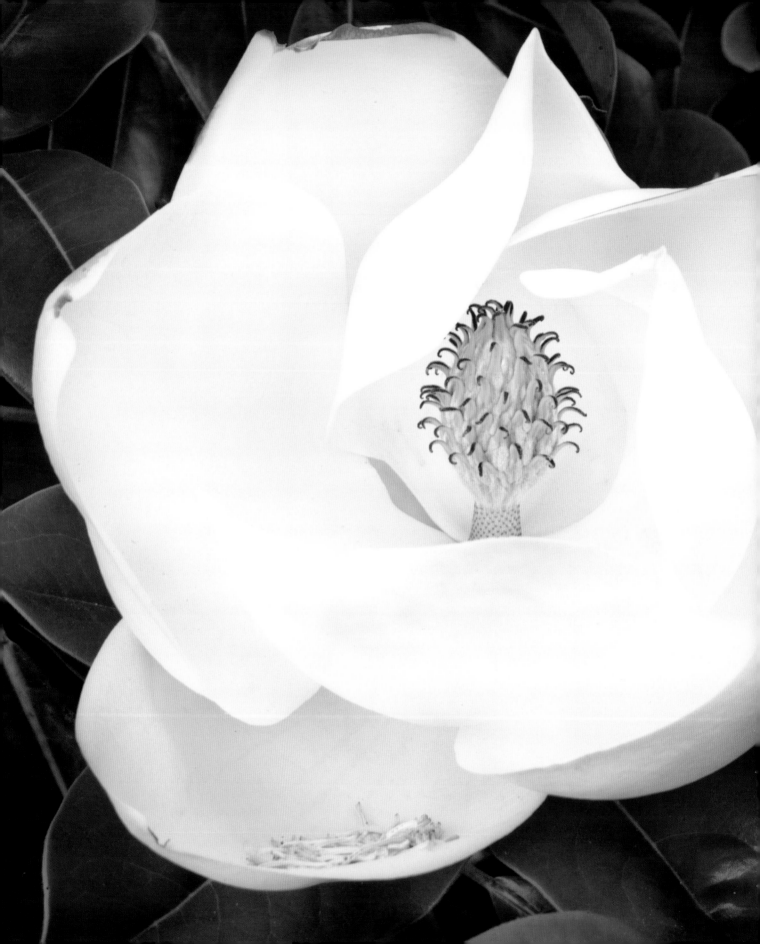

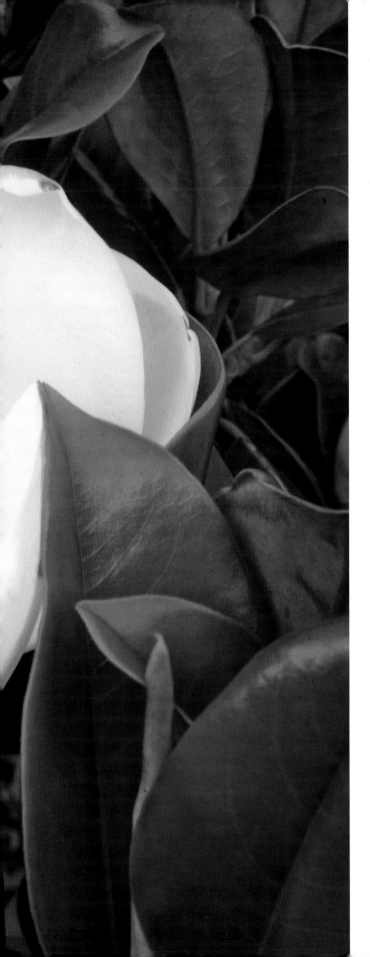

there is a drawing entitled "A Floral Antique." Pictured there was a drawing of the umbrella magnolia flower complete with labels describing the flower's primitive features, contrasting them with more modern adaptations. And this book, first published in 1957, had been sitting above my desk, unread, for years. A word about umbrella magnolia (*Magnolia tripetela*), because it is the magnolia Watts features. It, like the big leaf magnolia (*M. macrophylla*) and Virginia magnolia (*M. virginiana*), can be grown, and found in the wild, farther north than southern magnolia. If, then, you live north of where southern magnolia grows (the warmest parts of USDA Zone 6), try examining the umbrella, big leaf, or Virginia magnolia, because their reproductive structures are similar to those of the southern magnolia. Depending on the species, magnolia flowers can vary from 3 to 12 inches wide, and their decorative cones—some a beautiful red blush color—can vary from egg-shaped ovals to bumpy cucumber shapes.

A drawing in Watts's book highlights eleven primitive features of the magnolia flower. Here are three: the flower is a wide-open bowl, not a tube with a narrow entrance (the latter developed later to help route pollinators to the sexual parts of many flowers); the petals are separate, not united along their sides (petals of more modern flowers tend to be united along their sides); and the flower's seed-bearing parts are held in the cup of the flower instead of forming a swelling below the other floral parts. Other primitive features of the magnolia flower include its large number of stamens and pistils. As if to prove that "when the student is ready the teacher appears," all this information came not only accompanied by an illustration but couched in the words of a naturalist who was as much poet as scientist. May Watts described her encounter with

Large in size and reputation, southern magnolia flowers get lots of attention, but many of this flower's subtle details, like the way its discarded stamens collect in its cupped petals, are often overlooked.

umbrella magnolia in the Great Smoky Mountains in this way: "As I stood at the side of the hard modern road by the shiny modern automobile, and cupped the moonlight of the magnolia flower in my two modern prehensile hands, the warm June dusk around me seemed to brighten to a warm dawn—the dawn of flowering on the young earth. I could imagine the plash of broad reptilian feet behind me, and could pretend that I was seeing what no man ever saw, one of Nature's first experiments in producing a showy flower."

Until two years ago, I knew only three stages of the southern magnolia flower. One was the bud (a very graceful flame-shaped affair), one was the open bloom ("conspicuous enough to please the nearly blind," wrote garden writer Henry Mitchell), and one was the fruit structure (technically called a follicetum but popularly called a cone). Magnolia cones, which turn a blushing pink to rich reddish brown in the fall and have red or orange bean-sized seeds, are favorites of flower arrangers. I had also seen the amazing way the flowers' shiny, brilliantly colored seeds were attached to the cone—by stretchy

BELOW As southern magnolia flowers develop, curly stigmas emerge from the top half of the floral axis as strap-like stamens develop below.

RIGHT Curly stigmas and the hairy covering of southern magnolia's ovaries are clearly visible in this close-up.

RIGHT BELOW This magnified view reveals the sticky surfaces of southern magnolia stigmas, which help capture pollen.

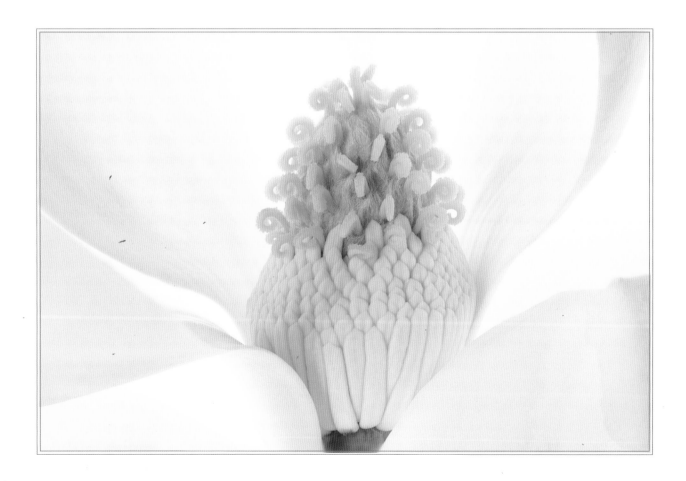

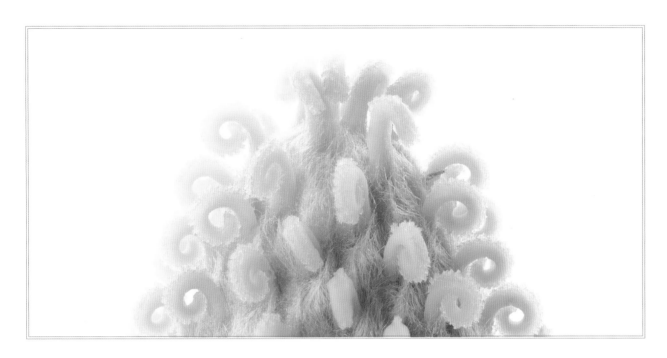

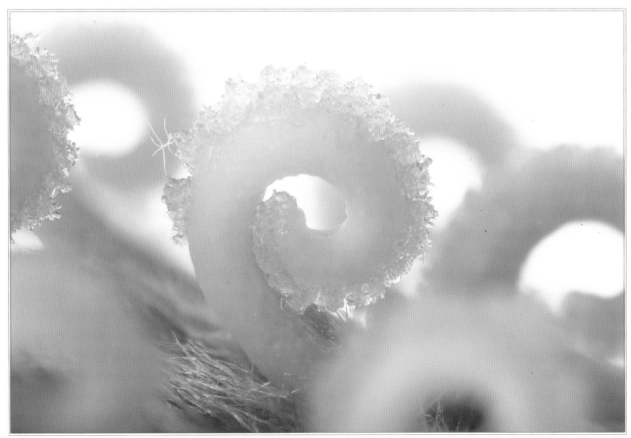

threads that you could pull out almost like taffy. And I had noticed that sometimes these threads allowed the seed to dangle and sway in the wind, effectively offering themselves to birds and small mammals. If I had seen what happened between those stages, it hadn't registered.

So, I started looking. I will be able to describe what I saw in botanical terms only because I consulted an expert who hybridizes magnolias and I visited several relevant websites that gave names to what I was seeing. I can't underestimate the importance of both activities, because having someone to corroborate what you are seeing helps you see more. Here are highlights of a magnolia flower maturation process that takes all summer to unfold.

As the magnolia's petals (technically tepals) turn brown, they seem to want to protect the developing cone. They collapse onto themselves and sometimes form a cup

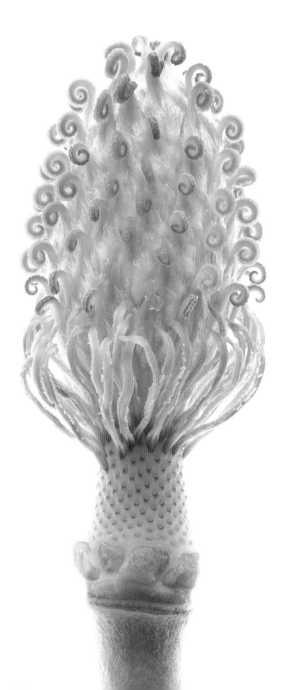
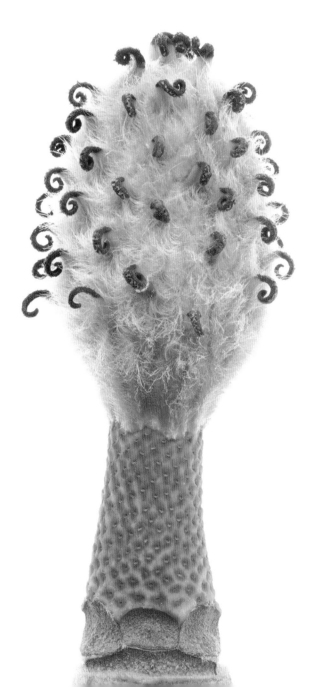

around it. If you peek inside, you find some insects are still working there, and not one of them is happy about your intrusion. After most of the petals have fallen off, there is often one aging petal—sometimes two—folded over the top of the developing cone. It sits there like a beret and gives the cone a jaunty appearance.

The southern magnolia cone varies in size and appearance, depending on how mature it is. In mid-July, the cones on my tree are about 2½ inches long and shaped something like a rabbit's foot. The surface of each cone is woolly but soft as silk, and it has the texture of a quilt, because it is divided into chambered sections. At the top of each section (or carpel) is a tiny, dark brown hook, which is the remains of the stigma, or female part of the flower. The cone sits on a column to which the flower's stamens (male parts) were once attached. Pink, maroon, or brownish dots mark the spots where these strappy white appendages (the stamens) once clung to this column. As they fall off, the stamens often collect in a clinging concave petal below, forming a pond of white-to-brown discards.

Below the stamen column are dark, woody-looking petal scars where the petals have fallen off, and below the petal scars is a handsome pedestal (peduncle) about 1 to 3 inches high. This pedestal, which on my magnolias is covered with a downy, cinnamon-brown pubescence, is so uniform and chiseled-looking it looks machine-made. Taken together, the woolly cone, the polka-dotted column, the woody petal scars, and the chiseled pedestal seem so finely crafted and artistically combined, they look like they belong in a museum case somewhere. I pick one and keep

it on the kitchen table where scores of visitors, southerners all, find it stunning but have no idea what it is.

And this is just the beginning of what takes place on the tree. As the cone grows, the carpels (chambers in the quilt) swell, getting fat as the seeds inside develop. Finally, the carpel splits down the middle, folds back, and, like a woman releasing a baby through the birth canal, the seeds with reddish orange coats are expelled. Watch this

LEFT A developing southern magnolia cone (follicetum). (Left) The flower's curly stigmas are golden brown and some stamens are still attached. (Right) The flower's curly stigmas are dark brown and all stamens have dropped.

RIGHT Southern magnolia seeds are released from the tree's cones on taffy-like threads.

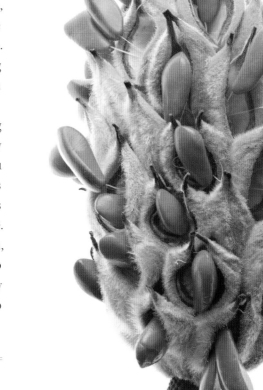

process closely enough and you'll begin to feel like a parent in the delivery room, almost overwhelmed by the miracle of it all.

And the big miracle of the magnolia seed birthing is accompanied by other impressive events as well. In the course of all this watching, there were days when

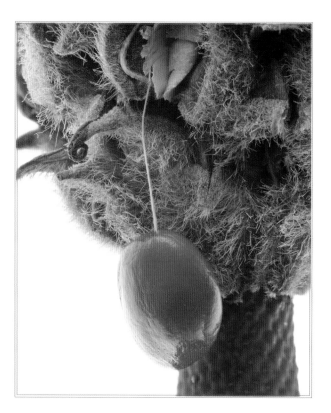

I watched in the rain and the sound of the rain on the magnolia leaves was as percussive as the rain on a tin roof. There was the day when the sound of the cicadas and the smell of the magnolia flowers blended into one synesthetic summer stew. And there was the day when the sound of one leaf falling, from the top of the tree to the bottom, reminded me of a pinball machine, as the leaf bounced off first one branch, then another, then another, in its interrupted passage to the ground.

And finally, my favorite magnolia event is something to look for after a rain. Sometimes, under a southern magnolia, you will find a leaf that has curled up with its underside on top. On my trees, these undersides are a cinnamon-brown that turns coffee-brown when wet. As rainwater pools in such a leaf, it forms a puddle so dark it looks like liquified mahogany. It is the richest brown I have ever seen. Like magnolia pods, these little leaf pools are fun to bring inside, where they last for days, drying out and getting paler only gradually. Small and temporary as they are, these leaf pools impress me no less than the grand flowers and stunning seedpods of these massive trees. If the southern magnolia is an epic poem—grand, steeped in history, and dramatic—these little leaf ponds are haiku—small but astonishingly profound.

LEFT Close-up of a southern magnolia seed on a thread.

TULIP POPLAR

Liriodendron tulipifera

First, a confession: for twelve years, I have wanted to cut down a tulip poplar in my front yard. Most of the time, I experience it not as a tree but as a conduit for water being sucked out of my garden. Because of the way it is situated in the landscape—hemmed in by the house, a power line, and stands of other trees—you can't really see anything but its trunk (and, if you look straight up, the underside of its canopy). Unlike my next door neighbor's tulip poplar, which has some branches that pose gracefully outside my second-story window, the tulip poplar in my front yard grows as most forest-grown tulip poplars do—with a trunk that shoots 50 feet straight up before its first lateral branch appears. True, it contributes to the leafy canopy sheltering my home (and provides all those ecological services, like cooling in summer, for which we value trees), but mostly I experience it as just a greedy pole.

Its litter is what reminds me it's a tree. I was making some headway in convincing my husband (and myself)

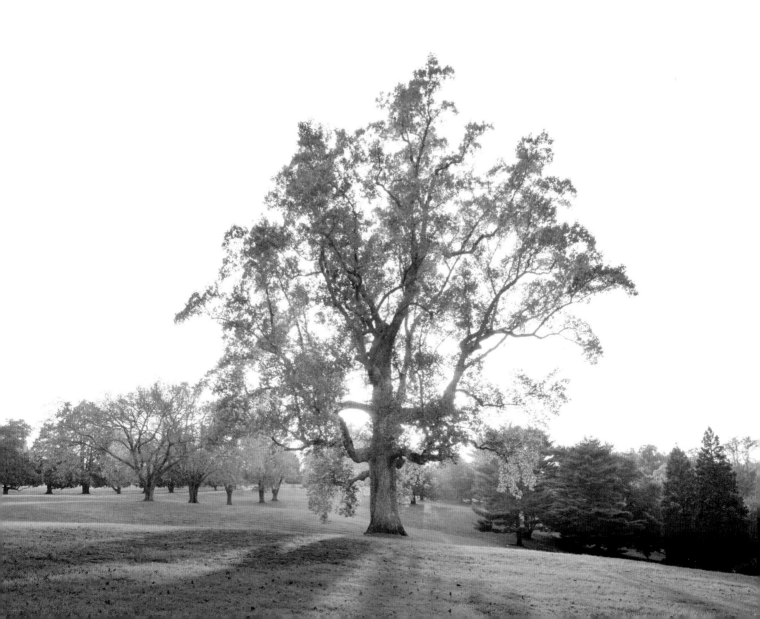

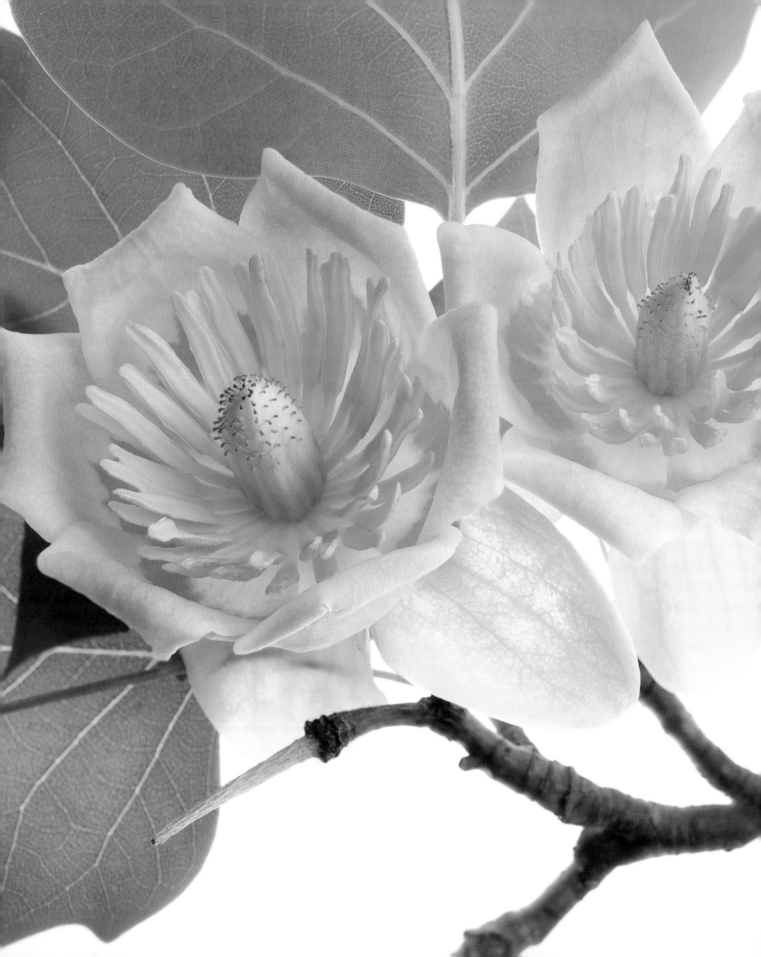

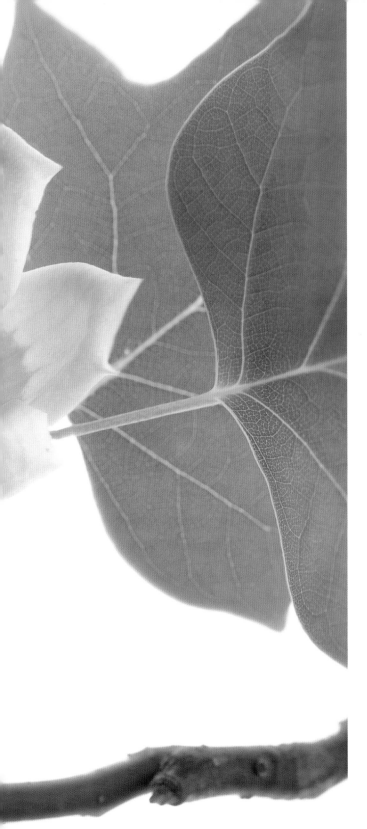

that our tulip poplar should be removed one April when I first noticed some of its flowers on the ground. Tulip poplar flowers often come down with stalks and leaves attached, making a cushy landing with their flowers standing straight up. I know squirrels love tulip poplar buds, which is why you find so many of them, half-eaten, on the ground, but why these whole flower-laden twigs come down, I don't know. Anyway, as if to make a point to a disgruntled gardener, these flowers often land, presumptuously, in the garden, where, lo and behold, they look gorgeous. Late one April, one even landed in the birdbath I'd positioned at the base of my tree, where it looked, for all the world, like a yellow and green water lily. A more romantic soul would have taken this as a sign the tree was pleading for its life, and the thought crossed my mind, but the truth is, for a tree-hugger, I'm pretty hard-hearted. Instead, my tulip poplar held its ground not because it successfully seduced me with a floral offering but because it was big, it would have been difficult (and expensive) to remove, and I, the tree lady, would have been embarrassed to remove it. Like other trees spared for equally unpraiseworthy reasons, this one continued to put on rings despite the fleeting preferences of a human being.

Oddly, despite my ambivalence toward this particular tree, I've always loved tulip poplars in general, and I would argue that they are one of the most rewarding species to watch. Because the species is widespread in the eastern United States and its flowers and leaves are so unusual, it's one of the first trees children are introduced to in grade school, but there is more to this tree than Miss Jones probably told you. The "packaging" of the tulip poplar bud is even more intricate than I indicated on page 83. In addition to being held behind a pair of stipules (leaf-like flaps) that look like praying hands, the embryonic

Two showy tulip poplar flowers and the woody axis of the previous season's cone (lower left) appear on this twig.

tulip poplar leaf is folded first like a valentine (down its midrib) then over (with its stalk bent and its apex pointing down). It looks like something ingeniously packed into a flat-rate postal box. Behind that first folded leaf is a series of additional leaves and stems nested like Russian dolls, and a stack of them coming out in the spring—first one folded leaf, then another and another from a stack of clasping stipules—creates an appealing pattern.

Among the easiest tree buds to recognize in winter, the tulip poplar's fat, green terminal buds (as well as its lateral buds) turn from bright green to a dark red, and some of them have a smoky white coating that makes them look as if they've been sprayed with a powdery antiperspirant. The species is also distinguished by big, almost round

leaf scars punctuated with scattered bundle scars. And if you can find a sapling tulip poplar (or a tree with low, young twigs), you'll discover its smooth bark is marked with highly visible lenticels (white dots indicating the locus of air exchange). Such twigs have a really nice fragrance—sort of a musty menthol—if you abrade the bark with your fingernail.

Tulip poplar leaves are famous for their shape—with four major lobes (pointed sections) and a depression instead of a tip at the end that makes them look saddle-shaped. Their iconic shape (the one illustrated most often) is also reminiscent of the shape of a tulip flower, but tulip poplar leaf shapes vary more than most people realize. The leaf shapes vary somewhat on the same tree, and, more significantly, in different parts of the country and within different parts of the same region. In fact, there is a different array of tulip poplar leaf forms characteristic of trees growing in the mountains, piedmont, and coastal plain. Some tulip poplar leaves are squarer than others, some have more pronounced lobes than others, some have more points along their margins, but they are all a smooth, uniform green, with a lustrous upper side and whitish underside.

Because they have long petioles (leaf stalks) and lots of surface area, tulip poplar leaves flutter dramatically in the wind. This fluttering may have inspired the tulip poplar's common name, which connects it to the unrelated, but even more fluttery leaved, true poplars. What I find most compelling about tulip poplar leaves, however, is their fall color. The fall foliage of the tulip poplar is often

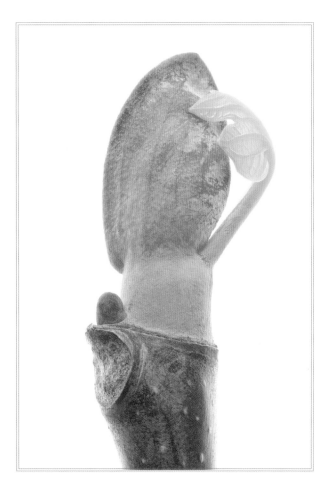

LEFT A nascent leaf emerges beside a tulip poplar terminal bud.

RIGHT This one small tulip poplar twig presents half a dozen interesting features. Look for (from bottom to top) a leaf scar, a stipule scar, a small brown lateral bud, brownish stipules (curling back), a large green terminal bud, and a newly emerging leaf. The stipules protect the terminal bud over the winter.

described as "buttery yellow," but to my mind there is a mix of colors, not a single color, that gives the tulip poplar its characteristic fall look. In late summer and early fall (especially if the summer has been dry), some tulip poplar leaves are half golden yellow and half deep, rich brown, while others are still entirely green. This mix gives the tree a patterned look, like an old-fashioned calico print. And even later in the season, and in wetter years, it is a mix of yellows and browns, not yellow alone, that communicates tulip poplar to me.

Tulip poplar flowers are extraordinary, too. For one thing, for forest tree flowers, they are huge. You just don't expect to see 1¾-inch flowers on a common, temperate zone tree that grows to be 100 feet and sometimes 200 feet tall. One wag has pointed out that the tulip poplar's assets—height and showy flowers—cancel each other out, since you need a bucket truck to see the flowers in the crown of a 100-foot-tall tree! Most forest trees in the temperate zone have smaller, wind-pollinated flowers, whereas the large flowers of the tulip poplar (a member of the Magnolia family) attract pollinators. Because the genus to which the tulip poplar belongs, *Liriodendron*, was wiped out in Europe and many other parts of the world during the ice ages, the tree, with its impressive flowers, made quite a splash when it was reintroduced to Europe in the mid-1600s. Seventeenth century plant collectors begged New World explorers and colonists to send them this tree, and when the species (*L. tulipifera*) first bloomed again in England (in the garden of the Earl of Peterborough), we are told "visitors came from far and near . . . to admire its beauty."

In addition to the fact that it is large for a tree flower, the tulip poplar flower is noteworthy for its color and structure: six green to light yellow petals with dramatic orangey red splotches near their bases, three sepals that gracefully curve back below the petals, and, inside the cupped petals, a circular rank of over thirty strap-like stamens surrounding a dense, brushy-looking column

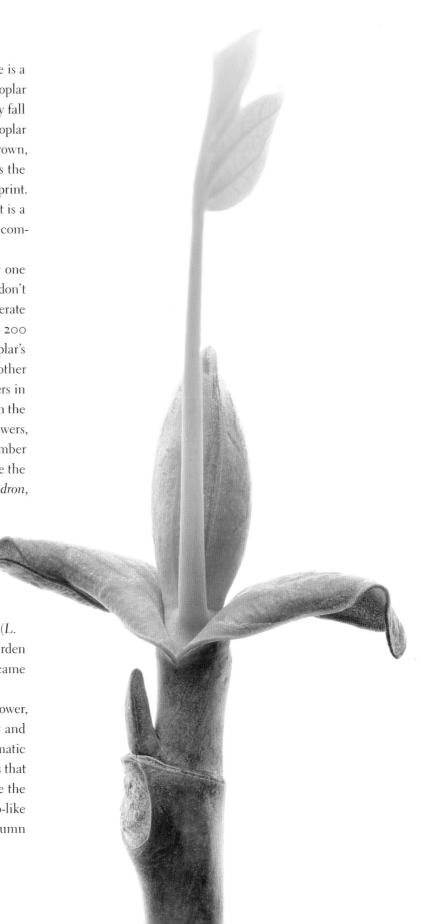

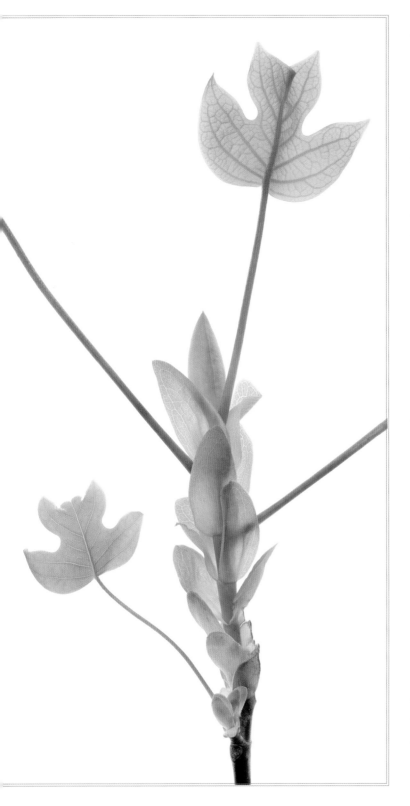

of pistils. This arrangement is quite attractive to the human eye, and, fortunately, to flies, beetles, honeybees, and bumblebees, because the tulip poplar needs these insects to pollinate its flowers—and it needs them to do it in a hurry. From a USDA publication, I learned that pollination of the tulip poplar flower must occur soon after the flowers open, "while the stigmas [sticky tops of the pistils] are light colored and succulent; brown stigmas are no longer receptive to pollen," and that normally the receptive period is only "twelve to twenty-four daylight hours long." It seems this tree puts a lot of energy into a big show with a very short run.

Look for tulip poplar flowers between April and June, then look for the cones (technically samaracetums) that follow them. These aggregates of winged fruits, called samaras, are about 3 inches tall and 1 inch wide, are shaped sort of like a shaving brush, and they change from green to light brown as they mature. On each fruiting structure, the seventy or so samaras are arranged like overlapping blades around a central axis, and, in fall and winter, you will see them in varying stages of "whole-ness" in the tops of the trees. They often look like flowers themselves when they have dropped all but their lowest samaras and the remaining ones surround the central axis like petals. Even after all the samaras have fallen and been dispersed by wind, the cone's pointy central axis is highly visible in the tops of the trees. And you'll find twigs bearing remnants of tulip poplar cones, including the woody central axis, on the ground fairly frequently.

One could argue that, in winter, tulip poplar's cones are showier than its flowers were in spring. Certainly they are more visible because they are not obscured by leaves and they stay on the trees longer, for several months.

LEFT Among tulip poplar traits to look for are the leaves' long stalks and the tree's leaf-like stipules, which persist for a while on young twigs.

RIGHT Look on the tulip poplar winter twig for resting buds, almost round leaf scars, and encircling stipule scars.

Miss Jones really should have told us about these cones, because they make tulip poplars extremely easy to identify in winter. And because there are so many tulip poplars growing along highways in eastern North American woodlands (as well as in other temperate parts of world, to which they have been introduced), there are millions of people who could be recognizing these trees on a regular basis, if they only knew them by their fruit.

There are hundreds, sometimes thousands, of cones in the tops of large tulip poplars, and when the light strikes them, the trees light up like candelabra. The tan blades of tulip poplar samaras seem to be inordinately reflective, and perhaps because of the low angle of winter light, they really do shine like candles. My husband and I like to hike on December 31 (a great way to end the year), and we get as much of a rush from the light in the tulip poplars as some people do from the neon lights in Times Square.

Although people tend to overlook them, the tulip poplar's windborne seed structures (its samaras) are interesting after they've separated from their cones, too, and when you become alert to them, you'll discover how commonplace they are on the ground. In January, I ran into one, just one, in front of a Hampton, Virginia, lecture hall, and I actively searched for the parent tree but I couldn't find it. Books say they can travel 600 feet in the wind, but this winged seed must have traveled farther. Earlier, in November, Bob reported that they were piling up on his sidewalk, and at my home 100 miles away, a December snowfall brought them down en masse. In fact, they were like tree shadows on top of the snow.

Each blade-shaped samara is about 1½ to 2 inches long, with an angular, pinched-looking protuberance at the end, and it is in this end that the seed resides. If there is a seed inside. I once casually tried to pry a tulip poplar seed out of its winged blade with my fingernail, only to wind up in an involved, weeks-long correspondence with a botanist as I tried to figure out why I could find no seed. A preamble to a sample e-mail: "Nancy—I've been mulling over the tulip poplar seed problem. A few days

ago I picked up a branchlet with several samaracetums that had fallen onto the sidewalk just outside the Science Center door. How convenient. I've cut several of the samara basal regions apart with a razor blade, and all from the batch prove to be sterile." It seems that very few tulip poplar samaras contain viable seed (only about 10 percent). And although no one has confirmed this for me, I think this low fertility rate must have something to do with how short a time the flowers are sexually receptive.

As I searched for seed in tulip poplar samaras, I had another hypothesis about why I could find none. "If it's ripe, it's gone" is the message inscribed on a popular napkin for gardeners, and surely the birds that take tulip poplar seeds in winter had already scarfed up most of the fertile seeds? This idea led to some further investigations into which birds actually eat tulip poplar seeds. Books said purple finches and cardinals were the principal users, but why had I never seen a cardinal, Virginia's state bird, eating a tulip poplar seed, abundant as both were around me? My chagrin at not having seen this was reinforced by a blog entry I found on the Internet. Frederick Atwood of Fairfax, Virginia, wrote, "A wing of tulip poplar seed drifted down. Since I had heard a purple finch calling as it flew over earlier, I looked up into the tall tulip poplar hoping for a purple finch. But instead, three house finches and a cardinal were up there silently manipulating the seeds with their tongues and beaks to extricate the little bit of food from inside." Now I'm *really* eager

BELOW Aggregates of winged seeds arranged like overlapping blades around a central axis characterize the cone (samaracetum) of the tulip poplar.

RIGHT Wind disperses the winged, single-seeded fruits of tulip poplar.

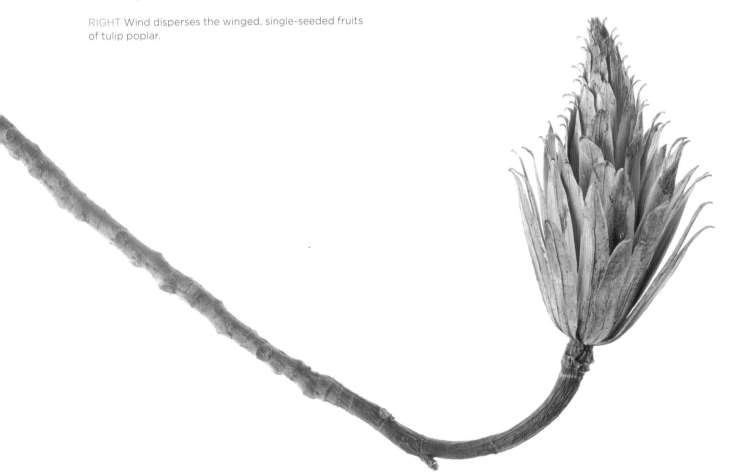

to see a cardinal extricating a tulip poplar seed! And it is urgings like this that keep the world charmed for tree observers. I imagine this tableau of a cardinal eating tulip poplar seed is commonplace in my neighborhood, but it has the value of a rarity when you haven't seen it yourself.

And finally, two other important tulip poplar observables are bulk and bark. Tulip poplars have the genetic potential not only to get tall but also to get fat: the largest tulip poplar trunk in the nation is over 9 feet in diameter. And in Virginia, there are more tulip poplars in the woods, by volume, than any other tree. This is the tree Daniel Boone made a 60-foot canoe out of and the tree Charles Frazier, in *Cold Mountain*, described as putting you in mind of locomotives set on end. The tree that launched my career as a tree chaser was a tulip poplar in Bedford, Virginia, (another behemoth over 9 feet in diameter), that I had to drive 155 miles and play hooky from my job to see. A tree over 9 feet in diameter does not disappoint, especially if you are by yourself and have to search the woods for it. (Unfortunately, that tree lived to see itself surrounded by a subdivision and chain link fence.) On a favorable site, tulip poplars grow fast, so a big tulip poplar may not be inordinately old (the Bedford tulip poplar grew near a girth-enhancing spring), but this is a species that breaks the norm of fast growth being correlated with short life. The tulip poplar's average age at natural death

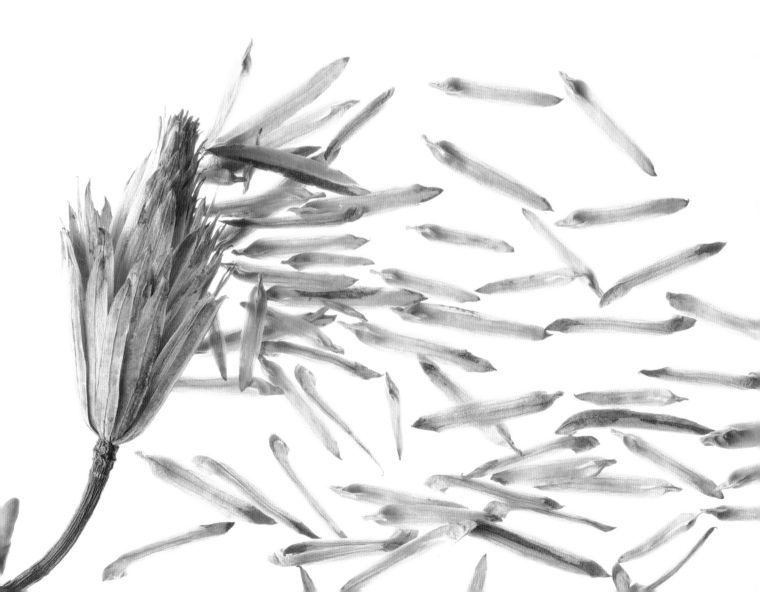

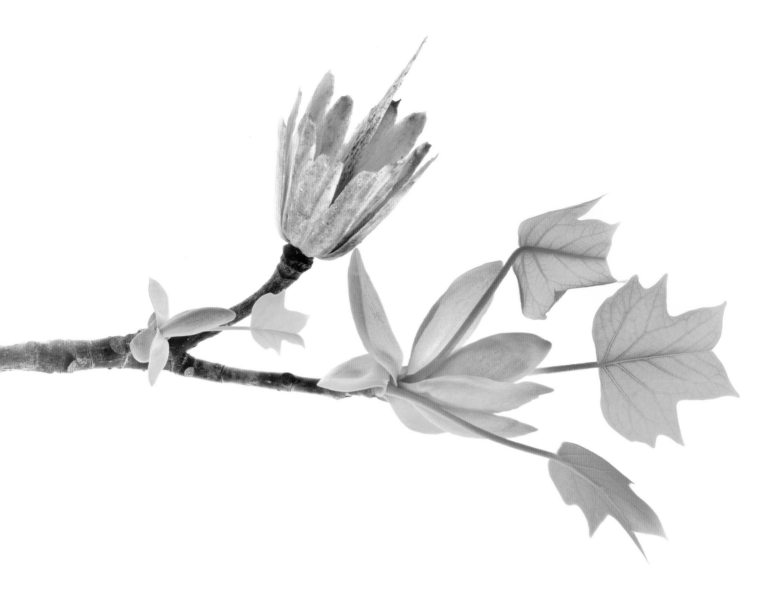

is 200 to 250 years, and some individual trees may live to be 500 years old. Such a long life is really unusual for a tree species that also has this said about it: you have to stand back after you plant it so it won't hit you on the chin as it grows!

One way I've learned to tell whether a tulip poplar is old is by its bark. I write about this with some trepidation because I've not seen this characteristic discussed anywhere in print and I am far from an expert on tree bark, but here's what I've seen. When my husband and I visited the legendary tulip poplars in North Carolina's Joyce Kilmer National Forest, I was struck by what I thought was vandalism to their lower trunks. Because of its bald,

pockmarked appearance—places where it seemed bark had been removed—I thought visitors (aka vandals) had been taking away pieces of these trees' bark. Later, when I saw some almost equally old (but better hidden) tulip poplars in Shenandoah National Park, I noticed similar pocked surfaces on the lowest portions of their trunks and realized this must be a characteristic of old tulip poplars. This piece of lore gleaned from personal observation meant more to me than lots of what I've learned from others. Imagine, then, how thrilled I was to be walking through a friend's garden—attending to ground-level plants, not the trees—when my eyes registered "old tulip poplar." I had spotted that characteristic pocked bark

near the base of a big trunk, and, sure enough, when I looked up, there were the saddle-shaped leaves of the tulip poplar.

Which brings me back to the tulip poplar in my front yard. In an effort to see what others see in tulip poplar tree bark, I took a closer look at my underloved tree's bark. I find most published descriptions of tree bark totally unhelpful (they say "deeply furrowed" but compared to what?), but I found something that looked really helpful in *The Sibley Guide to Trees*. Sibley wrote that the tulip poplar's "mature trunk has distinct chiseled ridges with paler furrows" and provided a useful illustration. Those paler furrows seemed unmistakable, so I went outside and took a look. On the north side of my tree, which I examined first, the furrows were not only not paler than the ridges, but they seemed darker (could this just be a consequence of being on the shady north side of the tree?), but when I walked around to the south side of the tree, there they were: furrows clearly lighter than the ridges, and not only that, as I proceeded around to the west side of the tree, the ridges began to take on that ropey look visible in the Sibley illustration. Toward the bottom of the west side of the trunk, the ridge pattern became much more like herringbone, and then at the very base of the tree, near my prized *Sarcococca hookerana* (sweet box), I noticed a hint of the bald, pocked look I'd come to associate with old tulip poplars.

Soon after this discovery, someone told me to check out the tulip poplars in a yard several houses away, and there the same pattern repeated itself, only on bigger trees with more deeply furrowed bark and

more blue-green lichen on the north and east sides. The base of one tree, over 5 feet in diameter, was so bark-bald at the bottom it looked like an old-growth tree. In fact, this neighbor's yard, which I'd never before explored in its entirety, boasted an impressive grove of old tulip poplars, and the homeowner told me her Victorian house had been built in the 1890s from the wood of tulip poplars harvested on the property.

Suddenly my tulip poplar seemed like a member of an indigenous tribe—too young to be a sibling of my neighbor's trees, but quite likely a relative. And although this particular tulip poplar is still far from a favorite of mine, it seems more valuable, for its long-term connection to this landscape, than most anything I could grow beneath it.

LEFT Remnants of the previous season's cone (samaracetum) often still cling to tulip poplar twigs as new leaves appear.

RIGHT There are strap-like stamens and a greenish column of pistils in the center of the tulip poplar flower. The column of pistils will develop into the samaracetum, or cone.

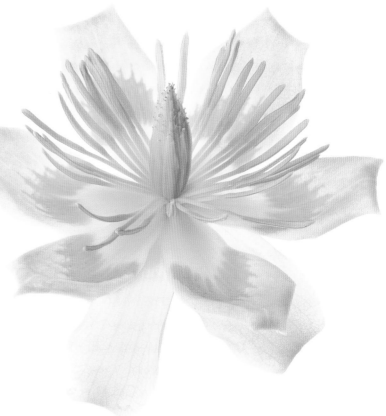

WHITE OAK

Quercus alba

"I am working, working, working," said the poet in answer to his children, who wanted to know how he was spending all those quiet hours in his room. Those words, from a poem by Paul Zimmer, came back to me as I lay in a hammock, swaying under a white oak, looking up into its limbs. "I am working, working, working," I might have said, since I was dutifully observing a white oak from a new vantage point. No one observing me would have believed it, but I was actually working on improving my tree observing. Few disciplines involve hammocks, but I had found a righteous reason for spending more time in mine.

It had occurred to me that to really appreciate a tree one should spend more time experiencing the world the way it does, which means holding still. I wanted to see my oak's acorns ripening, experience its rooted constancy,

RIGHT Although only a single leaf still clings to this twig, many oaks, including white oaks, retain many of their leaves through the winter.

and examine the many visitors to its limbs, bark, and leaves. Not all of that did I accomplish, but what I did see was remarkable enough to turn me into an evangelist for tree-watching from the perspective of a hammock. Looking directly up into a tree is entirely different from looking at it from the side. It changes not only your perspective but what you can see. And observing from a position flat on your back is as humbling as praying on your knees. "This is what it must be like to go snorkeling," I thought on my first day of such tree viewing, because in the presence of this tree that I had known, I thought fairly intimately, for thirty-six years, I saw phenomena that seemed as new to me as exotic fish. I also experienced the height of my tree the way snorkelers must experience the ocean depths, only the shock was more profound since these phenomena had been right under (actually above) my nose for decades.

There is too much to tell relative to what I've seen from my hammock, but many of my most lasting images and impressions involve bark, ants, spiderwebs, and weather. A wonderful British book, *The Natural History of the Oak Tree*, will alert you to hundreds of the birds, moths, beetles, bugs, spiders, other invertebrates, fungi, mushrooms, toadstools, lichens, and mosses that occupy an oak tree, and while the species may vary where you live, the general categories are relevant. When you think of the inhabitants of an oak tree, think not of a small community but of a metropolis like New Delhi or Tokyo, because the tree is teeming with animal inhabitants, many of them too small or too well hidden to see, but some, like the ants, quite visible. Ants will use you and the ropes in your hammock as new commuter lines to their tree destinations, but most interesting to me was the way they navigated tree bark. Watching them travel up and down the bark highways on my tree's trunk (and

To appreciate the bulk and bark of a massive white oak, look up into its branches rather than straight at them.

into and out of its crevices) helped me see the trunk's varied topography much more clearly. I have probably read a hundred descriptions of white oak bark, descriptions using words like "irregularly platey" that do little to create visual images for me, but following an ant up the trunk of a white oak is like tracing a three-dimensional bark image in your brain.

Through binoculars, the exterior of my old white oak looks like a living landscape, with blue-gray lichens and emerald-green mosses growing like ground covers along its horizontal branches. There the bark is layered almost like stratified rock, with inch-high gaps creating caves between some layers. The overhanging bark functions as awnings, providing shelter to butterflies, roosts for bats, hiding places for spiders, and protection for moth cocoons. I've yet to see a bat emerge from a roost under this bark, but I know they are there; I see them fly at dusk. On other parts of the tree, including its two main trunks, there are smooth patches where the bark is as gray as ash, turbulent areas where the bark pattern has been disturbed by a wound, and flaky areas where the bark is so loose and ragged it looks like ruffled bird feathers.

While bark-watching, I have seen sunlight and dew illuminate thousands of seldom seen strands of spider silk strung among these trunks and branches. It's not that at one moment you can see these silken threads well and then you can see them poorly; it's that at one moment they exist and then, given the evidence of your eyes alone, they don't. In fact, the best web I ever saw in this tree appeared for only about 30 seconds. For those 30 seconds, it was as clear as a bell—attached by guy wires to the two main trunks, its delicacy in contrast to the posts to which it was attached reminded me of Philippe Petit's wire strung between the Twin Towers. The web itself was only about the size of a small frying pan, but for a few seconds, in late afternoon light, some of the radial silk threads took on an otherworldly metallic gold, green, and blue glow. Then the light changed and the entire web was gone.

Lying below and looking up into the top of my white oak, the tree seems both taller and more massive than from any other perspective. I can actually see into the very top of the tree and am impressed with the way its structure (and some expert pruning) have allowed every branch its space. It's as if there had been an understanding among the branches: OK, you're going there, I'll go here, and the same for most of its leaves and twigs. I am struck by the responsiveness of the top of the tree to the slightest breeze—it's another ecozone up there—and by the sound of the wind (actually of the many different winds) in its canopy. For pure drama, one of the most exciting shows to watch under a white oak occurs during the prelude to a thunderstorm, when the wind picks up and the leaves rage. How the top of the tree can move so wildly and the lower trunk remain so implacably immobile is a mystery. Of course, hanging out under a tree during a thunderstorm is not wise, but during what may have been the most violent thunderstorm this tree has ever experienced, I was nearby under a protective roof and watched as one of its two main trunks moved ever so slightly. This was about twenty years ago, and I knew at the time I was seeing something highly unusual. No hint of motion have I seen in the lower part of either trunk again.

Not just viewed from my hammock but from any vantage point, it's clear that my oak is old and probably in decline, but there's an adage I keep in mind when speculating about a white oak's death. White oaks, which can live 600 years, are said to be 200 years growing, 200 years living, and 200 years dying, so even if my tree is in decline, it may stand a long time. Like everyone else who shares space with an enormous white oak, I speculate about its age, but it wasn't until I had time to think about it in my hammock that I did the math and realized that it is possible that my tree was growing before the first

Newly emerging white oak leaves range in color from buff pinks and dull reds to powdery greens.

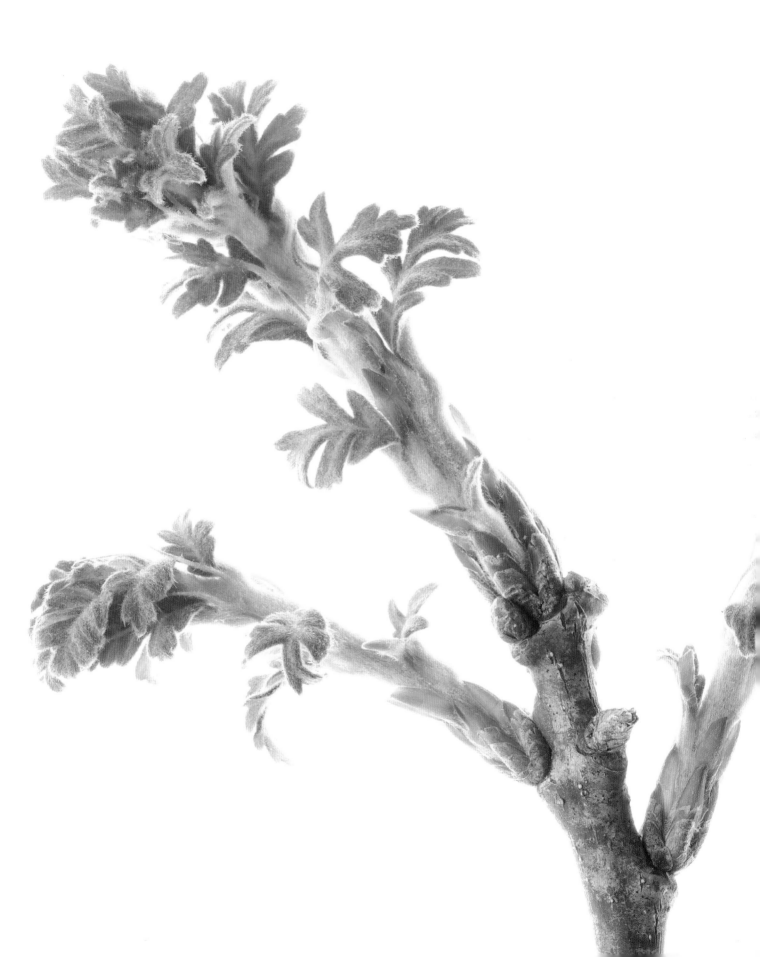

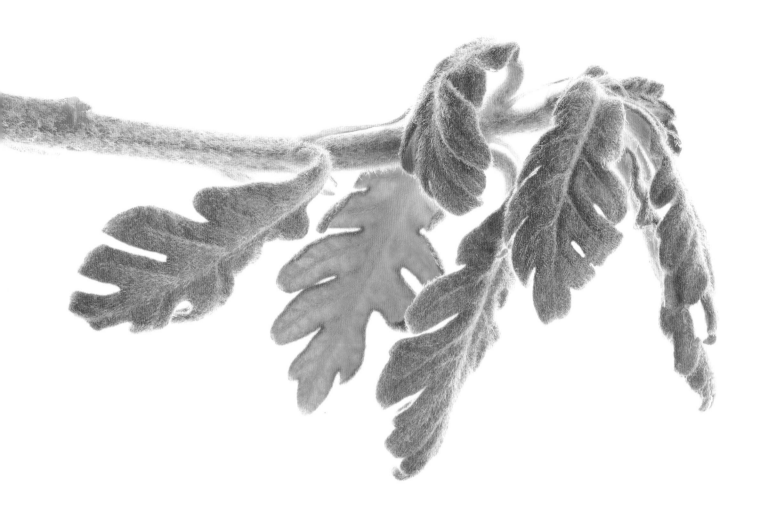

Englishmen settled in Virginia (1607). It's probably not that old, but even if it is only 100 or 200 years old and lives only another fifty years, surely it deserves some sort of recognition for living through just the traumas I am aware of—droughts that turned the red clay in our county to dust; infestations of tent caterpillars that required it to put out two sets of leaves for successive springs; hurricanes Camille, Agnes, Juan, Isabel, and that unnamed thunderstorm that made one of its massive trunks tremble. Travelers marvel at European cathedrals that took hundreds of years to complete and that have survived the vicissitudes of history, but in many of our own neighborhoods are living trees that have survived as long with little or no recognition.

Among shade trees, white oak (*Quercus alba*) is, to my mind, the most valuable. Not only does it have the potential to live an especially long time but its shape is that of the quintessential sheltering oak. When grown in the open, many white oaks grow as tall as they are wide, 80 to 100 feet, and the result is a very wide-spreading tree with a beautiful dome-like crown. Because they get so big, they require lots of space: ¼ to ½ an acre. I cringe when I see someone plant a small, short-lived tree in a space that could have accommodated a white oak. Even though

Young white oak leaves have a soft, hairy pubescence that helps them retain moisture.

their range includes most of the eastern United States, there aren't many places large and protected enough to accommodate a white oak throughout its long lifetime, and it's a shame to waste such places on small, short-lived trees. As a person who has planted a white oak 30 feet east of where it should have been planted and who rues that decision almost every day, I would suggest placing a white oak with the care and attention you would give to locating a new city; given all the life forms that will inhabit the oak, this is not unlike what you are establishing. And it's equally wise, when considering taking down an old oak, to understand how much you'd be destroying. To appreciate the implications of taking down a tree, read W. S. Merwin's essay "Unchopping a Tree," in which the narrator provides heartbreaking instructions for rebuilding a tree, including reattaching all its nests, twigs, and mosses, only to conclude that such a structure, unlike a real tree, would be so unstable the motion of clouds might topple it.

Other white oak attributes worthy of special interest include its leaves, flowers, and acorns. White oak leaves are among the easier tree leaves to recognize. They alternate along the stem, are usually 4 to 10 inches long, and have five to nine rounded, finger-like lobes and wedge-shaped bases. In spring and summer, the leaves are a flat green to blue-green on top and a paler, whitish green underneath (although if you are looking up into them from the perspective of a hammock, they'll be backlit by the sun and appear to be shades of vibrant yellow green). While not noted for their fall color, some white oaks turn rich fall colors, including wine reds and brick oranges, before turning brown, and many hold their old brown leaves through the winter and into early spring. In the middle of March, when the red maples are in full bloom, most of the old leaves are still on many of my white oaks.

I find the white oak's brand new leaves the most beautiful, though. As they emerge, white oak leaves are miniaturized versions of their adult selves and range in color from buff pinks to dull reds and powdery greens. Because they are covered with fine hairs, which they will lose later, they have a soft, cottony texture and are irresistible to touch. But the purpose of the fine hairs on a baby white oak leaf serves the tree not the toucher. Botanists depict one of the key functions of the leaf as an exchange in which the leaf must spend water to buy carbon dioxide. It is to the tree's advantage for the leaf to spend as little water as possible in the transaction, and the fine hairs on a baby white oak leaf (or any leaf) help slow water loss.

Another interesting thing about oak leaves is that they manufacture tannin as they grow and this makes them less tasty to, and digestible by, most caterpillars. In *The Natural History of the Oak Tree*, David Streeter describes the way caterpillars must time their hatching to the emergence of oak leaves because if they hatch too early, they will starve. If they hatch too late, they may also starve, since the leaves will be too tough and full of tannin to eat. I can report that the tent caterpillars in my neighborhood seem to have gotten this timing down pat, because some years they almost completely defoliate my Buckingham County white oak, requiring it to put out an entirely new set of leaves. Gypsy moth caterpillars, scourge of oaks but as yet not epidemic where I live, also emerge early (but not as early as some other caterpillars), and I am told they are somewhat tannin tolerant.

As white oak leaves are emerging, it's also time to start looking for flowers. They appear on the same tree but in separate inflorescences. The male flowers, which are clustered along tassel-like catkins, are easiest to see and they appear first. My journal notes remind me that on April 3 of one year, the yellow-green catkins on a young white oak in my yard (not the one above my hammock), were 1 inch long and still pointing upward, and the leaves at that time were ½ inch long. By April 16, the catkins on the same tree were 3 to 4 inches long and dangling; its leaves were about 2 inches long. The tiny flowers lining the male oak catkin soon mature, shed their pollen, turn brown, and fall to the ground, where they often collect along sidewalks and roadsides and turn bracken brown.

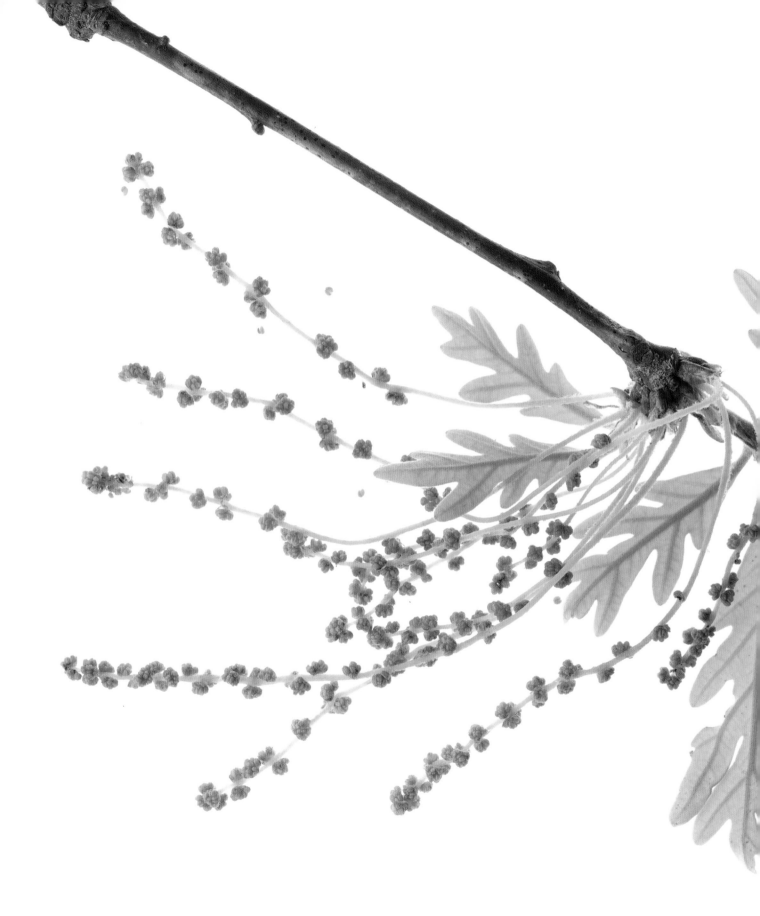

Female white oak flowers are much harder to spot, at least until after they've been pollinated and have begun to resemble acorns. But if you really want to get intimate with this tree, you will want to see the female white oak flower prior to pollination. Unfortunately, this phenomenon wasn't visible from my hammock, because the few flowers my old white oak produces are too high. Instead, I found flowers on a branch of a young white oak right at eye level. (If you want to watch white oak flowers mature into acorns, I'd suggest you mark them with a bright-colored piece of yarn or string, because the bigger the leaves get, the harder it is to find the specific flowers or acorns you want to watch.) As with the male flowers, the time to look for female flowers (which you can assume are blooming when the male flowers are shedding pollen) will vary depending on your latitude and altitude. The range of blooming times usually listed for white oaks growing in the eastern United States is late March to mid-May. I can expect to find female flowers blooming on white oaks in mid-April in central Virginia (when petals and flowers are falling from nearby tulip poplars), but even in the same backyard, some white oaks produce flowers earlier or later than others.

The first visible signs of female flowers are yellow-green blobs with reddish markings emerging from axils of new leaves. In two or three weeks, these blobs (usually two or three of them) will have extended outward from the branch on green stalks about ¾ to 1 inch long, grown into orbs about ⅛ inch in diameter, and developed a textured surface reminiscent of the scales on an acorn cap (at this stage they are actually rings of bracts at the base of each flower). At the top of each orb is a protrusion that looks like the tied-off portion of a balloon, and from this protrusion extend the dark, brownish black stigmas that received male pollen. About a month later (early June, where I live), each orb looks downright acornesque,

Male white oak flowers dangle in tassel-like catkins.

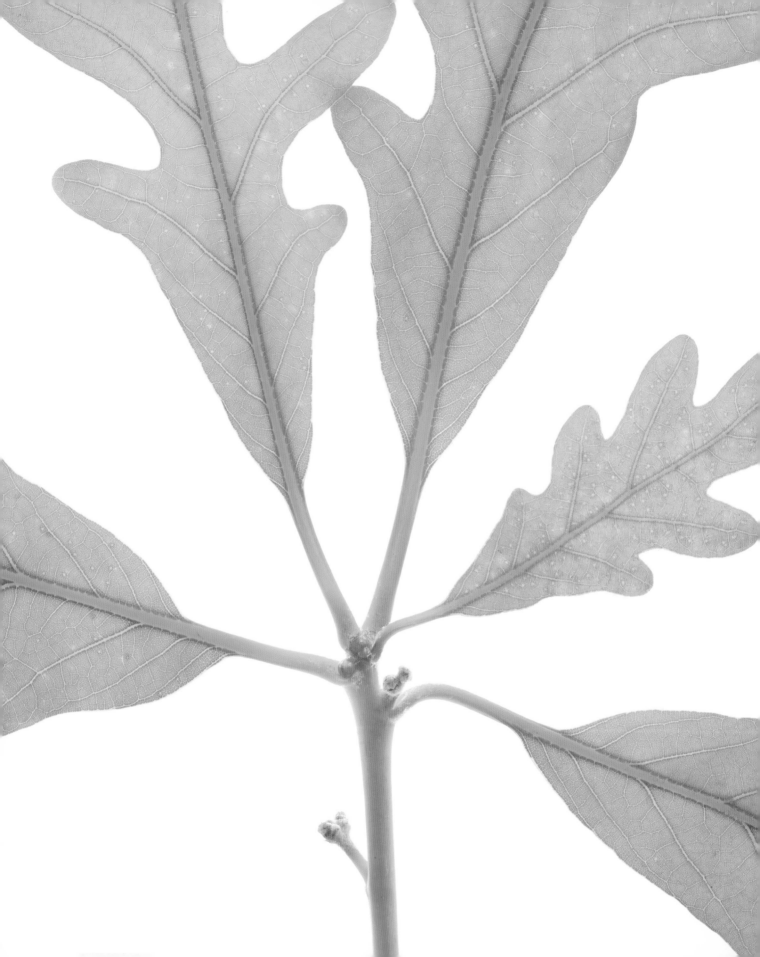

covered as it is in pale green scales with brown markings and sporting a tiny point (remnant of the flower style) in the middle, but it has a rather flattened shape, like a tire lying on its side. Most clusters include two to three acorns, each about ⅓ inch in diameter, but some runts will be aborted. Over the summer, the robust immature acorns continue to grow, the runts shrivel up, and by early fall the growing acorns have become more oblong, with

FAR LEFT You'll need to look carefully to spot white oak female flowers among the leaves.

BELOW LEFT This close-up shows female white oak flowers emerging from the axils of new leaves.

BELOW As white oak flowers mature, you will begin to see rings of bracts reminiscent of the acorn cup scales they will become.

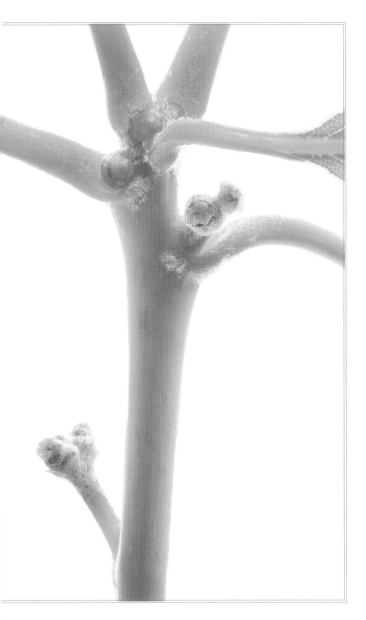

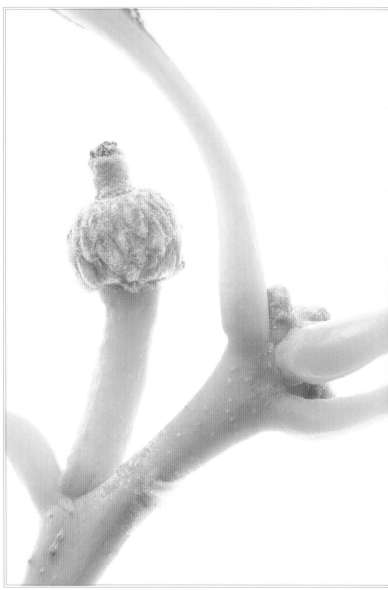

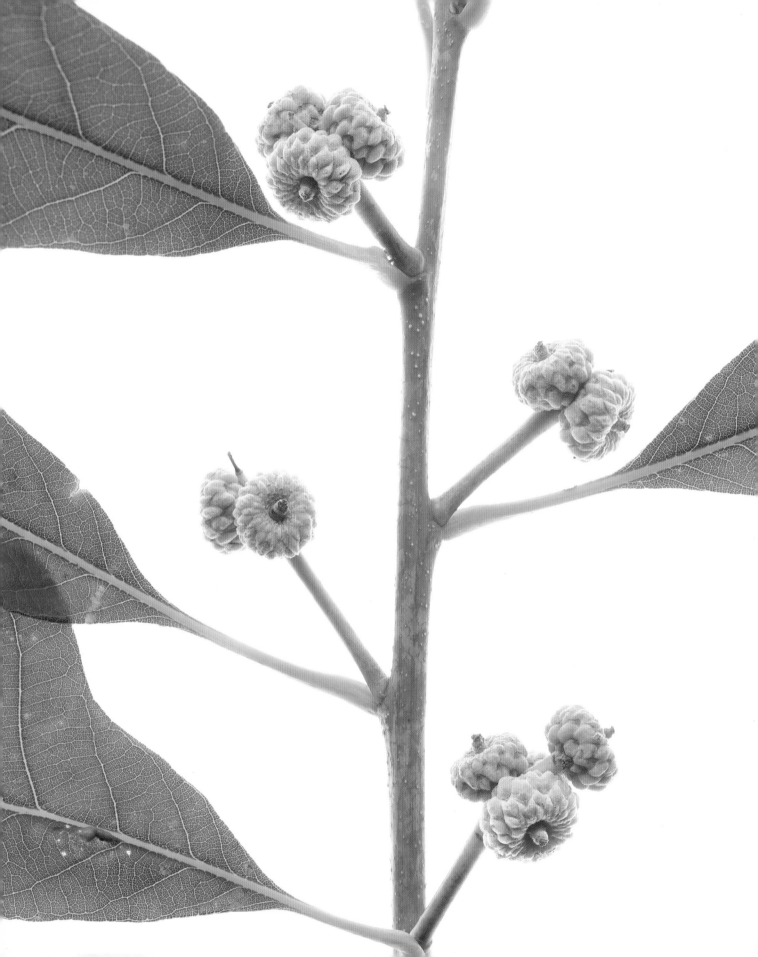

green nuts showing above their greenish tan to brown caps. Before falling in September or October, the nuts will have turned a light brown and their caps will cover only about a quarter of the nut. They are relatively small (¾ inch) but sweet, nutritious, and relished by all sorts of animals who scarf them up almost as soon as they fall. In fact, scientists say light white oak acorn crops are often almost completely destroyed by animals and insects, and it's only in years of heavy acorn production that white oak acorns survive to germinate.

In addition to flowers, nuts, leaves, and bark, the white oak tree has dozens of other attributes one might observe up close, but two that routinely grab my attention are its galls and unusual twig breaks. Galls are abnormal growths that oaks (and other plants) develop in reaction to the presence of certain insects. Tiny gall wasps are responsible for most oak galls, which provide food and shelter for the developing larvae. Galls often appear on leaves and twigs, where they seldom hurt the tree but look strange and worrisome enough to stimulate people into fits of unnecessary spraying. The wool sower gall, which often appears on my white oaks in spring, is a spongy white mass about the size of a ping-pong ball. Its furry surface, dotted with brownish red splotches, reminds some people of a toasted marshmallow. Inside are small seed-like structures in which the larvae of nonstinging wasps less than ¼ inch long develop. Oak apple galls, which look like round sacks (first green and pliable, then brown and papery), are also familiar to most oak observers. They, too, are caused by tiny gall wasps, which bore holes through the surface of the mature galls to escape.

Under my massive white oak, and under other oaks, including post oaks, in my neighborhood, I also find twigs with strangely broadened areas where they have detached

from the tree. The twigs, usually about 6 to 18 inches long, come down in spring and summer bearing green leaves and later in the season bearing brown leaves or no leaves. Almost every oak twig I pick up under my white oak has this unusual, pancake-like "spread" at its base. This is not normal abscission, I concluded years ago, and I have asked dozens of experts for explanations, none of which seemed to fit. I do not think this is the result of cicada egg laying that has weakened the twig, nor does it exactly fit the damage patterns of longhorn beetles. Among the latter are twig pruners and twig girdlers that leave characteristic mandible marks and egg niches that

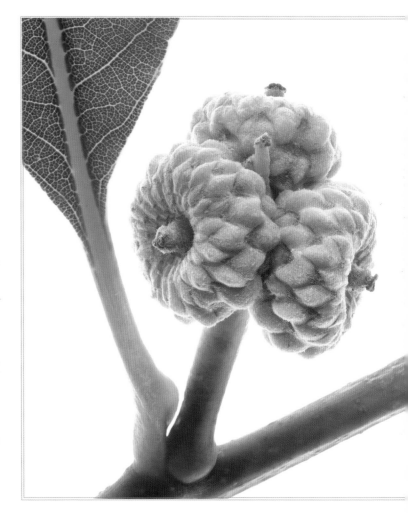

By early summer, the developing white oak acorn looks a little like a treaded tire. The nut itself isn't visible. By late summer, the green nut will have expanded to the point that the acorn cap covers about half its surface.

don't seem to be present on my twigs. The twig pruning doesn't seem to hurt my tree, and it's possible it helps. In *Late Night Thoughts on Listening to Mahler's Ninth Symphony*, Lewis Thomas describes the incredible relationship between a beetle that searches out mimosa trees in which she lays her eggs, then girdles the twig on which they reside so the emerging larvae will have dead wood on which to feed. That mimosa-beetle relationship is interesting in itself, but even more interesting is the fact that, according to Thomas, the mimosa lives decades longer with this pruning than it would live without it.

I have no idea whether my oak has such a relationship with an insect, but especially now that I have my binoculars and viewing platform in the hammock, you'd better believe I'm on the lookout for insects laying eggs in my oak twigs. It's one thing to have your questions answered by experts, but it's an entirely more satisfying thing to have them answered by your own observations, so I continue to look, look, look.

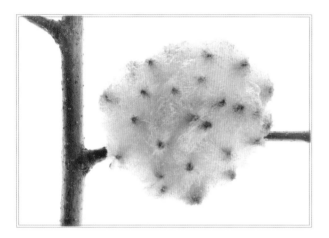

The wool sower gall often appears on white oak twigs in the spring.

WHITE PINE

Pinus strobus

"How few attend to the ripening and dispersing of the white-pine seed!" wrote Thoreau in *Faith in a Seed*, and he explained one of the reasons why: White pinecones are in the tops of the trees, and climbing until one can reach "the dangling green pickle-like fruit" presents challenges like figuring out how to hold onto the tree trunk with one hand while holding the cone in the other and how to cast down one's booty when it wants to stick to the pitch on your fingers. "It is the stickiest work I ever did," wrote Thoreau.

I'm almost embarrassed to reveal how clean my white pine investigations were. Yes, I got pitch on my fingers when handling pinecones and branches, but my journey to the top of a white pine was downright antiseptic compared to Thoreau's. I viewed it from a third-story window in the Science Building at Randolph-Macon College, where I discovered I could peer almost directly into the top of one young, but cone-bearing, tree. There, with the aid of a pair of $1500 binoculars (borrowed), I viewed the female "flowers" and immature seed cones of the white pine. "Rarely seen, even by students of plant life" is the way Walter E. Rogers (*Tree Flowers of Forest, Park and Street*) characterized white pine "flowers," and in this case, the lack of seeing is understandable, because,

to borrow another phrase from Thoreau, the female cone-flowers of the white pine are "well-nigh inaccessible to man."

The "flower" of white pine is definitely a phenomenon worth looking for, but just the process of figuring out what it is, where it is, and how to best view it will teach you a lot about white pines (not to mention where the best pine-top viewing stations are). *Flower* is a word that most botanists don't apply to conifer reproductive structures (conifers present their ovules naked to the world, without the ovary wall of a true flower), but many naturalists do refer to these structures as flowers, and, although they are tiny, the immature seed cones of the white pine certainly look floweresque. My first encounter with them was in a photograph on the Internet, then in an ancient publication of the U.S. Department of Agriculture in which V. M. Spalding (1899) described the "purplish rosy lips of the erect pistillate cone [of the white pine]." I just had to see those rosy lips.

White pines, and in fact all pines, have separate male and female cones on the same tree. The male cones (technically strobili) are usually in the lower part of the tree's crown, but most people wouldn't recognize them as cones. The female cones, which are usually in the upper part of the crown, take two full growing seasons to mature, and at maturity look like the brown woody structures we all recognize as cones. Young white pines (five to ten years old) can produce cones, but you're more likely to find cones on trees twenty to thirty years old, or older. In central Virginia, the time to look for male and female "flowers" (or flowery, developing cones) is late April or early May (later than the same structures appear on other pines), when new shoots (candles) are also emerging. In more northern climes, I'm told they appear in early June. The male cones resemble Q-tips or, as their pollen sacs swell and their axes elongate, miniature ears of corn. Collections of these ¼- to 1-inch oval to cylindrical structures look at first like miniature pineapples, with around thirty-five tightly packed tan cones arranged spirally around a central axis and a ruff of new needles (like the leaves of a pineapple) extending from the top.

Over time, the male cones' pollen sacs swell, split open, and release pollen to the wind, and the yellower with pollen they become, the more flowery they look. Unlike the female cones, these male cones don't persist on the tree; they elongate, spill their pollen, turn brown, and fall off, littering the ground with what look like brown grubs or worms that soon disintegrate. They live long enough to produce prodigious pollen, though. Sometimes referred to as "yellow snow," pine pollen will not only coat your car but so fill the air that it looks like clouds of brimstone.

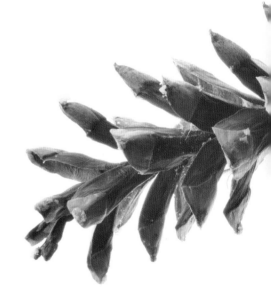

On this white pine twig there are a two-year-old mature cone (left) and several immature female cones. The tiny female cones (sometimes referred to as flowers) are emerging from new needle and shoot growth in the center of the photo.

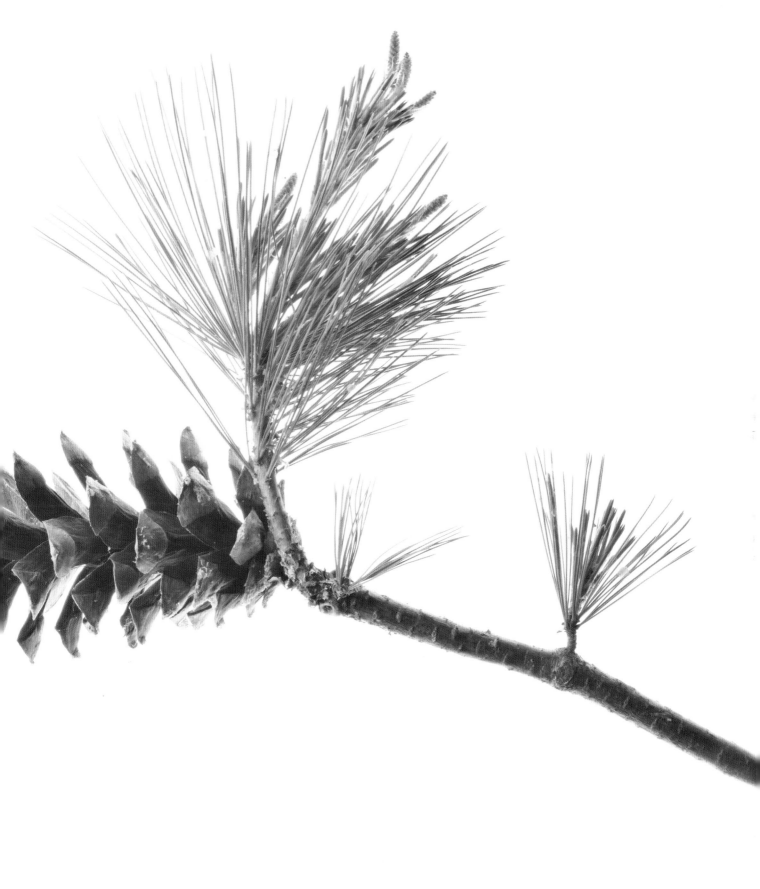

Donald Culross Peattie, in his classic *A Natural History of Trees*, described the impression this phenomenon made on sailors off the coast of "aboriginal" New England: "When the male flowers bloomed in these illimitable pineries, thousands of miles of forest aisle were swept with the golden smoke of this reckless fertility, and great storms of pollen were swept from the primeval shores far out to sea and to the superstitious sailor seemed to be 'raining brimstone' on the deck."

The female "flowers" are infinitely harder to see. I can now spot them with binoculars in the tops of most of the white pines on my property, but I saw them better when I viewed them from the university window, and even better when Bob mailed me one he had collected. To photograph them, Bob envisioned having to climb a

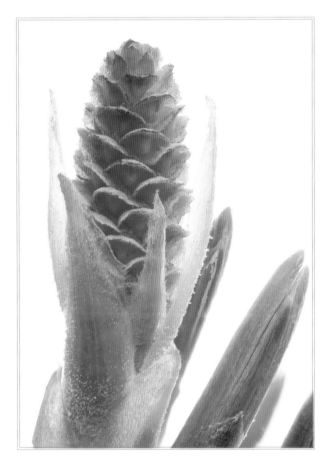

tree, but he finally got lucky when he spotted a white pine with mature female cones relatively low in its canopy next to a suburban parking lot. Knowing it must produce its "flowers" low, he watched it for new female "flower" development, and was able to clip one with telescoping pruners. It's worth noting that while tall white pines present among the hardest obstacles to viewing their immature female cones, windfalls from these and other pines are not unusual, and such breakage will sometimes bring the unobservable into view.

From a distance, for immature female cones, you will want to look for tiny, finger-like projections emerging from the tops of new shoots in the upper canopy of the white pine. (On pines of other species, their location on the shoot and orientation may be different.) I've not seen them when they are really tiny (under ¼ inch long) and reportedly looking like golden green buds or bumps, but I have seen them when they are ½ inch long, cylindrical, and possessed of the rosy-edged scales that Spalding described as lips. Under magnification, their tips look all the redder, and their scalloped scales (which will become the woody scales of the pinecone) look downright fleshy. They are, in a word, gorgeous, and well worth the search for them.

Wind carries pollen from the male cones of neighboring trees to these immature female cones, and the female cone's scales (with ovules under them) spread apart to receive it. The scales then close, sealing the cones, which, by the end of the summer, have matured into bullet-like cones about ¾ to 1½ inches long. For a while they remain upright, but as they grow and get heavier, they begin to sag and become more horizontal.

LEFT A magnified view of white pine's newly emerging female cones reveals the "rosy lips" of these cones, which some observers refer to as flowers.

RIGHT The reddish structures in this photo are newly emerging female cones of white pine.

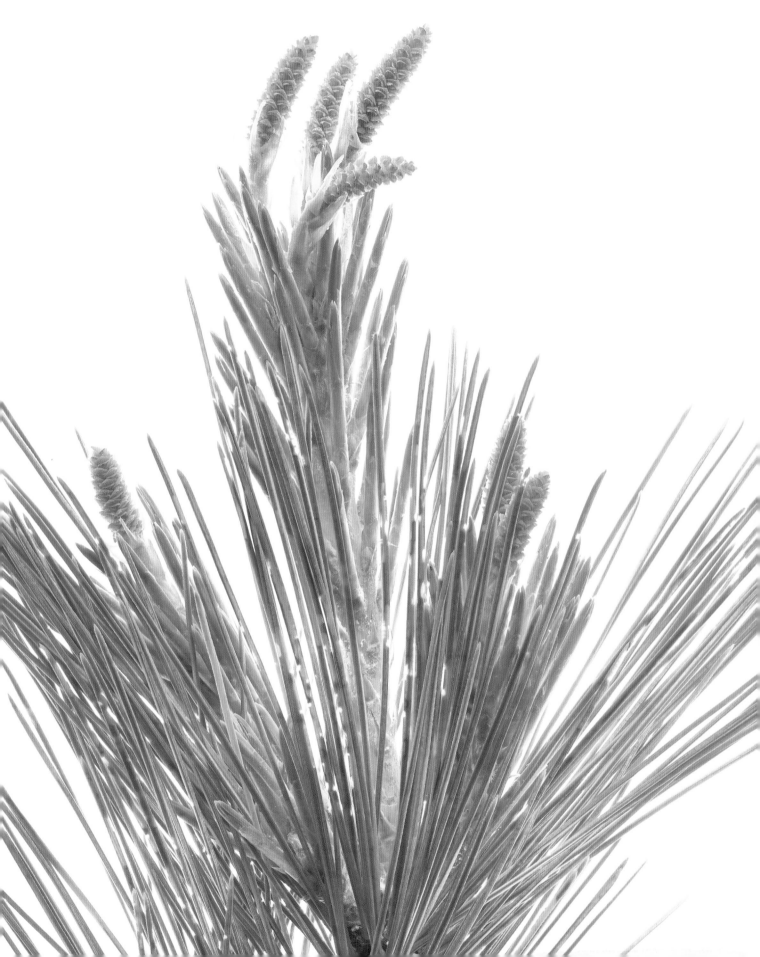

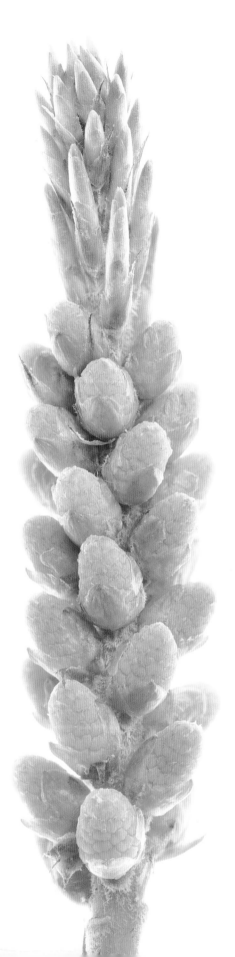

The next spring, these first year cones, which are easy to spot in the tops of the trees, begin lengthening quickly, until they take on the pickle-like look Thoreau described. By the time the female "flowers" are blooming, the previous year's cones are about 2½ to 3 inches long and pendulous. Their scales are a gorgeous verdigris, their scale tips a reflective brown that looks almost metallic in some lights. (In other lights, the entire immature cone looks almost purple.) By September, the white pine's female cones will have reached about 6 inches in length, the seeds inside will have ripened, and they'll have begun to take on the brown color and woody texture we associate with pinecones. It's sort of strange, actually, that the pinecone should have so many extraordinary stages over the course of two years but that we focus on only the last one, the mature pinecone.

Cones, seeds, candles, needles—all these white pine features reward closer inspection, and while you may not have white pine in the neighborhood, you may have a different species of pine on which you can observe them. Members of the genus *Pinus* are native to most of the Northern Hemisphere; they grow in habitats from swamps to dry mountaintops. Of the around 100 species in the world, over a third are native to North America. In the United States (according to the U.S. Fish and Wildlife Service), pines are noticeably absent only from parts of the prairies and deserts.

Eastern white pine, also known as northern white pine and Weymouth pine, grows where both Bob and I live, in Virginia's piedmont and coastal plain. But white pine isn't the most common pine in my own neighborhood. Until Bob and I launched this project, I was more familiar with Virginia pine (*Pinus virginiana*) and loblolly pine (*P. taeda*). But we decided to focus on this iconic tree of

Immature male pollen cones aggregate along a stem from which new needles are also emerging (at top). Together, they resemble miniature pineapples.

the north to balance our inclusion of southern magnolia, iconic tree of south. The natural range of white pine looks like two brush strokes—one that covers southeastern Canada and the Great Lakes region, and all of New England, another that runs down the Appalachians into Georgia. And, like the tree I watch on the Randolph-Macon campus in Ashland, Virginia, it is often planted outside its native range.

Tall and stately are the two adjectives most often used to describe the overall look of white pine, but the tree you see in the forest may look quite different from the tree you see in the park or yard. Yard and park trees, grown in the open, typically have a symmetrical, pyramidal shape (their crowns getting more horizontal as they age), and their whorls of branches clothe the tree all the way, or about two-thirds of the way, to the ground. In the close confines of the forest, however, the trees lose their lower branches, and the tallest white pine in Virginia, a behemoth 170 feet tall, doesn't begin to branch until about 100 feet up on the tree. Famous for their tall, straight trunks, white pines were the trees of choice for ships' masts in the seventeenth and eighteenth centuries, and competition for New England's white pines (the British crown wanting to reserve the best ones for the Royal Navy's ships) helped precipitate the Revolutionary War. Although peering into the feathery top and looking at the bark of a forest-grown white pine can be interesting (the top responds to breezes imperceptible on the ground), for the most rewarding white pine viewing, I'd recommend a tree that is, as Horace Walpole once put it, "feathered quite to the ground."

On a young, open-grown white pine, it is easy to see the characteristic white pine habit of branches forming from the same point on the trunk. These whorls of branches, stacked 1 to 2 feet above each other, form distinctive horizontal planes or platforms, and you can count those platforms to get a rough approximation of the tree's age. Also distinctive are white pine's soft, blue-green needles in bundles of five. Each species of pine

has its characteristic number of needles per bundle (Virginia pine has two needles per bundle, loblolly has three), and white pine is the only pine east of the Rocky Mountains that bears its needles in bundles of five. White pine needles are also characterized by a longitudinal white stripe that runs from base to tip and by what is called a "deciduous sheath." All pines have needles arranged in bundles with papery sheaths enclosing their bases (and holding them together), but white pine (unlike loblolly and Virginia pine) sheds its sheath by the end of the summer of its first growing season. (This is one thing that differentiates soft from hard pines, white pine being a "soft" pine.) White pine needles are also somewhat unusual in that they are shed after their second growing season, unlike the needles of most other pines that persist on the tree longer, and they are more flexible than most other pine needles. All in all, the delicate, 2- to 5-inch needles of white pine seem somehow more artfully constructed and refined than the needles of other pines. When you encounter them after a rain, with the last drops of water clinging to those thousands of blue-green tips, there's a glistening so elegant, and so ephemeral, it's poetic.

Needles in general get much less attention than leaves, but they are, in fact, modified leaves and perform the functions of leaves. Through photosynthesis, they manufacture food for the tree (and because they are evergreen, they do it all year). They also conduct the leafy functions of photosynthesis, cell respiration, and transpiration (exchanging carbon dioxide, oxygen, and water vapor with the air), and like the needles of all conifers, white pine needles help "sift" snow. According to some biologists, the size and shapes of needles have evolved, at least in part, to help snow sift to the ground instead of accumulating on the branches and breaking them. And it is not just pine needles that have their characteristic sizes and shapes, evolved over the millennia to best serve the tree. One way to way to tell a spruce from a fir is by the shape of the needles—stiff spruce needles are round in cross section (you can roll a spruce needle between your

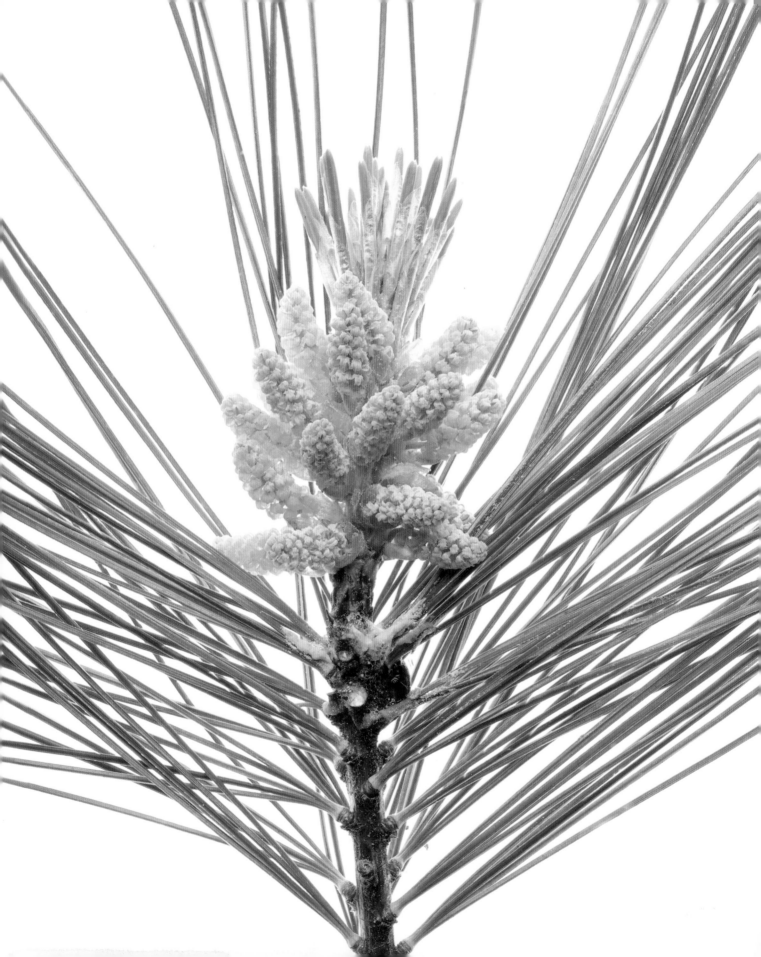

thumb and forefinger); softer fir needles are flat (they won't roll).

Another way to appreciate pine needles is to see them at different stages in their development. The first needles to top the stem emerging from a pine seed grow in a way that the American naturalist Winthrop Packard compared to a fairy palm tree. In *Old Plymouth Trails*, he wrote: "Their single stem and the spreading whorl of leaves at the summit of it are in about the same proportion as those of a palmetto whose great leaves have been tossed and shredded by trade winds. That so tiny a twig could become, in the passage of centuries even, a 200-foot tree seems difficult to believe. . . . Thus easily may we be deceived by small beginnings." Needles emerging from white pine candles are equally impressive in their promise. A candle is the combination of new shoot and needle growth that characterizes pines in the spring. Except for the uppermost candle or leader, which remains upright, the candles grow upright until they begin to sag (becoming more horizontal or even drooping), and they are a yellower green than the surrounding foliage. A new candle is comprised of a central flexible shaft bordered by what look, at first, like tiny celery-green toothpick tips. Soon these "toothpick tips" begin to look more like golden-brown quivers from which green arrows are emerging. The quivers are the needle sheaths, the arrows the pine needles, and there are five—count them, five—tiny needles in every quiver. Why that should be so startling is hard to say, but it has something to do with the recognition that this tree knows exactly what it is doing and repeats it with exactitude.

White pine's mature, woody female cone, the cone it has taken two years to produce, is also emblematic.

LEFT As they mature, male pollen cones elongate and begin to release their pollen.

RIGHT This magnified view shows the individual pollen sacs of white pine pollen cones, nearly all of which have split open and released their pollen.

Ripening in September, the white pinecone is, like the tree, sort of elegant: slender, sometimes curving at the tip, with silvery splotches near the apex of each overlapping scale, no sharp prickles, and little globs of white resin here and there. When conditions are right for seed release, the cone's scales dry and curl back, creating spaces that allow the wind to grab and disperse the winged seeds previously wedged between them. How does the cone know when conditions are right? I doubt anyone knows the complete answer to that, but we do know that white pinecones are programmed to open in warm, dry weather, when conditions are favorable for seed dispersal and germination, and to close when the weather is cold and wet, unfavorable for seed dispersal and germination. And they

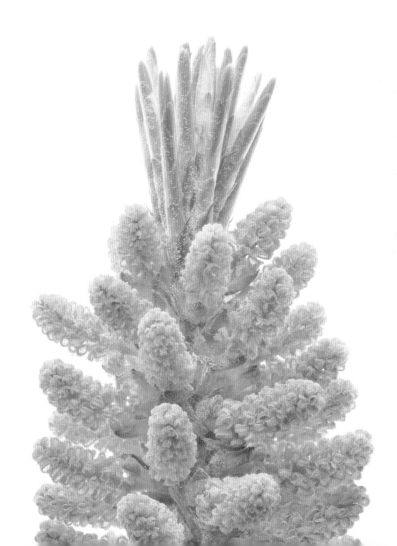

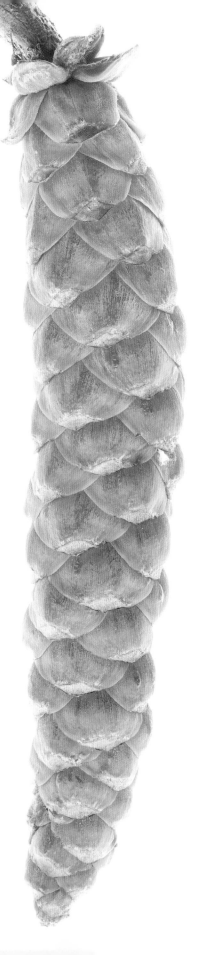

do this even after their seeds have been dispersed and they are on the ground, as craftspeople who work with cones soon learn. The cones of some other pines require the heat of a fire to open them, and jack pine (*Pinus banksiana*) has an "opening code" so complex you'd think a lawyer drew it up. For a description of the sequence of events required to open a jack pinecone—not just a forest fire but the ignition of a short-lived, lamp-like flame fed by the cone's own resin, then a cooling period—read Collin Tudge's *The Tree*, which outlines this and other jaw-dropping details about cones and other tree features.

Not only is there variation in the sizes and shapes of cones belonging to pines of different species, but there can be significant variation between the cones of individual trees of the same species. In other words, the cones of one loblolly pine can be quite different from the cones of another loblolly pine. (White pinecones are less variable than those of the loblolly, but I'm told there may be some tree-specific cone traits in white pines as well.) I share the following observation, which is less relevant to white pines than to loblollies, because of what it illustrates about seeing. Forester Tom Dierauf tells a story about an employee at a Virginia Department of Forestry pine seed orchard, who knew the loblolly pines in his care so well that he knew which female pinecone came from which tree. "He was just a high school boy, but he got to know the trees so well he could identify some of them by their cones, some by their needles, some by the configuration of the needles—how dense they were, how they radiated on the twig. All the experts respected his opinion." This was important because in order to conduct accurate crosses between outstanding parent trees (trees selected for remarkable straightness, growth, or crown

LEFT When only a year old, the female cone of the white pine is a study in metallic greens and browns.

RIGHT Globs of white resin make the scales of mature white pinecones look as though they've been frosted.

characteristics), it was essential to know which cones came from which parent trees. "They had a map [diagram showing where clones of each parent tree grew], but if Charles said a tree was misidentified, the experts would yield to his opinion. He had looked at the trees carefully day after day for years." Seeing with such precision is as inspiring as it is rare, especially when it comes to tree phenomena, and it proves how much we could see that is usually outside our awareness.

There are usually two seeds lodged behind each scale of a white pinecone. Unlike the large seeds of pinyon pines (the western pines from which pine nuts are harvested commercially), white pine's oval seeds are tiny, about ¼ inch long with wings about ¾ inch long. They, too, are edible (sweet and nutritious) but too much work for all but the most dedicated wild food foragers to harvest. (Squirrels, of course, have all the time in the world and work over a pinecone the way a human being does an artichoke.) After dry weather, which opens the pinecone scales thus freeing the seeds wedged between them, a strong wind preceding a thunderstorm will sometimes whip up a shower of pinecone seeds. When the rain actually comes, however, the cones close up again. But that's just part of the drama of the dispersal of the white pine seed. Sometimes, when investigating trees and searching for tree information, you come across a naturalist you enjoy as much as you enjoy your trees, and Winthrop Packard has been such a discovery for me. Here's another taste of his writing (from his observations of white pine groves around Plymouth, Massachusetts, published in *Old Plymouth Trails*):

> It is often a surprise to me to see how far a seed will fly with but one wing. The air currents set it spinning the moment it leaves its parent tree making of it at once a tiny gyroscope with a single blade of a propeller. Its gyroscopic quality steadies it and the whirl of its propeller tends always to lift its weight. . . . The stronger the wind the more the whirl of that

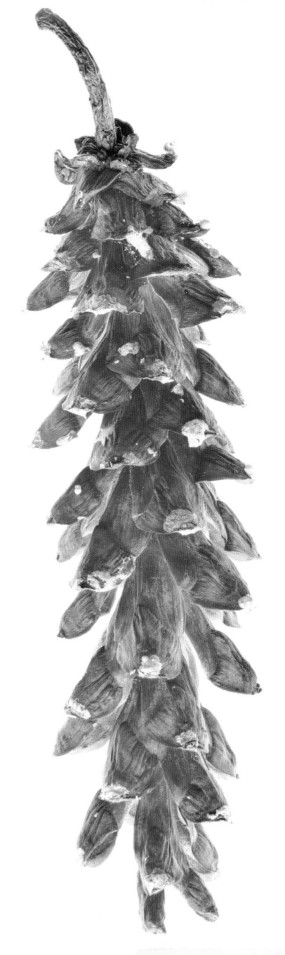

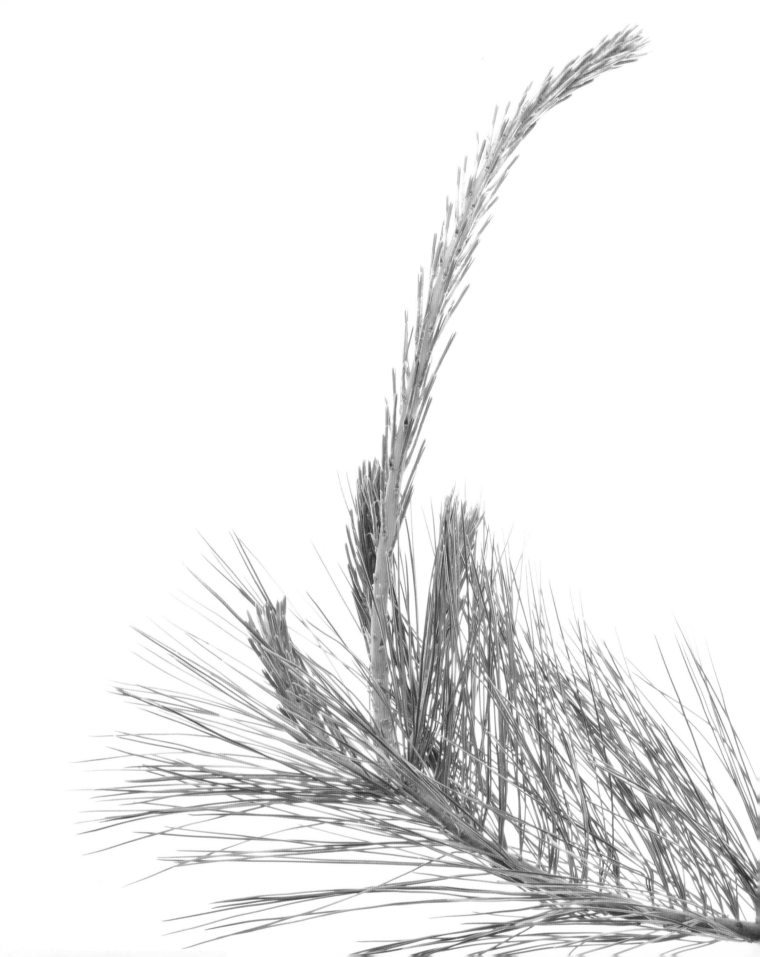

tiny propeller tends to keep it in air and with a good September gale thrashing seed out of its cones a pine tree may be planting its kind for miles to leeward. The seed that brushed my cheek this morning made no such offing. Caught in a back eddy it whirled round a sunny glade for a moment, then in a sudden lull spun directly downward to the grass. There again its shape favored it. The first grass spear stopped its spinning and it dived plummet-like out of sight, the thin propeller becoming a tail that kept its head downward while it slipped most cannily to the very mould.

Gyroscopic seed, its spinning stopped by a grass spear, its head slipping "most cannily" into the mould: such descriptions remind me how reinforcing it is to find someone who shares your passion, how inspiring it is to encounter someone who sees better than you do, and how instructive (and awe-inspiring) it is to focus on trees, their seeds, and their marvelous methods for launching their offspring into the world.

LEFT New shoot and needle growth results in the upright pine structures commonly referred to as candles. This candle is from the white pine.

RIGHT White pine seeds, which are only about an inch long including wings, develop between the pinecone's scales. They are released when the scales dry and separate, freeing the seeds wedged between them.

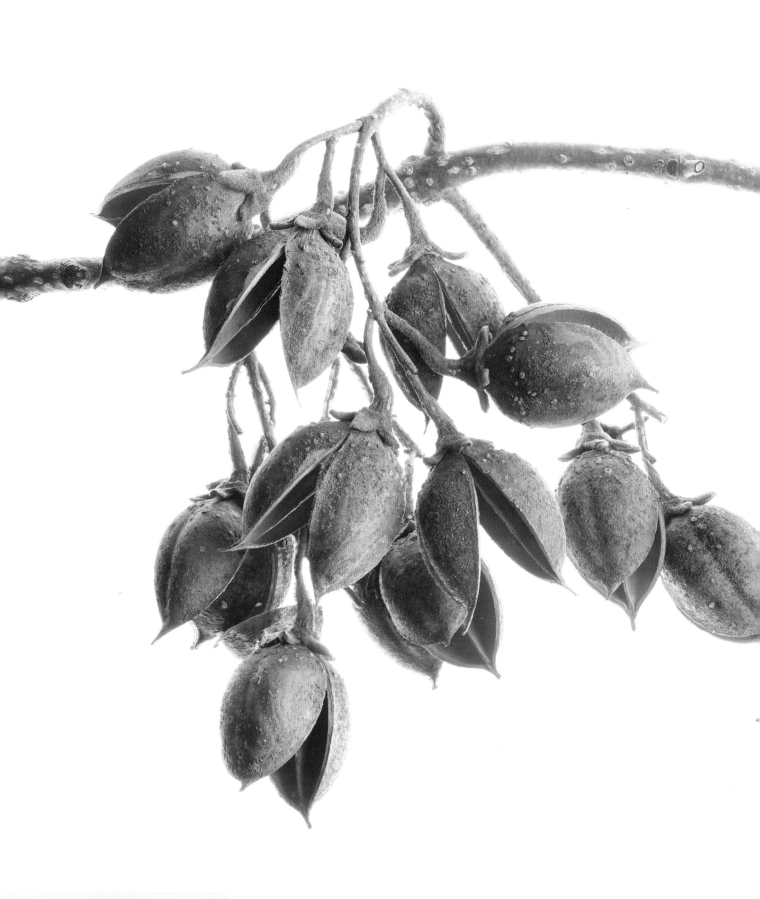

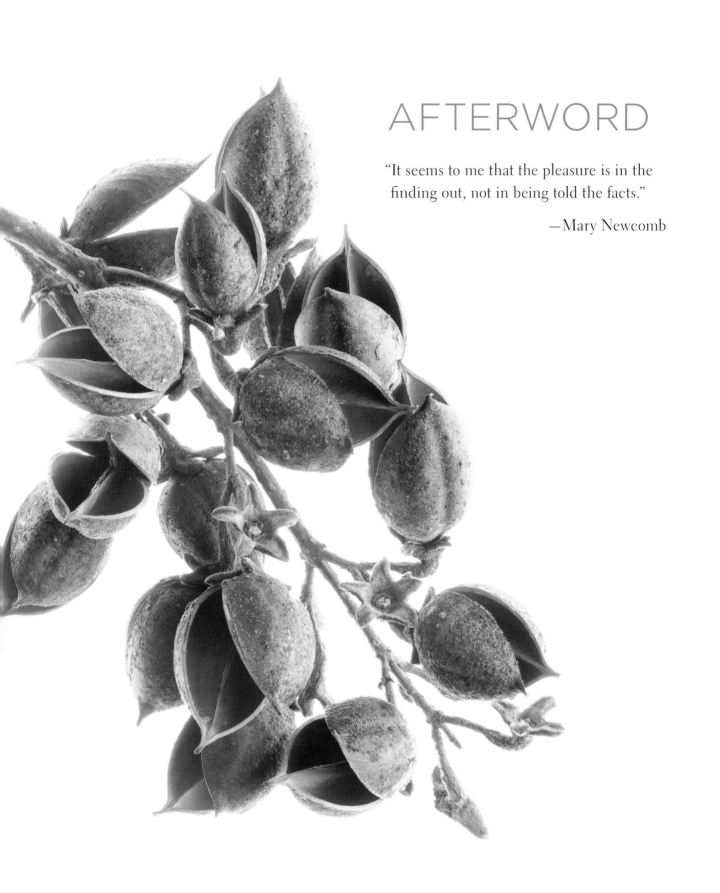

AFTERWORD

"It seems to me that the pleasure is in the finding out, not in being told the facts."

—Mary Newcomb

"WE COULD HAVE DONE the whole book right here." That's Bob, surveying the scene around the Burger King parking lot at Zion Crossroads, Louisa County, Virginia, April 14, 2010. We are meeting there for a plant material handoff of some sort—sometimes I took him specimens I thought he might photograph, sometimes he shared things he wanted me to write about—and sometimes the trees around the parking lot proved as interesting as what we were sharing. On that day, in a narrow, bowling alley-like strip of land between our parking lot and another lot next door, here is some of what we saw: paulownia (with old fruit, new buds, flowers), red maple (leaves at half-open-umbrella stage), black cherry (blooming), red cedar, hickory (with faded bud scales still clinging to twigs, old nut shells on ground), white pine (two big, nice ones under towering gas station sign, probably planted when sign went up), Virginia pine (male cones full of pollen), white oak (with catkins), red oak, tupelo (gorgeous shiny leaves, lots of flowers). Also lots of trash and cigarette butts. And behind Burger King were a black cherry in bloom, a sycamore, a mimosa (leaves just coming out, seed pods still clinging), a black locust (in flower early), lots of tulip poplar, ailanthus, and silver maple.

Bob wasn't kidding when he said we could have done the whole book right there, which illustrates one conclusion Bob and I drew from this project: you don't need a wilderness or a botanical garden to make meaningful tree observations. A backyard or even a waste place will do, and the biggest obstacle to tree viewing is in thinking there's nothing worth viewing in the locales we frequent. George Orwell once observed that to see what's in front

of one's nose requires constant struggle, and he was right. It's sometimes harder to see the familiar than the unusual, because in order to really see the familiar, you have to break the habit of overlooking it.

There's a wonderful example of how important backyard tree observations can be in the example of British octogenarian Jean Combes, who recorded tree blooming times in her neighborhood for over sixty years. According to the Woodland Trust, Combes's record-keeping started at age eleven, but thinking they were childish, she destroyed those records. She started again at age twenty, meticulously recording the dates when the first leaves appeared on oak, ash, horsechestnut, and lime (linden) trees. Her records are now used by scientists investigating the effects of climate change on trees.

A second conclusion we've drawn is that there is always more, much more, to learn about even the trees you think you already know. "It doesn't have flowers," one of Bob's neighbors insisted when he stopped by to ask if he could photograph the flowers of her sweetgum tree. "It just has those awful spiny balls." Always the gentleman, Bob diplomatically pointed out that flowers, like the ones blooming in the sweetgums at that moment, preceded the gumballs. And I've had my own comeuppance with know-it-all-ness, too. One late April day, Bob showed me a twig with fruits that looked like anorexic pea pods hanging on it. The pods were only about 1 inch long and so thin they looked more like fringe than they did like pods, but I could see they were tiny, dark green preemie pods with maroon edges. I'd like to think I'd have figured out what they were eventually, but Bob prompted me first, telling me they were immature redbud fruits. And redbud

PREVIOUS Empty now, these large, conspicuous seed capsules of *Paulownia tomentosa* (princess tree) held thousands of seeds before they spilled.

RIGHT The fragrant white flowers of wild black cherry (*Prunus serotina*) bloom after the tree's leaves have emerged.

is a tree I had thought I knew well. Now I watch my redbuds not just for their ebony resting buds, their heart-shaped leaves, their humming bird-like flowers, and their mature pea-like fruits but also for the fringy protrusions that precede the mature, plumped out pods. And it's a wonder to me now that I could have overlooked them before. "Once you know it, it's got neon on it," birder Linda Cole once told me, in reference to the thrushes, a group of birds she'd struggled to identify then delighted to know, and the same could be said of tree traits. If you're unaware of a particular tree trait, it might as well be invisible, but once you're alert to it, you'll never not see it again.

There is also a kind of momentum that builds as you identify more and more tree traits. Once I became alert to the short spurs (woody stack of leaf scars) on the ginkgo, I began to see them on fruit trees, another group of trees that has them. After watching the development of the blue "berry" of a red cedar, I had new appreciation for the fat blue fruit on the prostrate junipers (same genus

as the red cedar) in the planting strip in the Barnes & Noble parking lot. Suddenly those beat up plants seemed less inert than they had previously. And after searching hard for a beech seedling with its seed leaves still on, I happened upon a maple seedling that I realized was also still sporting its seed leaves. That seedling, which friends and I found in the woods, had vibrant red seed leaves (strap-like leaves below its "real" leaves), and we thrilled at our discovery. Only later did I realize that every one of the hundreds of red maple seedlings I pull out of my planting flats every spring is also sporting its seed leaves,

although they're usually green. Until I had learned more about seed leaves, it hadn't really registered that their seed leaves (cotyledons) were different from their characteristic top leaves. Now I'll always notice that.

Because finding answers for most of the questions our tree investigations generated has been so much fun, I'd also like to comment here on this kind of learning in general. It seems too obvious to say that the most enjoyable and meaningful learning occurs when questions precede answers. But if that is so obvious, why do we give answers (especially to children) before students have questions? There is a revealing line in a novel by Haruki Murakami (*Kafka on the Shore*), when the narrator describes a school outing during World War II. It was an unusual time (the country was at war and, because of food rationing, children were encouraged to hunt for food wherever they could find it), but the narrator describes this as a typical school outing: "everyone carried canteens and lunches with them. We had nothing in particular we were planning to study, we were just going up into the hills to gather mushrooms and edible wild plants." In my state, a school outing without a list of educational objectives ("the students will learn . . .") is almost illegal. As if to prove the importance of generating questions before presenting answers, a friend of mine once totally remade one of the first tapes available for learning bird calls. The publisher of the tape had given listeners first the name of the bird, then the bird call. Robert Conklin (and later producers of such tapes) realized that was backwards. If you really wanted people to learn bird calls, you needed to play the call, let the listener generate some thoughts about it, and possibly a

Often hidden under heart-shaped leaves are the graceful, immature seed pods of eastern redbud (*Cercis canadensis*).

guess as to which bird's call it might be, and then provide the answer. Question first, answer later.

For those of us desperate to interest upcoming generations in the natural world, there must be a lesson in this. Don't tell too much. Instead try a ramble into the hills with no objective, which might generate some questions. I leave this project having learned lots and had many of my questions answered, but what gets me up in the morning is not the new information now catalogued in my brain but the questions for which I still don't have answers and phenomena I still haven't seen. What's the reason for the pancake-like end of the detached oak twigs I find on the ground? Will I ever see a hairstreak butterfly or its eggs on my eastern red cedars?

And finally, two observations by others. The first has to do with being a beginner and all the advantages and disadvantages that bestows. As an adult who still sometimes stumbles over the words *stamen*, *style*, and *stigma* (in public, that is; I can sort them out in private), it took some nerve to undertake this book. The proverbial words that gave me the courage were these: "Sometimes the newcomer sees farthest." Sometimes, unburdened by the categories already outlined by others, the newcomer can see things experts overlook or see differently. And, not only that, but every discrete observation is unique. Just because there is a botanist out there for whom the words *stamen*, *style*, and *stigma* (not to mention *strobilus*, *pro-phyll*, and *valvate stipule*) slip off the tongue like *knife*, *fork*, and *spoon*, doesn't mean you, the struggler, can't observe something he or she hasn't. I can't tell you how many times I called a botanist or forester with a question about some tiny tree trait, and he or she said "I have no idea" or "I haven't seen it myself." Music to my ears! The answers to most questions a beginning tree observer might have *are* out there—on the Internet or in the mind

of some scientist or naturalist—but nowhere, until you make them, are the observations you can make on a particular day, in particular light, in particular weather, through the lens of your particular eyes. The real danger is probably not being beginner enough. The most startling tree observation I made in the two years I worked on this book was of a dogwood with turquoise blossoms. I turned a corner in Ashland, Virginia, and there they were—turquoise blue. Almost immediately my brain kicked in and started sorting things out according to the categories it already knew—horizontal branching structure on tree blooming in mid-April in central Virginia with large, four-petaled flowers—no, those flowers must be white dogwood blossoms. And suddenly they were. But I am here to report that, in some strange light, through the eyes of an observer not on drugs, dogwood blossoms can appear turquoise.

The second observation I'll end with comes from Diane Ackerman's book *The Zookeeper's Wife*. Ackerman is describing the importance of a particular insect collection when she writes, "What is being collected is not the bugs themselves but the deep attention of the collector. That is also a rarity, a sort of gallery that ripples through the mind and whose real holdings are the perpetuation of wonder in a maelstrom of social and personal distractions. 'Collection' is a good word for what happens, because one becomes collected for a spell, gathering up one's curiosity the way rainwater collects." Observing trees is like that—something that requires you to collect yourself and train your attention on something capable of perpetuating wonder. With that in mind, Bob and I invite you to gather up your curiosity and go forth—into the woods, into the backyards, and even into the waste places, where you can encounter the incredible organisms that are trees.

CONVERSION CHART

INCHES/MM
1/32 inch = 0.5 mm
1/16 inch = 1.5 mm
1/8 inch = 3.2 mm
1/4 inch = 6.4 mm

INCHES/CM
1/2 inch = 1.3 cm
3/4 inch = 1.9 cm
1 inch = 2.5 cm

FEET/M
1 foot = 0.3 m
1 yard/3 feet = 0.9 m
200 yards = 183 m
600 yards = 549 m

MILES/KM
1 mile = 1.6 km
100 miles =161 km
200 miles = 322 km

POUNDS/KILOS
1 pound = 0.4 kilo

ACRES/HECTARES
1/4 acre = 0.10 hec
1/2 acre = 0.20 hec
1 acre = 0.40 hec

REFERENCES

Ackerman, Diane. 2007. *The Zookeeper's Wife: A War Story*. New York: W. W. Norton & Company.

Andreae, Christopher. 2006. *Mary Newcomb*. London: Lund Humphries Publishers.

Bell, Richard. 2005. *Rough Patch*. Wakefield, West Yorkshire: Willow Island Editions.

Burns, Russell M., and Barbara H. Honkala, tech. coords. 1990. *Silvics of North America: 1. Conifers; 2. Hardwoods*. Agriculture Handbook 654. Washington, D.C.: USDA, Forest Service.

Cohu, Will. 2007. *Out of the Woods: The Armchair Guide to Trees*. London: Short Books.

Collingwood, George H., and Warren Brush. 1984. *Knowing Your Trees*. Washington, D.C.: American Forestry Association.

Darley-Hill, Susan, and W. Carter Johnson. 1981. Acorn dispersal by the blue jay. *Oecologia* 50: 231–232.

Deakin, Roger. 2007. *Wildwood: A Journey Through Trees*. New York: Free Press.

Dirr, Michael. 1998. *Manual of Woody Landscape Plants: Their Identification, Ornamental Characteristics, Culture, Propagation and Uses*. Champaign, Illinois: Stipes Publishing.

Edlin, Herbert L. 1978. *Trees, Woods and Man*. London: Collins.

Frazier, Charles. 1997. *Cold Mountain*. New York: Atlantic Monthly Press.

Heinrich, Bernd. 1997. *The Trees in My Forest*. New York: Harper Collins.

Holthuijzen, Anthonie M., and T. L. Sharik. 1985 The avian seed dispersal system of eastern red cedar (*Juniperus virginiana*). *Canadian Journal of Botany* 63: 1508–1515.

Illick, Joseph, 1919. *Pennsylvania Trees*. Harrisburg: Department of Forestry, Commonwealth of Pennsylvania.

Illick, Joseph. 1924. *Tree Habits: How to Know the Hardwoods*. Washington, D.C.: American Nature Association.

Lewington, Richard (illustrations), and David Streeter (text). 1993. *The Natural History of the Oak Tree*. London: Dorling Kindersley.

Maloof, Joan. 2007. *Teaching the Trees: Lessons from the Forest*. Athens and London: University of Georgia Press.

Martin, Alexander C., Herbert S. Zim, and Arnold L. Nelson. 1961. *American Wildlife and Plants: A Guide to Wildlife Food and Habits*. New York: Dover Publications.

McClure, Mark S. 1974. Biology of *Erythroneura lawsoni* (Homoptera: Cicadellidae) and coexistence in the sycamore leaf-feeding guild. *Environmental Entomology* 3: 59–68.

Merwin, W. S. 2010. *Unchopping a Tree: The Book of Fables*. Port Townsend, Washington: Copper Canyon Press.

Murakami, Haruki. 2005. *Kafka on the Shore*. Trans. Philip Gabriel. New York: Vintage.

Nabokov, Vladimir. 2000. *Speak Memory*. New York: Penguin.

Packard, Winthrop. 1920. *Old Plymouth Trails*. Boston: Winthrop Packard.

Peattie, Donald Culross. 1991. *A Natural History of Trees of Eastern and Central North America*. Boston: Houghton Mifflin.

PLANTS Database, USDA. http://plants.usda.gov.

Reid, William, Mark Coggeshall, and H. E. Garrett. 2009. Growing Black Walnuts for Nut

Production. www.centerforagroforestry.org/pubs/index.asp#walnutNuts.

Rogers, Julia Ellen. 1923. *The Tree Book: A Popular Guide to a Knowledge of the Trees of North America and to Their Uses and Cultivation*. New York: Doubleday.

Rogers, Walter E. 1965. *Tree Flowers of Forest, Park, and Street*. New York: Dover Publications.

Sibley, David Allen. 2009. *The Sibley Guide to Trees*. New York: Knopf.

Sorensen, Anne E. 1981. Interactions between Birds and Fruit in a Temperate Woodland. *Oecologia* 50: 242–249.

Spalding, Volney M., Bernhard E. Bernhard, Filbert Roth, and Frank H. Chittenden. 1899. *The White Pine*. Washington, D.C.: Division of Forestry.

Suzuki, David, and Wayne Grady. 2004. *Tree: A Life Story*. Vancouver: Greystone Books.

Thomas, Lewis. 1983. *Late Night Thoughts on Listening to Mahler's Ninth Symphony*. New York: Penguin.

Thoreau, Henry D. 1993. *Faith in a Seed: The Dispersion of Seeds and Other Late Natural History Writings*. Washington, D.C.: Island Press.

Tudge, Collin. 2006. *The Tree: A Natural History of What Trees Are, How They Live, and Why They Matter*. New York: Crown.

Watts, May Theilgaard. 1999. *Reading the Landscape of America*. Rochester, New York: Nature Study Guild.

Wulf, Andrea. 2009. *The Brother Gardeners: Botany, Empire and the Birth of an Obsession*. New York: Knopf.

Zimmer, Paul. 1983. "Work," in *Family Reunion: Selected and New Poems*. Pittsburgh, Pennsylvania: University of Pittsburgh Press.

ACKNOWLEDGMENTS

"Is 'flower stalk' an acceptable substitute for 'pedicel'?" and "May I describe the gumball as a multichambered fruit instead of multiple fruit?" The answers, from botanist John Hayden, were "yes" to the former, "no" to the latter. And so it went, for over a year, as I attempted to describe tree traits in terms that would engage beginners without upsetting experts. Never was there a more patient, and engaged, mentor than University of Richmond biology professor John Hayden, who helped me through more nomenclature tangles than I care to count. He wasn't just a helpmate, he was a fellow explorer, who occasionally shared his own discoveries and made mine seem as important as his. What a teacher.

If my experience is typical, all plant lovers are inveterate sharers, and never in the course of this book's creation did anyone hesitate to answer a question Bob or I asked. Among those who shared their expertise were forester Tom Dierauf, Monticello plant historian Peter Hatch, Virginia Tech forestry professors Jeff Kirwan and John Seiler, Virginia Tech entomologist Chris Asaro, Smithsonian Institution research associate Arthur Evans, and naturalists Byron Carmean, Judy Molnar, and David Liebman. Agecroft Hall horticulturist Scott Burrell, Montpelier horticulturist Sandy Mudrinich, and Maymont horticulturist Peggy Singlemann provided insight into the characteristics of cone-bearing trees, and Kansas State University nut crops specialist William Reed corrected some of my mistaken ideas about black walnuts (including when to harvest them). Elizabeth Mundy shared leaves from the Japanese maples at Acer Acres (what a collection!); Linda Armstrong, Mike Fitts, John Hugo, and Louise Witherspoon provided editorial and artistic insight.

Randolph-Macon College professor Gregory Daugherty helped me translate pre-Linnaean Latin plant polynomials, and the following colleagues went out of their way (sometimes literally) to help Bob and me find branches, blooms, and other plant parts when we needed them: molecular biologist Chris Herbstritt, Brookside Gardens plant collections manager Phil Normandy, and Virginia Natural Heritage Program chief biologist Chris Ludwig. Jon Golden and Tina Nunez provided technical and research assistance, and Timber Press editor-in-chief Tom Fischer and editor Ellen Wheat provided suggestions that made this a better book.

As always, Bob and I thank our spouses Bobbi Llewellyn and John Hugo for logistical and emotional support (how lucky that both of them are psychologists!). And we want to give special thanks to my grandson David Hugo, who, when nine, discovered the hummingbird shape in the redbud flower and inspired us to look more closely at all of our trees. To be able to see as David sees, I would trade many lesser talents.

INDEX

Page numbers in **bold** type indicate main text sections and pages with photographs.

Abies, 59, 60, 62, 219, 221
Acer, 41, 44, 56, 69, 72, 84, 101. *See also* red maple (*A. rubrum*)
 japonicum, **46–47**, 50
 negundo, 1, 4, 56, 86, 88, **93**, 101
 palmatum, 41, **46–47**, 50
 pensylvanicum, 101
 saccharinum, **100**, 101
 saccharum, 87, 88
achenes, 69, **121–123**, 125
Ackerman, Diane, 231
Aesculus, 41, 84, 101
 hippocastanum, 26, **27**, 41, 62, **82–86**, 88, 101
Ailanthus altissima, **21**, 62, 85, 86, 88, **89**, 101
alder (*Alnus* species), 56, 58, 69
 smooth, **30–31**
Amelanchier, **16–17**, 19, 57
American basswood/linden (*Tilia americana*), 62, **64–65**, 68, 84
American beech (*Fagus grandifolia*), **104–115**
 beechnuts, **114–115**
 buds and twigs, 82, **84**, 86, 88, **111**
 cotyledons, 104–106, **105**
 distinctive bark, 96, **98**, 99
 fall leaves, 41–42, **50**
 flowers, **106–107**, **112–113**, 115
 habitat, 103, 109
 unfurling of buds, **14**, 15, **108–113**
American elm (*Ulmus americana*), **54–55**, 56, 58, **70–72**
American holly (*Ilex opaca*), 24, 26, **28–29**, 45, 50
American sycamore (*Platanus occidentalis*), **116–129**

achenes, 69, **121–123**, 125
 distinctive bark, 90, 94, **95**, 116–118, **117**, 127–128
 flowers, 125, **126–127**, **128**
 fruits, 69, **120–126**
 habitat and habits, 103, 118, 127, 128–129
 leaves/leaf attachment, 50, **51**, **118**, 128, **129**
 stipules, 118–**119**, 121
 twigs, **87**, 88
angiosperms, 59
anthocyanin production, 44–45
apple (*Malus domestica*), 44, 62, 151–152
ash (*Fraxinus* species), 41, 56, 72, 84, 101
 white, **56**, **57**, 58, 88
Asimina, 58, 84
aspen (*Populus* species), 56, 128

bark, **90–101**
 describing, **90–92**
 lenticels, **92**, 93
 species easy to identify by, **93–101**
Bartram, John, 52, 140
basswood (*Tilia* species), 58, 62
 American, 62, **64–65**, 68, 84
beech (*Fagus* species), 56, 57, 69, 73, 90, 101, 128. *See also* American beech (*F. grandifolia*)
 European, 96, 109
Betula
 alleghaniensis, 90
 lenta, 101
 nigra, **90**, 94, **96**
 papyrifera, 94, 178
bipinnate leaves, 41
birch (*Betula* species), 56, 58, 93, 101
 black, 101
 river, 90, 94, **96**

 white, 94, 178
 yellow, 90
birds, and fruit, 72–73, 80, 144, 147, 194
black birch (*Betula lenta*), 101
black cherry (*Prunus serotina*), 58, **92**, 93, **94**, 101, **228–229**
black locust (*Robinia pseudoacacia*), **22–23**, 24, **42–43**, 62, 84, 90, **91**
black oak (*Quercus velutina*), 78, 84, 101
black walnut (*Juglans nigra*), **130–139**
 bark, 136, 138
 diverse cultural views of, 130–132
 exuding juglone, 130–131
 flowers, **134–139**
 leaf scars, **88–89**
 nuts, 130–**133**, 135–136
 and The Nut Wizard, 130, 131, 132
 range, 103
 seedlings, **131**, 136
blue jays, seed dispersal by, 72–73
Boldridge, Frank, 135
botanical names, 20–21
boxelder (*Acer negundo*), 1, 4, 56, 86, 88, **93**, 101
buckeye (*Aesculus* species), 41, 62, 84, 101. *See also* horsechestnut (*A. hippocastanum*)
buds, **82–87**
bud scales, 82
bundle scars, 85, **88–89**
bust years, 73–75

candles, 214, 221, **224**, 225
Carmean, Byron, 77, 90
carpel, 185
Carpinus caroliniana, 69, 90, 92, **93–94**, 101
Carya, 30, 41, 56, 58, 69, 72, **73**, 101, 118
 ovata, 32, **33**, 90, 99, 101

Castanea, 58, 69, 72
 mollissima, 72, **73**
Catalpa, 41, 56, 62
 speciosa, **2–3**, 4, 62, **63**
Cater, Ruth Cooley, 88
catkins, **6**, **31**, 58, **82**, **206**
cauliflory, 68
cedar (*Cedrus* species), 62
cedar apple rust, 151–**152**
Celtis, 101
Cercis, 62, 228–229, **230**
 canadensis, 62, **66–68**
cherry (*Prunus* species), 44, 69, 72
cherry, black (*Prunus serotina*), 58, **92**,
 93, **94**, 101, **228–229**
chestnut (*Castanea* species), 58, 69,
 72
chestnut oak (*Quercus montana*), 2, **3**
Chinese chestnut (*Castanea mollis-*
 sima), 72, **73**
climax tree, 109
Cohu, Will, 28, 96
Cole, Linda, 229
Combes, Jean, 228
compound leaves, 41
cones, **58–62**, 69, 144, 149, 222
conifers, 60–62
Conklin, Robert, 230
conversion chart, 233
Cornus florida, 4, **5**, 24–**25**, 26, 41, 62,
 83, 84, **85**, 101, 231
cotyledons, 104–**105**
crape myrtles (*Lagerstroemia* species),
 90, 101
cross-pollination, 139

Damp Horse mnemonic, 101
Darley-Hill, Susan, 72–73
Deakin, Roger, 131, 132, 133
"debris," gifts of, 26–27
Dierauf, Tom, 222–223
dioecious, 144
Diospyros virginiana, **18**, 19, **69**, **72**,
 94, 96, **97**

Dirr, Michael, 136, 138, 178
dogwood (*Cornus florida*), 4, **5**, 24–**25**,
 26, 41, 62, 83, 84, **85**, 101, 231
Douglas-fir (*Pseudotsuga* species),
 58–59
drawing trees, 30

eastern redbud (*Cercis canadensis*),
 62, **66–68**
eastern red cedar (*Juniperus virgin-*
 iana), **140–152**
 bark, 90, 96, **97**, 151
 "berries" (cones/fruits), 69, 140,
 142–143, 144, **150–151**
 cedar apple rust/galls, 151–**152**
 "flowers" (immature cones), 147–151
 foliage, 141, 144, **145**, 152
 food for olive hairstreak butterfly,
 152
 as gymnosperm, 59
 range, 103, 141
 seed dispersal, 144, 147
 strobili, 60, 141, 144, **146–149**
Edlin, Herbert L., 104–105
elm (*Ulmus* species), 56, 57, 69, 72
 American, **54–55**, 56, 58, **70–72**
 slippery, **86**, 88
 winged, 101
English walnut (*Juglans regia*), 131,
 132, 135
Enz, Peter, 159
European beech (*Fagus sylvatica*), 96,
 109
Evans, Arthur, 50

Fagus, 56, 57, 69, 73, 90, 101, 128.
 See also American beech (*F.*
 grandifolia)
 sylvatica, 96, 109
fir (*Abies* species), 59, 60, 62, 219, 221
flowers, **52–58**, **62–68**. *See also*
 pollination
 appearance of, 58
 catkins, **6**, **31**, 58, **82**, **206**

cauliflory, 68
 discovering, 52–54
 noteworthy, **62–68**
 perfect, 57
 sex of, 56–58, 59
 stamens, 57, **182**, **184**, 185
 tendency to overlook, 18, 54–56
Fraxinus, 41, 56, 72, 84, 101
 americana, **56**, **57**, 58, 88
frugivores, 144
fruit, **69–81**
 achenes, 69, **121–123**, 125
 cotyledons, 104–**105**
 dispersal of, 69, 72–75
 mast/bust years, 73–75
 questions for observing, 72
 samaras, 1, 4, 69, **72**, 192–197
 study-worthy, 75–**81**
 terms to describe, 69
 time sensitivity of, 19

ginkgo (*Ginkgo biloba*; stink bomb
 tree), **153–167**
 distinctive shape, 156–157
 film of swimming sperms, 153, 165
 The Ginkgo Pages, 156
 history and range, 103, 156
 leaves, **154–155**, 157–**158**
 medicinal extracts of, 158
 odorous "fruit," 156, 158, **164–167**
 ovules, **154–155**, 156, 159–160, **162**,
 163
 pollination droplets, 160, 163, 165,
 167
 reproduction in, 153, 156, 159–165
 sex of, 158–159, 165–166
 strobili, **159–161**
 twigs and leaf scars, 87, 88, 156, **157**,
 229
Grady, Wayne, 58
gymnosperms, 59–60, 160, 163

hackberry (*Celtis* species), 101
Hamamelis virginiana, 58, 72, 84

Hatch, Peter, 79
Hayden, John, 163
Heinrich, Bernd, 24
hickory (*Carya* species), 30, 41, 56, 58, 69, 72, **73**, 101, 118
 shagbark, 32, **33**, **90**, 99, 101
holly, American (*Ilex opaca*), 24, 26, 28–**29**, 45, 50
Holthuijzen, Anthonie, 147
horsechestnut (*Aesculus hippocasta-num*), 26, **27**, 41, 62, 82–**86**, **88**, 101

Ilex opaca, 24, 26, 28–**29**, 45, 50
Internet resources
 general, 27–28
 ginkgo trees, 153, 156, 163
 maple helicopter flight, 176
 Project Budburst, 170
 Silvics for tree range, 103
ironwood (*Carpinus caroliniana*), 69, 90, 92, **93**–**94**, 101

jack pine (*Pinus banksiana*), 222
Japanese maple (*Acer palmatum*), 41, **46**–**47**, 50
jizz, 38, 92
Johnson, Carter, 72–73
journaling, 31–32
Juglans, 41, 56, 57–58, 69. *See also* black walnut (*J. nigra*)
 regia, 131, 132, 135
juglone, 130–131
Juniperus, 141, 147. *See also* eastern red cedar (*J. virginiana*)

Kirwan, Jeff, 135–136
Kwant, Cor, 156
Kyrgyzstan, 131–132

lateral buds, 82, 83
Latin names, 20–21
leaf-catching, 43
leaf scars, **85**–**89**

leaves, **38**–**51**
 appreciating leaf color, 41–45
 beauty of imperfect, 45, 50
 focus on leaf size, 38–39
 on leaf form, 39–41
 making leaf collections, 43–44, **46**–**49**
 marcescent, 42
 production of red, 44–45
 transpiration, 38–39
lenticels, 93
Lewis Ginter Botanical Garden, 26–27
Liebman, David, 152
linden (*Tilia* species), 58, 62
 American, 62, **64**–**65**, 68, **84**
 little leaf, 62
Linneaus, Carl, 20–21
Liquidambar styraciflua. *See* sweetgum
Liriodendron tulipifera. *See* tulip poplar (*L. tulipifera*)
little leaf linden (*Tilia cordata*), 62
live oak (*Quercus virginiana*), 77
loblolly pine (*Pinus taeda*), 218, 219, 222
locust, black (*Robinia pseudoacacia*), **22**–**23**, 24, **42**–**43**, 62, 84
London plane tree (*Platanus ×acerifo-lia*), 94, 118, 121, 128–129
Ludwig, Chris, 105, 106

Maclura pomifera, 69, 72, 78–**81**, **101**
Magnolia, 57, 58, 62, 181. *See also* southern magnolia (*M. grandiflora*)
 tripetela, 181, 182
Maloof, Joan, 30, 50, 169
Malus domestica, 62, 151–152
maples (*Acer* species), 41, 44, 45, 56, 69, 72, 84, 101. *See also* red maple (*A. rubrum*)
 Japanese, 41, **46**–**47**, 50
 silver, **100**, 101
 sugar, **87**, 88
marcescent leaves, 42

mast years, 73
McClure, Mark, 50
McDougle, Sandy, 52
Merwin, W. S., 205
metric conversion chart, 233
Mimosa, 41, 69, 212
Mitchell, Henry, 182
Molnar, Judy, 152
mulberry (*Morus* species), 41, 56, 58, 69, 72

Nabokov, Vladimir, 43–44
naked buds, 84
naming, pros and cons of, 19–21, 231
Natural History of the Oak Tree, The (Streeter), 201, 205
northern catalpa (*Catalpa speciosa*), **2**–**3**, 4, 62, **63**
northern red oak (*Quercus rubra*), **6**–**7**, **40**, 41, 101
northern white cedar (*Thuja occiden-talis*), 90, 96
Norway spruce (*Picea abies*), **60**
Nut Wizard, 130, 131, 132
Nyssa sylvatica, 20–21, 45, 50, **51**, **58**, 86, 88, 90, 101

oak (*Quercus* species), 41, 56, 57, 58, 72, 73, **76**–**79**, 82, **83**. *See also* white oak (*Q. alba*)
 black, 78, 84, 101
 chestnut, 2, **3**
 live, 77
 northern red, **6**–**7**, **40**, 41, 101
 overcup, 77
 post, **87**, 88
 sawtooth, 76–77, **78**
 southern red, 34–**35**, 41, 78, **79**, **87**, 88
 willow, **36**–**37**, 38, 77
olive hairstreak butterfly (*Callophrys gryneus*), 152
online resources. *See* Internet resources

open-pollinated trees, 41
Osage-orange (*Maclura pomifera*), 69, 72, 78–**81**, **101**
Out of the Woods (Cohu), 28
overcup oak (*Quercus lyrata*), 77

Packard, Winthrop, 221, 223, 225
Paulownia tomentosa, 39, 41, 62, 84, 101, **226–227**, 228
pawpaw (*Asimina* species), 58, 84
Peattie, Donald Culross, 216
pedicels, **12**, 13
peduncle, 185
perfect flowers, 57
Persian walnut (*Juglans regia*), 131, 132, 135
persimmon (*Diospyros virginiana*), 18, 19, **69**, 72, 94, 96, **97**
petioles, 190
photographing trees, 30
Picea, 59, 60, 62, 219, 221
 abies, **60**
pine (*Pinus* species), 60, 62, 92. *See also* white pine (*P. strobus*)
 jack (*P. banksiana*), 222
 loblolly (*P. taeda*), 218, 219, 222
 virginiana (*P. virginiana*), 60, **61**, 218, 219
pistil, 57, **197**
Platanus, 27, 43, 58, 90. *See also* American sycamore (*P. occidentalis*)
 ×*acerifolia*, 94, 118, 121, 128–129
pollination
 open-pollinated trees, 41
 pollination droplets, 160, 163, 165, 167
 self-/cross-pollination, 139
 showy flowers to aid, 62, 191, 192
 wind-pollinated trees, 56, 58, 170
Populus species, 56, 128
post oak (*Quercus stellata*), **87**, 88
princess tree (*Paulownia tomentosa*), 39, 41, 62, 84, 101, **226–227**, 228

Project Budburst, 170
Prunus, 44, 69, 72
 serotina, 58, **92**, 93, **94**, 101, **228–229**
Pseudotsuga, 58–59
pussy willows (*Salix* species), **82**

Quercus, 41, 56, 57, 58, 72, 73, 76–**79**, 82, 83. *See also* white oak (*Q. alba*)
 acutissima, 76–77, **78**
 alba, 8–**9**, 10, 40, 41, 198–212
 falcata, 34–**35**, 41, 78, **79**, 87, 88
 lyrata, 77
 montana, 2, **3**
 phellos, **36**–37, 38, 77
 rubra, 6–7, 40, 41, 101
 stellata, **87**, 88
 velutina, 78, 84, 101
 virginiana, 77

radicle, 77
Reading the Landscape of America (Watts), 179, 181–182
redbud (*Cercis* species), 62, 228–229, **230**
 eastern, 62, 66–68
red cedar. *See* eastern red cedar (*Juniperus virginiana*)
red maple (*Acer rubrum*), **168–177**
 buds and twigs, 87, 88, 101, 176
 flowers, **12**, 13, 20, 21, 56, 58, 168–174
 leaves, **44**, 45, **177**
 male fruits ("helicopters"), **74**, 75, 174–176
 Project Budburst, 170
 range, 103
 seedlings and seed leaves, 229–230
red oak, northern (*Quercus rubra*), 6–7, **40**, 41, 101
red oak, southern (*Quercus falcata*), 34–**35**, 41, 78, **79**, 87, 88
red oak group, 78

Reid, William, 133, 139
reproduction, angiosperm. *See* flowers; fruit
reproduction, gymnosperm, 58–62, 221–225. *See also* ginkgo (*Ginkgo biloba*)
resources, 27–28, 30
resting buds, 82
river birch (*Betula nigra*), 90, 94, **96**
Robinia pseudoacacia, **22–23**, 24, **42–43**, 62, 84
Rogers, Julia Ellen, 106, 111
Rogers, Walter E., 147, 149, 213

Salix, 56, 57, 58, 72, 101
Salix species, **82**
samaras, **1**, 4, 69, 72, 192–197
sassafras (*Sassafras albidum*), 41, 58, **59**, 90, 101
sawtooth oak (*Quercus acutissima*), 76–77, **78**
Scott, Peter, 15
seed cones, 58–60
seeds. *See* fruit
serviceberry (*Amelanchier* species), **16–17**, 19, 57
sex of tree, 62, 144, 158, 167, 170
shagbark hickory (*Carya ovata*), 32, **33**, 90, 99, 101
Sibley Guide to Trees, The (Sibley), 197
silver maple (*Acer saccharinum*), **100**, 101
Silvics of North America (Burns and Honkala), 28, 103
simple leaves, 41
Singlemann, Peggy, 62
slippery elm (*Ulmus rubra*), 86, 88
smooth alder (*Alnus serrulata*), 30–31
Sorenson, A. E., 147
southern magnolia (*Magnolia grandiflora*), 178–186
 flowers, **179–186**
 follicetum (cones), 182, 184–186
 human attachment to, 13, 178–179

leaves, 179, 186
pedestal/peduncle, 185
range, 103
seed birth, 185–186
stigmas, **182–184**, 185
southern red oak (*Quercus falcata*),
34–**35**, 41, 78, **79**, **87**, 88
Spalding, V. M., 214, 216
spruce (*Picea* species), 59, 60, 62, 219,
221
Norway, **60**
squirrels, 27, 80, 136, 168, 189, 223
stamens, 57, **182**, **184**, 185, 186
stink bomb tree. *See* ginkgo (*Ginkgo
biloba*)
stipules, **39**, 118, **119**, 189–190, **191**, **192**
Streeter, David, 205
striped maple (*Acer pensylvanicum*), 101
strobili, 144, **149**, **159–161**, 214
sugar maple (*Acer saccharum*), **87**, 88
Suzuki, David, 58
sweetgum (*Liquidambar styraciflua*)
appreciating, 13
bark and twigs, 86, 88, **99**, 101
flowers, 30, **52–53**, 58, 228
fruit, **15**, 27, 69, 75–**77**
leaves, 44, **48–49**, 50
pollination, 56
terminal bud, 84, **85**
sycamore (*Platanus* species), 27, 43,
58, 90. *See also* American syca-
more (*P. occidentalis*)
London plane tree, 94, 118, 121,
128–129

ten tree profiles, 13, **103–225**
terminal buds, 82–83
Thomas, Lewis, 212
Thoreau, Henry David, 75, 213, 214,
218
Thuja occidentalis, 90, 96
Tilia, 58, 62
americana, 62, **64–65**, 68, **84**
cordata, 62

transpiration, 38–39
tree-of-heaven (*Ailanthus altissima*),
21, 62, 85, **86**, 88, **89**
Trees, Woods, and Man (Edlin),
104–105
tree traits, **38–101**
bark and twigs, 90–101
buds and leaf scars, 82–89
experiencing the jizz, 38
flowers and cones, 52–68
fruit, 69–81
leaves, 38–51
pleasure of observing, 21, 24
as time sensitive, 19
and tree evolution, 15
tree viewing overview, **18–35**
appreciating tree vitality, 13–15
conclusions, 228–331
getting started in, 18–24
on naming, 19–21
recognizing tree traits, 21, 24
tree viewing strategies, **24–34**
drawing and photographing, 30–31
equipment, 32
gifts of "debris," 26–27
journaling, 31–32
making contact, 32–34
utilizing aids, 27–30
watching a singular tree, 26
Tudge, Collin, 222
tulip poplar (*Liriodendron tulipifera*),
187–197
ambivalence toward, 187, 189
bud and leaf scars, 82–83, 84,
189–**193**
bulk and bark, 195–197
flowers, 56, 58, **188–189**, 191–192,
197
fruit of, 69, 72
leaves, 38, **39**, 41, **102**, 190–191, 192
range, 103
samaras and cones, 192–**196**
stipules, 118, 189–190, **191**
twigs of, **87**, 88, 190–**193**

tupelo (*Nyssa sylvatica*), 20–21, 45, 50,
51, **58**, 86, 88, 90, 101
twigs, **86–89**, 92, 101

Ulmus, 56, 57, 69, 72
alata, 101
americana, **54–55**, 56, 58, **70–72**
rubra, 86, 88
umbrella magnolia (*Magnolia trip-
etela*), 181, 182
understory trees, 109

Virginia pine (*Pinus virginiana*), 60,
61, 218, 219
Virginia Tech study, 72–73

walnut (*Juglans* species), 41, 56,
57–58, 69. *See also* black walnut
(*J. nigra*)
English/Persian, 131, 132, 135
Watts, May Theilgaard, 179, 181–182
Web resources. *See* Internet resources
white ash (*Fraxinus americana*), **56**,
57, 58, 88
white birch (*Betula papyrifera*), 94,
178
white cedar, northern (*Thuja occiden-
talis*), 90, 96
white oak (*Quercus alba*), **198–212**
acorns, **8–9**, 10, 73, **209–211**
bark, 92, 101, **200–201**, 202
caterpillar pests, 204, 205
flowers, 205–**209**
galls, 211, **212**
inhabitants of, 201–202, 211–212
leaves, **40**, 41, 202–205, **208**
life span, 203–204
range, 103, 205
size and placement of, 202,
204–205
twig girdlers, 211–212
white oak group, 78
white pine (*Pinus strobus*), **213–225**
bark, 92

white pine (*continued*)
 candles, 214, 221, **224**, 225
 "flowers" (cones), 213–**218**,
 220–223
 needles, 219, **220**, 221
 pollen, 214, 216, **221**
 range and habit, 103, 218–219
 seed dispersal, 221–223, **225**

wild black cherry (*Prunus serotina*),
 58, **92**, 93, **94**, 101, **228–229**
willow oak (*Quercus phellos*), **36–37**,
 38, 77
willow (*Salix* species), 56, 57, 58, 72,
 101
winged elm (*Ulmus alata*), 101
winter buds, 82

witch hazel (*Hamamelis virginiana*),
 58, 72, 84
Wulf, Andrea, 140

yellow birch (*Betula alleghaniensis*),
 90

Zurich University Botanical Gardens,
 156, 159